D0484569

# Technoscience and Cyberculture

# Technoscience and Cyberculture

Edited by

Stanley Aronowitz,
Barbara Martinsons,
and
Michael Menser
with
Jennifer Rich

## Routledge

New York and London

Published in 1996 by

Routledge
29 West 35th Street
New York, NY 10001-2299

Published in Great Britain by

Routledge
11 New Fetter Lane
London EC4P 4EE

Copyright © 1996 by Routledge, Inc.

Printed in the United States of America on acid-free paper

All rights reserved. No part of this book may be reprinted or reproduced or utilized in any form or by any electronic, mechanical or other means, now known or hereafter invented, including photocopying and recording, or in any information storage or retrieval system, without permission in writing from the publisher.

**Library of Congress Cataloging-in-Publication Data**

Technoscience and cyberculture / edited by
Stanley Aronowitz . . . [et al.].
p.    cm.
Includes bibliographical references.
ISBN 0–415–91175–3. — ISBN 0–415–91176–1 (pbk.)
1. Technology—Social aspects. 2. Technology and civilization. 3. Science—
Social aspects. 4. Science and civilization.
I. Aronowitz, Stanley.
T14.5.T4464   1995
303.48'3—dc20                                                95–22528
                                                                    CIP

British Library Cataloging-in-Publication Data also available.

# CONTENTS

# Acknowledgments

This book is the product of a conference held in New York City by the Center for Cultural Studies at the City University of New York Graduate Center, in the Spring of 1994. The principal organizers were Barbara Martinsons, Stanley Aronowitz, and the 1993-1994 Cultural Studies Fellows, Michael Menser, Lauren Kozol, and Caroline Pari. Paul Mittelman, Sam Binckley, Joe Pilaro, Wayne van Sertima, Brian Bergen, Dustin Ehrlich, Foster Henry, and the entire audio-visual staff at CUNY were of indispensible assistance and made both the book and the conference possible. We would like to thank all of the participants of the conference for their contributions.

The editors gratefully acknowledge the permission of the following publishers to reprint for this volume these essays: St. Martin's Press, Incorporated, for "Virtual Capitalism" by Arthur Kroker, from *Data Trash* edited by Arthur Kroker and Michael A. Weinstein, copyright © Arthur Kroker and Michael A. Weinstein; Semiotext(e) Autonomedia, for "Mapping Space" by Jody Berland from *semiotext(e) CANADAs* copyright © Jody Berland; Duke University Press, for "Earth to Gore, Earth to Gore" by Andrew Ross, from *Social Text 41* (Winter 1994), and "Math Fictions" by Betina Zolkower, from *Social Text 43* (Fall 1995), both copyright © Duke University Press.

We would also like to thank Eric Zinner of Routledge for his encouragement and editorial expertise.

# Introduction

# Establishing Markers in the Milieu

*Jennifer Rich and Michael Menser*

With the advent in the last forty years of the fields of cultural studies and the social study of science, we have become cognizant of the ways in which technology is intricated within a wide range of both discursive domains and professional practices. Technologies are not merely enacted in these regions; the imbrication of technology alters the fields themselves and affects our attempts to map them and our activities within them.

The articles in this collection, although widely divergent in areas of inquiry, all mark sites where technology has altered or undermined the epistemic bases of disciplinary practices and cultural analyses. Each piece spotlights a nexus where culture, technology, and science intersect, alerting us to the ways in which this nexus is embedded in both practical and personal spaces including entertainment, sex, pedagogy, art, and the built environment.

In the first section, "The Cultural Study of Science and Technology: a Manifesto," Michael Menser and Stanley Aronowitz provide a tactical approach, alerting the reader to categories and concepts that may be useful in reading the essays that follow.

# Jennifer Rich and Michael Menser

The four essays in Section Two, "From the Social Study of Science to Cultural Studies," mark the field of studying science and the manner in which science is shaped by technologies and constructs narratives. In this section, Dorothy Nelkin provides a historical contextualization of the social study of science by tracing the evolution of new epistemologies of scientific and cultural investigation. In her essay, Sharon Traweek intervenes in the discourses concerning knowledge production, gender construction, social relations, and the role of the military through a comparative study of physics labs in the U.S. and Japan. She offers a critique of the metanarratives so often deployed by sociologists of science by situating herself as an "outside observer" in the lab.

"Everybody Will Count" is the utopian motto of a nationwide transformation in the teaching and assessment of school mathematics. Under the current reform—the "new new math"—traditional word problems increasingly adopt the form of open-ended, realistic, and multicultural story problems. Reconstructing in the form of a play the ethnographic evidence drawn from field work in the fourth and fifth grade classrooms of the public bilingual school in El Barrio (East Harlem, New York City), Betina Zolkower examines the dystopian effects that result when the subjects-supposed-to-count are interpolated by these math fictions.

In the final essay of Section Two, three proposals are made for the cultural study of (techno)science. In her article, Emily Martin focuses on the situatedness of scientific practices and knowledge production within the discursive domains of politics, cultural ideolog(ies), and environment(s). Employing the concepts of the citadel (walling in and walling out scientific inquiry), the rhizome (the actual, unmappable, and inextricable interconnectedness of science and culture) and the string figure (a conceptual telescoping of the shifting cartographies of the relations of science and culture), Martin presents a picture of a ceaselessly heterogeneous patchwork of (inter)relations between science, culture and technology.

In Section Three, "World, Weather, War," Andrew Ross, Jody Berland, and John Broughton survey the post-Cold War applications of technologies produced by the military-industrial complex both for its continued economic viability and for its preservation as a hegemonic and determining force of both cultural and technological/scientific innovation. In his analysis of the current

2

legitimation crisis within business and the military, Ross discusses a largely ignored aspect of Al Gore's *Earth in the Balance*, arguing that Gore charts a new site of deployment for the military-industrial complex: a global, environmental Marshall Plan. Jody Berland examines another deployment of corporate and military technologies: the construction of Canadian nationhood through the sophisticated techno-territorializing of its topography and weather. Through this function, the military-industrial complex becomes a protective and domesticating force, foretelling natural and military disasters and thus presenting itself as an indispensable investment in both the security and self-image of Canada. In a similar vein, John Broughton examines the televising of the Gulf War's "smart bomb" video to discuss the domestication of the military apparatus and its exploitation of the various psychodynamics of self-identification.

Section Four, "Markets and the Future of Work," comprises three essays that explore the relation of class, employment, and global and local technological systems. William DiFazio looks at a variety of local job sites (from medical labs to longshoreman to the welfare office), and examines the role of technologies in the deskilling of workers and the overall displacing of labor both functionally and ideologically. Arthur Kroker assesses what he considers to be the technological-media monolith by way of a refiguring of Marxist class analysis. This amounts to a "Theory of the Virtual Class" and an analysis of the utopian visions of the resulting economic and social divisions. Manuel De Landa occupies a counterposition to Kroker—and to many of the other essayists—by critiquing the notion of monolithic, global, capitalist systems, and by conceptualizing "capitalism" as an antimarket, and through this conceptualization, charting a history of contramonolithic markets.

In Section Five, "Bioethics," two analyses are offered, examining the implications of medical science's alliance with the legal code in determining issues concerning the ethics of health care. Philip Boyle discusses the background for ethical thought on these issues. Ralph Trottier recounts his research on epidemiological work carried out in Georgia and Florida.

Section Six, "Risky Reading, Writing, and Other Unsafe Practices," continues some of the issues addressed in Section Four by constructing a kind of "reading/writing" that attempts to rewire cultural notions of "safety,"

"other," "self," and "security." The first paper in this section focuses on the American Psychological Association's endorsement of current popular and scientific pathologizing of the coupling of children and desire. Peter Lamborn Wilson provides a critique of the production of striated psychic, cybernetic and bodily spaces and the concomitant attempts at safety through inviolability. Barbara Martinsons considers the technologies of "reading" photographs and the possibilities of agency (or, in Heidegger's language, *presencing*) for photographic subjects. Samuel Delany suggests that science is the theory of technology and that literature—through its mass production by the printing press and typewriter—is one of its manifestations. Instead of Bakhtin's dictum that all written works are novels, Delany follows Cocteau's (and Heidegger's) move, in which all art, indeed everything valuable in the world, is poetry.

In Section Seven, "Visualizing and Producing Anarchic Spaces," Lebbeus Woods and Michael Menser examine how the interconnection between traditional architectural paradigms and commercial and state interests results in the production and surveillance of cultural spaces. Woods analyzes contemporary architectural practices that privilege consumerist approaches to the design of cultural spaces. Menser's essay continues the discussion of cultural space by claiming that the state is the chief producer of space and the condition of possibility for architecture. Like De Landa in Section Four, the Woods and Menser essays point to the heterogeneity among technocultural practices and redeploy philosophical concepts and controversies into cultural spaces.

# I

# The Cultural Study of Science and Technology: A Manifesto

# 1

# On Cultural Studies, Science, and Technology

*Michael Menser and Stanley Aronowitz*[1]

## I. Introduction: On the Relations among Science, Technology, and Culture

The problems addressed—and continuously refigured—in this collection of essays concern the ways in which technology and science relate to one another and organize, orient, and affect the landscape and inhabitants of contemporary culture.[2] Culture, science, and technology, although distinct on specific levels, have been and continue to be inextricably bound to one another in such a fashion that each actually merges *into the other*, laying lines of contact and support. These relations involve a kind of complexity which prohibits us from claiming that any one of the three is distinctly prior, primary, or fundamental to one of the others. Various kinds of relations ensue (and are possible): technology shapes culture; science epistemologically grounds technology; science as an epistemology presupposes the technological; (techno)culture produces (techno)science; culture is always technological but not always scientific, and so on. Furthermore, science often legitimates one cultural practice over another as in the normative approach to physiology in which science distinguishes/legitimates what is "natural" and prescribes corrective therapy for what it deems "unnatural."

In order to undertake the *cultural study* of technoscience, we begin with the following propositions: (1) an inquiry into the practice and effects of science must internally locate the systems and objects of technology; (2) an

investigation of critical sociocultural issues such as (un)employment in the global market, violence and American culture, or the Human Genome Project must consider the involvement of technological "advances"—whether in the manner of an invading army, a logical argument, or a "new" and/or "improved" product—into various cultural spaces or institutions (including legal, medical, art- and media-related, religious). (3) Because of its social, cultural and politically privileged relation to what is "true" and "universal," and the way in which it simultaneously deploys and is constituted by technological development, the discursive-ideological role of "Big Science" is more than just one cultural practice among others. In contrast to the position of many practitioners of the new social studies of science, science is not "just another cultural practice or discourse," nor is technology "just another" set of objects.

Cultural critics, both contemporary and otherwise, have often claimed that science is the dominant institutional and ideological player in the global cultural scene, the one that most dramatically affects, or, more precisely, permeates (but does not determine) our corporeal, subjective, and social being. Yet science itself is dependent upon technologies, in such a way that it is not simply a theoretical enterprise which smoothly subordinates technological advancement in order to produce "applied science." However, just because science "depends upon" technological advancement does not mean that this advancement determines either scientific practices and ideologies or scientific status and power. Technology does not *determine* social organization nor does it *cause* the rise of global capitalism (see De Landa, this volume). We claim that, although technology and science may be everywhere, there is no determinism anywhere, if by determinism we signify a one-to-one correspondence between the causal agent and its effects; rather technology *permeates*, or inheres in, all these regions, practices, and ideologies. Consequently, cultural studies must critique determinism in all its forms (political, economic, philosophical, religious, technological, scientific), including the language of causality and must, as an alternative, construct a theory of *complexity*.

## Complexity/Complication

Our counter to determinism is a theory of *complexity*, of complications and implications rather than determinate sequences of causes and effects. To complicate is to be transgressive, to "mix things up," to *ontologically* complicate things so as to break down "disciplinary" boundaries which have abstractly extracted and com(de)partmentalized to such a degree that the objects of study have been "emptied out," casting nature, culture, and technology as closed

systems or pure objects where each one brackets off the other.

This method of *complication* makes us question the relationships of the key themes under consideration and allows us to gain a certain footing, though perhaps still quite a precarious one. As such, technology *challenges* us in such a way that it has displaced both its users and critic-users (there is no simple separate category "critic"). The objects of our critiques have become impure, confused, indistinct, "fuzzy" in the way in which even mathematics has accepted "inexactness" as sometimes closer to the way things really are.

To "complicate" means to bring together that which lies close, to recognize the multiplicities inherent in these now indeterminate objects and "fuzzy" events. In the case of the hi-lo debate, mass (technological) media such as television and the like are said to "lack" culture even though "high" cultural objects such as a minimalist painting or a Godard film obviously involve and employ technologies too (although perhaps technologies are perhaps employed differently in "high" and "low" cultures).[3] Nevertheless, both these cultures are technological, that is, technocultures. In fact, the significations of neither minimalist painting nor a Godard film can be understood outside the technologies which they employ. As Stanley Cavell and others have argued, film is a new ontology: its transformed experience transforms all experience. And it may be said that minimalism calls attention to painting as activity rather than representation. Fabrication is not representation; it is autopoeisis.

*Technoculture(s) and technoscience(s)*: such wordplay resolves nothing, but it complicates everything. It forces us to realize that the technological is not so easily distinguished from the "human," since it is within (medical technologies, processed foods), beside (telephones), and outside (satellites). Sometimes we inhabit it (a climate-controlled office space), or it inhabits us (a pacemaker). Sometimes it seems to be an appendage or prosthetic[4] (a pair of eyeglasses); at other times, human beings appear to serve as the appendages (as in an assembly line). Things and their events and states are complicated. Technologies often "relate" to us; at other times we relate to them. The flows are rarely unidirectional; or alternatively (the heterogeneity thesis), perhaps there are many different kinds of technologies, and each "class" effects us in very different ways.

What follows from this seemingly "groundless" footing is that any proposal presupposing some sequential progression of distinct stages comprised of "pure" objects will not respond to our problem; it will not *implicate* technology. What we intend is a "frontal assault" beginning with categories and concepts which are so entrenched in our culture that they are too easily thrown around (despite their excessive "dead weight")—technology, science,

culture. These categories have lost their disciplinary and ontological integrity since, in the realm of experience and ontology, each of them is permeated and penetrated[5] by the other two (again, in multiple ways and to varying degrees with differences of privilege). However, our methodological position is such that the critique deployed amounts to a head-on collision with what has been characterized as disciplinary and institutional methods (and culture). Donna Haraway, astute cultural critic that she is, mounts a different *approach*. One might call it a "backdoor assault," beginning with the appropriation of a somewhat marginal (fictional) concept, the cyborg, which amounts to the utilization of a literary and cinematic narrative device *realized* as a concept for an ontological and phenomenological treatise deployed in the form of a manifesto.[6] However, Haraway's *position*—but not her approach—on technology, science, and culture is one which we largely share. As such, with Haraway, we are against positions which:

> from *One-Dimensional Man* (Marcuse, 1964) to *The Death of Nature* (Merchant, 1980), espouse the analytic resources developed by progressives who have insisted on the necessary domination of technics and have recalled us to an imagined organic body to integrate our resistance.[7]

## II. Studying Culture — Cultural Studies

### A. Reading Culture(s)

American culture is technoculture, from the boardroom to the bedroom. This is not to say that there is just one American culture; there are many, yet each is a technoculture. Truckers and cyberpunks, rap musicians and concert pianists, even hippies and the Amish all employ technologies in such a way that their cultural activity is not intelligibly separate from the utilization of these technologies. The Amish have their wagons and farm equipment, the hippies their Volkswagen buses. The rap DJ has his or her turntable, which is employed differently from the turntable of a commercial radio DJ; the cyberpunk has a computer complete with modem, and this utilization differs from the accountant at his or her computer console.

One cannot simply list the beliefs, ideologies, and activities of the American "people" without examining their objects and technological systems and understanding that they too are "American," even though, as sometimes happens, the objects and values seem to be contradictory. Consider motor-cycles, for example: just as the Harley Davidson is "American"

so is the sometimes maligned Kawasaki *Ninja*. Derogatorily called a "rice-cooker" by more-American-than-thou down-home, nationalist types, the *Ninja*, marketed for U.S. consumption, embodies a separate American authenticity—the desire for sleekness and speed—more than does the Harley. Yet, the Harley-Davidson, with its excessive rumblings and low-rider seating, plays to the American need for "individuality" (although realized by a process of mass production)—to be noticed, to put on a show—including the spectacle of leather pants and jackets (one of the uniforms of individuality), burnished chrome, and a gratuitously vibrating throttle (which is not about just function but the "show"). The point of this example is that distinguishing what is "of" a particular culture is quite difficult (or controversial in this case): products designed and produced by the Japanese can be quite American, or, in other cases, appropriated as such. What technologies have made explicit is that cultural boundaries have always been more or less *permeable*, and cultural objects both transmit cultural beliefs and practices yet remain *indeterminate*.[8] Even age-old traditions reproduced through millennia selectively adopt new technologies, as in the recent case of various Tibetan orders' utilization of CD-ROMs for the storage of the most sacred of scriptures.

Although these technologies are not specifically "American," we can see how the elements of the spectacle are incorporated into many branches of science. The microparticles that are the "objects" of theoretical physics must be "visualizable," that is, they must be subject to visual representation in order to prove that "crudely" constructed paper-and-pencil models are, in fact, representations of the real world (thus, in the essay by Samuel Delany, science is a theory of technology, not of the "real world"). The picture *is* the model for any possible scientific statements. In recent decades, as concepts such as "strings" and "fields" have edged "objects" to the margins, the problem of visualizability has become more intense: how to represent the (indistinct, indeterminate or "fuzzy") unrepresentable and maintain the underlying claim of all science that its objects are, in principle, subject to observation (or at least representation). Indeed, observation remains, despite much discussion, the last outpost of refutation.

This issue became "dramatic" during the competition between Pauling's postulation of the triple-helix structure of DNA and the opposing double-helix position of Watson and Crick. Even though Pauling's was the earlier conjecture, once the double helix was seen in a photomicrograph (even though the scientists who took the picture had no "knowledge" of what they were looking at) and then "pictured" (and identified), the two-strand model won the day ("stole the show"). The centrality of the visualized, of the spectacular, in the construction of scientific proofs, as in the design of a motorcycle,

may, from a cultural perspective, outweigh mechanical reliability or even the most convincing "purely theoretical" reasoning.

American culture cannot be totally understood, either pragmatically or ontologically, by the descriptions of practices carried on within its geographical boundaries. Indeed, it is doubtful that any culture, especially nowadays, can ever be identifiable simply as what takes place within its spatial limits—especially with the proliferation of diasporas—however, we must be careful when we speak in such language since spaces themselves are constructed differently by cultures and technocultures. That is, space (both as a mythical-scientific-philosophical notion and as a material, "lived in" territory) is a cultural product, shaped by human beings, technologies, and the "earth itself."[9] The earth too is social and socializes us.[10] This last point raises one of the more contentious methodological issues in contemporary social sciences: the question of social constructionism and the ascription of agency.

Reacting against biological determinism that, among other treacheries, has buttressed the notion that individual and collective life chances are inherent in the human physical constitution by virtue of race, gender or ability, "progressives" have militantly offered the countertheory according to which *everything* is socially constructed. In this extension of a neo-Kantian framework, all questions of affectivity and signification are subsumed under the categories of the social and the invocation of materiality is seen as an insidious pretense for reproducing inequality (or at best is a naive and dated endorsement of empiricist objectivity). Even Foucault who, in any case, was ambivalent about this question, has been recruited to the social-constructionist side.

Yet, even if sexuality, for example, signifies a culturally permeated discourse, it is not solely constituted by the elements of discourse. Of course, we do not engage in sexual activity merely to reproduce the species, although biological reproduction is one of the serendipitous outcomes of some "pleasurable" sexual practices. Discourse, institutional power, and culture push the boundaries constructed by biology and physiology, and indeed permeate the soma, not to say the human genome, in ways that many writers, including Freud himself, have suggested. But permeation's "pushing the boundaries" is not the same as eliminating entirely the materiality of sexuality (indeed, it may even presuppose it). Just as, notwithstanding its many variations, eating is not entirely subsumed by culture but responds to physiological necessity, sexual life is, most invisibly, shaped by large historical, biological, and even geo- and ecological movements over and about which the individual, community, and nation have little consciousness or practical-functional

understanding. While it is undoubtedly important that recent work on sexuality stresses the extent to which the causal relation of nature and culture needs emendation, the pendulum may have swung too far. Below we offer, situated among others who have worked in this area, an alternative to the binary of bio-physiological and cultural explanations of human events, by suggesting the category natures-cultures. On the way, we address issues of determinisms of all sorts of theories of causality as a mode of reasoning in philosophy and the human sciences.

## B. Framing Technology

When technology is implicated, we discover that its composition is akin to a knot—a classic kind of "problematic" since, when a knot is untied, something once tightly fastened is let go. Cultural studies emerges from and is assembled within this knotted contemporary landscape of technoculture(s) and its correlate technoscience(s) through a charting of the lines without untying the knot. As for the claim that specific cultures are hegemonic, and, that technologies are employed to enforce and expand this hegemony, how does the claim change if the culture itself is "technological"? What does the deploying and what is employed? Perhaps it is more accurate to say that technoscience's employment of universal concepts is what is hegemonic (by definition since, according to many, the laws of science are universal a priori, and even among those who dissent, who can argue with what science has "accomplished"?). How then does technoscience relate to technoculture? Are the two distinct? We claim that the two are not equitable, yet their separability is even more controversial. For example, De Landa (following Haraway and Deleuze and Guattari among others) argues that there is heterogeneity in scientific practices and technological apparati, whereas Kroker and many others consider the apparatus to be monolithic, and see American techno-culture as hegemonic without bringing science into question."

Through the implementation of a kind of "complexity theory," cultural studies may recognize the always-present complexity of technologies, and chart the manners in which a technocultural entity or apparatus takes on different functions or produces different effects when it changes *milieu* (as with the Coca-Cola bottle dropped from the sky in the film *The Gods Must Be Crazy*). Again, the shape-shifting nature of cultural studies can be seen to be quite adept in following the varying relations in which technologies are constructed and deployed in order to follow the multiple effects and

# Michael Menser and Stanley Aronowitz

subordinations that are produced, disseminated and reproduced—entrenched, in various contexts. It is equally crucial to avoid positing universal descriptions or analyses of what it is that technologies mean (signification) and do (both in terms of their hegemonic power and functional capabilities). For example, for many in the U.S., the Internet and the building of the information superhighway *may* offer subversive, antihegemonic possibilities to computer users. This *may* allow a different sort of culture to emerge, one with values which are less commercial, antipanoptic, and procommunity. "Hacker culture" has, to a degree, embodied this, and the relatively "free" flows of information generated by the "Net" to date do offer some real possibilities for alternative social-informational arrangements not offered by other media (TV) or social institutions (schools). However, these countertendencies made possible by new technologies do not warrant the overly optimistic or utopian assessments offered by various technophiles. This is a hot topic for many of the essayists in this collection (see especially Kroker, De Landa, Berland, Menser, Ross, Delany, and Wilson). It must be admitted that the "Net" is still frighteningly male-dominated (or does gender difference become imperceptible in cyberspace?), and the access to computers across socioeconomic and class lines is severely limited.[12] Nevertheless, we may speak somewhat optimistically of the rhizomatic, decentralized, antihierarchical relations which the Net has begun to offer. Yet, what happens when we shift *milieu?*

In China, the word "network" does not give rise to such notions of the subversion or decentralization of power. In his essay "In the Kingdom of Mao Bell," science-fiction author Neil Stephenson (sadly) reports that in Han Chinese, "network" was "the term used by the Red Guard during the Cultural Revolution for the network of spies and informers that they spread across every village and neighborhood to snare enemies of the regime."[13] What good is the Net if the purveyors of power are the only ones who have access to it?[14] It makes power that much more imperceptible and more difficult to appropriate and subvert. In terms of the reception of advanced information technologies—faxes, modems, cellular telephones, computers—Stephenson argues that China neither fears nor fetishizes technology as Americans do, but instead subordinates it quite "practically" to facilitate most of their cultural norms (which are anti-individual but also antimonolithic since they involve mostly small-scale business enterprises). Local enterprises are better linked and informationally connected to each other, but because of many "impediments"—cultural, conceptual, and arbitrary—no "hacker culture" has emerged, nor has much democratic desire ("information wants to be free" is not a popular slogan). Stephenson in contrast to much of modernism, recognizes that the mere appropriation of a computer network does not necessarily produce new cultural ideas

(although so many modernists do! See Latour's *We Have Never Been Modern*, 1993). However, in a more "optimistic" moment, Stephenson suggests that the Chinese are somewhat fed up with their overtaxing, excessively centralized government (which was created, let us not forget, through the importation and refiguration of a Western idea, Communism), and watch lots of TV beamed in through Hong Kong. Thus, a backlash of sorts is possible. This is already happening in Canton province, although we most likely will have to wait for the annexation of Hong Kong to see what will happen next.

At this stage, it is perhaps helpful to employ three methodological distinctions inherent in our questioning and locating of the technological. The first is *ontological*: what technology is. On this plane of inquiry, we offer a theory of complexity which posits that technology, science, and culture all mix together along a continuum such that each object, to varying degrees, is the result of each of these three. The second is *pragmatic*: what technologies do; and third is *phenomenological*: how technologies affect our experience in ways that are not bound to questions of function. In regard to the example of the motorcycles, the pragmatics of these technologies is most evident in terms of the *Ninja*, which employs developments in building materials and combustion systems that enable the rider to travel faster. In the case of the Harley-Davidson, the issue of phenomenology arises; here the point is of the spectacle, of being on display. The more advanced *Ninja* loses out to the Harley on this issue (although its ability to rapidly accelerate is certainly spectacular, the characteristic "on display" mode of "cruising" is not so feasible precisely because of its speed and "aerodynamic" seat design which has the rider lean forward onto the gas tank). Thus, even in the land of jet fighters and supersonic air travel, of "efficiency" and "whatever works," there is an aesthetic-phenomenological component to technologies which sometimes supersedes that which is labeled "more advanced" (efficient) and high-tech (up to date). Technocultures do not employ technologies just for pragmatic reasons, but for social (or class) status and the "spectacular" effects that shape experience.

By briefly drawing these methodological distinctions, we are again trying to make evident that technology and its relations to science and culture are increasingly complex, and not simply a matter of such ideological values as "functionalism" and "efficiency." Let us take another example. Current systems of communications (telephone, fax, e-mail) make possible a kind of "closeness" by way of a relatively speedy exchange of oral or written content. Some exchanges are made in days and weeks (mail), others in "real time" (certain forms of computer bulletin boards, and so on). Provided we agree to leave our bodies behind, we are able to enter these increasingly "efficient" planes of semiotic exchange.[15] In terms of transportation, trains, planes, and

automobiles have seemingly caused space to "shrink," (provided one first has access to a certain flow or accumulation of money). This "shrinkage" occurs, however, on the experiential (phenomenological) plane. The world has not actually (ontologically) decreased in physical size. Nevertheless, even on the phenomenological plane, this shrinkage is somewhat dubious.

In each of these cases (transportation and communication), technologies are able to link because they simultaneously bypass. Thus, again on the phenomenological plane, time and space *appear* to physically "shrink" such that (certain) distances are overcome, but other experiential distances are created. Thus, for example, I talk to a "close friend" in Washington D.C. (from my apartment in New York) more often than I talk to my neighbor. My neighbor is bypassed, my friend 250 miles away is linked to me. (In a more "rural" area, for example the Bighorn Mountains of Wyoming, neighbors can become literally indispensable for survival.) Notions of community and "neighborhood" have drastically shifted such that what is physically near is—in some contexts—so easily overcome that it often bears no relation (is not a "neighbor") to us, or we bear less of a relation to it precisely or in spite of the fact (this is the complexity) that we are so (spatially) close. Thus, technology does not shrink all space and time, but instead links-bypasses. The two are inseparable. Technological networks which establish new connections selectively accent or displace previous ones.

## C. On Studying Culture and Challenging Intellectual Diversity

This collection contains a series of critical forays into the debates surrounding technology, science, and culture all of which are heterogeneously tied to what we call "cultural studies." This is, among other designations, the name we give to the transformation of social and cultural knowledge in the wake of an epochal shift in the character of life and thought whose origins and contours we only dimly perceive. If we grant the proposition that the personal is the political, does this transformation guarantee that the political has any kind of efficacy when entrenched along the terrain of technoculture? What we do know is that the old formulae no longer add up. Whether inspired by Marx, Nietzsche, or Heidegger—the three thinkers who, according to some (Allan Bloom among others), have egregiously sundered the old certainties of ancient philosophy upon which our civilization rests—social and political thought has grown accustomed, however uncomfortably, to uncertainty. Whereas knowledge within the disciplines operates according to algorithms that are regarded as ineluctable to the objects to be studied, the antidiscipline

of cultural studies asserts that disciplinary rules are signifiers of a discursively constituted regime of truth complicated and implicated in power. And, against one of the hallowed mantras of modernity, cultural studies refuses to exempt technology or, especially, science from this assertion.

### Situatedness: On the *Milieu* and the Problematic

Cultural studies always emerges "in the middle of things," within a certain set of surroundings—historical, temporal, geographic, ethnic, sexual, technological—that is, in a *milieu*. Cultural studies relates to this *milieu* by way of the construction of a *problematic*. The methods of cultural studies are transgressive and interventionist (as opposed to disciplinary or *"com(de)part-mentalized"*[16]), largely because of the space from which they are employed. Although the space of cultural studies is not institutionally "central," it is not accurate simply to label it "marginal" or "far from the center of things." Rather, cultural studies is "on the margins," traveling along that in-between space where boundaries mark off, privilege, or displace one space or practice from another.[17] Cultural studies inhabits a *borderland* (to use the term of Gloria Anzaldúa [1987]), a space not striated (com(de)partmentalized) by fenced-in flows, but a place where each act produces an incision (no matter how small). Cultural Studies cuts out spaces from existing disciplines, not to cordon off but to connect, to stitch together patches of students and professors: an imperfect and impure (heterogeneous) patchwork which smooths out a space so that those who choose to forgo the pseudosanctity of the disciplinary "preserves" may come and go.[18]

Cultural Studies begins in the middle, an intercession interfering with the relations among persons, places, and things without entirely (transcendentally) detaching itself or totalizing the field of inquiry. Cultural studies has no first principles, fixed means, or established ends, but instead, always begins in a middle (*milieu*) with a situation or problem *from which* it forges and navigates an in-between space where methods from existent disciplines—sociology, philosophy, history, literary theory, and others—may be appropriated and refigured. This kind of appropriation amounts to a transformative deployment, since methodologies once entrenched within a disciplinary interior are now positioned "out of place." Also, new methods are assembled (for instance, Haraway's "Situated Knowledge," Woods's "Anarchitecture," and Deleuze and Guattari's "Cartography." Also see Menser's "Becoming Heterarch . . .")[19] which emerge or are "carved out of" a cultural terrain, built within and around issues and events which come to signify and organize our

cultural landscape. Cultural studies' position is "out of place" and its methodology is bound to a continuous heterogeneity which forbids theoretical totalization and, on the contrary, enables "an intimate experience of boundaries"[20] such that boundaries are no longer lines of division but actually are places to inhabit and/or pass through (boundaries are planes rather than abstract, two-dimensional lines; they are "borderlands").

## D. Cultural Case Studies

### 1. TV and the Human Genome Project

Television combines various material devices (auditory and visual) and bears on different aspects of cultural life (aesthetic, experiential, and functional). It plays a fundamental role in politics (news media), economics (consumer-oriented programming, the structural entrenchment of advertising in the "commercial break"), and passively positions the viewer (the sedentary couch potato) before the ever-more "spectacular" program. Television alters perceptions of space and time, of distance and nearness, and changes what counts as and constitutes experience, thus: "I've never been to L.A. but who would want to go there with all those riots, fires, and earthquakes"; or, similarly: "But that's not how Arnie handled the husband's demands on *LA Law*."

The multiple lines of constitution are just as complex in regard to the largest funded scientific undertaking in the world: the Human Genome Project. What might seem to be an impartial endeavor placed under the auspices of a subarea of biology (genetics) is also crucially linked to such diverse fields as insurance, law, and medicine and their institutions, as well as profoundly shaping debates around issues of privacy rights, the integrity of the human body, and the problematizing of what is natural (human), or what constitutes personal or social identity.

The Human Genome Project's complexity involves everything from genetics techniques to ethical and legal theory. The television is a *complex object*, constituted by and related to many fields, from solid-state physics to politics. Television and its critics, each of us included, all lie along a specific kind of cultural continuum such that each object (or person or field of inquiry) inheres in or inextricably relates to the others. Most crucially for us, both the genome project and TV are composed by and related to technoscientific production and the "technocultural" in general. How could a single-disciplinary study deal with either of these topics?

With this said, it should be clear that we do not seek "intellectual diversity" merely to obey the current fashion for "multi"-this or "inter"-that.

What we ask of our theories and theorists is a rigorous analysis of the objects (if they still exist) and relations that compose each (group of) individual(s), with each theorist focusing on particular issues (for example, the impact of the way the "war on drugs" is presented on TV, or the implications for U.S. health care of the Human Genome Project) or relations (for example, class's relationship to technoeconomic "advancement") which are then tied to, rather than abstracted or extracted from, the cultural continuum of various practices, values, and institutions, and apparati of power. Because these objects and issues are multiplicities in themselves, the strictures of disciplinary critique often fail to recognize the complex nature of the objects, the relations constructed, and the many effects that result.

## 2. Mass Media Culture

In these times of fragmentation, plurality, and fracture, is it feasible to posit something called "mass" culture? Yes, but the term must be (and has been) contextualized in terms of the segmentation of audiences, and therefore of genres, the persistence of (ever-diminishing) spaces of resistance to homogenization, and the effectivity of technology. Mass culture or mass media implies (as in mass production) that there is a production of a great quantity of more or less uniform objects (be they information, things, images, or narratives) which are then disseminated to a great quantity of users or receivers. In the case of mass media, television programs have reached audiences of more than a billion—as in the recent case of the 1994 World Cup soccer games. To us, mass culture is defined by homogenized content disseminated to an audience whose collective characteristics are increasingly cut from the same cloth. This is not to say that there is one culture and it is "massive." There is a mass culture that many of us share, practice, or receive (or (re)produce), but it is constituted by various, often diverse, groups.

From the mid-1950s through the 1960s, culture critics, philosophers, and social analysts were preoccupied with the effects of this supposed technologically induced massification of culture on the closely related issues of individuation, everyday life, and politics. From left to right there seemed an almost unanimous agreement that television was a catastrophe, and that the greatest hope of the enlightenment—the rational, independently minded individual rising to ever greater mental challenges and improving human existence as he or she did so—was all but nullified. The pervasive technophobic pessimism of mass culture dominant in intellectual critics has proven shortsighted. Nothing was or is as monolithic as they feared. Surely, the

outpouring of cultural studies of various media and popular culture genres demonstrates nothing if not diversity in content as much as in audience for TV's products. Still, despite these refutations, the thesis of the cultural apocalypse lingers.

Even as mainstream trade publishers calculate their offerings on purely market-based criteria—indeed the numbers game has virtually displaced all other criteria for trade publishing—a proliferation of smaller imprints, including university and academic commercial presses, is increasingly occupying the space vacated by the biggies. As desktop computer programs have become the publishing technology of choice, the way has been opened for a proliferation of specialized firms. In the face of this truly radical shift in the character of publishing, the number and influence of independent bookstores oriented toward more serious "general reader" books has actually grown in this era of corporate mergers and acquisitions. Fifteen years ago, analysts confidently, if mournfully, predicted the demise of the bookshop and the rise and dominance of the shopping mall bookselling chains such as B. Dalton, Pickwick, and, more recently, the highbrow Borders. Almost no one foresaw the emergence of smaller stores which carry university and academic press books as well as the trades, and which offer to special-order almost any title in print.

This surprising development may be viewed as further evidence of market segmentation, but it also attests to the resilience of the serious reader. Needless to say, this is an instance of how computer technologies contribute to diversity not only at the level of production and genres, but also in terms of maintaining, even generating new audiences. With the development of electronic publishing, books and their markets are undergoing yet another transformation. Like the earlier centralization, which witnessed the conglomeration of publishing with information and entertainment industries, the coming merger of books with informatics will not remove issues of access. Just as computerization of library services has resulted in a horrendous decline of browsing and casual book-reading, and a concomitant refiguration of the library as a site of information search, so informatics puts a new spin on the market: If the book is an instance of hyperspace, is the computer screen a new branch of television? Does paperlessness make reading a virtual experience?

## III. Cultural Studies Means Studying Technology (and Science, too)

We would now like to make a further claim regarding the theoretical activity of cultural studies. It is often assumed that one of the principle features which distinguishes cultural studies from traditional disciplinary study is its

recognition of the cultural embeddedness of knowledge production. Cultural studies inquires into the conditions from which it establishes its questions, issues, methods, and objects. That is, it continuously interrogates its own subject position and the role this particular locale plays in the shaping of its theoretical discourse, as well as registering the political implications of this position. Essential to this "situatedness" is an interrogation of what overtly stands as the most "essential" feature of cultural studies: "culture." Thus, if there is some fundamental "ground" in cultural studies, it is this troublesome category, and we propose that perhaps the most effective category for problematizing culture—and the study of it—is technology. What also arises here is a theory of complexity which critiques the traditions that still adhere to concepts of causality and its correlates "progress" and determination. Analytically, there can be no *progress* without *causality*.

In *We Have Never Been Modern*, Bruno Latour problematizes culture by challenging its distinctness from nature, arguing that "the very notion of culture is an artifact created by bracketing Nature off. Cultures—different or universal—do not exist, any more than Nature does. There are only natures-cultures, and these offer the only basis for comparison."[21] We agree, but wish to add that the same goes for technologies. They, too, are bracketed off in such a way that they are *mistakenly* seen as distinct entities, often deployed by certain (usually Western)[22] cultures to bring about specific changes ("progress") within cultures, either close to home, or hegemonically to appropriate and annihilate the practices of less technological cultures. While we certainly do not deny that certain cultures dominate others, the nature and role of technologies are more complex and ambiguous (and certainly less deterministic) than some critics of the enterprises of modernity claim.[23]

Technology is not simply a system to be deployed—as the U.S. Army was deployed in the Persian Gulf; rather, it constitutes what we refer to as "culture" itself. We claim, continuing the discussion in the first section, that technologies, nature, and culture are all intertwined, not just in practice but ontologically. Thus, technologies are deployed, but they also employ and engage human beings and nature in such a manner that a continuity among the three arises that prevents any essentialist isolations of one from the other. That is, a subject cannot be defined simply as a human being. To be a subject is to be natural-cultural-technological; to be a social animal is to be techno-social.[24]

Both subjectivity and agency are wrapped up (knotted) in technological systems. To have "power" and "prestige" is to possess or be able to access the most advanced of technological systems (whether a private jet, CD player, or laptop). Sociality, politics, perception, experience—not to mention love and friendship ("You never *call* me anymore!")—many of our most fundamental

categories have been challenged or changed by technology. The question of mediation is relevant here. However, the relations seem more entangled than is usually claimed by theorists who see technologies as *merely* "mediators." Nowadays, even the production of a human being can be infiltrated by the technological, thereby challenging our notions of what constitutes parenthood and subjecthood.

Let us offer yet another example of what we take to be a crucial project in cultural studies, which frames a contemporary debate through an earlier American cultural critic, John Dewey. Technological, social, and biological determinism, which present themselves as antinomies of each other, are all instances of the Western obsession with the question of causality. None of them challenges the view that there is a cause to every effect, failing to distinguish among Aristotle's taxonomy of causes, particularly immediate, efficient, and final causes. These determinisms share the underlying metanarrative of linear temporal order (first, second, . . . *n*) and implicitly remain ensconced in the Newtonian world picture for which effects are the direct result of an external mechanical cause. Social constructionist determinism finds no merit in the biological reduction of intelligence (as measured by standard tests) to genetic characteristics of race and gender. The social constructionists substitute the determinism of social and historical conditions, asking, appropriately, what the standard tests measure and under what conditions may an individual perform well on tests that presuppose a specific cultural *milieu*. Academic performances are subsumed under these categories without respect to the performer; the performer is seen as a "product" of her or his conditions, but not as a subject who produces the conditions.

Similarly, the technophiles adopt an implicitly behaviorist view when they ascribe the decline of cultural "standards" and political culture to technologically mediated entertainments such as TV, movies, and video games. For some, TV "causes" violence, for others it causes illiteracy, and still others attribute the supposed political ignorance of the masses to the limited access to information caused by television's near-monopoly on news. Implied in all of these critiques is that, if video technology was absent, the conditions would exist for cultural progress, that is, the survival, even the broad dissemination, of high culture. Of course, the notion that technologically mediated images—the visual culture—are patently inferior to the literate culture parallels other statements according to which oral culture is not only temporally "earlier" than writing, but is clearly subordinate. What is at stake in both of these cases is the validity of the Lockean concept of humans as a blank sheet of paper upon which society, through the family, school, and the media, imprints values, beliefs, and knowledge—in short, the standard socialization model.

Recall Marx's apposite refutation:

> The materialist doctrine concerning the changing of circumstances and upbringing forgets that the circumstances are changed by men and that it is essential to educate the educator himself. This doctrine must, therefore, divide society into two parts, one of which is superior to society.

Again: "The chief defect of all hitherto existing materialism . . . is that the thing, reality, sensuousness, is conceived only in the form of an object of contemplation, but not as sensuous human activity, practice, not subjectively."[25]

Perhaps the most dramatic refutation of this mechanical materialism may be found in Dewey's fecund essay, "The Reflex Arc Concept in Psychology." Here, Dewey recalls one of the classic examples of behaviorism: the child sticks its hand into a lighted flame on the top of the stove. The child withdraws the hand from the fire. Having been burned, it knows that lighted flames can hurt. The stimulus, fire, causes the burning sensation which, in turn produces knowledge. The reflex arc, stimulus/response is the ultimate cause of learning. Behaviorist psychology remains enclosed in the model of stimulus-response-learning-altered-behavior.

Dewey's refutation consists in asking what the conditions were that motivated the child to put his or her hand into the flame (curiosity, desire, excitement, and so forth). He substitutes the picture "circuit" for "arc" indicating that the subject (child) is implicated in the action/reaction. The fire "causes" the physical sensation "burn," and the child reacts by withdrawing its hand, but the child is as much the author of the action as is the fire; there is no simple causality in the event. In fact, Dewey casts doubt that the event may be understood in terms of the motion of objects. In a word, where is the "subject" in the event? Just as the genome project cannot be fully grasped without taking its functional teleology into account nor the biological and physiological activity of eating as a mediation between humans and "nature" understood without grasping that the meat and tomatoes, the nature stand-ins, are already permeated with human aims, so the natural event of the interaction of the child with a natural event, fire, is not without presuppositions.

These examples are not identical to social constructionist critiques of biological or behavioristic determinism. In all of them, natures-cultures constitute a circuit within which the concept of causality is only an abstraction of a process—a freezing of time in the immediate event whose temporal order is indeterminate. Does the event of the burning begin with the child's decision to extend its hand, with the negligence of an adult in forgetting to turn off the burner, with the existence of the fire or all of the above? Is the "subject" of the event negligence, desire, the physiology of the derma, the effects of fire?

# Michael Menser and Stanley Aronowitz

## IV. Possibilities

There is no single methodology which unites the essays of this volume. Yet, if we may harken back to Haraway one last time, cultural studies, like Haraway's "knowing self," "is partial in all its guises, never finished, whole, simply there and original; it is always constructed and stitched together imperfectly, and *therefore* able to join with another, to see together without claiming to be another."[26] Cultural studies proceeds by way of a cutting-out and stitching-together of the various theories and theorists (and experiences and narratives) extracted or escaped from the various epistemological prisons (the disciplines are in this reading forced, intellectual labor camps). This weaving together utilizes differences without isolating or "preserving" them (as one might save a half-eaten sandwich by cordoning it off in cellophane). Cultural studies stitches together a patchwork connecting many levels of difference. As such, its essence (forgive the term) is expansive in the sense that stitching is expansive, full of far-reaching, yet intimate, connections. In this sense, cultural studies is not an "architecture" which deploys some fundamental *arche* or principle in order to rigorously transform the appropriated site according to the teleological demands of a particular (financial, social, political, disciplinary) investment and an already chosen operational scheme (for a critique of this kind of architecture see Wilson, Menser, and Woods, this volume). Out of this situating in the technocultural *milieu*, this volume aims to develop a multivarious study of technology and science, that pays attention to *complexity* and *situatedness*. While there is much controversy—and perhaps not a lot of consistency—in responses to technology's challenge, we believe that at its best, this is the strength of cultural studies: heterogeneity which is not simply an intellectual diversity.

## Notes

1. This essay would not have come together to the degree that it has without Barbara Martinsons, who not only functioned as editor, but, indeed, is the "absent" third author of the piece.

2. The quagmire begins, just what are the bounds of this (or any) culture? At issue is American principally, but also Canadian, European, Japanese (and others to a lesser extent).

3. On this topic, see the essay "Culture Between High and Low" in Aronowitz's *Roll Over Beethoven* (Wesleyan, 1993).

4.  Technology as prosthetic may not be described so simply as some "add-on" or appendage to an already whole body. Haraway writes: "Prosthesis becomes a fundamental category for understanding our most intimate selves. Prosthesis is semiosis, the making of meanings and bodies, not for transcendence but for power-charged communication" (*Simians, Cyborgs, Women*, p. 249, n. 7) Here technology appears in its most social sense, in that it acts as relations or mediators among human bodies, which permit sociability, whether it be linguistic, mythological, tools or technologies. How are technologies different from the rest (Haraway entrenches technology with the others on this list)? Perhaps in technological systems, the nature of the relations (or mediation) is different. Perhaps not. (In Heidegger, for example, this means the construction of the "standing-reserve" which is particular to technology and not to tools, language or myth.)

5.  Following what was argued earlier, each category is *permeable*, that is, receptive to and constituted by flows from all three: each mixes in the other such that there is no sacrosanctly distinct "other." However, that is not to say that, on another level, hegemonic penetrations are mounted from one to another: e.g. scientificity (the epistemological discourse of science which excepts culture) shapes political culture but is constituted by religious culture (which is noted for the adherence to concepts such as faith, privileged regions of interpretations, patriarchy, humanism etc.)

6.  What we have appropriated are the narrative devices of disciplinary ontology and science.

7.  Donna Haraway, "A Cyborg Manifesto," in *Simians, Cyborgs, and Women: The Reinvention of Nature* (New York: Routledge, 1991) p. 154. However, the question of the relation between technology and the (essential) deskilling of human bodies remains a significant problem for us (more so than for Haraway), such that although we remain "progressive" on this issue, in Haraway's derogatory sense, we do not posit an organic whole to which one should return. The question of the essential nature of human beings and their relation to work then becomes an issue (for us, not for Haraway). Are we positing work as an essential human activity? If not, then why are we worried about "deskilling"?

8.  Throughout this essay we shall be arguing that technologies and cultures permeate each other and are not "deterministic." Thus, not only is American culture(s) permeated by other cultures (European, Asian, African, etc.), but American culture(s) is (are) permeated by technology such that it is (they are) technoculture(s).

9.  See Menser, this volume.

10. On the cultural production of space and the spatial situatedness of culture,

see Henri Lefebvre's *The Production of Space*, trans. Donald Nicholson-Smith (Cambridge, MA: Blackwell, 1991) and Deleuze and Guattari's *A Thousand Plateaus*, trans. Brian Massumi (Minneapolis: University of Minnesota Press, 1987) and Manuel De Landa's *Phylum: 1000 Years of Non-Linear History* (New York: Zone, 1995).

11. See Kroker, De Landa and Menser in this volume, as well as De Landa's *War in the Age of Intelligent Machines* (New York: Zone, 1991) for a historical and critical account of the development of various technoscientific systems and their relation to various aspect of cultures, especially the military as distinct from the social-political.

12. See also Aronowitz and DiFazio's *The Jobless Future* (Minneapolis: University of Minnesota Press, 1994).

13. *Wired* February 1994, p. 100.

14. In *The Electronic Disturbance* (New York: Autonomedia, 1994) it is argued that the once subversive and anti-hierarchical models of the rhizomatic-nomadic have been most effectively appropriated by the highest reaches of international corporate power.

15. On this issue, note Peter Lamborn Wilson's essay in this volume, where he wryly comments that the slogan "Reach out and touch someone" as employed by the telephone companies (in this case AT&T) is precisely what one *cannot* do with a telephone.

16. We deploy this admittedly unwieldy term in order to stress that academic specialization takes the institutional form of departments whose fields of inquiry *compartmentalize* the objects of inquiry so as to prevent communication between these overspecialized fields. Thus, departments for the most part are walled-off compartments which methodologically *secure* and cordon off their objects making interdisciplinary access illegitimate or at least taboo such that one is forced to adopt the methods of a departmental domain in order to have legitimate access to its objects.

17. The borders of particular interest to cultural studies are those which mark off the humanities from the social sciences, but especially of concern are those which mark off biological, physical, computer, and chemical science as well as architecture and engineering. For an exploration into the permeability of the margins among psychoanalysis, religion, politics, history and literature, see Wilson's aptly titled "Boundary Violations," in this volume; in regard to architecture, see Woods.

18. Perhaps the most difficult and dangerous part of our task is to allow the space to expand but still remain smooth (not striated with impenetrable fences). That is to say, in our own struggle at CUNY, cultural studies may

become an Intercultural Studies Ph.D. program, but how can it avoid all the pitfalls of the disciplines while still enabling its products—and yes, even cultural studies students are products—to get jobs. This causes us to question not only what the curriculum and requirements should be, but where these students (and faculty) might come from, and to where the students are sent. The academic trajectory of training incoming *tabula rasa* in order to shape these tablets into future faculty has been challenged. Thus, even the teleological trajectory which shapes every academic department has been destriated, made smooth. But how to make smooth space? Certainly a few striations are necessary (just as the disciplines themselves are "actual," if not necessary, and there are certainly pockets of inquiry akin to cultural studies within those confines)—but how to prevent them from becoming subordinated enclosures? How do we jump off the track while still accessing it (and still leaving open the possibility of jumping off again in order to set up new camps, to construct and cross new interchanges. As Haraway states, it ain't just about networks, but about weaving together patch-works. [*Simians, Cyborgs, and Women*, p. 170]).

19. See also Menser, in this volume.

20. In cultural studies mathematics is also utilized, but it becomes a phenomenological geometry, shifting from the *abstracted plotting* of points and lines to the analysis of the *embedded experiencing* of divisions, enclosures, and free spaces (for more on the latter, see Woods and Menser, in this volume)."Borderland phenomenology" is the character-istic mode of Donna Haraway's cyborg; a "being-in-the-border" rather than a "being-in-the-(totalized) world." A cyborg is in and of the borders among animal, man,and machine, situated along the many dimensions which constitute both the unified self and the multiple others in a kind of continuum. A cyborg *is* and is *in* the "integrated circuit"; its being is "heteroglossic." (Haraway, p. 181.) It is through this phenomenological borderland geometry that we recognize the heterogeneity and impurity of our categories, selves, and experience. "The topography of subjectivity is multidimensional" (For more on Haraway's usage of geometry, see "Situated Knowledges" *Simians, Cyborgs, and Women*, p. 193). Cultural studies is where cyborgs come to study.

21. Bruno Latour, *We Have Never Been Modern*, trans. Catherine Porter, (Cambridge, MA: Harvard, 1993), p. 104.

22. For a cultural and historical account of how non-Western cultures have utilized technologies for empire building and hegemony, see Deleuze and Guattari's *A Thousand Plateaus*, trans. Brian Massumi, (Minneapolis: University of Minnesota Press; 1987 [1980]) pp. 351–473 which discusses the Mongols and Chinese among others.

23. For a scathing critique of the Modernist analysis of technology,

see Latour (cited above). Also, for an examination of the role which nation-state productions of spaces play in the fixing of technocultural operations, see Menser, in this volume.

24. As such, phrases such as "the death of the social" are too crude, too apocalyptic for us. It makes it seem as if the social was once pure, undiluted by technological systems, and now it has been trampled to annihilation. Sociality has been technosociality for quite a while, and how would one substantiate the claim that those cultures without technologies are "more social" than ours?

25. Karl Marx, *Third Thesis on Feuerbach*, trans. Rodney Livingstone and Gregor Benton (New York: Vintage Books, 1975).

26. Haraway, p193.

# II

# From the Social Study of Science to Cultural Studies

# 2

# Perspectives on
# the Evolution of Science Studies

*Dorothy Nelkin*

The burgeoning field of Science Studies has developed a creative, yet often chaotic and controversial agenda. As an interdisciplinary field, it has attracted historians, philosophers, scientists, ethicists, sociologists, political scientists, and anthropologists to the study of scientific processes, methods, institutions, and implications. They have developed many different approaches to the understanding of science and its role in society. The field shares no common conceptual framework, no common methodology, not even a common name. Programs are variously called Science, Technology, and Society Science; Technology and Human Values; Science Studies; Political Studies of Science; and Cultural Studies of Science. The social studies of science, as Mario Biagioli has described it, is "a cross disciplinary bricolage."[1]

Though rapidly expanding, intellectually lively, and socially important, programs in Science Studies have always been controversial, and they are increasingly so today. Concerned about declining public support for science, some scientists are alarmed by efforts to demythologize their work. They have attacked science studies scholars as science bashers, alarmists, ideologues, or at best foolish, faddish, muddled or left wing.[2] The only reason to study science, they believe, is to explain or promote it to a wary public.

Scholars within the field of Science Studies are themselves struggling over their mission. Is the purpose of studying science to promote science and

# Dorothy Nelkin

science literacy, and to help frame policies that will advance research? Or is it to analyze and critique science policy decisions? Is the field a forum for technology assessment intended to develop regulation? Or a study of values in dispute? Is the study of science an extension of the sociology of knowledge? Or, more recently, of the broader cultural study of social institutions? The social study of science has been all of these things, and the place of cultural studies may be better understood in the context of the evolution of this complicated, anarchic field over the past 25 years. So let me offer a very brief review.

As a distinct area of teaching and research, science study programs were first organized in the late 1960s in response to demands for "relevance" that grew out of the political currents of that time. Public intellectuals of the 1960s writing in the area—Jacques Ellul, Paul Goodman, Paul McDerott, and Louis Mumford, for example—write critiques of science, its technocratic values, and its social implications. The early science, technology and society programs at Harvard and Cornell were formed by policy-influential scientists who wanted to translate and communicate their knowledge in order to enhance public understanding of science, to counter growing criticism, and to serve the pragmatic interests of science policy. These policy-directed programs yielded studies of scientometrics and science indicators, analyses of changes in governmental science policy, and research on science literacy and science communication.[3]

The critiques of the 1960s, however, also encouraged studies of the social and environmental implications of science and the values threatened by technological change. These included case studies of controversies,[4] attitude surveys,[5] technology assessments, and risk analyses.[6] Scientists often mistrusted and dismissed such research, preferring a more celebratory and less critical approach to science and a more technical and less political approach to problems such as risk. And they feared the implications of growing interest in citizen participation in technological decisions. Fields such as risk analysis and technology assessment sometimes moved out of academia and into technical, corporate, or governmental agencies. Meanwhile during the 1970s, several related fields formed to explore particular implications of science and technology. Programs in Bioethics focussed attention on the ethical implications of science and, especially, medical advances; environmental programs centered on the environmental consequences of technological change.[7]

During the 1970s and 80s, growing interest in the social impacts of science and technology often led to debates over technological determinism.[8] Does technology follow its own course independent of human direction, or is it shaped by social and cultural fores? Is science a neutral, autonomous activity or a culturally driven enterprise? Such questions encouraged a second generation of Science Studies, focused less on the social impact of science

and technology than on the social processes of research and the ways in which science itself is shaped and influenced by social values.

Sociologists have approached the study of science in several ways—ranging from examination of its internal social structure[9] to studies of "Science in Action," as Bruno Latour called his influential book on the social construction of science.[10] The so-called "structural-functionalists," influenced by the work of Robert K. Merton, study the organization of the scientific community, exploring its norms, its system of rewards and sanctions, its organization into specialties, and its patterns of communication. "Social constructivists," in contrast explore the process through which scientific knowledge is developed, how "facts" are created, incorporated, or resisted, and how new knowledge becomes certified as scientific or excluded as myth.[11] Questioning assumptions about scientific objectivity, social constructivists have examined the strategic conduct of scientists, their employers, and their sources of support. Assuming that interests and beliefs will effect the construction of knowledge, they have encouraged a multi-dimensional perspective that has had significant influence on the science studies field. Science is no longer accepted as a given without the mediation of cultural codes, social and economic forces, and professional interests. To the dismay of many scientists, these analyses treat science as a social and cultural product, and the scientific community as a labor force.

These ideas attracted historians and anthropologists to the study of the culture of contemporary science and technology. The history of science is, of course, a very old and well established discipline that had long focussed on stories of remarkable discoveries and biographies of great men. Science studies perspectives have significantly influenced historical research. Robert Proctor, for example, has questioned the assumptions underlying the notion of value-neutrality, reconceptualizing the history of science in terms of its interaction with politics, and documenting the political and social origins of scientific ideas.[12] Thomas Hughes developed a network approach to science and technology, exploring the interaction of a variety of components—including hardware, personnel, organizations, political interests, laws, and regulations—as they affect the development of technological systems.[13] Historians and sociologists have combined the social, technical, and political insights of various disciplines to understand how particular technologies, ranging from bicycles to electric power systems, evolved. Distributing causality throughout the system—locating causal factors in both technological and social components—they have avoided the reductionism of the early debates over technological determinism.

So too have anthropologists who approach the study of science through laboratory ethnographies, biographies of scientists, rhetorical analyses of scientific discourse, cross cultural comparisons, and research on popular

images and representations of science.[14] Their work is providing insight into the broader cultural forces that influence both science and its popular appropriation.[15]

These trends have also influenced science policy studies. Accepting the importance of social and cultural influences on science, students of science policy have expanded their interests well beyond the earlier focus on research priorities, budgets, and the immediate pragmatic concerns of scientists. Many policy studies today approach science less as an autonomous, internally-directed activity than as a political and economic resource—an institution embedded in an economic, political, and legal culture. They explore the political use of scientific expertise, the role of science in the courts, the links of scientists to powerful economic groups, and the relationship between science and major social institutions such as the media, religion, the workplace, and the courts.[16] Some scientists these days have also adopted a more cultural view of their enterprise. This is a time when scientists are confronting controversies over many areas of research (animal experimentation, fetal research)—and over science education (the creation-evolution dispute). They are facing a declining public willingness to support costly research projects (the superconducting-supercollider). And serious problems of fraud and misconduct are changing the public image of science. In this context, some scientists seem more willing to consider the influence of social and economic pressures on science, and particularly on the way science can be exploited or abused.

Others, however, despair when questions are raised about scientific objectivity, and they try to draw rigid boundaries between facts and values, between science process for discovering truth and scientists as individuals interacting with the political process; between the agenda of science and the conclusions of research; between "policies for science" (i.e. those determined by vested interests) and "science for policy" (those scientific—i.e. neutral, value free—studies that are relevant to policy decisions). And they profoundly resent the questioning of scientific neutrality as a challenge to rationality. They believe that studies of science by "outsiders" (read Science Studies scholars) are encouraging anti-science sentiments and a "flight from science and reason."

Humanists and social scientists, defining their work as "cultural studies of science" and bringing to bear their skills in interpreting narratives and discourse, have now entered this anarchic and contentious field. The time is certainly ripe; for as I have suggested, scholars in this field are receptive to social and cultural perspectives. However, cultural approaches to science may be at least as controversial as the broader field of study I have briefly described.

The development of cultural studies to date has partly reflected their institutional origins. Ironically, cultural studies began most vigorously in technical universities such as MIT and RPI where many students are more literate in scientific than cultural matters. These schools have a pedagogical imperative

to extend their students' understanding of the cultural context of science and technology.[17] But cultural studies quickly extended beyond these institutions, for there are many issues in contemporary science calling for creative exploration through the tools and insights of humanistic disciplines. What is the social meaning of the increased commodification of science, its role as property, its marketing strategies, and its product lines? What is the cultural importance of the growing capacity for prediction and social control embodied in the "new biology"? As research in genetics and the neurosciences enhances the ability to predict human behavior, how will this bear on the power of institutions? On pressures for social conformity? On civil liberties? Old questions are assuming new dimensions in the 1990s. What is the relationship between science and religion as science infringes on "sacred" concepts of the body? How is science being appropriated as a "natural" explanation of social differences, a confirmation of cultural beliefs, and a justification for social policies? And finally, as we witness an erosion of the moral authority of science, what will this mean for the historical image of science as a neutral arbiter of truth?

While there are engaging and creative opportunities for cultural analysis, there are also certain risks. Cultural models in a post-modern world tend toward self-reflection, abstraction, and decontextualization. I see in certain cultural analyses an apolitical tendency to disembody science and technology, to disengage them from economic and political realities. I see a tendency to ignore the powerful pressures—from special interests seeking scientific legitimation or competitive industries seeking market opportunities—that drive the direction of science and technology and shape their social impact. Ironically, such perspectives can revive the discredited view of science as an apolitical, disembodied institution. But more dangerous, they can encourage the belief that science and technology are intrinsically inexplicable, inevitably unpredictable, and ultimately outside the sphere of human responsibility and deliberate control.

## Notes

1. Mario Biagioli, "Cultural Anthropology and Cultural Studies of Science," Lecture, New York University, January 27, 1994.

2. Such critiques have been precipitated by Paul Gross and Norman Levitt in *Higher Superstition*. (Baltimore: Johns Hopkins Press, 1995). They appear in science magazines, and in conferences such as "The Flight from Science and Reason," sponsored by the New York Academy of Sciences, May 31, 1995.

3. See reviews of these fields in Sheila Jasanoff, ed., *The Outlook for Science, Technology and Society*. Symposium Report, Cornell University, 1992.

4. Dorothy Nelkin, ed., *Controversy: Politics of Technical Decisions* (third edition), (Thousand Oaks, CA: Sage Publications, 1993).

5. Jon D. Miller, *The American People and Science Policy*, (New York: Pergamon Press, 1983).

6. For a review of the literature and bibliographical material, see Sheila Jasanoff, Gerry Markle, J. Petersen, Trevor Pinch, eds., *Handbook of Science and Technology Studies*, (Thousand Oaks, CA: Sage Publications, 1995).

7. See the Hastings Center Reports, *passim*.

8. Langdon Winner, *The Whale and the Reactor*, (Chicago: University of Chicago Press, 1986).

9. Michael Mulkay, "Sociology of the Scientific Research Community," in Ina Speigel-Rosing and Derek de Solla Price, eds., *Science, Technology and Society*, (Beverly Hills: Sage Publications, 1977).

10. Bruno Latour, *Science in Action*, (Cambridge, MA: Harvard University Press, 1987).

11. W. Bijker *et al*, eds., *The Social Construction of Technological Systems*, (Cambridge, MA: MIT Press, 1987).

12. Robert Proctor, *Value Free Science?* (Cambridge, MA: Harvard University Press, 1991).

13. Thomas Hughes, *Networks of Power*, (Baltimore: JohnsHopkins Press, 1983).

14. See, for example, Sharon Traweek, *Beamtimes and Lifetimes*, (Cambridge, MA: Harvard University Press, 1988).

15. For the popular appropriation of scientific images see Dorothy Nelkin and Susan Lindee, *The DNA Mystique: The Gene as a Cultural Icon*, (New York: W.H. Freeman, 1995).

16. See, for example, David Dickson, *The New Politics of Science*, (Chicago, University of Chicago Press, 1988).

17. See discussion by Kenneth Kenniston in Sheila Jasanoff, 1992, *op. cit.*

# 3

# When Eliza Doolittle Studies 'enry 'iggins

*Sharon Traweek*

A good deal of European, American, and Asian knowledge has been produced in colonial situations; in any case it is unclear whether I or the people I study are in the colonial role. The Asian, North American, and European physicists—mostly men—I study are obviously in a position to resist the attentions of this white woman. I "study up," to use Laura Nader's graphic phrase.[1] We all know that physicists have more power—intellectually, institutionally, financially, politically, and socially—than anthropologists and historians; it does not much matter that some of us might not want their power. The power dynamics that saturate everyone's research might be more noticeable to those of us who seem to be on the bottom, where the epistemological and gender dynamics conventionally merge.

Many have argued that the role of the researcher in the production of knowledge has been erased in academic accounts for a specific set of reasons and by a specific set of narrative devices.[2] They have suggested that the mythological, abstract, omniscient, absent narrator from nowhere be replaced by other kinds of narrators and narratives, especially stories about finding sense in the mess of everyday life, about situated knowledge. But how do we actually do fieldwork and archival work without lofty observations and our own politely muted voice-over reverberating in our minds? That position of the

know-it-all *Nova* narrator is already taken by the people I study, at least when they speak in public. Some of my colleagues in science studies compete with them, making the claim that their more truly abstract voices explain how the scientists' voices are actually parochial.[3] I prefer to locate the multiple voices we each use for making our stories, whether we are doing science or science studies.

## Eliza

Not long after I was asked to supply a title and abstract for this volume, I was channel-surfing late one night and found *My Fair Lady*,[4] the Audrey Hepburn/Rex Harrison version. 'enry was trying to teach Eliza the proper way to speak: "The rain in Spain stays mainly in the plain." Eliza kept violating 'enry's vowels, especially that little letter "a" (*pace* Lacan) and the not-so-little, disembodied, letter "i."[5] "The r'eye'n in Sp'eye'n stays m'eye'nly in the pl'eye'n" is not the proper voice for surveying one's domain. 'enry's solution was to put Eliza in the closet with a special device of his own invention. Eliza was obliged to activate this apparatus with her voice, recording the traces of her vowels. When Eliza came out of the closet for good, she spoke perfectly. But, as we learn in the ball scene, she had not learned to speak like 'enry; she learned to speak like 'enry's theories. A smarmy linguist, a practical rogue, who teaches whoever will pay him and who blackmails those who try to hide the class lurking in their voices (science without honor!) announces that Eliza cannot be English because her voice has no place there; he knows she must be foreign, and that she must have had an excellent teacher. He concludes that she is Hungarian and exceptional, just like him. 'enry, the face of science, gives us a *sotto voce* laugh, a last laugh at his former foreign student.

Eliza first approached 'enry to be her tutor so that she could get a better job; 'enry laughed at her. Suddenly 'enry realized that he could use Eliza to win a bet about his theories; he bribed Eliza to be his research subject, promising her a sojourn in the upper classes. (And later on, 'enry reaches an arrangement with her father who refuses the higher bribe in honor of his *carpe diem* philosophy, deploring the invitation to adopt a middle-class philosophy of delayed gratification.) Do these transactions qualify as informed consent? And who speaks for the ethics of science here? Is it Colonel Pickering, the military man who brought home the etiquette of empire? Is it 'enry's mother?

To begin their experiment 'enry decrees that Eliza must be bathed and dressed in new clothes by the household help/lab assistants; all this activity is accompanied by the sound of Eliza's howl. Eliza finally quiets when placed

in a large room and told that the bed is hers alone; she is confused. We are left to believe that Eliza finally has room for an "I," and that the devices in the bathroom, the bedroom, and the closet altogether create that big letter "A" in Eliza's new voice. She incorporates her prostheses.

When Eliza is discarded at the end of the experiment, after the ball, she returns to the flower market where she once lived. No one recognizes her; she no longer recognizes herself. She has lost her voice, her home, her flowers; she has gained the voice of science. The only people who remember her old voice and her flower market history are in the lab—which she now realizes is her new home. Her Pygmalion, her scientist, is her new love. Eliza and her father, objects of the scientist's gaze, were rewarded with social mobility. What but science could have changed nature from a street urchin into a fair lady? But wait! Does not Eliza now sound and act just like 'enry's mother? Where is nature? Where is science?

## Actants[6]

So who did you identify with in this story? Or, should I say—what—did you identify with? As for me, I could be Eliza, venturing into the Higg's physics lab, perhaps seduced by all the devices and the grants. It might be a big step up from my old neighborhoods in cultural studies and history and anthropology and women's studies, where maybe I became unrecognizable too. But then, I could never learn to speak in that voice of perfect truth. I do not live in the lab; I just get to visit. Or perhaps I am like the household help, assisting in the socialization of the novice scientists. I do not want to identify with Colonel Pickering, the paradoxical military man, the benevolent arbitrator, the source of the bet, and 'iggins's first, most important audience. Eliza's father is no better: his is the optimistic voice of corrupt progress, the voice, of America. Maybe I am 'iggins, making bets with the authorities so that I can find the real voice of science, insinuating my way in the lab by just being a girl. Trying to be honorable, once at MIT I even tried to apply for one of those permits for research with human subjects; I got lots of not-so-*sotto voce* laughs. Or perhaps I really am a closeted research instrument. To be truthful, I have sometimes described my anthropological fieldwork to physicists by claiming that "I am a detector." One morning I climbed onto the particle detector to talk to some physicists who were inside it, making adjustments.[7] They said they had just been talking about me, and had concluded that I could not do my research. Aghast, I asked why not. Well, they explained, you could not find out how we do experiments if you did not come here and spend a lot of time with us, but since you would then know us, your work would be subjective, so it is

not research. I asked if there were any alternatives to subjectivity and objectivity; this was judged silly. Then I brought up Bohr and Heisenberg.

Now I think I should have raised the subject of 'enry 'iggins's house and all the players in it. In the following, I want to introduce you to some of the players in my research, the analogs of the characters in 'enry 'iggins's house. I study scientific communities, in particular the international community of high-energy physicists. My interpretive tools come from cultural studies, feminist theory, gender studies, science studies, and subaltern studies. Since the early 1970s I have conducted about six years of fieldwork at some of the major national high-energy physics laboratories where this community gathers: about two years at the Stanford Linear Accelerator Center; two and a half years at KEK, the Japanese National High Energy Physics Laboratory at Tsukuba, Japan; six months at Fermi National Accelerator Laboratory in Illinois; and shorter visits to CERN in Switzerland, DESY in Germany, and Saclay in France; I have also visited physics departments at universities throughout the United States and Japan, and attended innumerable particle physics colloquia, workshops, and conferences. Since the mid-eighties I have spent about a third of my time in Japan, and the focus of my research has been on the global transformation in the production of basic scientific research.

## Eliza Morphs to *Obachan*

In the last few years I have taken a role in my texts, telling about the situations in which I heard the physicists' stories, and telling you what was made of me by these physicists, so that you might make something of them. When I first began to study physicists in Japan and the United States during the mid-1970s, I learned that wearing my miniskirts to the lab reduced the physicists responses to one.[8] Twenty years and fifty pounds later I found that in Japan I was assigned another singular role: *obachan*. This might be translated as "auntie"; in Japan, slight, demure, young women become, in time, formidable middle-aged forces: Meg Ryan morphs into Bella Abzug. (Maybe, in Steven Perella's terms, I am the monstrous mid-morph.)[9] They can be seen everywhere, elbows out, getting seats on the subway, the best vegetables at market, and the best deals at the stock market. They carry large bags in which absolutely anything can be found. *Obachan* are eccentric, endearing, irritating busybodies and will not be ignored. Some of my hosts explained that, as a fieldworker in my late-forties, I was just like an *obachan*.

I have argued elsewhere that had I not attended to all the bodies in the field, this busybody and the kinds of bodies that only physicists can have,

all these erotics of fieldwork, I would have learned much less about these high-energy physicists' embodied rationality.[10] I have tried to present some stories about how bodies and minds are entwined in labs, stories that may challenge some assumptions about the production of a certain kind of privileged knowledge, a way of knowing that is profoundly gendered and cultural and material, a way of knowing that has its own gender troubles, cultural troubles, and material troubles.[11]

## Eliza and Mrs. Higgins as Scientists: Japanese Women Physicists and Their Devices

There are, of course, many scientists, engineers, and physicians in Japan who are women, in both universities and the private sector.[12] A few are eminent members of the Japanese National Academy of Sciences. Although my next research project will focus on them more directly, I can report on some of my preliminary fieldwork. There appear to be interesting generational differences among the Japanese and American women working now in science, engineering, and medicine, just as there are among the men: the historical moment in which each generation has been educated and begun careers has presented different opportunities and difficulties. The senior generation of Japanese women physicists finished secondary school before the educational changes of the Occupation; most, but not all, are physicians or in pharma-cology. They were usually educated in the first of the women's universities in Japan, and have spent all their careers working in Japan. Many of this senior generation seem to have come from families which included other researchers and teachers.

The mid-career generation attended secondary school during the Occupation period and the post-Occupation period until the "Oil Shock" (late 1970s Arab oil boycott). Interestingly, many of the midcareer scientists and engineers attended universities in Europe, including the former Soviet Union, or North America, either as graduate students, postdoctoral researchers, or both. Those at midcareer often lead research groups, collaborate with colleagues abroad, are invited to major international conferences, and publish in the major international journals of their field. This midcareer generation seems to come from families that could afford to educate daughters during the economic difficulties of the postwar period. Several have told me that seeing that fifties film about the Nobel Prize winner Madame Curie was a crucial inspiration for them in becoming scientists.

# Sharon Traweek

The youngest generation of women scientists attended secondary school after the "Oil Shock." (This coincides with the emergence of Japan as one of the richest countries of the world, with international responsibilities.) These women are part of Japan's baby boom. The eldest boomers are just now beginning their careers. They are benefiting from changing cultural attitudes about women's work, and from the enactment, in April 1986, of the Japanese version of an Equal Rights Amendment.

So far my research has been confined to the midcareer scientists and engineers. They have maintained the working relationships they forged as graduate students and "postdoc" researchers through collaboration, international conferences, and correspondence. It appears to me that, in Japan, as in some other Asian countries, this path is traveled far more frequently by women. This career path may seem ordinary to many Europeans and North Americans; in fact, because of our scientific ethnocentrism, it is what we might expect of bright people from Asia and the southern hemisphere: to come to the "center of the action" for education and return to the "margins," proselytizing the true words of science; then to come back to the center to seek confirmation for any interesting work they may have done at the periphery.

Since Japanese women rarely occupy administrative, departmental, or professional positions of power in Japan, often the only intellectual community open to them is the one they left behind in North America or Europe; consequently, they work hard to maintain those ties. Yet many Japanese scientific, technical, and medical communities remain isolationist; indeed only in a few specialities do the practitioners maintain frequent and active contact with colleagues in other countries and read journals published outside Japan. Of course, this is quite understandable: until recently Japan was not rich enough to support the so-called "research infrastructure" for scientists, engineers, and physicians.

## Lab Assistants

I have visited the laboratories of two Japanese, female, midcareer, high-energy physicists, neither of which had much resemblance to the other labs I have visited. I will discuss my experience at one of the labs. When I arrived at the lab, I immediately noticed the stuffed animals perched on the computer monitors; there were vases of flowers too. The young men and women in the crowded lab were all talking to each other about their tasks, talk punctuated with flirting and teasing and giggles. They were undergraduates; the professor told me that she did not attract graduate students, who tended

to work with the men in her department. I asked how she got the elaborate computing equipment that crowded the small room. She explained that she had called a big Japanese company and told them that she had an idea for a piece of equipment they might be able to build, adding that if they gave her the prototype, she would train undergraduates to use it, and the company could then hire the graduating seniors to develop the technology for commercial uses. (Japanese undergraduates are extremely eager to gain employment at the prestigious companies in Japan; the competition is intense).

I asked her where she got the data tapes and she replied that, having worked on the big, multinational collaborations, she knew which tapes were sought by the most powerful subgroups and which tapes were thought to be interesting, but much less likely to reveal the most desirable anomalies; she said she asked for those odd tapes, and got them because of her long ties to the group. She had designed her equipment to help her search those kinds of tapes.

When I asked the students if it was difficult to learn how to use the equipment, they said yes; then, giggling, they pointed out that, whenever any-one found something interesting or unusual, they had a little party, sponsored by their professor. They quickly printed out a sample of their last "discovery." When they have found enough, their teacher can write a paper for the international journals and the international conferences, which she does.

I would like to point out that this laboratory—the equipment, the students' learning, the tapes, and the papers—by all the usual ways of doing high-energy physics, should not exist: the professor has no research funding. She gathered these resources through her own personal and familial networks, after she returned to Japan from graduate school and a postdoctoral research assistantship abroad. She does it by tinkering with the Japanese business world, the Japanese academic world, and the international high-energy physics community. She has devised a new kind of inscription device.[13]

Powerful computing technologies are just within the grasp of these scientists operating labs at the edge of the richest national scientific communities. That technology, as prosthesis, opens the international research community for them. Remember Eliza in the closet with 'enry's equipment? Can we now imagine a career for Eliza in science? Did she take that apparatus out of the closet to the flower market? Did she teach her friends to speak in many voices? Did they take over the flower trade in London?

# Sharon Traweek

## Forgetting Colonel Pickering in American Physics

At a major conference in the mid-eighties, I overheard a prominent Japanese high-energy physicist inviting a well-known American to visit his university and his research project; at a certain point in the negotiations, the Japanese physicist said to the American that if his colleagues in Japan discovered that the American had any association with Star Wars research, the situation could become very unpleasant for everyone. The American said that he was not involved in that work, and the negotiations continued. Neither had offered his own opinions about Star Wars.

Their silence was more consistent with the actions of American high-energy physicists than those of the Japanese. In over fifteen years studying American high-energy physicists, I have found their posture on military funding to be one of intellectual condescension, not one of morality or political values. That is, military funding is seen ultimately as funding for applied research: to get it, one must at least say that applications of one's work are eventually possible. The American scientists I have studied are very proud to say that they have never done any applied research, just as 'enry 'iggins scorns the work of his former foreign student.

There are two obvious contradictions in their position. One is that about three-quarters of all people who have *completed* postdoctoral research associateships in high-energy physics (that is, three to six years research beyond the doctorate) *leave* academia. (By contrast, almost all those receiving Ph.D.s in high-energy physics in Japan have remained in the field.) Several senior American high-energy physicists have told me that they assume that many of these former junior colleagues are now working on defense-related research. One such former high-energy physics postdoc, whose research is funded by the U.S. Navy, told me, apparently in mock horror, than one of his students actually wanted to work for the CIA; when I mentioned this to a senior high-energy physicist, he merely said with disdain that such behavior among one's students had to be expected if one had any involvement with military funding.

In the 1980s, Japanese high-energy physicists queried me often on American scientists' participation in "Star Wars" (Strategic Defense Initiative) and other forms of military funding. Just as I had left MIT in 1986 for Japan to do fieldwork, many committees had been constituted at MIT and many fora had been scheduled to discuss the implications for MIT, pro and con, of this greatly expanded funding. Since various notices and minutes of the MIT faculty senate were being sent to me, I could show all that information to the Japanese scientists. They too were scheduling many meetings and constituting

committees to discuss the implications of such Star Wars research funding for Japanese science. They were surprised at the fact that these topics elicited so little interest among the American high-energy physicists at KEK. One American scientist at KEK was quite interested, but he was a nuclear physicist visiting the Photon Factory, and he had been doing research in Germany for over a decade.

This difference in opinion was also quite noticeable during the 1991 Gulf War, which I spent in Japan. The American physicists at the lab seemed very supportive of the war effort, occasionally expressing surprise that any thoughtful person could be opposed to it. Conversely, the Japanese high-energy physicists seemed quite surprised that any thoughtful person could support that war. I noticed that these two groups did not mention their views to each other, although there was considerable discussion within each group. Several Japanese expressed real surprise and disappointment when I showed them American media reports that a significant proportion (perhaps twenty percent) of the high technology in American weapons was made in Japan; they said Japanese media were not carrying such reports. Many mentioned that they thought that if world opinion forced Japan to increase the role of its military, the right-wing forces which had ruled Japan from the mid-1930s to the mid-1940s might regain control; these physicists thought that those forces had never been completely repressed, partly because of the American Occupation and Cold-War policies, and were actually still strong in the 1980s.

Another contradiction in the Americans' disdain for military funding is the involvement of many prominent high-energy physicists, including Nobel Prize winners and laboratory directors, in JASON, an organization of about fifty scientists, founded in the late 1950s, which evaluates scientific and technological projects for the U.S. government, most of which projects are military.[14] Membership, which is quite stable, is limited and by invitation only and, until fairly recently when two women joined, only men.

The group meets in Washington, DC, every spring, and hears a number of presentations about proposed United States government scientific and technological activities. The JASON membership then decides which proposals they will evaluate; such selection bestows a certain prestige on those proposals, and is actively sought by government agencies. JASON then meets for several weeks each summer (for the last several years in La Jolla, the most affluent part of San Diego, California) to evaluate the proposals in detail; there is a certain competition among the members about who has the "highest level" government security clearance, because only those with the highest clearances can work on whatever project they choose. At the end of the summer they provide their evaluations; a few JASON members meet in

Washington, DC, in the fall to conclude that year's activities and plan the next.

High-energy physicists who participated in JASON in the late seventies insisted to me that, because their *primary* research was not funded by the military, they were able to independently evaluate the proposals they studied for JASON, unlike scientists whose primary work was funded by the military. They argued that this was a service they provided their country as responsible citizens, and gave examples of projects negatively evaluated by JASON which would have cost many, many millions of dollars and might have endangered U.S. foreign relations had they been built.

They acknowledged that there were personal benefits: intellectual challenges, excellent colleagues, prestige, very generous *per diem* stipends and salaries, and the opportunity for their families to spend the summer in the very expensive beachfront resort of La Jolla, which many would not ordinarily be able to afford on even the most elevated academic salaries.[15] Some JASON members have changed their research specialization as a result of projects they studied with JASON, and their work is now primarily funded by the military.

In 1990, the current chair of JASON, Curtis Callan, a theoretical physicist on the faculty at Princeton, addressed the ethics of participation in JASON in a newspaper interview:

> We feel we have a duty, that it is important to work on national defense problems. We'd like our effort to have positive effects. . . . Given the realities of the world and that there is conflict and there are armies and the world is not completely benign, I don't see any ethical problem in advising our government to make sensible and effective choices.[16]

## Is There No Colonel Pickering in Japanese Physics?

I found that senior and midcareer Japanese high-energy physicists were extremely interested in JASON and seemed well informed about its activities and membership; since 1976, when I first did fieldwork in Japan, they have asked me many detailed questions about it, and they tell me that they believe no comparable organization exists in Japan. To my knowledge, no high-energy physicist members of JASON, in spite of their prominence, have been invited to Japan since joining JASON. The Japanese have said that they believe it would be very difficult for a high-energy physicist in Japan to belong to such an organization and have the respect of one's colleagues. When I asked about other kinds of Japanese physicists, such as nuclear physicists, they said they did not know.

# When Eliza Doolittle Studies 'enry 'iggins

Even though most high-energy physicists in Japan are from the more conservative universities in the northeast, and work at a national laboratory where political activity is at a minimum, they seemed to me determined to avoid any association with military funding, and to shun Americans who receive such funding. It would appear that Japanese high-energy physicists, at least, have no ties to military research or funding, either direct or indirect, as some of their American colleagues do. I have no data on whether Japanese nuclear physicists and cosmic-ray physicists have any links with military funding in Japan or are concerned about foreigners who do, although some have had long-term collaborations with Americans who receive such funding. The Japan Physical Society (JPS) long ago passed a resolution against physicists participating in projects supported by the military. That resolution was reprinted on the front page of the program for the JPS annual meeting in 1991.

## Forgetting the Laboratory Help

Much of the work done by company engineers and technicians in Japan is done by graduate students and postdocs in the United States—at much lower cost, at least, in the short term. (Current NSF stipends for advanced graduate students are over $14,000, and postdoctoral research associates receive about $25,000; although these amounts are quite generous compared to those in the social sciences and humanities, they are modest compared to the salaries those physics graduate students and postdocs might expect working in private businesses.)

There is a very powerful ethos learned by undergraduates in American university labs about the importance of learning to work well alongside some senior esteemed technician, an ethos which extends through graduate school and into the major research labs, where there is always a small cadre of exceptionally skilled "technicians" highly adept at transforming experimentalists' designs into prototype equipment. The "shop" facilities in which they work are very well supplied. These facilities and the craftspeoples' salaries are funded by the laboratories' operating budgets, monies which are not available to Japanese labs.

This different division, due to government funding constraints or opportunities, of research labor corresponds to a very different social allocation of knowledge with different personal, social, economic, and political consequences. The work done by younger company engineers and technicians in Japan is done by physics graduate students and postdocs in the United States, as I mentioned earlier. In Japan, these young people become, in turn, senior

engineers and technicians with greater opportunities and responsibilities; in the United States approximately three-quarters (the proportion has steadily increased with the scale of experiments) of the young researchers in experimental high-energy physics become, at about thirty-five years old, a surplus science labor force. They learn (often with strong feelings of bitterness, anxiety, and inadequacy, which seem to stay with them, sometimes accompanied by boastful stories about the past, for decades) that they must find employment elsewhere.[17]

I have found no government agency, no laboratory, and no university which keeps records on where these people find work. My own, as yet rather limited, research on this topic indicates that they usually move into astrophysics, geophysics, physical oceanography, computer science, and biophysics to work on projects defined by others; some work in universities (often, apparently, on Department-of-Defense-funded research projects), some in government weapons labs, and some in industry. In my small number of interviews with such people, only those who had help from senior high-energy physicists in making this transition now work on projects funded, at least in part, by the Department of Defense.

Different government policies on funding of basic scientific research benefit different sectors of society outside the labs: in Japan, expertise develops in the private sector from collaborating on high-energy physics projects; in the United States, people trained in the very large high-energy physics research teams take their skills to other projects in universities, the military (including national weapons laboratories) and, to a lesser extent, private industry. The live-in novice physicists in American labs are more like the help in 'enry 'iggins's house; the engineers in Japanese labs do not work for the physicists.

## Witnessing Scientific Colonialism:
## Japan as Eliza, Studying an American 'iggins

The relation of margins and centers is being renegotiated globally, not just in 'enry 'iggins's house: as manufacturing moves to Third World countries, service and knowledge become the preferred mode of production in rich societies. The sciences are among the most privileged and powerful forms of that knowledge; the knowledge producers and the knowledge consumers are beginning to learn how to produce and use this knowledge in new ways and with new technologies, especially computers.

The infrastructure for producing "world-class" research knowledge is extremely expensive; only nations with the very highest GNP can possibly build it. Furthermore, not all rich countries decide to allocate the necessary resources for research and development of new knowledge, estimated at up to ten percent of GNP and approximately ten percent of the workforce. Scientists, engineers and physicians in the United States gained this infrastructure during and just after World War II; Japan is gaining it now. Korea, Taiwan, Hong Kong and Saudi Arabia are not far behind; China, India, Brazil, and Mexico are following.

Until such an infrastructure is firmly in place, there may be decades, even centuries, of teaching, learning, and using knowledge produced elsewhere; there will also be decades of amplifying research defined elsewhere. These national differences in the worldwide production of scientific, technical, and medical knowledges are strongly affected by international political conditions. For example, when European countries were controlling colonies, they often encouraged the building of scientific, technical, and medical research institutions. However, research done in such colonies primarily consisted of locating important raw materials (for example, botanical specimens) to be further studied at institutions in Europe. The colonies also sent their most promising students to Europe to study further. Although the formal system of colonies has disappeared, these distinctions between nations that produce research and nations that provide the raw material for research have not. It is intriguing how rarely countries have moved from one category to the other, as the United States did during World War II and as Japan is now doing.

## Inversions: Building a Lab at the Flower Market

The high-energy physicists in Japan work at the margins of two empires: the international scientific community, which is based in North America and Europe, and the Japanese scientific community, which is based in the universities and the Ministry of Education. A few high-energy physicists used that *bachigai,* outsider position to build Tsukuba Science City, Tsukuba University, and KEK, the Japanese National Laboratory for high-energy physics. They accomplished this through strategic use of *gaiatsu,* foreign pressure, among other strategies, and made the most of the Japanese public's and government's concerns about *kokusaika,* Japan's national identity in global politics. By building a national laboratory with state-of-the-art research equipment, they vastly increased their status in the international scientific community, but that community is still centered somewhere else. Japanese scientists now

wield some power in that international high-energy physics community, but few American or European physicists have yet bothered to learn about the political economy of big science in Japan. I am certain that the next generation of high-energy physicists in Europe and North America will.

The usual way of talking about the production of knowledge in physics does not include discussions of the women scientists in Japan, the shifting military presence in physics or the "absent presence" of all those disappeared postdocs. Nor do we usually think of going to Japan to watch how the production of scientific knowledge is changing. All these odd players have a voice in my narrative (and I do, too), even if none of us can be heard speaking that masterful voice of authority of the Euro-American man of science. Eliza, Colonel Pickering, the absentee father, the household help, Mrs. Higgins, and even the closeted devices all should be in the story, along with 'enry. He uses them all to build his voice-over. 'enry needs to notice these players anew, and he needs to help them in order to rebuild the voices of the sciences.

## On the Edge

Remember that where there is gender trouble, where there is culture trouble, where there is material trouble, there is certainly epistemological trouble. I do not want to erase this trouble nor to resolve it. I want to enlarge it. There are no satisfactory categories. We are living in a world of blurred genres. Those who persist in the quest for pure categories, those who persist in the quest for singular generics, those who persist in building analytic Leviathans, are all living in an eighteenth-century European mind. We need interpretive strategies for blurred genres, for mid-morphs, for a world of plurals, for a world of irreducible complexity. We must learn to theorize without categories, without singular generics; we must learn to think carefully about necessarily messy worlds.

## Appendix: Twenty Years of Questions[18]

For about twenty years I have been attending to how Japanese and American high-energy experimental physicists have decided, in the postwar period, what new questions they want to address in particle physics, and what accelerators and new detectors ought to be built to help them answer those questions; I have also studied how they have amassed the resources to do their experiments and build their labs in the context of fluctuating global

political economies, and how they pass these skills to the next generation. More recently I have been focusing on how their ways of making experimental high-energy physics are changing as once-marginalized groups (Japanese men and women scientists, American minorities, including women) gain new status and access to the worlds of making decisions about the next physics questions and the next equipment to be built. In my research on the globally dispersed high-energy physics community, I have been asking a set of related questions; they could all be framed as: How does a novice member of this community comes to have "common sense"? What have all skilled members of the community learned, whether or not they are conscious of having learned it? What do they all recognize immediately as lacking their distinctive form of common sense? What are their varieties of common sense? How does it change? I am interested in how their knowledge, especially so-called craft or tacit knowledge, including knowledge about the community's history, is transmitted from one generation to the next, in this multinational community which is committed to discovery, and in which crucial features of their knowledge are never written.

I also study how different styles of research practices emerge and survive; I am interested in how their disputes are conducted and how factions are formed and maintained, how their community recognizes and limits variation in their practices. I am intrigued by how these practices differ along lines of class and gender, as well as lines of local, regional, national, and international political economy. I want to know how this powerful group creates and constantly recreates a discrete, identifiable community while operating all over the world in many different local, regional, and national cultures, when all its recruits are adept at practicing at least one other culture (beside "physics"), and probably several others. That question is related to how local, national, and international cultural and political economies are shaped by high-energy physicists and the work they do.

In my first book, I argued that there is a congruence between these high-energy physicists' cultural constructions of time and space in their everyday practices and in their knowledge system.[19] Important times in the lab (up/down time, beamtime, detector lifetimes, particle lifetimes, lab lifetimes, career time, and lifetimes of ideas) are classified either as replicable (can be accumulated) or ephemeral (slipping away). Replicable time, like beamtime and relativistic time, is desirable; ephemeral times are a constant source of anxiety. Replication can be both ideal and real, but the human social world is ephemeral. I focused on their material culture, huge research equipment called detectors, as both site and symbol of annihilation and resurrection of time for this community. I tried to convey that this was a highly masculinized

culture, reproducing privileged producers of knowledge, and that through their equipment I detected the distinctive shape of their desire for great ideas and careers.

I also accounted for the stages of an American life in high-energy physics, showing how the training of a physicist is an emblem of the community's sense of their shared past, present and future. I presented the stages of career physicists in the United States as a series of exclusionary, picaresque stories about men's lives, where losing innocence gains power. Throughout these American men's lives, time is an engendered source of anxiety: the possible insignificance of one's past, fear of losing research time, anxiety about future projects, and fear of the obsolescence of whatever work they do accomplish.[20]

## Notes

*I want to thank Stanley Aronowitz, Barbara Martinsons, Michael Menser and the other members of the Center for Cultural Studies for their kind invitation to participate in their very interesting conference and their gracious hospitality while visiting CUNY.*

1. See Laura Nader, "Studying Up," in Dell Hymes, ed., *Reinventing Anthropology* (New York: Pantheon Books, 1972). See also Laura Nader, ed., *Anthropology and Science* (New York: Routledge, forthcoming).

2. Donna Haraway, *Simians, Cyborgs, and Women: The Reinvention of Nature* (Routledge, 1991); Trinh T. Minh-ha, *Woman Native Other: Writing Postcoloniality and Feminism* (Bloomington: Indiana University Press, 1989).

3. See, for example, H. M. Collins, *Artificial Experts: Social Knowledge and Intelligent Machines* (Cambridge, MA: MIT Press, 1990), and with Steven Yearly, "Epistemological Chicken," and "Journey into Space," in *Science as Practice and Culture*, ed. Andrew Pickering (Chicago: University of Chicago Press, 1992).

4. "My Fair Lady" was a 1964 Warner Brothers movie directed by George Cukor, starring Audrey Hepburn and Rex Harrison; it was a film version of the Broadway show of the same name with Alan J. Lerner's lyrics and Frederic Lowe's music, which was in turn a musical version of George Bernard Shaw's stage play, *Pygmalion, a Romance in Five Acts* (New York: Penguin Books, 1951).

5. On actants see Jacques Lacan, *Ecrits: A Selection*, trans. Alan Sheridan

(New York: Norton, 1977) and *The four fundamental concepts of pyscho-analysis*, edited by Jacques-Alain Miller and translated by Alain Sheridan (London: Hogarth Press, 1977).

6. For a discussion of actants in semiotic theory, see A. J. Greimas. For an application of the idea of actants in science studies see Bruno Latour, *Science in Action: How to Follow Scientists and Engineers Through Society* (Cambridge, MA: Harvard, 1987).

7. This paragraph is excerpted and revised from my "Bodies of Evidence: Law and Order, Sexy Machines, and the Erotics of Fieldwork among Physicists," in *Choreographing History*, ed. Susan L. Foster (Bloomington: Indiana University Press, 1995).

8. Part of this paragraph is excerpted and revised from my "Bodies of Evidence," in *Choreographing History*.

9. Steven Perella is an architect. The term mid-morph is from his unpublished paper "Why Architecture is Becoming Conversant."

10. See my "Bodies of Evidence: Law and Order, Sexy Machines, and the Erotics of Fieldwork Among Physicists," in *Choreographing History*, ed. Susan L. Foster (Bloomington: Indiana University Press, 1995).

11. For a discussion of how gender trouble is related to epistemological trouble see Judith Butler, *Gender Trouble: Feminism and Subversion of Identity* (New York: Routledge, 1990).

12. This section is excerpted and revised from my "Essay on Gender, Science, and Technology," for *Bulletin of the Institute for Women's Studies*, Ochanomizu Women's University, Japan (in Japanese and English) (New Series No. 5, 1991) (published 1993).

13. On the notion of inscription devices in science see Bruno Latour and Steve Woolgar, *Laboratory Life: The Construction of Scientific Facts* (Princeton: Princeton University Press, 1986).

14. Because JASON members work on "classified" (secret) projects, and the members choose to not identify themselves, the group is rarely mentioned in media available to the public. A recent exception is a newspaper article by David Graham entitled "When U.S. Has a Science Question, it Asks JASON," *San Diego Union* (15 July 1990, pp. B1, B4), which includes an interview with Professor Curtis Callan, a theoretical physicist at Princeton University and the group's current chair. Graham mentions that "Most of the 56 JASON members are physicists, although there are oceanographers, mathematicians, and electrical engineers, too. Their credentials are among the most impressive in science. Members include six Nobel laureates. Two JASONs are women." Graham also states that "at least 10 UCSD faculty members have been listed as part of the JASON group, including Edward Frieman, director of

Scripps Institution of Oceanography, and Herbert York, a former Chancellor of the University of California at San Diego who was a scientist on the Manhattan Project, which built the first American atomic bomb." (Photographs of York and Frieman accompany the article.) He adds that: "The JASON group was founded in 1959 with a core of scientists from the Manhattan Project who wanted to help guide development of new technology for defense uses, as they had done more than a decade earlier by translating nuclear theory into an awesome bomb."

15. Since I have been chided for identifying La Jolla as a resort, I feel obliged to make my point more specific. In the 1940s and 1950s, La Jolla had the reputation of being home to the Navy "brass" based in San Diego; it was also notorious then in southern California for its restrictive covenants against selling housing to Jews and many other minorities. It has long been home to the Scripps Institution of Oceanography, and during the 1960s the University of California at San Diego, which now enrolls nearly 20,000 students, was established there, on land between the beach front areas and Miramar Naval Air Base farther to the east; private enterprise laboratories, especially in biotechnology, followed. The land immediately north and especially east of the university, largely unoccupied until the mid-1970s, has become the site of phenomenal real estate development, commercial and residential, and is now called "the Golden Triangle" (parts of zip codes 92121, 92122, and 92037), at least by realtors. Up-scale tourism continues to be an important industry in beach front La Jolla; the shopping district includes many small expensive shops and several very good expensive restaurants, and short term summer housing there is also quite expensive. (The average price of the 73 single family houses *and* condominia sold during March 1990 in the prized 92037 zip code was $476,629 ("Southland Home Prices," *Los Angeles Times* (27 May 1990, p. K17); summer rentals are priced accordingly.) My point is that this older part of La Jolla, while certainly very pleasant, is an exceedingly expensive place for academics (and their families) to meet for six to eight weeks every summer, and to do so represents a substantial economic incentive for academics to become JASON members. It is widely believed in academia that salaries and benefits for Department of Defense research are more lucrative than those for the Department of Energy and far more so than those for the National Science Foundation; I have no data to confirm or refute this, although the high-energy physics conferences and workshops sponsored by NSF which I have attended over the last eighteen years have never been nearly so well endowed, although quite comfortable. Accommodations and amenities at the Japanese high-energy physics conferences and work shops sponsored by the Japanese Society for the Promotion of Science and by the Ministry of Education which I have attended have been comparable to those sponsored by the NSF.

16. David Graham, *op. cit.*

17. For a study of the postdoctoral career stage and the evaluation of these postdocs, see Sharon Traweek, *Beamtimes and Lifetimes: The World of High Energy Physicists* (Cambridge, MA: Harvard University Press, 1988), Chapter Three. I have had conversations with about twenty-five mid-career scientists who left high energy physics after completing a postdoc, and I have had detailed discussions with seven.

18. Portions of this appendix are taken, with revisions and additions, from my "Bodies of Evidence" in *Choreographing History*, ed. Susan L. Foster.

19. Sharon Traweek, *Beamtimes and Lifetimes: The World of High Energy Physicists* (Cambridge MA: Harvard University Press, 1988).

20. My next book, tentatively titled *Turbulent Phase Transitions in Japanese and American High Energy Physics*, is about how a group of high energy physicists from Japan and the United States worked together at a new laboratory in Japan. The larger story is about how some Japanese physicists, making use of their country's sudden wealth, transform the organization and practice and education of Japanese physics from the sort conventionally conducted in poorer countries into the sort conducted in very rich countries, usually referred to as "world class science." I am exploring the diverse strategies developed by various groups in the Japanese and American physics communities to enhance or thwart this effort and I am writing about how all these activities reverberate with practices in other parts of Japanese society and in physics communities in other countries.

# 4

# Math Fictions

*Betina Zolkower*

One gives examples and intends them to be taken in a particular way.—I do not, however, mean by this that he [sic] is supposed to see in those examples that common thing which I—for some reason—was unable to express; but that he is now to *employ* those examples in a particular way. Here giving examples is not an *indirect* means of explaining—in default of a better. For any general definition can be misunderstood too. The point is that this is how we play the game.
——Ludwig Wittgenstein, *Philosophical Investigations*, Para. 71.

A nationwide "mathematical empowerment" movement is underway throughout the educational system. Under the name of "new new math," to differentiate itself from the "new math" reform of the 1960s and 1970s,[1] this movement holds promises for a variety of constituencies: this country will be the first in the world in math and sciences, everybody will count, girls will be given a chance to become mathematicians, and African-American and other minority students "shall overcome, this time with algebra."[2] On both ends of the political spectrum, the claim is that the way out of poverty, marginality, and exclusion is dependent on the number of algebra courses we take. American employers must be able to search at home rather than abroad for more skilled armies of "problem-solvers."[3]

# Betina Zolkower

> We are at risk of becoming a divided nation in which knowledge of mathematics supports a productive, technologically powerful elite while a dependent, semiliterate majority, disproportionately Hispanic and Black, find economic and political power beyond its reach. Unless corrected, innumeracy and illiteracy will drive America apart.[4]

> By the year 2000, U.S. students will be first in the world in science and mathematics achievement.[5]

These two statements suggest a rather conspiratorial scenario in which the acceptance of the governing (homogeneous) "we" of the first citation is perhaps the beginning of our trouble.

"We" have a big problem, a severe crisis, a rampant social disease: innumeracy.[6] One of its main symptoms is the "underachievement" in mathematics of Latino students—one of the fastest growing ethnic groups in the nation's public school systems.[7] But we also have the solution: the new new math. With this antidote we will get out of trouble, and in the process we will achieve that old, nineteenth-century dream—the dream of becoming "a calculating people."[8] Yet, we have an even bigger problem: we are no longer the first in the world in math and science. Have we ever been? Not really. We have always been "behind" in math, a fact that, as early as 1701, surprised John Arbuthnot, an English mathematician who dismissed Americans as a "barbarous" people who "could not reckon above twenty."[9]

But now, more than ever, we need to get our skills in shape. As Labor Secretary Robert Reich predicts, the

> real economic challenge facing the United States in the years ahead—the same as that facing every other nation—is to increase the potential value of what its citizens can add to the global economy, by enhancing their skills and capacities and by improving their means of linking those skills and capacities to the world market.[10]

Thus, in order to become "number one," we need to join our forces to build a society of "symbolic analysts."

With the new new math reform, it looks as though, in the years to come, we will solve two problems at once: while making room for "everybody to count," we will build a nation of symbolic analysts. Yet, are these two goals compatible? In the first stages, it is possible that we will make it even harder for some children to count, but in the long run, we will all benefit. Such are the costs of progress.[11] After all, when it comes to problem-solving, what matters is no longer the final product nor the right answer. Problem-solving *strategies* should be the

focus, wherever they take us, as long as the process is accountable, inclusive, creative; in sum, fun.

In order to bring about the big dream, children and their mostly female teachers need to take seriously the task of solving little math problems.[12] But, as we know, math problems in school have always been meaningless, irrelevant; in sum, boring. Let me share with you this example from a 1797 copybook:

> How many minutes [were there] from the commencement of the war between America and England, April 19, 1775, to the settlement of a general peace, which took place January 20, 1783?[13]

Two hundred years later, the formula consists of transforming the content and delivery of the problems into seductive narratives which invite and entice students to solve them. We have turned word problems into story problems.[14] But what if the students, some of them "lacking" reading and writing skills, are not able to understand the problems? What if teachers themselves do not know how to solve them? None of this seems to matter. Even getting the right answer is not enough: we must produce "mathematical communicators," not mechanical rule-followers. And so, with the new new math we may not be able to find the right answer, but in the process we will become engaged (problems will look like the real world out there); we will feel included (problems will represent everybody); we will be heard in dialogue and have a chance to disagree (problems will be open for negotiation); and, last but not least, we will have a space to express our personal feelings, individual needs, and "mathophobia."[15] Now, what is "the view from below?" How do these new narratives— the story problems—interpolate the ones-supposed-to-count, the future problem-solvers, the learning subjects?

Before I start with the beef of the matter, let me indulge in a small confession (perhaps funny, because I will later discuss confessionalism in educational discourses and practices: the possibilities, and particularly the dangers). I feel a certain uneasiness in transporting to a conference on technoscience and cyberculture,[16] a myriad of stories I collected in two years of periodic visits to the fourth- and fifth-grade math classes of a public school in El Barrio (Spanish Harlem, New York City).

So, why am I here? I am here because, echoing Laurie Anderson "I was looking for you . . . but I couldn't find you." I was looking for you in all the wrong places; for example, at the last American Education Research Association Meeting in New Orleans. At this mega-event and other similar conferences, normal science coexists with a few panels, admittedly quite

packed, where radical pedagogues celebrate paradigm shifts in the field of education, sharing news with each other about students' resistance, teachers' empowerment, border pedagogies, subversion in educational praxis, and "postmodernist approaches to validity in qualitative research." That I could not find you in places like the one I have just described brings me to a question raised by Beatriz Sarlo, one of the most important cultural critics in Argentina: why is it that cultural critics do not care about elementary schools?[17] Although the referent was Latin America, her comment applies to the "Third World at home,"[18] and in particular, to the streets, garbage-filled vacant lots, tiny kitchens and bedrooms, overcrowded classrooms, and school yards in a state of chronic disrepair which frame the daily lives of thousands of children from unemployed, very poor, and recently emigrated families in El Barrio. The apparent lack of interest in examining the practices of schooling is especially dangerous today when, despite the available technocultural cornucopia— videogames, knowledge machines, and microworlds[19]—inner-city, elementary schools have become increasingly ravaged.[20]

In this post-Fordist, post-*Learning to Labor*[21] society, when cultural critics take the school as an object of inquiry at all, they are motivated by a search for new evidence of students' resistance. Thus, visiting a fourth- or fifth-grade math classroom accomplishes little. Except for a few so-called maladjusted, hyperactive, at-risk, or problem cases, children do not resist the symbolic violence[22] to which they are subjected. When they resist, they do so in ways that are far from obvious. We may be surprised to find that seven- to eleven-year-old students often want to learn even the most apparently obsolete chunks of knowledge presented to them on a daily basis by their math teachers, and that some of them enjoy such trivial activities as math challenges in which exhibiting perfect mastery over the multiplication tables is the only condition for winning the class struggle.

In the case of the early grades, our expectations are haunted by the ghosts of Althusser[23] and Bourdieu and Passeron.[24] Thanks to them, we under-stand schools as Ideological State Apparatuses in which routine pedagogical work functions as a relatively smooth operation, covering a systematic exercise of symbolic violence, always misrecognized as it refashions itself in new cloth-ing ("the famous new methods!").[25] We can accept Bourdieu and Passeron's dictum, that "there is no science but of the hidden," and set for ourselves the task of pushing "the truth of power relations to come into the open, if only by forcing them to mask themselves yet further."[26] Or, moving beyond the hermeneutics of suspicion, we may decide that such a Sisyphean task proves too unbearable or not worth the effort. Thus, we may forget about schools, or, alternatively, we may build small, progressive, ethnically and racially

integrated, schools (for our own kids), establishing oasis models to be imitated. In the meantime, most children have no choice but to attend mainstream, racially, and ethnically segregated, overcrowded schools.

So, after all, it may be worth looking at what actually happens in an elementary school math classroom. In keeping with Bourdieu, I propose we consider schools as fields in the following sense:

> In a field, agents and institutions constantly struggle, according to the regularities and the rules constitutive of this space of play (and, in given conjunctures, over those rules themselves), with various degrees of strength and therefore diverse probabilities of success, to appropriate the specific products at stake in the game. Those who dominate in a given field are in a position to make it function to their advantage but they must always contend with the resistance, the claim, the contention, "political" or otherwise, of the dominated.[27]

The field in question is a public elementary school located in El Barrio, a low-income, multiracial, predominantly Latino neighborhood described as one of the poorest in the nation. At present, this area is experiencing socioeconomic and cultural shifts associated with urban disinvestment, changes in local industry and immigrant influxes which have become common throughout much of the urban United States. Thirty percent of the students are of Mexican origin, over ninety percent are of Latino origin and fifty percent are classified as LEP ("Limited English Proficiency"). The stories I present here are part of an ongoing inquiry into the ways in which these (subaltern) learning subjects respond to the new new math and its seductive little narratives, that is, "the open-ended," "realistic," and "multicultural" story problems.

Now, what is the new new math reform all about? The new new math participates in a series of transformations of the mechanisms through which, since the nineteenth century, modern industrialized nations have exercised social control of their populations.[28] As described by Basil Bernstein, in the educational field these changes have taken the form of a shift from visible to invisible pedagogy.[29] The basis of visible pedagogy is a curriculum-centered model in which power relations are hierarchical and explicit, and discipline is harsh. In contrast, invisible pedagogy is based on a child-centered model[30] in which power relations are less obviously hierarchical and discipline is apparently relaxed. Children learn through activity and play. Work is pathologized: anything that resembles hard, routine work is interpreted as rote-learning and is therefore discouraged.[31] As described by Bernstein, one of the main characteristics of invisible pedagogies is the emphasis on subjectivity. Children are

encouraged to make their personal experiences public, and this creates the opportunity for constant monitoring.[32]

Responding to state and employer demands, practitioners in the field of mathematics education have begun to transmute into new pedagogical practices the last thirty years of research findings in various fields. Among these areas are: learning and cognition;[33] class, gender, and ethnic differences in mathematical ability;[34] mathematical anthropology and ethnomathematics;[35] and cognition in practice.[36] Out of these efforts emerges the new new math, whose main tenets I have charted as a series of dichotomies deploying terminology from several primary accounts of the reform.[37]

| OLD MATH[38] | NEW NEW MATH |
|---|---|

### THE SCIENCE

| | |
|---|---|
| Mathematics as a body of isolated concepts and procedures | Mathematics as problem-solving, communication, reasoning, and connections |

### THE MATH TEXT

| | |
|---|---|
| Meaningless | Meaningful |
| Arbitrary | Relevant |
| Artificial | Authentic, realistic |
| Eurocentric | Multicultural |

### THE COGNITIVE MODEL

| | |
|---|---|
| TRANSMISSION: Writing on the blank slate of the student's mind | CONSTRUCTION: Creating an environment for the student to construct knowledge |

# Math Fictions

### THE AIMS OF TEACHING

| | |
|---|---|
| Low order computation skills | High order problem-solving strategies |
| Rote memorization | Reasoning |
| Rule following | Real understanding |

### THE CONTEXT OF LEARNING

| | |
|---|---|
| Classroom as a collection of individuals | Classroom as a mathematical community |
| Authoritarian/monologic/ curriculum-centered classroom | Democratic/dialogic/ student-centered classroom |
| Individual work | Group projects |
| Teacher as dispenser of knowledge, and as the sole authority for correct answers | Teacher as catalyst for learning; logic and mathematical evidence as verification |

### THE FAMILY

| | |
|---|---|
| Parents' involvement in students' learning is limited to assuring that homework is done. | Parents are encouraged to a more active participation (e.g., family math programs). |

### THE EXAMINATION

| | |
|---|---|
| Measurement of limited areas of math competence | Authentic assessment of mathematics performance |
| Norm-referenced, multiple-choice tests (proxy items) | Holistic, multiple sources of assessment (open-ended, realistic problems) |
| Product-oriented, focusing on correct answers | Process-oriented, focusing on the appropriateness of the problem-solving strategies chosen, and clarity of responses |

# Betina Zolkower

| Temporal separation between instruction and evaluation | Blurred distinction between instruction and evaluation: learning is continuously monitored |

Thus, under the new new math regime, school mathematics has finally opened its doors to "culture," operating on the basis of what I provisionally identify as five regulatory principles: understanding, confession, dialogue, context, and difference. In what follows, I elaborate on each of these principles:

(1)UNDERSTANDING: We move beyond school mathematics as a mechanical practice of rule-following towards the generation of deeper understanding. "Activity" and the articulated reflection on that activity is what is taken as a sign of "real" understanding.[39] This understanding will be enacted—and meticulously evaluated —in the context of "portfolios" and "authentic" problem-solving performance assessment tests.[40]

(2) CONFESSION: Here we allow the self, the embodied subject, to enter mathematical discourses and practices so that—in the context of classroom debates, journals, and "portfolios"— anxieties, fears, and phobias will be brought to the surface, with intended therapeutic effects, particularly for girls and minority students.[41]

(3) DIALOGUE: relies on "empowering" students, by allowing them to take charge of their own learning process. In Walkerdine's terms, "the old methods of rigid, hierarchical organization and overt discipline gave way to a more invisible form of power: again, conflict between teacher and pupil becomes displaced onto rational argument, in which a central trope is the illusion of control."[42] Math classrooms are turned into micropublic spheres in which everything pertaining to problems—production, interpretation, strategies for solution, and final answers—is open for negotiation.

(4) CONTEXT: centers on bringing real life into the classroom and/or letting the students out of school to discover the mathematical concepts by exploring their environment. Researchers have documented extensively the skillful ways in which children and adults

handle mathematical concepts and operations in everyday, street, and shopfloor contexts. The principle of context results from a peculiar reading of these findings: since math works outside of school, why not try to draw the outside in or let the inside out?[43]

(5)  DIFFERENCE: aims at correcting the Eurocentric character of school math curricula by allowing space for the Other, that is, ethnomathematics. In the words of one of its critics, the logic is the following: "1. mathematics as an activity, if not as a body of knowledge, is not *culture-free*; 2. the learner's *cultural* equipment may prove at variance with the cultural prerequisites of mathematical activity and mathematical learning; 3. whenever this is the case, specific learning difficulties follow."[44] In order to deal with this situation, there are two programs at work: the strong program—adding units on non-Western math topics to the curriculum (Mozambican basket-weaving, Angolan sand-drawing, and so on.); and the weak program—inventing story problems which are multicultural in content rather than form (math problems about African-American astronauts, Mexican tortillas, and so on.)[45]

In order for these principles to operate fully, the mathematical text has to be radically transformed. The new story problems will increasingly perform a multivocal rather than a univocal function. As Yuri Lotman explains,[46] the univocal function of a text corresponds to a transmission model of communication (the text as an authoritative conveyor of unambiguous meanings; for example, artificial languages). In its multivocal function, the text operates as a generator of new meanings. In most cultural texts, the second function is the predominant one, although there is always an unresolved tension between the two.[47] This tension produces effects which are multiple and rather difficult to anticipate. With its emphasis on realism, multicultural embeddedness and open-endedness, the new new math may at first glance appear to privilege the multivocal function of the text. In principle, the new narratives should offer opportunities for generating new meanings. Yet, in the context of the existing pedagogical practices, the productive tension between the two functions of the math text results in the elimination of the multivocal. Students' ad hoc rules, survival tactics, and "horrible" errors[48] can be read as symptomatic of this reduction.

Now, what do we know about students' errors? Because we live in times when confessionalism figures prominently within math education, we

now have access to the very substance of students' thinking processes. Was this not always the case? In the times of Thorndike's connectionism,[49] we already knew that something was wrong with most children's math reasoning. As Worth Osburn noticed in 1929, students often formulated faulty rules, such as:

> You subtract when there are two large numbers in the problem. You add if there are more than two numbers. If there is a large number and a small one, you divide if it will come out even. If it won't come out even, you multiply.

This he diagnosed as a symptom: "harmful transfer is almost always based upon some element of form perceived by the eye."[50] In those times, the treatment for this failure was more training.

Nowadays, under subtler modes of regulation, beliefs, prejudices, opinions, feelings, and anxieties are slowly surfacing. Thanks to this invaluable information, school systems become more accountable, teachers get feedback in order to improve their methods and identify individual students' needs, students may express their anxieties and get over their "mathophobia," and parents are informed about every detail of their child's performance and become more actively involved in the learning process. You may be wondering, what is there for us, the cultural critics? The following pieces of ethnographic evidence,[51] presented in dramatic form, suggest that, in order for students to survive this reform they must negate the five principles defined above, and ignore the following solicitations: show me that you really understand, tell me how you feel, share your thinking with your classmates, pretend that school is like real life, and see your culture included in this text.

# THE RULES OF THE GAME
## *A Play in Nine Scenes*
### Prologue

CHORUS: Welcome to the wonderful world of problem exploration! . . . *Let's Think About It* is a booklet with eighteen nonroutine problems for you to solve. We suggest that each week your teacher read a problem to the class. Then you should reread the problem, think about the problem, organize your thoughts, plan a strategy, and attack the problem. You have the *entire page* to work on, and you can use more

paper if you need it. Explain your thinking. While the answer is important, what is even more important is *your thought process*—how you think, plan, organize, and work on the problem. When you have finished, check your answer and ask yourself, "Does it make sense?". . . Enjoy!![52]

## Scene One:
### *The Hint*

*(We are in a public, bilingual school in El Barrio (East Harlem, New York City). The math lab. This lab is a remedial program for students who score low in math.*[53] *About ten fourth-grade boys and girls sit around two tables with the* MATH LAB TEACHER *and her* AID. *Among them are* KAYLA, *who was born in New York City, and* ASIA, *who came from Jamaica six years ago. The teacher has just given workbooks to the students.)*

THE PROBLEM: What number belongs in the circle?

| START | divide | add | subtract | multiply | END |
|-------|--------|-----|----------|----------|-----|
| (?) | by 14 | 39 | 18 | by 6 | 216 |

HINT: Work Backwards[54]

THE TEACHER'S AID: Asia, they tell you to work backwards. I will give you another hint. What I'm giving you is "work backwards," but don't do exactly what they're telling you to do. No, if you do exactly what they're telling you to do, you're not gonna get the right answer. So, if you don't do that, what else can you do? Try the opposite. That's the only word I will say. Try the opposite of what they say to do.

ASIA: Miss, I got it!

KAYLA: I don't get it, miss!

# Betina Zolkower

THE MATH LAB TEACHER: If you take a minute and give yourself a break . . . just to think about it, you might get it. You're not gonna get it in less than one second. You need some time. . . . Kayla, why are you writing backwards? Upside down rather?

KAYLA: (*appearing naive*): Miss, you said . . .

*(END OF SCENE)*

### Scene Two:
### *Funny Jobs*

*(Same school, fourth grade, English-dominant class. About thirty-five students sit around six tables. Regular math period. After working individually on the "problem of the day" for about ten minutes, students and TEACHER begin the discussion.)*

NATIONAL COUNCIL OF TEACHERS OF MATHEMATICS: When students make public conjectures and reason with others about mathematics, ideas and knowledge are developed collaboratively, revealing mathematics as constructed by human beings within an intellectual community. . . . Like a piece of music, the classroom discourse has themes that pull together to create a whole that has meaning.[55]

> THE PROBLEM: Suppose you had 50 cents on Monday night. You took a job for a week that doubled your money each day. For example, Tuesday night you had $1.00. How much money did you have the next Monday night?

THE EXPERT: (*to the audience*): The correct solution of this problem demands the following operations: (1) construct a Monday-to-Monday chart which includes eight days, (2) obtain each day's wage by doubling the wage of the previous day, and (3) add the daily wages. Obtaining the correct answer—127 dollars and fifty cents—is contingent upon a clear understanding of three key linguistic signs in the problem's formulation, i.e., "week," "doubled," and "have" respectively.

*(The TEACHER: underlines the word "doubled" in the problem. During the course of the scene, she will write down on the board the steps suggested by the students, as well as her corrections.)*

TEACHER: Could someone give me some ideas on how we are going to solve this? Let's see if we can work on this together. Who can tell me what's the first thing we have to do? Eliza.

ELIZA: You have to put Monday 50 cents, then you have to add 50 cents for each, Tuesday, then Wednesday, like that.

TEACHER: One moment. There's a word that I underlined in the problem. What is it?

ALL: *(chorus)*: Doubled!

TEACHER: Doubled what?

ALL: *(chorus)*: The money!

TEACHER: Double each day. Double fifty, two fifties is a . . .

ALL: *(chorus)*: Dollar!

TEACHER: *(to ELIZA)*: What am I doing for Wednesday?

ELIZA: Adding 50 cents.

JORGE: No, double one is two!

TEACHER: Two dollars. Why Jorge?

JORGE: 'Cos it says double.

ALL: *(chorus)*: Oh!

ELIZA: Oh, you have to double the dollar?

TEACHER: Right. Then the next day I have one dollar plus one dollar.

(ELIZA *looks at the board visibly confused*)

VOICE FROM ABOVE: *(to the audience)*: What's the problem here? Could it be that Eliza has a hard time imagining a job that remunerates its workers in such a fashion?

ROBERT: Two dollars.

TEACHER: *(smiling happily)*: Two dollars. How about Thursday?

JORGE: Four dollars.

TEACHER: How did you get that?

ALL: *(chorus, raising hands and screaming)*: Miss, miss!!

TEACHER: *(continues, ignoring the screams)*: Every day, the following day you double it, and so on. . . . I don't want any sound effects. . . . I'll wait.

*(The level of noise increases. The TEACHER walks towards the light switch. As this is a routine practice, the level of noise diminishes even before she gets there. She still turns the lights off. Absolute silence. A few seconds later, the TEACHER turns on the lights again.)*

TEACHER: Laura, what do we do next?

LAURA: Miss, I don't know . . .

TEACHER: If you were listening to what we are doing on each step you would know what comes next.

LAURA: *(pointing to KAYLA)*: Miss, she was talking to me.

TEACHER: Then you ignore her; you don't blame that on her. If you don't pass the test what are you gonna say: Kayla was talking to me, that's why I didn't pass the test?

*(Noises get loud again)*

TEACHER: Tyronne.

TYRONNE: Six dollars?

TEACHER: *(impatiently)*: How did you get six dollars?

TYRONNE: Because you've gotta double four dollars.

THE PRINCIPAL: *(voice off, from the loudspeaker)*: Despite our weekly math challenges, there are always those who insist on not remembering their times tables.

TEACHER: Double four is . . . ?

ALL *(chorus)*: Eight!

ROBERT: Eight dollars.

HECTOR: Two times eight is sixteen. Monday is sixteen and that's it.

VOICE FROM ABOVE *(to the audience)*: Can we blame Hector, one of the best mathematical minds in the classroom, for this little error? He is one of the privileged few whose parents actually work and are given weekends off.

TEACHER: Wait a minute. How many days do we have to go to?

ALL *(chorus)*: 'Til Monday!

TEACHER: To Monday night. Friday is eight dollars. Then comes Saturday. Now Laura, what do we have to do?

LAURA: You have to add four.

TEACHER: Not four!

ALL: Eight!

KAYLA: You have to do eight plus eight.

## Betina Zolkower

TEACHER: Michael?

MICHAEL: You gotta double the eight two times, and that's sixteen dollars.

TEACHER: Sunday? Sadara?

(SADARA remains silent)

TEACHER: I don't understand, we've been doing it together since Monday, it is Sunday, you should know what I'm doing. Jocelyn?

(For a second, students look at each other perplexed. Giggles. Teacher remains oblivious to the incident)

JOCELYN: You put sixteen plus sixteen.

TEACHER: How much is that, Jonathan?

JONATHAN: Thirty-two dollars.

JORGE: You have to do it one more time.

TEACHER: Christina, why are we going up to Monday of the next week?

CHRISTINA: I know, is that. . . . It says at the beginning (begins reading): "Suppose you had 50 cents on Monday night," and then it goes . . . at the end it says, "how much money did you have the next Monday."

ALL: (chorus): Oh!

TEACHER: Very good, so it's not one week later, it's next Monday night, that means she works . . . ?

CHRISTINA: All days.

TEACHER: One week.

ASIA: It's a very tricky one!

VOICE FROM ABOVE *(to the students)*: Do the constraints of the problem conflict with your real-life expectations? Cut through noise. Do not take the referent too seriously, avoid the confusion of mistaking the simulacrum for the real thing. You know that school is one game and real life is another. Do whatever "the problem" is asking you to do, even if it does not make sense.

TEACHER: What do we do here?

ELIZA: You add thirty-two plus thirty-two equals sixty-four and that's the answer.

TEACHER: Excellent! Would anyone like to explain to me how they try to do it?

*(Hands up)*

TEACHER: Lamar.

LAMAR: I thought I had to do fifty plus fifty plus fifty plus fifty plus fifty plus fifty . . .

TEACHER *(interrupting)*: Ok, what part were you missing there?

LAMAR: To double it.

TEACHER: Did anyone try another way to do this? Louis.

LOUIS: I put Monday fifty cents, Tuesday one dollar, Wednesday a dollar fifty, Thursday two dollars like that, and then I added.

TEACHER: Oh, you added because it says each time.

*(LOUIS nods his head affirmatively)*

TEACHER: Percy, what were you doing?

PERCY: I was doing the same as you. Monday fifty cents, Tuesday one dollar, Wednesday two dollars, Thursday four dollars, Friday eight dollars, Saturday sixteen-dollars, Sunday thirty-two dollars, and Monday sixty-four dollars.

# Betina Zolkower

TEACHER: So you did it correctly on your own?

PERCY *(proudly)*: Yes.

TEACHER: You did this on your own, before we went over it?

ALL *(chorus)*: No! No!

JONATHAN: Miss, he got eight-fifty!

PERCY: I don't got eight-fifty!

TEACHER: All right, we are going to do mental math, and then we are going to gym.

*(Cheers)*

*(END OF SCENE)*

## Scene Three:
### *Forget about the Incas*

*(TERESA's home, the kitchen. TERESA is a ten-year-old fifth-grader who came from Mexico, together with her family three years ago. She is doing her math homework, which consists of a series of eight problems dealing with the Incas. I notice that TERESA is solving the problems correctly and relatively fast considering that she scores "less than average" on tests of reading skills in English. Eager to check her reaction to the "culturally sensitive" nature of these materials, I decide to interrogate TERESA on this matter.)*

THE PROBLEM: The Inca never discovered the wheel. Instead, they transported things on the back of animals called *llamas.* Suppose the Incan emperor had 117 gold bricks, and each llama could carry 9 bricks. How many llamas would the emperor need to carry his load?[56]

ME: Could you read this one aloud?

TERESA: The Inca never discovered the . . . whe . . . . What is this miss?

ME: Wheel. It means *rueda*.

TERESA: . . . the wheel. Instead they trans . . . transported things on the back of animals called . . . llamas, llamas?

ME: Yes.

TERESA: Suppose the Incan empe . . . What is emperor?

ME: In Spanish we say *emperador*.

TERESA: Oh! The Incan emperor had 117 gol brickes. . . . *Qué son brickes?*

ME: Gold bricks are *lingotes de oro*.

TERESA: Oh, I see. And each llama could carry nine bricks. How many . . . . It's easy miss! I have to divide!

ME: Wait, wait. Let's finish reading it.

TERESA: How many lla. . . . llamas would the empe . . . emperor need to carry his . . . what is load?

ME: Load. Load means *carga*.

TERESA: I have to divide 117 divided by nine.

ME: How do you know that?

TERESA: 'Cos here it says "each," and then it says "how many"!

VOICE FROM ABOVE *(to TERESA)*: Having difficulties in reading and understanding the problem? Follow this rule: don't waste your time trying to make sense of this problem; cut through the noise, just go for the key words, look for cues. Forget about the Incas!

THE CULTURAL CRITIC: Thus, attempts at representing the Other fail when the other is not given the tools to decipher the narratives which contain those representations. In this situation, the gesture of inclusion simply does not compute.

*(END OF SCENE)*

# Betina Zolkower

## Scene Four:
### *Tricks*

*(This scene takes place in an imaginary space in which little problem-solvers have a chance to respond to problem-setters, with the ethnographer's obvious mediation, for, as we all know, "the subaltern cannot speak." In this unlikely exchange, the main character is MANUEL, an eleven-year old fifth grader, who arrived from Mexico City about two years ago.)*

THE NEW YORK CITY BOARD OF EDUCATION: If you want to have a good test, you have to engage the students. They have to be interested in the material in the test. If they are not interested, they may not perform up to their capacity. The problems in this test are interesting for kids.[57]

ME *(to MANUEL, a week after he took the test)*: Suppose you have to describe what a word problem is to someone who comes from another planet and never went to school. How would you explain to this creature what a word problem is?

MANUEL: It has to do with math and there are a lot of words to trick you.

*(END OF SCENE)*

## Scene Five:
### *Fall from Innocence*

*(Back in the fourth-grade math lab. Students and teacher are discussing a word problem which contains a piece of irrelevant information.)*

THE MATH LAB TEACHER: Do we need to know how many people live in Kansas to solve this problem?

ALL *(chorus)*: No! Yes!

THE MATH LAB TEACHER: No, we don't. They're asking us how long would it take for Peter to get there, aren't they?

76

ALL *(chorus)*: Yes!

THE MATH LAB TEACHER: So, they're giving us too much information. Do you think they do that to confuse you?

ALL: No!

THE MATH LAB TEACHER: Yes!

*(Silence. Students look at each other confused.)*

THE MATH LAB TEACHER: Yes! They do that to trick you!

THE "AT-RISK" STUDENT: Those bastards!

*(END OF SCENE)*

### Scene Six:
### *Show Your Work*

*(Students in a fifth-grade, Spanish-dominant, low-ability class are working on the Practice Performance Assessment in Mathematics test. Representing the new assessment instrument are THE NYC BOARD OF EDUCATION, and THE DISTRICT STAFF DEVELOPER. Also in attendance are a number of characters from the past and present, including LUDWIG WITTGENSTEIN, MICHEL FOUCAULT, STELLA BARUK, and WORTH OSBURN, who contribute philosophical remarks which may have bearing on the problematic at stake.)*

THE NYC BOARD OF EDUCATION *(to the audience)*: The Performance Assessment in Mathematics (PAM) Test is a constructed-response test, in which students provide their *own* solutions to open-ended problems set in *realistic* contexts.[58]

THE STAFF DEVELOPER: The beauty of the PAM test is that we can see the child in a different light. It helps capture each child's idiosyncratic way of solving problems.[59]

# Betina Zolkower

MICHEL FOUCAULT: It is the examination which, by combining hierarchical surveillance and normalizing judgment, assures the great disciplinary functions of distribution and classification, maximum extraction of forces and time, continuous genetic accumulation, optimum combination of aptitudes and, thereby, the fabrication of cellular, organic, genetic, and combinatory individuality.[60]

THE CULTURAL CRITIC: The claim is being made that students' "real understanding," lies at an apparently well-defined, localizable point in a spectrum, ranging from "there is no doubt that the student is competent," to "the student has no understanding of how to solve the problem."[61]

THE NYC BOARD OF EDUCATION *(to the students):* The PAM test is designed to help your teacher know how well you can figure out how to solve math problems, and how well you can show or explain your strategies.[62]

MARCOS: They want to make sure you didn't copy it from your neighbor.[63]

> THE PROBLEM: Mr. Blair wants to cook a 10-pound turkey for Thanksgiving dinner. The directions state that the turkey must be cooked for twenty minutes per pound. If he wants the turkey to be ready at 5:30 pm, at what time should he begin cooking the turkey? Show or explain the steps you took to find your answer. Label your work. Be as complete as you can.

*(In an effort to follow the directions and to provide an account of the inner workings of their minds, students produce the following written statements.)*

ANA: First I divided 10 into 20. Next I used my times tables to help me because you need to know your x tables in order to divide. Finally I got two which was my answer. Because $10 \div 20 = 2$.

TERESA: First I suptrat 5:30 and 20 minutes and then it gif me 5:10. At last I read again and it gaf me the sam.

STELLA BARUK: *La vérité de l'erreur est précisément dans le rapport de désir que l'on entretien en mathématiques avec la vérité, dont on voudrait*

*qu'elle soit "comme ça," parce que les mathématiques sont ce qu'elles sont.* [The truth of error lies precisely in the relation of desire to truth that one has in mathematics, a truth which one would like to be "comme ça" because mathematics is what it is.][64]

JESSE: I add because it gave me a *good* answer and a *low* answer.

THE EXPERT: Jesse reflects on the fact that, as compared to multiplying, adding gives him a "better" answer, a low answer. It is interesting to notice that, in other cases—other problems—judgments about "good" and "bad" answers are formulated in more general terms. For example: "adding is better than subtracting," or, as one teacher put it, "multiplying is faster than adding."

VIVIAN: I add becouse I *have* to add 2:30 and 5:00 and because when I add it give me answer and I add because if I sudtrat it will come to a *ronge* answer.

WORTH OSBURN: What sane person would ever want to solve a problem or work an exercise in arithmetic for any purpose other than to obtain the correct answer?[65]

THE "SMARTEST": $20 \times 10 = 200$; 200 min = 3 hours and 20 min; $5:30 - 3:20 = 2:10$. Mr. Blair has to start cooking at 2:10 pm.

VOICE OF TEACHER *(resonating from the previous day)*: Boys and girls, remember, with one dot it's money and with two dots it's time!

MARIA: First step: I multiply 10 and 20. Second step: it became 200. Third step: Then I put the two little dots. So that means that Mr. Blair have to start cooking at 2 pm.

LUDWIG WITTGENSTEIN: However many rules you give me—I give a rule which justifies *my* employment of your rules.[66]

THE COOK *(about to put the Thanksgiving turkey in the oven)*: 2:10 may work for Mr. Blair, but if I want it done by 5:30, I better start warming up the oven at 2:00!

*(END OF SCENE)*

# Betina Zolkower

## Scene Seven:
### *Steps*

*(The teachers' lounge is temporarily turned into a research lab in which, among other activities, I conduct individual "problem-solving" sessions with students. PERCY was born in New York City and attends the English-dominant, fourth-grade class.)*

ME: Percy, do you know what a "two-step word problem" is?

PERCY: Yes, it's when . . .

ME: No, no, don't tell me. I just want to know if you know what it means. Now, let's say I write this down, three dollars and seventy-five cents. Could you come up with a two-step problem so that its solution will give you this number?

> PERCY'S NOTEBOOK:
> Tomy brot a hip hop tape that cotsed $1.00 and a peprony pizza cost 2.75. How many did he spet equals 3.75.

ME: Could you read it to me?

PERCY *(reads)*: Tommy bought a hip hop tape that costed $1.00 and a pepperoni pizza that costed $2.75. How much money did he spend?

ME: Ok, now...how do you solve this problem?

Percy: It's easy, miss! You just have to add. See . . . *(he writes 1.00 + 2.75 = 3.75)*

ME: So, how many steps?

PERCY: Two steps.

ME: Show me the steps. I see only one here *(pointing to his calculation)*.

PERCY: Miss, you don't understand! First step you go to the record store to buy the tape, and second step you go to the pizza place. You

couldn't buy the tape at the pizza place . . .

(END OF SCENE)

## Scene Eight:
### Make up Your Own Problem

(We are in the fifth-grade math lab. Students are asked to invent problems using the given information.)

THE PROBLEM: Use these numbers and the words on the Word List to write a story problem about a purchase at a computer store.

19.50          Word List: printer, tax, quiet, disks, sale
259.50
13.00
272.95

CARLOS (reads his problem, which the teacher enthusiastically has pinned on the bulletin board): David went to a computer store to buy things for his computer. He saw a printer. The sale price is $272.95 and a disk for $19.50. A quiet for $259.50. The person said plus tax at $13.00. Will you buy it? What is the total price? It is $564.95. Ok, I will take it. Have a nice day, Sir.

THE CULTURAL CRITIC: Under the new new math regime, math problems are to become problems *for* the students. It is claimed that if we give students the chance to produce their own problems, they will feel a sense of ownership. But, when students are asked to construct their own story problems, they produce narratives that *do* function as stories, at the expense of the very purpose of the problem, which is to pose a question and leave it to the reader to "figure out." As Wittgenstein points it out, "making a story and reading it" and "solving a problem in practical arithmetic," are two different language-games.[67]

STELLA BARUK: *Et j'ai vu, des mes yeux vu, une classe active pétrifiée par l'intensité de l'exaspération tranquillement manifestée par une petite fille*

à qui on demandait depuis un moment d'inventer un probléme de sous-
traction: "10 personnes sont sur la tour Eiffel, 3 tombent. Combien en
reste-t-il?" [And I saw, with my own eyes, a perfectly lively class para-
lyzed by the intensity of the exasperation quietly expressed by a little
girl who, upon being asked repeatedly to invent a subtraction prob-
lem, came up with this: "Ten people are standing on the Eiffel tower,
three fall off. How many remain?"][68]

(END OF SCENE)

## Scene Nine:
### The Nineties

(The last scene takes place in the teachers' lounge, again temporarily
turned into a research lab. This is a segment of a group discussion about
word problems.)

ME: I have a question for you. Some people think that solving problems
in school is like solving problems in real life. What do you think?

PERCY: No way! Not the same 'cos you have the real stuff, that's just
words (points to a story problem on a sheet). Out there you got the real
stuff . . . real money. If you're trying to count something, you can't do
it as well as you can do it in a book, 'cos they make you count money
these days. That's the nineties.

ME: So, it's easier to do it in school or in real life?

PERCY: In school.

ME: Why is that?

PERCY: 'Cos they teach you more than outside . . . they tell you what to
do.

(END OF SCENE)

## Epilogue
### *Rules*

I hate rules.
They make me wanna jump off the roof.
This is all I hear don't do this don't do that
and that's all I hear
There's one rule I can die over
it is youuuuu can't go out.
I hate that rule.

(Percy)

## *The End*

Let us step off the elaborate stage of the elementary school class-room; let us leave behind the exciting activity of problem exploration; and let us reflect on our play. For, in the modern school, everything is play, activity, exploration, discovery, construction, fun. There is no more work! When we embarked, we were told that at the end of the journey we needed to consider whether our answer made sense. But, as I am finishing without a solution, I cannot check my answer. Can we then make sense of these nonsensical scenarios?

As the title indicates, these stories are clearly about rules. We can see that it is not by following explicitly taught problem-solving strategies, but by obeying implicit rules, that students in general, and particularly those with low reading and writing skills, develop survival tactics. Some of these tactics are successful: you get the right answer; you convince the teacher that you really understand; you pass the test; you get a new bike. Other tactics are not: you get distracted by extraneous information; you waste your time; you fail the test; your Nintendo gets confiscated until summer.

These scenes also point to the dystopian noise effects that result when "culture"—in the form of everyday life themes, multicultural stories, and

# Betina Zolkower

realistic problem situations—is introduced into mathematics classrooms, textbooks and tests. Madness seems to emerge in the course of the students' struggle to sift through the noises which nowadays, under the new new math regime, cloud the supposedly transparent discourse of mathematics. How does this work? Or more specifically, what happens when math problems adopt the form of realistic, multicultural, and open-ended narratives such as "A Job for a Week," "The Incan Emperor," and "Mr. Blair's Turkey"? In the case of "A Job for a Week," children's difficulties in "following the rule"[69]—to keep doubling—have more to do with cultural assumptions they bring to the classroom than with the specific arithmetical operations they are expected to perform.[70] (Many jobs have days off during weekends, and no job doubles the salary each day.) As the teacher is unaware of the ambiguous nature of this text, and as she is eager to get through the lesson,[71] students' idiosyncratic ways of solving the problem are not identified, and their errors are attributed to lack of attention, deficient knowledge of "math facts," difficulties in implementing problem-solving strategies or some mysterious confusion. If and when the problem succeeds in seducing the subjects-supposed-to-count, things get out of control. Rather than producing an harmonious piece of music, the discursive community of the classroom dissolves into cacophony. This cacophony affords several directions of resolution. The opportunity could have been seized, for example, to establish, as part of the classroom dialogue, the contrast between the world of daily experience and the axiomatic nature of the mathematical domain. Yet, with thirty-five students in a room, background noises from the bulldozers deconstructing the school playground, and the pressure of the upcoming standardized tests, the only recourse left for the teacher is to turn off the lights.

And then what happens? We hear Percy's claim that he has solved the problem correctly and all by himself. The issue is not whether he is lying or telling the truth. After all, lying "is a language-game that needs to be learned just like any other."[72] Rather, the event itself throws into question the possibility that the math classroom could ever become a Habermasian space.

A more optimistic reading of our drama would examine the symptomatic nature of lying-games, tricks, and errors. As we are reminded by students and teachers throughout the play, math is a very tricky thing. To confront it, most students become automatons.[73] A few exceptions become tricksters themselves. They lie, they copy from a neighbor, they save their play time—or they optimize their test time—by skipping the content of word problems and going right to the cues, and they all find clever ways of wasting as many minutes of class time as they possibly can.

Consider the case of Kayla, who combines in an unexpected way the

hints given to her by the math workbook and by her lab teacher—"work backwards" and "try the opposite." We may endlessly speculate on whether her response results from a fatal misunderstanding or constitutes a solitary act of resistance. Is she being tricked or is she the trickster? In either case, her reaction is only possible in a context where things are not supposed to make sense. By bringing out the nonsensical in the teaching machine, the students' view from below may be seen as an immanent critique of the pretensions of realism, suspect gestures of inclusion, and illusions of control which characterize cutting-edge mathematical pedagogies.

At the risk of stating the obvious, I will suggest what this essay is not. It is not a rejection of the new new math; it does not denounce multicultural math education; it does not propose the replacement of pseudonarratives with true-to-life, genuinely inclusive texts. Finally, it does not propose the elimination of all math narratives in favor of a totally transparent, noiseless discourse.[74] In fact, this paper is not so much about math texts as it is about the ways in which these texts operate within current pedagogical practices. In other words, it is about the seductive power of math fictions, and their effect on the children as well as on the host of other characters you have just seen on stage.

Following Adda, Baruk, and Walkerdine,[75] what I suggest is that seducing students into doing mathematics by relying on supposedly realistic situations, by masquerading the quantitative into qualitative, or by emphasizing the extrinsic value of mathematics, whether status quo (getting a job) or radical (deciphering the operations of ideology behind, for example, governmental statistics), will not do. If the pleasures of mastering an abstract, formalized discourse are to be conveyed as such, what is necessary is perhaps not so much a reform at the level of the math text, but rather, a radical transformation of pedagogical practices and of the broader social and economic context in which these practices are embedded.

Although Percy does not always manage to get to school—even though he lives right around the corner—he does take his classroom work seriously. He is aware that "doing school" does not teach you how to "do life." Yet, he also knows that, for better or for worse, in school he will learn what he could not learn outside. Percy has a clear sense of the times he is living in. Although he hates rules, their existence, to some extent, must be reassuring for someone who is only nine years old: in school things are easier because "they tell you what to do." Yet, sometimes all Percy wants to do is play outside, but he is not allowed to.

"Why?" I asked him one day.

"Too dangerous, they could kill you."

# Betina Zolkower

## Notes

The Spanish version of this paper appeared in *Propuesta Educativa*, Vol. 5 no. 11 (December 1994). It also appeared in English in *Social Text*, Issue 43, (Summer 1995).

This paper could not have been written without the encouragement and financial support of the Spencer Foundation which granted me the Dissertation Fellowship for Research Related to Education. I am infinitely grateful to Lauren Kozol, who encouraged me to present an earlier version of this paper at the Technoscience and Cyberculture Conference, and then read and reread successive drafts *ad nauseam*. Her invaluable critical insights and her careful editing skills helped whip this essay into its present shape. I am also thankful to Kimberly Flynn for contributing her thoughtful remarks and her dramaturgical expertise. The main characters are, of course, the children. They are the ones who, unknowingly, most encouraged me to pursue this project and to shape it in the form of a play. I am also indebted to the teachers, the school principal, other school personnel, and district staff coordinators, who did more than just tolerate my daily intrusions in their field. I have benefited from the insightful comments of Hernan Abeledo, Stanley Aronowitz, Paul Attewell, Kimberly Flynn, Joseph Glick, Trenholme Junghans, Cindi Katz, William Kornblum, Yvonne Lassalle, Carmen Medeiros, Kim Paice, and Sharon Zukin. None of these should be held responsible for any imperfections in the final product.

1. Considering mathematics education in the United States since the beginning of the century, I roughly identify four periods: (1) 1900s to mid-1950s: "Bad" Old Math, (2) Mid-1950s to early 1970s: New Math, (3) 1970s: "Good" Old Math or "Back to the Basics," and (4) since the 1980s: New New Math or the era of "problem solving" and of "mathematical empowerment for all."
   This essay intentionally omits a discussion of the "new math" of the 1960s and 1970s, and the backlash period right afterwards. By emphasizing the dichotomy old math/new new math, I hope to examine the shift in pedagogical practices from a "visible" to an "invisible" model (Bernstein) as it operates in the field of mathematics education. In this sense, my work closely follows that of Valerie Walkerdine. Critically appropriating Bernstein's ideas, Walkerdine and her team at the University of London Institute of Education conducted a series of empirical and theoretical investigations in the area of girls and mathematics. See Basil Bernstein, *Class, Codes and Control*, Vol. 1, (London: Routledge, Kegan and Paul, 1975); Valerie Walkerdine, *The Mastery of Reason: Cognitive Development and the Production of Rationality*, (London and New York: Routledge, 1988); and Valerie Walkerdine and the Girls and Mathematics Unit, *Counting Girls Out*, (London: Virago, 1989).

2. The "Algebra Project," a math-science program in Cambridge, Massachusetts, has organized local communities to help make algebra available to all seventh- and eighth-grade students. The assumption is

that this subject will allow students to take advanced high school math and science courses, which form a gateway for college entrance. See Robert Moses *et al.*, "The Algebra Project: Organizing in the Spirit of Ella," *Harvard Educational Review* (1989) 59(4). Already in its tenth year, the project has extended to other areas of the country. In Missisipi, superintendents and local business leaders see this project as laying the groundwork for economic revival. Alex Jetter, "Mississippi Learning: We Shall Overcome, This Time with Algebra," The *New York Times Sunday Magazine*, February 21, 1993.

3. The disastrous consequences of math failure in relation to industrial needs have been an issue at least since the turn of the century. Today's claim is that the workplace requires more mathematical skills than in the past. Corporations continue to spend as much each year in on-the-job mathematics training courses for their workers as is spent on mathematics education in schools. See William B. Johnston and Arnold E. Packer, eds., *Workforce 2000: Work and Workers for the Twenty-First Century* (Indianapolis: Hudson Institute, 1987).

4. Mathematical Sciences Education Board, National Research Council, *Everybody Counts: A Report to the Nation on the Future of Mathematics Education* (Washington DC: National Academy Press, 1989), p. 14.

5. National Council on Education Standards and Testing, *Raising Standards for American Education: A Report to Congress, the Secretary of Education, the National Education Goals Panel, and the American People* (Washington DC: National Council on Educational Standards and Testing, 1992).

6. "Innumeracy, an inability to deal comfortably with the fundamental notions of number and chance, plagues far too many otherwise knowledgeable citizens." John Allan Paulos, *Innumeracy: Mathematical Illiteracy and Its Consequences* (New York: Vintage Books, 1988) p. 3. ". . . ignorance of basic quantitative tools is endemic in American society and is approaching epidemic levels among many subcultures of the American mosaic." Lynn A. Steen, "Numeracy," *Daedalus: Journal of the American Academy of Arts and Sciences* (1990) Vol. 119, No. 2, p. 211.

7. By the year 2000, one in every three American students will be a minority. Already the largest school districts in the U.S. are 70% black and Hispanic. The Hispanic population in the U.S. grows at five times the national average. *Everybody Counts.*

8. Patricia Cline-Cohen, *A Calculating People: The Spread of Numeracy in Early America* (Chicago and London: University of Chicago Press, 1982).

9. "An Essay on the Usefulness of Mathematical Learning," cited in Cline-Cohen, *A Calculating People* p. 9.

10. Robert Reich, *The Work of Nations* (New York: Vintage Books, 1992) p. 8. Reich defines symbolic analysts as those specialists, for the most part white, male, college-educated, who "simplify reality into abstract images that can be rearranged, juggled, experimented with, communicated to other specialists, and then, eventually, transformed back into reality" (p. 178).

11. "With each opportunity for progress, of course, there are opportunities for serious missteps. Even change that clearly leads to overall economic growth can have very uneven effects . . . . Change can weaken the bargaining power of some groups while strengthening that of others. Change can result in a growing gap between those fortunate enough to have the talents, education, and connections needed to seize emerging opportunities and those forced into narrowly defined, heavily monitored, temporary positions. This latter group could be forced to bear the costs of uncertainty." United States Congress Office of Technology Assessment, *Technology and the American Economic Transition* (Washington DC: United States Congress Office of Technology Assessment, 1988).

12. Teachers do not belong to the caste of symbolic analysts (Reich, p. 180). Yet their task is to nurture the future problem-solvers. As mothers and as teachers, women are made responsible for introducing children to this realm. Valerie Walkerdine in *The Mastery of Reason* suggests the need to explore "how women become positioned as quasi-mothers within the caring professions and how, within teaching, this renders them opposite to, and yet responsible for, the reasoning children they are supposed to produce" (p. 216).

13. Cited in Cline-Cohen, *A Calculating People* p. 123.

14. In fact, math problems have always been story problems and the stories told have centered mostly on the theme of work. For example:

> SERVANT PROBLEM (1598): A master bargained with a servant to give him 10 gulden a year and a coat. The servant remained only 7 months. At that time the master said: "Leave my house and take the coat that I gave you; I owe you nothing more." How many gulden was the coat worth? Cited in Lambert Jackson, *The Educational Significance of Sixteenth Century Arithmetic*, (New York: Teachers College, 1906) p. 161.

> WORKMAN PROBLEM (1817): A workman was hired for 40 days upon this condition, that he should receive 20 cts. for every day he wrought, and should forfeit 10 cts. for every day he was idle; at settlement he received 5 dollars: How many days did he work and how many days was he idle? From Willetts' *The Scholar's Arithmetic*, cited in Clifton Johnson, *Old-Time Schools and School Books*, (New York: Dover Publications, 1963) p. 311.

What would word problems look like in postwork societies? When invited to propose an example of a "fun" word problem and explain why it is fun, Alex (fifth grade) wrote the following: "Jorge has 6 Supernintendo games. He gave 3 to Alex. How many did he have left? It's fun because it talks about games and that's what kids are into this year."

15. Mathophobia is defined as an irrational fear of mathematics whose main symptom is a fixation upon isolated rules in contrast to an understanding of mathematics as a collection of interrelated concepts. See Diane Resek and William Rupley, "Combatting 'Mathopobia' with a Conceptual Approach to Mathematics," *Educational Studies of athematics* 11 (1980). For a critique of this approach, see Richard Winter, "Mathophobia, Pythagoras and Roller-Skating," *Science as Culture*, (1991), Vol. 2, Part 1, No. 10. On the use of computers to combat mathophobia, see Seymour Papert, *Mindstorms: Children, Computers and Powerful Ideas*, (New York: Basic Books, 1980) Chapter 2: "Mathophobia: The fear of learning".

16. "Technoscience and Cyberculture: Implications and Strategies," May 12–14, 1994, City University of New York, Graduate Center.

17. First Conference of the Inter-American Cultural Studies Network, Mexico City, May 3–5, 1993, Universidad Autónoma Metropolitana Iztapalapa.

18. Kristin Koptiuch, "Third-Worlding at Home," *Social Text*, (1991), 28 9(3).

19. According to Papert, "mathematics is the area in which the epistemic transition is more brutal for children" (p. 16). Rather than importing real-life environments into the school—students "are not easily uped,"—the best way to provide a "softening" context is to profit from the fact that throughout the world "children have entered a passionate and enduring love with the computer" (p. ix). "The Knowledge Machine offers children a transition between pre-school learning and true literacy in a way that is more personal, more negotiational, more gradual, and so less precarious than the abrupt transition we now ask children to make as they move from learning through direct experience to using the printed word as the source of important information." Seymour Papert, *The Children's Machine: Rethinking School in the Age of the Computer* (New York: Basic Books, 1993), p. 12.

20. Not coincidentally, the state is also abandoning the schools, as we see reflected in recent budgets cuts and in the politics of vouchers and school choice.

21. Paul Willis, *Learning to Labor: How Working Class Kids Get Working Class Jobs* (New York: Columbia University Press, 1977).

22. "All pedagogic action (PA) is, objectively, symbolic violence insofar as it

# Betina Zolkower

is the imposition of a cultural arbitrary by an arbitrary power." Pierre Bourdieu and Jean-Claude Passeron, *Reproduction: In Education, Society and Culture* (London and Beverly Hills: SAGE Publications, 1977) p. 5.

23. Louis Althusser,"Ideology and Ideological State Apparatuses," in *Lenin and Philosophy and other Essays* (New York: Monthly Review Press, 1971).

24. Bourdieu and Passeron, *ibid*.

25. Althusser, *ibid*., p. 157.

26. Bourdieu and Passeron, *op. cit.* Foreword to the French edition, p. xii.

27. Bourdieu and Loïc J. D. Wacquant, *An Invitation to Reflexive Sociology* (Chicago and London: University of Chicago Press, 1992), p. 102.

28. Michel Foucault, *Discipline and Punish: The Birth of the Prison* (New York: Vintage Books, 1979); Jacques Donzelot, *The Policing of Families* (New York: Pantheon Books, 1979); and Ian Hacking, *The Taming of Chance* (Cambridge: Cambridge University Press, 1990).

29. Basil Bernstein, *Class, Codes and Control*, Vol. 1, (London and New York: Kegan and Paul, 1975).

30. For a critique of child-centeredness in educational practices, see Valerie Walkerdine, "Developmental Psychology and the Child-Centered Pedagogy: The Insertion of Piaget into Early Education," in Henriques *et al., Changing the Subject: Psychology, Social Regulation and Subjectivity* (London and New York: Methuen, 1984).

31. Walkerdine and the Girls and Mathematics Unit, *Counting Girls Out,* (1989).

32. "One confesses in public and in private, to one's parents, one's educators, one's doctor, to those one loves; one admits to oneself, in pleasure and in pain, things it would be impossible to tell to anyone else, the things people write books about. One confesses—or is forced to confess. . . . Western man has become a confessing animal." Michel Foucault, *The History of Sexuality: An Introduction*, (New York: Vintage Books, 1978), p. 59.

33. Lauren Resnick, *Education and Learning to Think* (Washington DC: National Academy Press, 1987); Alan H. Schoenfeld ed., *Cognitive Science and Mathematics Education,* (New Jersey: L. Erlbaum Associates, 1987). The shift from a representational to a constructivist view of mind in the field of learning and cognition has fundamentally transformed educational discourses and practices. See E. von Glasersfeld, *Radical Constructivism in Mathematics Education* (Dordrecht: Kluwer, 1991); Paul

Cobb *et al.*, "A Constructivist Alternative to the Representational View of Mind in Mathematics Education," *Journal for Research in Mathematics Education* (1992), 23(1).

34. Elizabeth Fennema and Gilah Leder, *Mathematics and Gender* (New York: Teachers College, Columbia University, 1990); Herbert Ginsburg, and Robert Russell, "Social Class and Racial Influences on Early Mathematical Thinking," *Monographs of the Society for Research in Child Development* (1981), Serial No. 193, 46(6). See also: Rodney Cocking and J. Mestre, eds., *Linguistic and Cultural Influences on Learning Mathematics* (New Jersey: L. Erlbaum Associates, 1988).

35. Ethnomathematics is the mathematics which is practiced by cultural groups such as "national-tribal societies, labour groups, children of a certain age bracket, professional classes and so on," D'Ambrosio, "Ethnomathematics and Its Place in the History and Pedagogy of Mathematics," *For the Learning of Mathematics* (1985), 5(1). See also Claudia Zazlavsky, *Africa Counts*, (Boston: Pridle, Weber, and Schmidt, 1973); Paul Gerdes, "Conditions and Strategies for Emancipatory Mathematics Education on Underdeveloped Countries," *For the Learning of Mathematics* (1985), 5(1); Alan Bishop, "Mathematics Education in its Cultural Context," *Educational Studies in Mathematics* (1988) 19; and Marcia Ascher, *Ethnomathematics: A Multicultural View of Mathematical Ideas* (Pacific Grove, California: Brooks/Cole Publishing Company, 1991).

36. Michael Cole, J. Gay, J. Glick, and D. Sharp, *The Cultural Context of Learning and Thinking* (New York: Basic Books, 1971); Sylvia Scribner and Michael Cole, *The Psychology of Literacy*, (Cambridge, Mass: Harvard University Press, 1981); Barbara Rogoff and Jean Lave, eds., *Everyday Cognition: Its Development in Social Context*, (Cambridge and London: Harvard University Press, 1984); Terezinha Carraher *et al.*, "Mathematics in the Streets and in the Schools," *British Journal of Developmental* Psychology (1985) 3; Jean Lave, *Cognition in Practice*, (Irvine, CA: University of California Press, 1988); and Geoffrey Saxe, *Culture and Cognitive Development* (New Jersey: L. Erlbaum Associates, 1991).

37. *Everybody Counts*, Mathematical Sciences Education Board's National Research Council, *Curriculum and Evaluation Standards for School Mathematics* (Reston, VA: Author, 1989); Mathematical Sciences Education Board's National Research Council, *Professional Standards for Teaching Mathematics* (Reston, VA: Author, 1991); Jean Stenmark, *Mathematics Assessment: Myths, Models, Good Questions, and Practical Suggestions.* (Reston, VA: Author, Mathematical Sciences Education Board's National Research Council, 1991); and Stenmark *et al*, *Family Math*, EQUALS Program, Berkeley, CA: Lawrence Hall of Science, (1986).

38. See Note 1.

39. For a critical discussion of the rule-following/real understanding dichotomy as it is applied to the assessment of boys' and girls' performance in mathematics, see Walkerdine *et al.*, *Counting Girls Out.* (1989).

40. Authentic assessments propose tasks which are "representative of the ways in which knowledge and skills are used in 'real-world' contexts." John R. Frederiksen and Allan Collins, "A Systems Approach to Educational Testing," *Educational Researcher* (1989), 18(9), p. 20.

41. See Note 15 on mathophobia. The problem has also been defined as "math anxiety," that is, "a slight discomfort with mathematics . . . which] can develop into a full-fledged syndrome of anxiety and avoidance by the time one has graduated from school and gone to work." Sheila Tobias, *Overcoming Math Anxiety* (Boston: Houghton Mifflin, 1978), p. 24. The author's view is that word problems are "at the heart of math anxiety . . . . More than any other aspect of elementary arithmetic, except perhaps fractions, word problems cause panic among the math anxious" (*ibid.*, p. 129). The solution: the talking cure. "People who don't like math don't like to talk about math. Part of their avoidance mechanism is to pretend that it does not exist. But math does not go away. People need it at work, in calculating percentages, in dining out, and in handling money. A math clinic is designed to integrate talking about math into the learning process" (*ibid.*, p. 247). Cf. J. E. Sieber *et al.*, *Anxiety, Learning, and Instruction* (New Jersey: L. Erlbaum Associates, 1977).
    A psychological approach to math failure is not just an American phenomenon. With a more psychoanalytical flavor, anxious and phobic reactions to mathematics are widely diagnosed in France. Cf. Jacques Nimier, *Mathématique et affectivité*, (France: Stock, 1976). For a critique of the effects of "l'appareil psy" in math education, see Stella Baruk, *L'âge du capitaine: De l'erreur en mathématiques*, (Paris: Editions du Seuil, 1985).

42. Walkerdine *et al.*, *Counting Girls Out*, p. 35.

43. For references, see Note 36. The transmutation of these research findings into the didactic process operates in two directions: (a) bringing the outside in ("realistic problem solving," and "authentic assessment"), and (b) letting the inside out (e.g., the Boston-based Algebra Project, structured around students' explorations of the city's subway system).
    For critical considerations of the use of concrete situations in the introduction of abstract mathematical notions, see: Josette Adda, "Difficultés liées à la présentation des questions mathématiques," *Educational Studies of Mathematics* (1976) (7); Baruk; Claude Janvier, "Use of Situations in Mathematics Education," *Educational Studies of Mathematics* (1981), (12); and Walkerdine, *L'âge du capitaine* (1988).

44. Yves Chevallard, "On Mathematics Education and Culture: Critical

Afterthoughts," *Educational Studies in Mathematics* (1990) 21(3), p. 5.

45. As part of the broader multiculturalism debate, in the case of math education, this problem is formulated as follows: the association of school mathematics curricula with European thought affects the learning of mathematics by children and adults from diverse cultural backgrounds (D'Ambrosio, 1985). The solution proposed by many is the incorporation of ethno- and multicultural mathematics into the curriculum. The multicultural approach "is best seen as part of a general strategy of making mathematics more accessible and less anxiety-arousing among the wider public." ". . . all mathematics teachers should have at their fingertips stories on the origins and development of various topics in mathematics." George Gheverghese Joseph, "A Rationale for a Multicultural Approach to Mathematics," in David Nelson, George G. Joseph, and Julian Williams, eds., *Multicultural Mathematics* (Oxford and New York: Oxford University Press, 1993) pp. 19, 21. For a strategic use of the history of mathematics, recall Jaime Escalante, popularized by actor Edward James Olmos in the highly praised Hollywood film *Stand and Deliver*, who, in passing, reminds his Mexican-American students that the concept of zero was well understood by their ancestors.

 For critical considerations of multicultural math education, see Yves Chevallard, "On Mathematics Education and Culture: Critical Afterthoughts," *Educational Studies in Mathematics* (1990) 21(3); and Paul Dowling, "The Contextualizing of Mathematics: Towards a Theoretical Map," in Mary Harris, ed., *School, Mathematics, and Work*, (London, New York, Philadelphia: Falmer Press, 1991).

46. Yuri Lotman, "Text within a Text," *Soviet Psychology* (1988) 26(3). See also, Sylvia Scribner, "Modes of Thinking and Ways of Speaking: Culture and Logic Reconsidered," in P.N. Johnson-Laird and P.C. Wason, eds., *Thinking: Readings in Cognitive Science* (Cambridge: Cambridge University Press, 1977). In her discussion of verbal logic problems, Scribner proposes we consider arithmetical problems as a narrative genre "whose content is arbitrary and whose meaning resides in the relationships expressed." Thus, school mathematics presents "'arbitrary problems' in the sense that the problems derive from a system outside the learner's own personal experience and *must* be taken in their own terms" (p. 499) *(my emphasis)*.

47. Lotman, "Text within a Text".

48. "L'erreur-horreur." Baruk, *L'âge du capitaine* pp. 58–67.

49. Edward Thorndike, *The Psychology of Arithmetic* (New York: Macmillian Company, 1922). Thorndike's theory of learning is based on the notion of mental "bonds," or stimulus-response connections. According to this model, bonds are strengthened as a result of reinforcement or frequent use. In the pedagogical field, this approach translates into "drill and practice" instruction.

50. Worth Osburn, *Corrective Arithmetic*, Vol. II. (Cambridge, MA: The Riverside Press, 1929) p. 22.

51. All students, teachers, and NYC Board of Education officials are quoted verbatim. The Cultural Critic, the Expert, the Principal, the Voice from Above, the "At Risk" Student, and the "Smartest" are fictional characters. All statements by true characters are taken from transcripts collected during my fieldwork. The names of the students have been changed. Their writing is presented as found.

52. Fred Nagler and Madelaine Gallin, *Let's Think About It,* Student Book I (Educators Choice, 1992).

53. The math lab provides remedial mathematics instruction for students scoring low on standardized state and city math tests. "At each target site, a teacher and a paraprofessional team provide corrective mathematics instruction emphasizing error patterns, hands-on experiences, problem exploration, test taking skills and mental math." Office of Curriculum and Professional Development, NYC Community School District 4, *Curriculum and Professional Development Resource Guide*, (1993), p. 25.

54. There is a field of study that focuses on the role of hints in math learning. One of the stumbling blocks in this field is that "subjects who experience troubles in the solving process can hardly articulate these troubles." How do we get out of this vicious circle? Among other recommendations, Perrenet and Groen suggest that a hint which indicates "what one should not do (warnings for well-known errors and traps) is ineffective if it is not accompanied with instructions on what one should do." Jacob Perrenet and Wim Groen, "A Hint is Not Always a Help," *Educational Studies in Mathematics* (1993) 25, p. 317.

55. National Council of Teachers of Mathematics, *Professional Standards for Teaching Mathematics* (1991) pp. 34, 35.

56. Francis Fennell, *et al*, *Mathematics Unlimited, Practice Workbook*, (Holt, Rinehart and Winston, 1987) p. 52.

57. Head of Testing, New York City Board of Education, March 31, 1993. He was referring to the new 1993 California Achievement Test (CAT–5). The CAT–5 is a timed test consisting entirely of word problems. Children have less than a minute per problem. Limited English Proficiency (LEP) students are allowed to take the test in their native language.

58. As a complement to the usual multiple-choice instrument, the Performance Assessment in Mathematics (PAM) Test consists of three open-ended, realistic problems to be solved in a total time of 45 minutes.

59.  District Math Coordinator, in a staff development meeting.

60.  Foucault (1979), p. 192.

61.  The Cultural Critic refers here to the highest and the lowest of the six levels of competence in the performance of mathematics, as specified in the General Rubric for Rating Open-ended Mathematics Items, *Writing Rubrics for Open-ended Mathematics Items: A Training Guide* (New York City Board of Education, 1993).

62.  NYC Board of Education, in a pamphlet for students.

63.  Student's response to the following question: "What do they mean when they give you a word problem and they ask you to 'show work'?"

64.  Baruk, *L'âge du capitaine*, p. 48 (my translation).

65.  Worth Osburn, *Corrective Arithmetic: For Supervisors, Teachers, and Teacher-Training Classes* (Cambridge, MA: The Riverside Press, 1924) p. 124.

66.  Wittgenstein, *Remarks on the Foundations of Mathematics*, Part I, eds., G.H. von Wright, R. Rhees, and G.E.M. Anscombe, trans. G.E.M. Anscombe (Cambridge, MA and London, England: The MIT Press, 1967), Paragraph 113, (emphasis is his).

67.  Wittgenstein *Philosophical Investigations*: 3rd ed., Part 1 (New York: Macmillan Publishing Company 1958) gives a list of examples to illustrate the multiplicity of language-games, Paragraph 23.

68.  Baruk, *L'âge du capitaine*, p. 249 (my translation).

69.  Wittgenstein, *Philisophical Investigations*, p. 143ff.

70.  The inherently problematic nature of transfer from home to school is discussed at length by Walkerdine in *The Mastery of Reason* in her analysis of the "shop-ping game" situation. Whereas "slow" learners (girls) get caught in the fantasy of having a huge amount of money, "fast" learners (boys) realize that the game is an excuse for them to learn subtraction (1988, Chapter 7: "2 pence does not buy much these days: Learning about money at home and at school").

71.  Time and teacher's epistemology are the two main internal constraints of the didactic contract. Guy Brousseau, "Le contract didactique: Le milieu," *Recherches en didactique des mathématiques* (1988) 9(3). See also Yves Chevallard, *La transposition didactique: Du savoir savant au savoir enseigné* (Grenoble: La Pensée Sauvage, 1985).

72. Wittgenstein, *Philisophical Investigations*, p. 249.

73. "L'automath," Baruk, *L'âge du capitaine*.

74. "What is mathematics if not the language which assures a perfect communication free from noise?" Michel Serres, *Hermès IV: La Distribution* (Paris: Éditions de Minuit, 1977), p. 287

75. Adda; Baruk, *L'âge du capitaine*; and Walkerdine, *The Mastery of Reason*.

# 5

# Citadels, Rhizomes, and String Figures

*Emily Martin*

The field of social and cultural studies of science is already thickly dotted with the flags of explorers from other disciplines: history, sociology, cultural studies, philosophy, ethnomethodology, and so on, many wielding selectively some of the analytic categories and practical techniques of anthropology. In a recent review, Sharon Traweek counts, at a minimum twenty academic disciplines engaged in the study of science, medicine, and technology. It is in this epistemological context that I will discuss the contributions that I see anthropologists beginning to make in the study of science and culture.

Before proceeding, it is useful to note compelling and relevant questions that have been brought up by scholars such as J.P. Singh Uberoi. In his book, *The Other Mind of Europe*, Singh questions whether different conceptions of knowledge might have arisen from a different historical starting place, such as Paracelsus or Leibnitz, as instantiated in Goethe's writings, rather than those of Newton and Copernicus. The Third World Network's Declaration, "Modern Science in Crisis: A Third World Response," begins:

> There is a growing awareness that there is something intrinsically wrong with the very nature of contemporary science and technology. . . . Reductionism, the dominant method of modern science, is leading, on the one hand, in physics, towards meaninglessness, and on the other, in biology, towards

# Emily Martin

"Social Darwinism" and eugenics. There is something in the very meta-physics of modern science and technology, the way of knowing and of doing, of this dominant mode of thought and inquiry, that is leading us towards destruction. (Harding, 1993: 484–85)

In the face of all this work, what room could there be for even more inquiries? For another thing, what sort of a position is an anthropologist in from which to scrutinize, rather than just apply, Western science? Anthropology is part of a long tradition in which science was an intrinsic part of what we did. We produced ethnoscience, in which the others had the "ethno" and we had the "science." Anthropology liked to straddle the divide between the humanities and the sciences and claim some of both for its own. The "science" of linguistics could help us map the cognitive terrain of Philippine plant categories, or African knowledge systems. All of the natural sciences could be brought to bear on prehistoric remains, helping physical anthropologists understand the emergence of humans as a species. Thus we could produce cultural accounts in which the tools of natural science had an essential place.

In spite of these complications, my own desire to study Western science was spurred on by two main factors. First, I had the sense that there was something profoundly (and tantalizingly) elusive about the study of Western science. It seemed to entail one of those impossible conundrums, like trying to push a bus in which you are riding, or trying to see, like the fish in Marx's example, the invisible water in which one swims. If science is the ground of nature, and the ground of my thought about it, then how can I think about science outside of itself? This sense was brought home to me in a paper written by Gyorgy Markus, "Why Is There No Hermeneutics of Natural Sciences," (1987). In this work, Markus traces the extreme narrowness of the problems addressed by contemporary science to a deep transformation in the nineteenth century that resulted in science and scientists belonging to scientific research communities that became separated from the rest of society, and the questions they considered ceased to have broad cultural significance. This was a sharp discontinuity from the seventeenth and eighteenth centuries, when science was embedded in society, recognized as both widely influenced by and influencing of other discourses such as philosophy (Markus, pp. 16–17). Clifford Geertz, in a lecture on the possibility of a hermeneutic treatment of the natural sciences, summarized the implications of Markus's article thus: the view of nature now held by science (with some exceptions) no longer claims to be a worldview, in the interpretivist sense. In spite of and because of this, he urged his listeners to appropriate science as meaningful social action, to

see science as "a part of how things stand" constructed in a particular historical setting. He had in mind questioning what had come to be taken for granted as "truth" in the sciences: objectivity as a standpoint, nature as an object, and materiality as reality.

Perhaps these sentiments were what led Geertz to frame last year at the Institute for Advanced Study around the theme—"the social and cultural study of science." Perhaps these sentiments also led to his dismay when the group of us who were invited to be in residence failed utterly to create a working atmosphere, but instead acrimoniously bickered until the unpleasantness forced us to divide into two groups distinguished not by gender, age, nationality or discipline, but by our willingness or reluctance to give up the scientific point of view as a privileged one. The subgroup that was willing to (try to) give it up met for the rest of the year separately in the evening at Geertz's house.

The second factor that impelled my interest was a desire to look at science simultaneously as a "particular story of how things stand" and as an important part of the institutions that are exerting particularly brutal forms of power in the contemporary scene. Scientific institutions are implicated in large-scale political and economic forces abroad on the earth, structural forces that can be universal in their scope and that are often damaging in their effects.[1] These forces involve the increasing concentration and mobility of capital, which often lead to immiseration of the poor, and the concomitant restructuring of the organization of work, both inside corporations and factories and in the spread of "homework." Political and economic trends entail vast alterations in how information is stored and retrieved, and the extent to which biological research focuses on genetics. Some of their effects include dramatic changes in how both scientists and nonscientists conceptualize the components of the human body and the determinants of its health; the occurrence of virulent forms of racism, and an intense new biological essentialism.

The third factor that impelled my interest was my sense that, in spite of the number of disciplines already represented among those studying science culturally, cultural anthropology might have something important and even unique to add. I will now turn to this topic, addressing the various approaches to the cultural study of science from within anthropology, their benefits and shortcomings, under the three rubrics: citadels, rhizomes, and string figures.

## Citadels

The natural sciences of the present day are heir to processes that have left most of us thinking they are, in Sharon Traweek's terms, "cultures of no

culture." What sets them apart from the rest of history and society is that they claim to construct reality, but not to be themselves constructed. In a challenge to the veracity of this view, some anthropologists have begun to depict the very rich and complex cultures of the natural sciences, ensconced within their citadels apart and above the rest of society. Sharon Traweek has described some of the fundamental presuppositions about time, space, matter, and persons that give the world of a high-energy physicist meaning; she has shown how those fundamental presuppositions take one form in the U.S. and another, quite different form in Japan, thus demonstrating their historically contingent nature.

In showing us that the world within this citadel has a culture, in spite of itself, Traweek provides an insight of inestimable value. Occasionally she peers over the side of the citadel walls and wonders with her physicists what ordinary people outside are thinking about them: why, for example the U.S. government is declining to fund the Texas super-collider. But the very position that allows her to capture so richly and movingly the cultural world of physics means that she, like her physicists, rarely ventures outside the walls. Her anthropology is almost entirely done within. Her participant-observation in their world entails participation in their isolation, as they see it, and as Traweek, the ethnographer, experiences it through sharing their world. They are, in fact, outside society, encased in a culture of their own, but one that has little to do with anything outside it. The walls of the citadel (seen from this perspective) are left intact.

Traweek's groundbreaking work opens up intriguing new questions: What would happen if the ethnographer wandered around outside the citadel walls, and tried to find out why people do or do not support the super-collider? What if he or she tried to find out why Stephen Hawking's book *A Brief History of Time*, and the video based on it have become best-sellers? Now that we have the benefit of Traweek's work, the way is cleared to connect the lab in which the high-energy physicist tinkers with his machines, and the living room in which a family watches Stephen Hawking talk about the universe, thus calling into question the solidity of the citadel walls. There is another major approach to the walls of the citadel, taken by Bruno Latour. In a series of studies, beginning with a collaborative ethnography of a biology research lab, the walls between the conduct of science and the rest of society are shown to be permeable. We see how the making of facts, and the resources necessary to make them, depend on gathering allies in many places. Scientists must travel about into government agencies, manufacturing concerns, press offices, and publishing houses, all the while communicating intensively to build up supporters for the facts they wish to establish:

# Citadels, Rhizomes, and String Figures

They travel inside narrow and fragile networks, resembling the galleries ter-mites build to link their nests to their feeding sites. Inside these networks, they make traces of all sorts, circulate better by increasing their mobility, their speed, their reliability, their ability to combine with one another. (Latour, 1987: 160–61)

*Science in Action* breaks down the bounds of the walls of the citadel, but I would claim that this gain comes at too high a price. For the Latourian scien-tist who bursts upon the scene is an accumulating, aggressive individual born of capitalism, forming his networks and gathering his allies everywhere, resembling all too closely a Western businessman. We may wonder whether all scientists have, or ever had, such a monadic, agonistic, competitive approach to the world (Birke, 1986). In particular we might wonder whether some women scientists (for a host of reasons more excluded from playing these games than men) may have lived their scientific lives very differently, and garnered a measure of success in spite of it (Keller, 1983).[2]

Another approach to the citadel walls has been taken by anthropolo-gists like Rayna Rapp and Deborah Heath. They act as acute observers of the landscape who notice what should have been obvious to us all along, that many powerful collectives and interested groups dot the landscape all around the castle. Not only are they there, but they interact with the world inside the castle of science frequently and in powerful ways. It is as if we had thought of science as if it were a medieval walled town, and it turns out it is more like a bustling center of nineteenth-century commerce—porous and open in every direction. So Rapp describes how genetic counselors (they are not research scientists but professionals whose specific job is to translate between the science of genetics and the public) communicate the meaning and implica-tions of genetics and genetic testing to pregnant women. Nor are the women to whom they translate science mere passive recipients. Rapp's vivid material makes plain the complexity of fitting new knowledge to diverse lives: a work-ing-class, single mother chose to keep an XXY fetus (with Klinefelter's Syndrome), declaring him at the age of four, "normal as far as I am concerned . . . and if anything happens later, I'll be there for him, as long as he's normal looking" (Rapp, 1988: 152). On the other hand, a professional couple chose to abort a fetus with Klinefelter's, saying: "If he can't grow up to have a shot at becoming the President, we don't want him."

Positioning herself in a similar way, Deborah Heath has done ethno-graphic work on the interface between a genetics lab and people with Marfan Syndrome, a connective tissue disorder caused by a genetic abnormality, the one which probably affected Abraham Lincoln. In this interface zone she found that the National Marfan Foundation, the U.S. lay organization for affected

individuals and their advocates, holds meetings attended by genetics researchers as well as people affected by Marfan. Here the interface between the world of science and the public becomes membrane-thin. Researchers are "hurt" when people with Marfan do not like to look at a slide of an electron micrograph of the molecule altered by the genetic abnormality that affects them (someone in the audience hissed at the villain responsible for Marfan); researchers are "amazed" to see the phenotypic variability in the people who share Marfan Syndrome.

In an emotional consequence of this close contact between the inside and outside of science, one researcher became angry at Marfan patients after a National Marfan Foundation conference. She was unsettled because "the patients really think that I'm responsible to them." This expectation clashed with her belief that "pure science should follow its own course" even while she acknowledged that, with a little readjustment, she could push her research in directions that might provide more therapeutic findings (Heath, 1993).

In sum, ethnographic research shows that strict fixed borders between the pure realm of knowledge production and the "untutored" public do not hold up to scrutiny. The walls of the citadel are porous and leaky; inside is not pure knowledge, outside is not pure ignorance. This means the way is opened for a more complex, less flatly antagonistic attitude toward science than prevailed among some of us earlier. Scientific knowledge is being made by all of us; we all move in and out of the bustling city of knowledge production.

## Rhizomes

The next approach I will consider neither peers over the walls of science nor shows us how porous and leaky they are. This approach asks whether the layout and design of the castle itself, the logic of the actions of the scientists within it, may not be deeply embedded in the same countryside as the hamlets and villages surrounding it. This approach seeks to link the knowledge in the castle, and its manner of production, with processes and events outside of it.

Two images have been especially provocative to me in beginning to think about this problem, both of which were devised outside traditional anthropology. The first comes from Katherine Hayles's work on complex systems, or chaos thinking. She sees this sensibility arising in culture historically in many domains at once, such as in nonlinear dynamics and post-structuralist literature. She captures the nature of possible linkages between these domains in the image of a rising archipelago:

# Citadels, Rhizomes, and String Figures

Suppose an island breaks through the surface of the water, then another and another, until the sea is dotted with islands. Each has its own ecology, terrain, and morphology. One can recognize these distinctions and at the same time wonder whether they are all part of an emerging mountain range, connected both through substrata they share and through the larger forces that brought them into being. (Hayles, 1990: 3)

The image of an archipelago has the merit of suggesting that visions of the world that "rise up," seeming salient or passionately interesting in science, might be part of the same processes by which those visions seem equally gripping in very different contexts outside the realm of science. But its detriment as an image is that it is too solid, monolithic and, possibly, slow-moving. It can also imply that a substratum or deep structure underlies everything.[3] Another image that avoids these shortcomings comes from Deleuze in his imaging of the rhizome:

A rhizome as a subterranean stem is absolutely different from roots and radicles. Bulbs and tubers are rhizomes. Rats are rhizomes. Burrows are too, in all of their functions of shelter, supply, movement, evasion, and breakout. The rhizome itself assumes very diverse forms, from ramified surface extensions in all directions to concretion into bulbs and tubers. . . . Any point of a rhizome can be connected to anything other, and must be. This is very different from the tree or root, which plots a point, fixes an order. (29)

A rhizome may be broken, shattered at a given spot, but it will start up again on one of its old lines, or on new lines. You can never get rid of ants because they form an animal rhizome that can rebound time and again after most of it has been destroyed. (Deleuze 1987: 9)[4]

Rhizomic things "evolve by subterranean stems and flows, along river valleys or train tracks; [they] spread like a patch of oil (p. 7). This image might do well to capture the kind of discontinuous, fractured, and non-linear relationships between science and the rest of culture that Donna Haraway has given us. In tracing convoluted lines between primatology and movies about primates, Haraway writes:

The women and men who have contributed to primate studies have carried with them the marks of their own histories and cultures. These marks are written into the texts of the lives of monkeys and apes, but often in subtle and unexpected ways. . . . Monkeys and apes—and the people who construct scientific and popular knowledge about them—are part of cultures in contention. (Haraway 1989: 2)

# Emily Martin

None of the people I have mentioned in the archipelago-rhizome camp is by disciplinary training an anthropologist, and none has done traditional fieldwork. Are there ways of studying ethnographically the discontinuous, non-linear, fractured ways that might link the citadel to the rest of the world? My own recent work is an effort to do just that. And as an indication of how difficult it may be to gain legitimacy, when I described to Karin Knorr Cettins, one of my colleagues in science studies, the range of sites I use for my research (an immunology lab, various clinical HIV settings, AIDS activist volunteer organizations, several urban neighborhoods, corporate workplaces), she was horrified. Coming from a tradition of studying science inside the laboratory, she asked me, "Don't you know how to stay put?"

But with the image of a rhizome in mind, anthropologists of science need not be confined. Some people can peer over the castle walls; some can look through the holes in its walls; and others can trace the convoluted, discontinuous linkages between what grows inside the castle walls and what grows outside. Some objects or concepts become concrete inside the castle and extend outward, as what Latour calls "immutable and combinable mobiles" (Latour 1987: 227). These may be a written document such as a map, an object such as a telephone, a technique such as vaccination, or a concept such as the germ. Once at large, these entities may be used in ways that know no limit. Scientists may use them to enhance their own social position, as Latour has demonstrated in the case of Pasteur's use of vaccination. But equally, they may fail to have any effect, fail to be taken up or adequately taken up, or taken up beyond the intentions of their inventors. Parents' refusal of whooping cough vaccines for their children in the U.S. (estimates range as high as 70 percent in wealthy communities like Santa Fe and Santa Cruz) and the staggeringly wide usage of Prozac are examples of these two possibilities.

In cases like these, I would argue, the scientist and the layperson must be seen as coparticipants in the processes by which "mobiles" do or do not become part of our lives. As the authors of a definition of the field of cyborg anthropology put it; "Cyborg anthropology is interested in how people construct discourse about science and technology in order to make these meaningful in their lives. Thus, cyborg anthropology helps us to realize that we are all scientists" (Downey, et al., 1993). Another way to look at this is to think of entities that emerge from science as "technologies" whether or not they are machines or gadgets.

Prozac, for example, has been analyzed by Joe Dumit as a technology of self-making, in which the wide-spread desire among certain class segments of laypeople for a way to continuously refashion the self plays as large a role as the judgment of the psychiatric community or any other factor. Prozac can

be understood as a kind of interface between scientific research and people, through which a self-concept can be fashioned. Prozac is not an animate being like a therapist, exactly, but neither is it an inanimate object like a stone. Once a person has taken Prozac, it is alive in them; simultaneously, the person has ingested a technological device. Together they form a cyborg, part human, part machine. Human subjects produce machines, but their subjectivities in the present age are perhaps as much produced by machines (Dumit, 1993).

In my own work I argue that the concept of the immune system has become a technology of the measurement of health. Carrying with it elements of complex-systems thinking instead of lineal, mechanistic thinking, it produces powerful effects on the way health is conceived and measured. This new form of measuring health can be used as an index of differential survival in society: some will have good jobs, healthy bodies, strong immune systems, and protected living spaces and will live. Others, with none of these things, will die. This is an ethos of neo-Social Darwinism, in which some are seen as "unfit" disposable people, and some are seen as fit people of "high quality."

Nor do the effects of these technologies go only one way. To return to the image of the rhizome, ethnographic inquiry into the "ramified surface extensions" of Prozac or the immune system would be as likely to trace connections between propensities or disinclinations in the "general public" and what is thought a desirable project in science, as to trace connections in the other direction. In my own research, I found that most biological researchers operate with a mechanistic view of the body—the body is divided up into compartments, arranged hierarchically under the head of such ruling organs as the brain, clearly separated from the outside environment. Cause and effect are linear. In contrast most nonscientists operate with a very different notion of how the body works and how it relates to its environment. Often, the body is seen as a complexly interacting system embedded in other complex systems, all in constant change. No one part is ever always in charge. Change is nonlinear in the sense that small initial perturbations can lead to massive end results. One woman we interviewed as to her visualization of the immune system, rejected the image of the immune system on the cover of Time magazine (a boxing match between the vicious virus and the T cell). She said she disliked the image, "because it depicts such violence going on in our bodies." She insisted that such violence is "not in there." She claimed her own representation would be "less dramatic":

> My visualization would be much more like a piece of almost tides or something . . . the forces, you know, the ebbs and flows.
> [Could you draw anything like that?]
> I could. I don't think anybody would perceive it as a portrayal of the battle

# Emily Martin

within.
[What is it that ebbs and flows?]
The two forces, I mean, the forces . . . imbalance and balance.

As she spoke, she drew a wavy lines across the middle of the page, labelling it "the waves" and capturing her picture of the body in turbulent, constant change.

Often people interviewed in my study talk at great length about the impossibility of separating such an ever-changing body from its environment —health is affected by diet, water, air, mood, stress, relationships, the past, colors, work, and so on. Often people turn to alternative medicine—acupuncture, homeopathy, chiropracty, herbs, natural foods—to address these concerns.

A recent study published in the *New England Journal of Medicine* showed the extent to which Americans use alternative therapies: visits to alternative providers exceeded the number of visits to all U.S. primary care physicians in 1990:

> Extrapolation to the U.S. population suggests that in 1990 Americans made an estimated 425 million visits to providers of unconventional therapy. This number exceeds the number of visits to all U.S. primary care physicians (388 million). Expenditures associated with use of unconventional therapy in 1990 amounted to approximately $13.7 billion, three quarters of which ($10.3 billion) was paid out of pocket. This figure is comparable to the $12.8 billion spent out of pocket annually for all hospitalizations in the United States. (Eisenberg, 1993: 246)

Moving rhizomatically back inside the citadel of science, there is a group of scientists (Varela, Coutino) who are claiming that the body is made up of complex, nonlinear systems inseparable from their environment. They argue that the immune system is a self-organizing network, a complex system of the sort Vera Michaels meant to evoke by drawing turbulent waves. But today these scientists are considered "unconventional" and their views controversial. If this currently controversial view were to prevail within biological science (and there are many signs that eventually it will), surely we would want to point out that such a development would be a reflection of perceptions of health and the body held in the general population. It is important to remember, however, that such developments in science would be participating in broader cultural developments, not simply reflecting them. They might be rising on another island of the same archipelago, or participating in the proliferation of one part of a rhizome in another place.

## String Figures

As Max Black said long ago, metaphors both enlighten and blind at the same time (Black, 1966). I would not want anyone to take away the impression that there is an actual thing out there in the world that is the equivalent of the archipelago or the rhizome of knowledge. We are not looking for a thing, we are seeking to understand processes by which things, persons, concepts, and events become invested with meaning. Perhaps in the end, the best metaphor of all—my third and last—is one that consists almost only of process: Donna Haraway's evocation of string figures used in the game of cat's cradle:

> The cat's cradle figures can be passed back and forth on the hands of several players, who add new moves in the building of complex patterns. Cat's cradle invites a sense of collective work, of one person not being able to make all the patterns alone. . . . It is not always possible to repeat interesting patterns, and figuring out what happened to result in intriguing patterns is an embodied analytical skill. (p. 11)

An anthropological study of science involves playing a kind of cat's cradle, a serious game "about complex, collaborative practices for making and passing on culturally interesting patterns"(p .11). Understanding the processes of constitution of diverse, fragmented cultures is one significant task for ethnography.

I aimed to draw a map, but I have ended up with a game of string figures. That is because the "space" in which science and culture contend is too discontinuous, fractured, convoluted and in constant change for any map to be useful. To traverse such a space, we need an image of process that allows strange bedfellows, odd combinations, discontinuous junctures: Marfan people making geneticists feel guilty; such widespread demand for Prozac that the medical community is put on the defensive; the general public abandoning the nineteenth-century, mechanistic, linear view of the body before most of the biological sciences have; a conception of health based on the immune system that took the form of a scientific speciality (immunology) in the sciences only in the 1970s, having already reached general currency on the streets of Baltimore by the early 1990s.

You may have noticed that the picture of the world as complex, in constant, turbulent change, which I just claimed is "how it is," closely resembles the picture of the world painted by Vera Michaels, the informant I quoted earlier. This leads me to a final point. My initial worry was that you would not be able to get outside science in order to talk about it. I found that indeed you could not, but that is because science is not located where we thought it was. Rather than being produced in an isolated, privileged realm and trickling out

# Emily Martin

to inform the rest of us about what is "true," science is made continuously and permeates—historically constituted human culture. That the musings of an anthropologist about "how things are" should echo the musings of an informant, indeed, of many informants, and is no more and no less a product of the same permeation. And it is no more and no less an impediment to developing a cultural anthropology of science.

## Notes

1. These are part of what M. di Leonardo terms the "culturally constructed (but nevertheless) actually existing material world" (1991: 24).

2. We might wonder whether the growth of science such as highenergy physics, where research is conducted by large collaborating groups with cooperative links to other such groups, would mitigate any tendency toward individual competition (Traweek, 1988: 149, 153; Knorr Cetina, 1992).

3. At the conference on anthropology and the field, Talal Asad's remarks helped me see that the archipelago need not imply a deep structure. The deeper mass of the earth out of which land forms rise can simply represent "everything that is" not a particular structure of reality.

4. The image applied to language: A rhizome ceaselessly establishes connections between semiotic chains, organizations of power, and circumstances relative to the arts, sciences, and social struggles. A semiotic chain is like a tuber agglomerating very diverse acts, not only linguistic, but also perceptive, mimetic, gestural, and cognitive: there is no language in itself, nor are there any linguistic universals, only a throng of dialects, patois, slangs, and specialized languages. There is no ideal speaker-listener, any more than there is a homogeneous linguistic community. . . . There is no mother tongue, only a power takeover by a dominant language within a political multiplicity. Language stabilizes around a parish, a bishopric, a capital. It forms a bulb. (Deleuze, 1987: 7)

## Works Cited

Birke, L. (1986). *Women, Feminism, and Biology: The Feminist Challenge*. New York: Methuen.

Black, M. (1966). *Models and Metaphors*. Ithaca, NY: Cornell University Press.

Deleuze, Gilles and Felix Guattari. (1987) *A Thousand Plateaus: Capitalism and Schizophrenia*, Vol. II, Minneapolis: University of Minnesota Press

Di Leonardo, Michaela. (1991). "Introduction: Gender, Culture, and Political Economy: Feminist Anthropology in Historical Perspective." in Michaela Di Leonardo, ed., *The Racial Economy of Science: Toward a Democratic Future.* Berkeley, CA: University of California Press.

Downey, Gary, Joseph Dumit and Sharon Traweek. (1993) "Cyborg Anthropology: A Proposed Seminar at the School of American Research"unpublished manuscript.

Dumit, Joseph. (1993). "A Digital Image of the Category of the Person: PET Scanning and Objective Self-fashioning." unpublished manuscript. School of American Research.

Eisenberg, D.M. *et al.* (1993). "Unconventional Medicine in the United States: Prevalence, Costs, and Patterns of Use." *New England Journal of Medicine,* 328(4), 246–252.

Haraway, D. (1989). *Primate Visions.* New York: Routledge.

Harding, Sandra, ed. (1993). *The "Racial" Economy of Science: Toward a Democratic Future.* Bloomington, IN: Indiana University Press.

Hayles, N.K. (1990). *Chaos Bound: Orderly Disorder in Contemporary Literature and Science.* Ithaca, NY: Cornell University Press.

Heath, Deborah. (1993). "Bodies, Antibodies, and Partial Connections." Paper presented at School of American Studies Advanced Seminar on Cyborg Anthropology.

Keller, E.F. (1983). *A Feeling for the Organism: The Life and Work of Barbara McClintock.* New York: W.H. Freeman.

Latour, B. (1987). *Science in Action.* Cambridge, MA: Harvard University Press.

Markus, G. (1987). "Why Is There No Hermeneutics of Natural Sciences? Some Preliminary Theses." *Science in Context,* 1(1), 551.

Rapp, R. (1988). "Chromosomes and Communication: The Discourse of Genetic Counseling." *Medical Anthropology Quarterly,* 2(2), 143–157.

Third World Network. (1993). "Modern Science in Crisis: A Third World Response." In Sandra Harding, ed., *The Racial Economy of Science: Toward a Democratic Future.* Bloomington, IN: Indiana University Press.

Traweek, S. (1988). *Beamtimes and Lifetimes: The World of High-Energy Physics.* Cambridge, MA: Harvard University Press.

Uberoi, J.P. (1985). *The Other Mind of Europe.* Oxford: Oxford University Press.

Winner, L. (1985). "Do Artifacts Have Politics?" In D. MacKenzie and J. Wajcman, eds., *The Social Shaping of Technology: How the Refrigerator Got Its Hum.* Milton Keynes, England: Open University Press.

———. (1993). "Upon Opening the Black Box and Finding It Empty: Social Constructivism and the Philosophy of Technology." *Science, Technology, and Human Values,* 18(3), 362–378.

# III

## World, Weather, War

# 6

# Earth to Gore, Earth to Gore

*Andrew Ross*

As my title suggests, these comments are addressed to one of the most dismal spectacles that the Clinton Administration has served up—the case of the Disappearing Ozone Man, as David Corn described our vice president in the pages of *The Nation*.[1] The "Ozone Man" was the moniker used by George Bush on the campaign trail of 1992 to direct ridicule upon the erstwhile gentle Green giant from Tennessee and his environmentally-minded constituency, reviled by the same Bush as "the spotted owl crowd." Even for those with low expectations for a Clinton presidency, his association with Gore was expected, at the very least, to bear some kind of harvest for the environmental movement, invited into the corridors of power for the first time. Nothing, it was reasoned, could possibly be worse than the widespread damage wrought by Dan Quayle's Council on Competitiveness in its four years of pro-corporate butchery. Even with their critics holding their fire, it took the Clintonistas (as they are termed, incredibly enough, by movement conservatives) less than a year to dispel all illusions of an emergent Green government. Each new attempt to revise existing environmental legislation was currently being weakened in Congress, with the apparent assent of Clinton and Gore. Even the most worshipful of the army of Clinton environmentalists came around to agree that it is better to have no new environmental regulation at all than to risk enfeebling the current laws (especially big-hitter legislation like the

# Andrew Ross

Clean Water Act, the Endangered Species Act, and Superfund) by rendering them vulnerable to the principle of voluntary compliance, habitually favored by Clinton in matters of regulation. Under the terms of the GATT trade agreements, enthusiastically brokered by Clinton, many of the U.S.'s basic environmental laws—the Marine Mammal Protection Act, Corporate Average Fuel Economy Standards, the Magnuson Act and Pelly Amendment regulating overfishing, the Nuclear Non-Proliferation Act, Food and Water Safety laws, dozens of California laws on emissions, dangerous additives, recycling and waste reduction, and laws in every state that limit toxic substances in packaging—can be challenged as barriers to free trade by countries with virtually no environmental legislation of their own. Thirty years of hard-won achievements in the field of consumer and environmental protections, along with hopes of future advances, have been endangered with a stroke of Clinton's GATT pen.

Some commentators, such as Mark Dowie, have suggested that, far from guaranteeing environmentalists access to the White House, Gore, along with everything Gore represented to Greens, was expediently used by the Clinton Democrats to gain reverse access to the mainstream environmentalist lobby, co-opting the movement in the cause of the North American Free Trade Agreement (NAFTA), GATT, and the heavily procorporate President's Council on Sustainable Development, and exploiting their own inside knowledge of the divisions among environmental groups to gain an edge in crucial bargaining situations. While the White House has done little for the movement, the Washington environmentalists have done some stellar work for Clinton, winning him safe passage on NAFTA, above all.[2] Gore, in the meantime, had completed a remarkable transformation from the Ozone Man, the man who wrote *that* book, into Mr. America Online, tapping out heady, corporate-populist yarns about exploits in cyberspace, as he cruised an information superhighway (or the Infobahn, as it is known by cognoscenti wireheads, not for Euro flavor, I think, but presumably to evoke the thrill of speeding along the mother of all surface highways) that is about to be sold, lock, stock, and gigabyte to the telecom giants years before it is even built.

Although I would not dispute any of the elements of the narrative of sellout and betrayal laid out above, the story I want to tell about Al Gore is somewhat different. It is not a story about the greenwashing of campaign rhetoric, or a story about apostasy on the part of a once-idealistic boomer senator, although the apocalyptic devotionalism that is the house style of so many environmentalists might led one to conclude that apostasy would be more common than it seems to be in movement circles. To the contrary, the recent direction of White House policy regarding information technology and environmentalism is no evidence of the shortcomings of an administration with its

hands tied. It is quite consistent with the neoliberal framework developed by Gore in *Earth in the Balance*, a book that was flagrantly misread by those who skimmed it two years ago through rose-colored spectacles. Today, it repays some closer reading. "Al, Read Your Book" goes the grassroots slogan. It is not a book that will haunt Gore, but it may haunt us. The mistake, as always, was to take undue notice of the bragworthy rhetoric, the short-term promises, and the lucid blueprints, and to ignore the larger philosophical and economic framework. Much was made of Gore's understanding of and sensitivity to the entire spectrum of ecological issues, from local environmental racism to the global $CO_2$ debates. His indictments of the gospel of the GNP, of unfettered industrial growth and especially of "blind devotion to laissez-faire responses" (EB, p. 75)[3] were a welcome overture to those long accustomed to the corporate savagery of the Reagan-Bush years. It warmed some hearts to hear Gore notify global funding institutions like the World Bank that he and his senatorial crowd were "looking for ways to hold their feet to the fire." (EB, 344). Above all, Gore's strategic proposals for what he called a Global Marshall Plan on environmental issues spoke to those, ordinarily averse to chauvinistic thoughts, who felt embarrassed by the failure of the U.S. in particular to assert its leadership in global affairs, most visibly in Bush's humiliating behavior at the Rio Earth Summit. Even Gore's excesses in the field of climatic determinism could be construed as evidence of an overzealous commitment to the cause: he suggests, for example, that it was the famines generated by the Little Ice Age of the seventeenth century that drove Presbyterian Scots into their occupation of lands in Ulster (p. 68)! (Similarly, "it was the deforestation of Haiti, perhaps as much as the repression of the Duvalier regime, that led to the sudden arrival of 1 million Haitians in the southeastern United States" [p. 120]).

The indictments had depth, the proposals had teeth. All in all, Gore's book was received as an invigorating exception to the rule about the What-I-Believe genre of politician's campaign manifestos. It was not a book by someone who conventionally intended "to make a difference," it was a book that fully acknowledged and accepted the legitimacy of alternative politics, outside the Beltway, as they say. This, then, was the origin of the perception that Al Gore had written a radical book that, once elected, he would be pressured to forget.

Let us examine the evidence. The book was written in the period between 1987, when Gore ran an unsuccessful campaign organized around environmental issues, and 1992, when his environmental expertise and advocacy helped to rally movement activists' energies to the Clinton-Gore ticket.

# Andrew Ross

What had been perceived as a "peripheral" campaign issue in 1987 had moved center stage by 1992. Environmental issues became mainstream politics in the late 1980s, when a spate of extreme meteorological events and patterns injected apocalyptic concerns about environmental disaster directly into the rich millenarian stew of prophecies cooked up by several years of Christian Armageddonism that had surrounded and partially penetrated the White House. Let us not forget that the global floods and famines of 1988 and 1989 were as portentous to the religiously inclined as to the scientifically inclined. Most important, in these intervening years, an end had been declared to the Cold War, and the national security pundits were frantically running through a checklist of ideological pegs upon which to hang the extensive wardrobe of the permanent arms economy. Gore's book, published the month before the election of 1992, responded to the demands of the moment in a number of ways—three of which I will outline here.

(1) Gore establishes a pervasive kinship between ecological crisis and the latest crisis of Cold War liberal consensus politics. The same principles that govern the healthy balance of elements in the global environment govern the healthy balance of government. In the case of the U.S., this analogy, as you can imagine, accords the status of a law of nature to both the government system of checks and balances and the constitutional equilibrium between rights and responsibilities, socially cemented by the culture of consensus that effectively supports what many citizens have come to regard as a one-party state. U.S. government, in other words, is a more or less perfect political ecosystem that performs best when its survival is imperiled by some external threat, imaginary or otherwise. According to Gore, however, the consensus-building machine of liberal capitalism has been thrown out of whack by the collapse of the communist threat. Somehow this is related, by analogy, or by some deep structure of planetary consciousness, to the ecological crisis, and yet Chaos Theory explains that this crisis is a natural circumstance, and that it means that we are moving to a higher state of equilibrium. (Outside of *Jurassic Park*, I have yet to see a critique of Chaos Theory that fully exposes its own kinship with New Right biologism, underpinned by the flexible economic regimes of post-Fordist economics). What Gore invites, then, is this conclusion: far from owing anything to the legitimation crisis of the national security state and the permanent war economy, the latest consensus crisis of liberal capitalism should be seen as a natural event, especially since the whole world is in a state of disequilibrium—"nature is out of place." The time is now ripe for the emergence of a new stable state of world equilibrium, consciously directed by the need to rescue its natural resources.

This "watershed" opportunity to forge a global civilization is further

Americanized when Gore compares it to the federal challenge faced by the thirteen founding colonies, conscious of their need to forge common interests and identity. His most consistent frame of reference, however, is the strategic formation of the Cold War.

(2) Gore proposes to replace the war against the communist threat with a war against the environmental threat. The threat to the global environment is ideologically continuous with the communist threat to freedom, so much so that Gore everywhere borrows the terms of military strategy to describe the new menace. (Recall that his 1987 campaign slogan was to declare a "war on pollution" while other candidates were merely, and cynically, echoing Reagan's "war on drugs.") Thus, according to Gore, environmental problems can be classified (a) as local skirmishes, (b) as regional battles, or (c) as strategic conflicts that not only endanger the stability of major nations, but have a clear global context for their origin and resolution. Drawing upon the Cold War policy framework for responding to this menu of threats, Gore imagines the U.S. reaffirming its leadership role by rising to the challenge of the new planetary threats of global warming, the population crisis, and the prospect of large-scale eco-collapse. "The sword is still in the stone," he writes, invoking a new Camelot of anointed eco-warriors. Not only will this be a just war, like the war against fascism, but its mobilization, which Gore decides to term the Strategic Environment Initiative, will embrace a global Marshall Plan, inclusive, this time, of Africa and the Third World.

Such rhetoric was shared by powerful military-industrial mavens like Sam Nunn, with no abiding interest in ecological matters, but with an urgent need to diagnose a new national security threat as a way of preserving the massive research apparatus of the military and intelligence agencies. In 1990, Nunn, Gore, and other Democrats on Nunn's Armed Services Committee proposed to create a Strategic Environmental Research Program, overseen by a Defense Environmental Research Council, that would divert a substantial portion of the defense budget to meeting the environmental threat. From the viewpoint of the Nunn school, strategic environmentalism was one of the best shots at legitimately maintaining an interventionist military apparatus. Elements of that retrofit policy have come into play in recent years, from the planned reassignment of portions of NORAD's massive offensive system, to the refunctioning of the U.S. Navy's global espionage and surveillance networks, and the flourishing of environmental programs at the Pentagon under the wing of Sherri Wasserman Goodman in her new position as deputy undersecretary of defense. The result is an ironic twist upon the peace movement's agenda of turning "swords into ploughshares." In the next few years, it seems likely that embryonic elements of a military-environmental-industrial complex

will come into being as a way of securing and completing the globalist ideologies of the New World Order.

The Gulf War, fought over colonial control of ecological resources, and opposed most successfully on ecological grounds, was the prototype for the eco-wars of the twenty-first century. The discourses of international affairs and world government are increasingly turning to the concept of "environmental security" as an organizing principle. Gore's explicitly militarized descriptions of measures needed to assess and combat environmental risks are a stark recognition of this "postideological" development.

(3) Cognate with this creation of a new strategic threat, Gore's book lays out some of the basic principles of free-market environmentalism, which the Clinton Administration is everywhere pioneering. While capitalism is generally regarded by Gore as a law of nature, it is incomplete as an economic system if it does not incorporate environmental costs and benefits. Environmental accounting will not hamper capitalism, it will perfect capitalism. Consequently, environmental policy measures are necessarily seen to be serving our economic interests, while free-market environmentalism is viewed as an opportunity to steal a march on Japan before it launches another competitive "quality revolution." Here, then, is the belief that environmentalism will soon be a *condition* for economic growth, and not a condition of the limits to growth. In recent years we have seen the establishment of the first international elements of free market environmentalism with the activities of the World Bank's Global Environmental Facility, which has proven more powerful as a global policing mechanism (that is, a medium of deregulation) than the UN's Sustainable Development Commission. In the U.S., the local equivalent—a trading market that allows companies that pollute below certain levels to sell pollution credits to dirtier companies—has been legislated under the Clean Air Act of 1990. This is intended to solve the problem of the uneven costs incurred in controlling emissions by different companies in different industries. The law introduces a new property right (the right to pollute, which, like all liberal rights, can be threatened or damaged), surely one of the most bizarre outcomes of the New Democrat thinking that purports to "use" the market to regulate market forces.

The simplest explanatory source for this philosophy can be found in *Mandate for Change*, a policy blueprint prepared for the Clinton Administration by the Progressive Policy Institute (the think tank of the Democratic Leadership Council, which, like most institutions of the New Democrats, borrows the language of progressives to advance neoliberal ideas). For the New Democrats, progressive politics means transforming markets into democratic tools, and introducing entrepreneurial ethics into all aspects of public sector

policy-making. The kind of neoliberalism exemplified in *Mandate for Change* positions itself as iconoclastically willing to harness the power of markets, as opposed to hidebound liberalism's investment in centralized bureaucratic structures. Nowhere is this difference clearer than in environmental policy, where liberal preference for "command-and-control" regulation and government spending is relegated in favor of market-based incentive systems like tradable permits, virgin materials fees, and other Green taxes. In its essence, free-market environmentalism can be seen as a way of using society, considered to be anti-competitive, to liberate the hitherto fettered forces of the market.

Gore's proposals agree with the *Mandate For Change* group: where ecology is concerned, the market is not the problem, it is the solution, offering the most powerful and efficient means of producing corporate compliance with sustainable environmental standards. Most of the Clinton Administration's woolly behavior in environmental lawmaking appears quite coherent when viewed from the neoliberal perspective of what Gore calls the "modified free market."

It is a mistake to view the Gore school of environmental policy as autonomous, divorced from other fields of policy-making. It must be seen in relation to Gore's activities as Clinton's technology czar. First of all, it should be noted that Gore is no newcomer to the role of Infobahn booster. It is true that this is the task officially assigned to him within the Clinton administration, and, it should be said, a task that seems designed specifically to downplay his anticipated capacity for environmental advocacy. In a major statement on technology policy in September 1992, Clinton emphasized that this task of "coordinating the administration's vision for technology" was "a real job," in contrast to the ceremonial presumptions normally made of Vice Presidents. In fact, Gore had long been active in prototype legislation for the Infobahn (arguably more active, as it happens, than on environmental legislation). In December 1991, his High-Performance Computing Act was signed into law to lay the foundation for a national computer network linking government, universities, industry, and libraries. In the White House, his profile as an environmentalist served him well in instigating the first official trial run, in November, of the Infobahn with the creation of a National Information Infrastructure Testbed. Called Earth Data Systems, this "testbed" project links computers via telephone lines at nine sites across the country to share twenty years of environmental data on tropical deforestation and ocean pollution. Pursued by a model network of public and private institutions (AT&T., Oregon State University, the Department of Energy's Sandia National Laboratory, the Digital Equipment Corporation, University of California at Berkeley, Ellery Systems Inc., Essential Communications, and Hewlett-Packard), this was intended to be

a showcase public interest project—no pornography, no data snooping, no consumer marketing, no virtual shopping clubs, no corporate computer crime, in short, none of the embarrassing traffic that is likely to clog the Infobahn once the ribbon-cutting ceremonies are over. No, with Al in charge, we are led to believe that the cable and the phone companies will bust their collective gut to save the rainforests.

As for the actual rules of the road, Gore's job is to supervise the Information Infrastructure Task Force, set up to provide legal guidelines on patent and copyright issues (how to break the hacker, shareware ethics), privacy issues (how to protect corporate property as well as personal data), and technical policies regarding the "compatibility" of networks (how to arrange marriages in heaven for the telecom giants). The official debate, involving much publicized hand-wringing on Capitol Hill, is over the anticipated contract between federal funding and corporate development of the superhighway system—a contract, we are reminded by PBS Democrats, that is as much a social contract as an economic one. Indeed, the analogy is made, whenever possible, with the Defense Interstate Highway Bill of the postwar years, which Gore's father played a leading role in enacting, and which Gore, in his book, cites as an unexpected offshoot of the triumphant struggle against Communism (EB, p. 270). As we know, the social and environmental ramifications of the interstate system have been immense: the consolidation of an automobile culture dependent on unrenewable energy resources; the reshaping of population demographics across the nation; the vast restructuring of social and racial relations between cities and suburbs, to name just a few. There is more than a little naïveté to the boosters' argument that the infohighway will do for the sluggish pace of commerce what the interstate highway did for the productivity of the nation's travel and distribution system. Sometimes the analogy is with the flow of goods facilitated by the nineteenth-century transcontinental railroad system. This ought to strike us as a more likely comparison if we consider the gifts of millions of acres of public lands to the railroad barons who built the system (the historical prototype for all subsequent, large-scale, state subsidies for private development). The state's role then may be similar to the one being forged with the data despots and media moguls who will build the Infobahn. So, too, while the interstate highway system was built with federal dollars, the result was a massive subsidy for the automobile and petroleum industries. In each case, then, an arrangement is worked out for the state to assist capital. Whether the state pays for the road or not, the result is to provide public assistance for private profit. It has more or less been decided that private companies will assume control over the vast bulk of the investments required for the Infobahn, with federal funding

providing strategic stimuli as an all-purpose catalyst. (The only thing likely to retard this process is that a fiber-optic based network will not be technologically feasible for many years to come, and if built prematurely, may become a white elephant.) Pressured by Democrats who want a public right-of-way provision written into superhighway legislation (S. 1822—the upcoming revision of the Communications Act of 1934), Gore has the job of ensuring "universal access" to the system, a vague principle at best, and a hollow protection for those whose lives are already highly regulated by computerized workplaces, and who are therefore unaccustomed to viewing computers and computer skills as a tool for mastering and negotiating their daily environment.

Dominating the liberal framework of the Infobahn debates are concerns about privacy (it must be protected) and public interests (they must not be paved over). And yet the enduring liberal distinction between private and public has been complicated by at least two related features of the cybernetic landscape: (a) the growth of DARPA-initiated Internet—one of the strangest outgrowths of the military research nexus, and (b) the emergence of that equally strange, new, social formation often referred to as virtual communitarianism—strange because it seems to reduce any notion of community to the technical capacity to access and communicate, and because its functional category of on-line identity seems to owe more to postmodern fiction than to any traditional juridical conceptions of possessive individualism. Despite all the hype about electronic town hall meetings, it is not at all clear to me whether the conception of virtual publics corresponds in any fundamental way to what public sphere advocates think of as meaningful, except as a space where communication flourishes in principle, in the abstract, as it were. Perhaps this presents more of a problem to left thought that appeals to the virtues of the public sphere (always just having been enjoyed recently and now lost) than to the corporate or government power interests who are already paving the road to cyberspace with their good intentions. The intoxicating allure of entering an info-wonderworld has been taken to mystical extremes in recent advertising camapaigns by major phone companies, mining the abstract appeal of "community"—we're all connected—built on long distance communication.

In the course of the last year, talk about the "information superhighway" has fallen off, or at least declined in noise level from its 1993 crescendo. What happened? (a) The planned revision of the telecommunications laws was deferred until the configuration of political forces on Capitol Hill was more decidedly in favor of corporate control, and (b) the relevant corporations got a little nervous about the planned massive mergers between telephone and cable networks. In the interim, the Internet became a corporate highway by default, increasingly utilized for everyday business and research, as it expanded its

# Andrew Ross

World Wide Web sector. With the ascendancy in Congress of Gingrich's Republicans, invocations of cyberhype have taken on populist trappings, however right-wing. Clinton/Gore's cyberpolicy has been positioned, by contrast, as top-down. For example, the White House's newfound e-mail capacity to transmit government reports, policy plans, and robo-responses presents an opportunity to make end runs around the established news organizations. Government propaganda can go directly to the people, unedited and uninterpreted by the media's fierce and fearless guardians of public knowledge. The capability of a central information apparatus to construct a one-way, multilane superhighway in this manner militates against Gore's own comparison between the architecture of parallel computing systems and the decentralized "design advantage" of systems of capitalism and democracy (EB, pp. 358–89). Unlike the command-and-control centralism of Communism and central processing units (CPUs) respectively, representative democracy operates more efficiently as a decision-making model, while parallel computing distributes processing capacity more advantageously around the memory field.

The strangest and most revealing comparisons, however, emerge around the analogies that Gore draws between information ecology and the ecology of natural resources. Gore does not flinch from the cliché that there is a carrying capacity to our human ability to process information, and therefore that information overload is structurally similar to the exhaustion of natural resources. Here is one example from his book:

> Our current approach to information resembles our old agricultural policy. We used to store mountains of excess grain in silos throughout the Midwest and let it rot, while millions around the world died of starvation. It was easier to subsidize growing more corn than to create a system for feeding those who were hungry. Now we have silos of excess data rotting (sometimes literally) while millions hunger for the solutions to unprecedented problems. . . . Just as we automated the process for converting oxygen into carbon dioxide ($CO_2$)—with inventions like the steam engine and the automobile—without taking into account the limited ability of the earth to absorb $CO_2$ we have also automated the process of generating data—with inventions like the printing press and the computer—without taking into account our limited ability to absorb the new knowledge thus created. (EB, p. 200)

Or another example:

> Vast amounts of unused information ultimately become a kind of pollution. The Library of Congress for instance receives more than ten thousand periodicals each year—from India alone! And given that some of our accumulated

information and knowledge is dangerous—such as the blueprint for an atomic bomb—keeping track of all the data can become as important as it is difficult. What if this toxic information leaks into the wrong places? (EB, p. 201)

What are the consequences of this kind of nonsense talk that compares information resources to natural resources? Perhaps not much, even though these kinds of mixed metaphors are increasingly normative in debates about information technology of the sort that the Gores of the world are officially appointed to regulate. Or are we indeed talking about a new discourse of regulation, one that reconciles the language of free-market environmentalism with the language of the Infobahn, playing off information abundance against resource scarcity in the time-honored fashion now updated to address the new commodity status of information and nature respectively? It does seems significant that these expressions of abundance and scarcity, fundamentally linked, are working out their dialectical form at this moment in time, the one offering rewards to the high-tech professional managerial class, the other visiting austerity measures upon information-poor sectors of society. Taken together, they constitute a powerful new discourse of repressive liberation, specific to the new neoliberalism, and occupying the immediate horizon of our mediated political experience.

## Notes

1. David Corn, "Al in the Balance," *The Nation*, April 25, 1994, pp. 545–46.

2. Mark Dowie, "Friends of Earth—Or Bill: The Selling Out of the Greens," *The Nation*, April 18, 1994, pp. 514–18.

3. Al Gore, *Earth in the Balance: Ecology and the Human Spirit* (New York: Houghton Mifflin, 1992) (cited as EB).

# 7

# Mapping Space: Imaging Technologies and the Planetary Body

*Jody Berland*

For communication purposes a satellite is any heavenly object off which radio signals can be bounced. [1]

## Angels' Flights, Digital Sights

When we look at the weather to find out what is coming, we now take the viewpoint of the angels: looking down at the earth, rather than up at the sky. Sadly, we do without the celestial music, though one sometimes hears a heavenly choir begin to sing on MeteoMedia, the Montreal-based, cross-Canadian, cable weather station, as the scenery switches from tossing waves to satellite views of the cloud-covered earth. Our wisdom of the skies comes to us—ordinarily with less paradigmatic pluralism, but with an equal assurance of divine knowledge—by virtue of NASA, a host of circling and geostationary satellites and a plethora of cybernetic and optical innovations, whose products are stunningly beautiful but completely silent, unlike trees, winds, insects, and animals, whose sounds once taught our elders to know what was coming. Our ancestors looked upward, and saw in the stars what they already knew: the twinkling outline of goddesses and gods, mythic animals, and other astrological figures caught in the timeless spin of cosmic

destiny. Looking downwards, we too see what we know: a battle between cold and warm fronts, the chaotic coherence of global meteorological systems rendered visible by the spasmodic movements of digital clouds, and the reassuring vision of a distant but attentive eye, which can translate atmosphere, movement, change, land, and sensation into the legible surface of a screen.

What does it mean that we now view the skies looking down, rather than up? What do we read in these images, and why do they seem so dangerously eloquent?

In thinking about these questions, I have calculated seven types of possible readings: genealogical, meteorological, sociospatial, utopian, visual-picturesque, cosmological, and ecological. These are conceived in no particular order, and with no compunction to separate science from myth or infrared radiometers from other practices of divination: for accuracy of prediction, the ostensible object of this observational system, is not measurably improved by recent technological improvements, as most people know in a commonsense sort of way but forget, with classic Orwellian doublethink, once they are in front of the television screen. To improve weather prediction, this technically sophisticated image production apparatus requires a comparably sophisticated computer that can simulate climate conceptually as well as visually; that is, which can produce climate models at an adequate level of complexity to meet the exigencies of nature itself, a capability that the images strongly imply but do not achieve. "What goes on inside the machine are imitations only, schematics of storms, line drawings of the weather," writes climatologist Thomas Levinson. "Outside, overhead, the real thing dominates. The occasional failures of the computers become a kind of reminder, a relatively gentle warning: for all the power of the latest computers the weather itself remains in some way intractable, out of control."[2] Notwithstanding this flaw in the production of actual useful knowledge, television weather forecasting and a larger, public, imaginary space are technically and semantically dominated by satellite images. My analysis of this interesting anomaly is formulated from the perspective of a Canadian; that is, as one to whom space, landscape, and observational technologies, and their densely historical imbrication, hold particular relevance and meaning. This perspective enables me to consider satellite weather images in terms of surface and depth, politics and money, distance and myth, all at the same time.

Technically speaking, it is difficult to state exactly what these images are. Our first challenge is to define the object of which we speak. Satellite images originate from the trajectory of mapmaking, and in a sense are maps themselves; on television weather reports, we see digital clouds and cold fronts made flat and topographically familiar by means of superimposed

political boundaries, usually shaped from the perspective of somewhere above the Southern half of the North American continent. If you look at satellite views on American TV and newspapers, you will note that Canada has no surface; its topography is absent, and the country is represented metonymically by its weather, mainly the cold we send south. Arguably this is part of the same trajectory that produced what Pierre Berton calls "Hollywood's Canada": that snow-covered, meteorologically overdetermined, uninhabited, if not uninhabitable landscape that American cinema has represented as Canada for some sixty years.[3] Canada's peripheral (but resource-rich) political status is thereby represented as a natural consequence of its "posterior destiny"[4]: This view, like American weather maps and many world maps, places Canada off-center, graphically empty if not absent altogether, thereby rendering its marginal politicoeconomic identity as a function of a geographically determined history. In contrast, the satellite pictures sent out on Canada's weather channel show Canada obligingly sharing the continental territory and all its weather systems. To put this in context, our weather forecasts are exhibited and transmitted east-west across Canada by Canadian broadcast satellites, but the information itself comes from American and European satellites. In other words these are maps of technoterritory as much as they are maps of geophysical terrain.

Maps celebrate simultaneously the love of surfaces and the inspiration of movement in which surfaces disappear. Like maps, satellite images unite the dream or record of travel with the passion for appropriate measurement. Maps create a visualization of traversable space which is pragmatically linked to the anticipated exigencies of unaccustomed, uncharted, or unfriendly movement. To historians, anthropologists, and even some cartographers, maps also offer a visual encyclopedia of the myths, values, and political assumptions of a particular culture at a particular time. Also in the tradition of maps, satellite images search out profitable or otherwise interesting spaces from the vantage point of excellent technologies, and from a great authoritative distance, while rhetorically and gorgeously referencing their own capabilities in this regard. "All maps state an argument about the world," Harley reminds us,

> and they are propositional in nature. All maps employ the common devices of rhetoric such as invocation of authority. This is especially so in topographical . . . or in thematic maps. . . . Maps constantly appeal to their potential readership through the use of color, decoration, typography, dedications or written justifications of their method. Rhetoric may be concealed but it is always present, for there is no description without performance.[5]

Satellite images confirm their mappish status by overt rhetorical

flourishes in the direction of digital artifice (spasmodic cloud-cover shifts, for instance), which blend effectively with the timeless objectivism of unearthly silence. These graphics arbitrarily and instrumentally redraw spatial relations and boundaries, up and down in geometric space as well as side to side, while celebrating the abstract representational world of surface; in other words, they are definitely maps.

But actually these images are not maps at all. From a technical, tele-visual, and even rhetorical perspective, they function as documentary pho-tographs, that is, as technically inscribed visual records of the earth's "real" surface as it appears in a specific moment of time. "The photographer," claims Lewis Mumford, "must take the world as he finds it."[6] That is to say, the pho-tograph emphasizes temporality by separating the image from it, as these images do. Of course the world changes not only from one moment to another, one view to another, but also from one lens to another. All the more reason to call these images from space photographs. They are in fact computer-generated or digital simulations of photographs, or to be more precise, virtual images digitally processed to look like photographs.

The observational technologies that produce these virtual pho-tographs have grown considerably more advanced than those used in early Landsat pictures, when measurement of visible and near-infrared radiation allowed scientists to measure such things as atmospheric temperatures, veg-etation cover of land surfaces, and biological activity in the oceans.

In the twenty years following the first Landsat launch, the develop-ment of radar, Doppler, infrared, and microwave radiometers further enabled satellites to measure water vapor and condensation, atmospheric temperature ,and radiation patterns in the upper atmosphere, surface and cloud tempera-ture, levels of ocean waves and sea salinity, and the ozone layer, which is a Canadian technical specialty. In each instance, information is produced by scanning an atmosphere that is highly complicated in texture, movement, and dimensionality. Selected information about this atmosphere, including heat, light, and the presence of other measurable materials, is produced by converting data into numbers and radioing these numbers to an earth-based computer, where data "becomes imagery on photographic film, which, in turn can be put to a variety of uses."[7] With this "imagery on photographic film," It is not only the photograph that is virtual, but also the imagery itself. Without these instruments, this information/image would not exist.

As the technology progresses, additional atmospheric conditions, such as temperature, clouds, and the presence or absence of light, have become measurable data. This has a dual advantage: these conditions are now themselves visualizable to the post-panoptic observer, and they cease to be

obstacles to the accuracy of ground surveillance that could be achieved from above. Darkness and cloud cover no longer serve to hide what is beneath. Like other information about the earth surface and atmosphere, these natural conditions—day or night, heat or cold, windiness, cloudiness—are computer-processed into a composite image of brilliant colors that are gorgeous to behold and only arbitrarily related to earthly manifestations. Infrared satellite images, or what I am calling virtual photographs, show us that white is cold, black is hot, the winds range from blue to yellow, and the oceans from red to purple, while the hole in the ozone is grey or violet. We are looking at a new type of landscape literacy, in which the "modern" perspective of the human eye is rendered obsolete—arguably turning Galileo's telescope, the first direct optical challenge to the combined rule of divine authority and common sense, backwards to view the earth, and so creating a radically new type of divine knowledge.

Satellite-based observational technologies thus render the earth's surface, together with its surrounding atmosphere into usable visible information. Like medical X rays, which have similarly functioned to replace the human eye with optical technologies, they render surface/body boundaries obsolete. They reveal to us what is hiding in the oceans, and the deserts, and the jungles, and the wind. Each space, like the human body in an x-ray, is rendered transparent. Both types of body are thereby urged to greater productivity, a more efficient yielding of secrets, contents, products, knowledge. This rendering-into-image is closely linked to processes of medicalization performed by modern science, particularly on the woman's body, which paradoxically disappears behind its contents. Symptoms are thereby rendered into visible information that can be acted upon by the physician, with or without the participation of the patient. Perhaps this connection, and the concomitant hierarchization of knowledge that results, explain the bedside manner of many weather forecasters.

But the analogy is limited in at least one respect: organs and fetuses are already known to us as tangible objects; satellite optics are unique, however, in that they create images, or surfaces, out of materials which were not previously conceived as visual. Before satellites, we did not conceive of air, wind, or temperature, even warm and cold fronts, as visual matter, just as we did not conceive of human organs or the human fetus in the same way before X ray and ultrasound. Satellite photos create a virtual photo from a virtual image/surface which is actually a three-dimensional environment in constant flux. Without imaging technologies, these materials would not exist as images. The hyper-tech design makes the image look as veritable as a photograph, whatever the origins and veracity of its digital parts. In other words, this

veracity is a rhetorical, not a literal effect, since a significant effect of this capability is that images can be created quite independently of their natural referents. Neither producers nor consumers have any way of knowing, for instance, whether reports of the current weather in militarized regions are accurate. This is one cause for the meteorological controversies stirred up by the recent "Desert Storm" in the Gulf.

Another effect, as I have already implied, is that we have come to conceptualize the climate as part of the planet's body and the planet's health. Thunder and lightning are not read as the expression of deistic rage, or as proof of a natural, sublime force moving through the universe, but rather as a battle between warring physical elements in a torn and fragile body, into which viewers are doubly implicated in the very act of looking. Like the woman on the table, we become both viewer and viewed when we gaze at the screen containing the "post-panoptic" planet. Like her, our double-identity is mediated by a scientific instrument which brings "our" hidden truths into view. Like her, or like her body, we discover our invisibility in that very moment/act of display. Thus we defer gratefully to the intended eye.

Now this information has scientific and commercial as well as military importance, but as the history of map-making and more contemporary observational technologies shows, the needs of scientific, commercial, and military interests are often quite difficult to distinguish. As we know from the look of TV weather reports, meteorology has been quick to employ new, space-based, digital and observational technologies as they develop. In fact, meteorology was the first practical ("nonmilitary") application of NASA's satellites and satellite-based technologies, and remains its most visible client. The weather service was NASA's first public application, and television is the weather service's most important customer after the military. Meteorology is thus both ideal ground and favored progeny of growing tactical alliances between satellite-based optical technologies and communications, data processing, computer graphics, and commercial television, each of which has become technically and economically essential to the survival and growth of the other. Television culture would not be the same without satellites, especially in Canada; satellite communications would be impossible without advanced computer programs; space exploration would not have obtained adequate political backing without various "useful applications," such as weather, which, in any case, are useful to military missions; and weather maps make lousy TV without computer graphics. That is finally how we have to understand these images. They are social constructions arising from the complex imperatives and alliances of three interdependent industries: paramilitary space exploration; computer software; television. Because those institutions

need each other more than we need them, we have the Weather Channel. Thus (echoing Orwell once again) we learn to celebrate science while forgiving its errors on a daily basis.

Yet what the images evoke is far more compelling and eloquent than all this would suggest. For satellite views of the earth's surface show us not only the weather (if you are trained to read them) but also the following: this is one planet, one life, one world, one dream. This is the view of the globe from the eye of god. This is the promise of earth without its wars and bestiaries. This is our planet, its orbs humming with light and shadow in praise of the benevolent, distant eyes of the celestial panopticon. This is the gorgeous, metaphysical triumph of the technological sublime, displaying itself in perfect harmony with the arcane laws of nature. This is the magic of a revitalized myth of origins, addressing us personally from our television screens, entering the intimate domestic spaces and rituals of the everyday, but still in possession of all its mysterious, inaccessible, distant power.

Satellite images of the planet are thus a contemporary version of what Walter Benjamin termed the aestheticization of politics, a concept he first used to critique his contemporaries' "avid romanticization of the technology of death."[8] For by virtue of the satellite panopticon, the image of the globe is now summonable as an iconic ode to world peace, ecological interdependency, and love for a newly fragile planet, Gaia, a concept Lovelock himself attributed to the new, photographic view of earth from space, introduced in the 1960s. This earth-Gaia is a biospheric world system whose simple and self-sufficient enormity (Lovelock hopes, comparing earth simultaneously to cybernetic systems and the human body) can surely survive whatever we might do to it.[9] This same view of earth from space celebrates the panoptic lens whose monumental scale and technical complexity relies on equally monumental technological, commercial, and above all military interdependency. "We look at earth differently," claims SPAR Aerospace in a recent magazine advertisement, "to guide our challenges in the 21st century."

The image is of a distant planet emerging from darkness. "Pictures from space of our planet Earth have been instrumental during the past 15 years in increasing the awareness of the earth as a finite resource," choruses a photo album advertisement in the same publication, a *National Science and Technology Week* special newspaper supplement (October, 1992) on Canada in space. The publication was part of a government/industry campaign to increase Canada's investment in space technologies, whose technical and economic imperatives reorganize countries and industries into deboundarized and dependent entities propelled ceaselessly forward by the global pressures of corporate and military enterprise.

# Jody Berland

## Satellites and the Theory of Reverse Adaptation

The first American satellite was sent up in 1958, the year NASA was formed to administer the U.S.'s space race with Russia. The first "application" satellite launched by NASA carried meteorological instruments. Its genealogy exemplifies what Langdon Winner calls the process of "reverse adaptation": with a complex technological system in place, you search for applications, and thus reverse the conventional relationship of means and ends.[10] Contemporary weather forecasting is the visible end of this means, that is, the near-instantaneous transformation of three-dimensional or extremely distant atmospheric data into two-dimensional images on a monitor. This capability arose from a complex interdependent system of satellite-based radar, infrared and near-infrared imaging systems, meteorological software and data processing, telecommunications, computer graphics, and television, and remains one of the more important "applications" of NASA space and related technological research.

Canada was the third country in the world to launch a satellite, *Alouette 1*, in 1962. Early in the development of space research, Canada committed itself to developing and interpreting satellite communications, initially to help communicate across the vast regions of the country's north. In 1972, the launch of *Anik A1* made Canada the first nation to place a domestic satellite in geostationary orbit. During this period, Canadian earth-observation technologies were being tested on U.S. satellites. Communications and aerial photography were already Canada's fields of expertise, and its space activities quickly focused on these, as most suited to Canadian needs. Aerial photography had found uses in both military and commercial activity from as early as the 1920s; by the 1930s, the National Research Council was developing equipment for plotting maps from highly oblique aerial photographs and a stereoscopic plotter. Canada's Air Force activity was concentrated on photographic surveying during World War II.[11] The newest satellite, *Radarsat*, introduces a new generation of remote sensing from space, and will raise earth surveillance capabilities to a new level.

European science began to measure climate and temperature in the seventeenth century at least in part because of new questions and needs created by travel. If we are to believe the technical books, policy-makers, and science writers, something like the reverse is true in Canadian history: satellite-based exploration and research came to set the technical framework and goals for Canadian science and technology because of Canada's unique climate and topography. Canadians pioneered the use of satellites to observe, map, and communicate with remote, frozen areas that were previously out of

bounds for geological science and/or electronic media. Such experience helped to provide the technical and mythical infrastructure for nationhood; displayed on maps from above, Canada could thereby be "pictured" as a modern nation. Together with the railroad, this conquest-through-depiction made Canada for the first time visualizable as an integrated, differentiated whole.

Canada's climate and vast northern territory have thereby been fused with the imaging technologies that represent them, together producing the conceptual maps of nationhood that surround us today. This capability also laid the foundation for Canada's secure technical niche in space research. Our climate and territory are understood as the rationale for and subject of Canada's most important contribution to space science: remote sensing technologies, which ride piggy-back on NASA satellites to produce brilliantly improved images of the earth's surfaces. These technologies make possible the beautiful, mythically reuniting landscapes of the late-twentieth century: color-coded digital images of the earth's surface from space in which changes in the atmosphere, the topography and vegetation, and human or mechanical activity can be detected from many miles above our heads. This colorful digital landscape also works as metonym for our uniquely cosmopolitan, multicultural, and globally sensitive nationhood: it thus symbolically confirms the fusion of a techno-apparatus with a land that is precisely here and nowhere else. But at the same time, threatening to override this sentimental link is the satellite view's favored status as metonym for global technocratic power, and, as such, (paradoxically once again) this power is out of our hands.

Canada's space research continues to develop expertise and technologies in aerial surveillance and measurement. This specialization is still represented as one that originates in nature, that is, in Canada's geophysical destiny, which compels scientists to map, survey, communicate across the mountains, the tundra, the ice fields. Yet most current projects are linked to larger projects funded by NASA or the European Space Agency. What is paradoxical here is not so much the implosion of land, landscape and Landsats, as the ironic reiteration of the same structural paradox that previously befell Canadian broadcasting. Canada built one of the most technically sophisticated communication infrastructures in the world, reaching even to remote regions of the north, with the purpose of extending citizenship to those it could not be profitable for private broadcasters to reach. It became, in what communication historians term a "tragic paradox," a superb vehicle for the dissemination of American television. Similarly, none of the satellites which now provide weather data to Canadian meteorological services are owned by Canada. This is why the "natural" logic of continental interdependency—the fact that weather systems are, after all, continental, if not global, is variously

challenged and confirmed by weather maps in the two countries. We are look-
ing at a relationship that is at once geographical, technological, administrative,
and cultural. Canadians define ourselves in terms of a natural topography and
living system—in this case, the weather, appropriately subject to a continental
aerial gaze. But the U.S. takes its borders—topographic, technical, even
meteorological—for granted.

## Canada's Space

> Know the enemy, know yourself; your victory will never be endangered. Know
> the ground, know the weather—your victory will then be total.[12]

Between 1959 and 1984, the U.S. Department of Defense spent over
seventy billion dollars on military space programs, excluding expenditures on
NASA. And between 1983, when President Reagan announced his new pro-
gram for the military defense of space, and 1992, the United States will have
spent over one hundred and fifty billion dollars on space. The "pathological
prosperity" suggested by these sums was part of a:

> massive state subsidy to US high-technology industrial research. It generated
> breakthroughs in medicine, computer software design, and laser technology,
> which US private capital then sought to exploit commercially. At the same time
> it acted as a slush fund for projects which failed to win support elsewhere.[13]

This level of state expenditure—what we call astronomic sums—
means that space technology needs have acquired enormous power to deter-
mine the patterns of scientific, technological and economic activity through-
out the economy and, increasingly, across the globe. We must find our place
in this technological market, according to advisors, or we will be left far
behind, frozen, as former Conservative Prime Minister Mulroney said of us
should we reject NAFTA, in the headlights of progress.

One Canadian policy advisor, Director of Scientific and Technological
Strategical Planning for Canada's Department of National Defense (DND), but
formerly with the Weapons Division of Canadair, wrote this to convince a 1983
conference of government and corporate leaders of the importance of space:

> Canada, as a member of the Western Alliance, will become increasingly
> dependent on a strong technological infrastructure to support her commit-
> ments to collective defense. Yet paradoxically, that very infrastructure is the
> essential element needed to build a reliable lifeline to a sound economic

future. Clearly in the years ahead, industrial strategies will need to be devised which accommodate the parallel, and indivisible, objectives of national security and national socio-economic development. Space is one area that holds considerable promise.[14]

It took me some time to unpack the thinking of this author and his colleagues. It works like this. Space technologies are so complex that they require huge technical and political investments that have major implications for the economy. This is justified by the fact that we in the West are democracies, unlike the Soviet Union, which (being undemocratic) spends more than it can afford on space. To defend ourselves from aggressive Soviet space systems (note that this was written in 1983; the language of advisors in the 1990s is more neutral, global-market-oriented, for who knows who will be in the market for these devices?) we have to develop competitive capabilities and R&D in high-tech industries which will have dramatic implications for the shaping of public policy and industrial strategy. They note that Canada's expertise lies in remote manipulator systems, used on the space shuttle; communications hardware; electrooptical sensing; and digital image processing.[15] Fortunately these have economic benefits which will trickle down to the rest of society, since we are a democracy. Of course the "trickle-down" effect is not only economic; it is also (or perhaps mainly) technical and aesthetic, as many visual artists and computer programmers are aware. Today, for instance, Toronto is home to North America's first Digital Image Works for postphotographers: as a result of such digital processing, journalists claim, documentary photos may never again be what they seem. Our own DND space planner argues that the cost of NASA's Apollo program was more than recouped by savings that later accrued through the use of space in such areas as weather information, agricultural development, resource exploitation, and communications. Future uses, he adds, include mining the asteroids that orbit the sun between Mars and Jupiter; mining and processing resources on the moon; space colonies; and the use of laser beams transmitted from satellites to propel aircraft and spacecraft. "As always," Ellington concludes, "military applications will likely continue to pace technological progress."[16]

It is this prospect that accounts for the theme of paradox and irony that all too characteristically structures this Canadian account. "At the same time," Ellington writes, "high technology is recognized as a key determinant of social progress and economic well-being, and it seems ironic that the attainment of these socio-economic objectives should be paced by an impetus arising from military needs."[17] The paradox arises from the conflict between (national) social and economic well-being and (international) military objectives. Space

exploration magically resolves that conflict by contributing to both simultaneously. Alternatively if you don't keep up with the pace of international space exploration, your country will disintegrate, and be frozen, so to speak, in the headlights of progress.

Canada's military advisors have thus come to call space a "paradox of opportunity." If we continue to develop peaceable space technologies, they argue, we can simultaneously advance our technological resources, increase our useable knowledge of nature, develop peaceful and profitable spin-offs, and keep our place in the continental military-economic system. They would approve of my dentist, who tells me he can fill my teeth with non-toxic white matter because of research in space. Their position is also an indirect acknowledgment that Canada is itself a kind of satellite, a poor relative with higher altitude and moral consciousness, whose economic survival depends on remaining useful to the surveillance requirements of continental military defense. Being so conscientious, so marginal, even Canada's quasi-official military thinking has been articulated in terms of this paradox: space research earns health and well-being for its citizens by advancing the dangerous militarization of space. Once again Canada volunteers the humanist impulse in its technocratic trajectory. It dreams of a social democratic prescription for an order in which governance regrettably travels from the imperatives of continental technical systems to the policies of the state, rather than the reverse.

In the 1990s, space policy advisors have more neutrally emphasized the Canadian government's growing needs for "surveillance over a variety of activities through her vast and largely uninhabited area and the approaches thereto."[18] These authors argue that the armed forces of the future must be equipped with a certain amount of the most advanced equipment, whose selection "must be based primarily on the requirements for security, but which should be able to 'perform tasks' that make valuable contributions to the country in times of peace." Nonmilitary threats cited in this domain include environmental degradation and international drug traffic, which employ the same technologies as those needed to verify arms control agreements and other surveillance and monitoring tasks "for national civil as well as defense needs."[19] Our security from unexpected weather, drug traffickers, and Iranian or North Korean military conspiracies is thus assured.

## The Weather Forecast

Popular reliance on weather forecasts has helped to legitimate huge expenditures on space and computer technologies with a mainly military

genesis and purpose. The scope and expense of satellite observation far surpasses its demonstrated usefulness to transforming weather prediction. It adds twenty-four hours to a forecast, making five-day forecasts possible, but predictions are still wrong over twenty-percent of the time, except in the important cases of hurricane movement and other catastrophes, and military needs, neither of which requires or receives routine exposure on daily television. Continuous, satellite-based, weather forecasts accomplish something else: they create a consumer market for satellite surveillance services that otherwise would have to be funded entirely by government and military agencies. Our everyday need and aesthetic appreciation for these services (much aided by the entertaining sophistication of constantly improving visuals and computer graphics) is therefore both facilitator and by-product of government space and defense policy.

Weather forecasts rely on a set of technological tools originating in what, in this context, it still makes sense to call the military-industrial complex (everything from satellites, radar, and other optical equipment, to software and television itself), whose socially beneficial applications are thereby demonstrated on a daily basis. However, it is not the practical benefits to our everyday lives that make these images so seductive, so compelling, so visually delicious. They are these things because they seem to represent a longed-for reunification of science and art; because they offer the pleasure of panoramic distance and the spectacularization of a passive landscape by means of which space technologies culminate two hundred years of colonial geography;[20] because they re-sanctify the deep, gender-based metaphors of earth and observer by elevating the act of perception into the higher, more "advanced" reaches of cosmic science; because they equally remind us of the utopian possibility of a grounded universal totality. Most of all, however, their power to draw our gaze derives from their very ambiguity, the way these images oscillate with perfect majestic equivocation between sublime beauty and unseen powers of scrutiny and domination, the way they stand for, and between, a world in harmony and a world of smart, silent, desultory destruction and death.

## Notes

Portions of this paper have appeared, in earlier versions, in the following publications: "Remote Sensors: Canada in Space," In *Semiotext(e) canadas*, ed. Jordan Zinovich (New York: Semiotext(e), and Peterborough, Canada: Marginal Publications, 1994); and in "Imaging Weather: TV and the Celestial Panopticon," in *Culture Lab 2*, ed. Brian Bolgon (Princeton Architectural Press, 1994). Warm thanks to the editors of these publications for their permission to use and continue this work.

# Jody Berland

1. Brian Winston, *Misunderstanding Media* (Cambridge, MA: Harvard University Press, 1986), p. 245.

2. Thomas Levinson, *Ice Time: Climate, Science and Life on Earth* (New York: Harper & Row, 1989), p. 118.

3. Pierre Berton, *Hollywood's Canada: The Americanization of our National Image* (Toronto: McLelland and Stewart, 1975). This argument has been elaborated in Jody Berland, "Weathering the North: Climate, Colonialism and the Mediated Body," *Relocating Cultural Studies,* ed. Valda Blundell, John Shepherd and Ian Taylor (London: Routledge, 1993).

4. Cf. John Agnew, "Representing Space: Space, Scale and Culture in Social Science." in James Duncan and David Ley, eds., *Place/ Culture/ Representation* (New York: Routledge 1993), p. 259.

5. J.P. Harley, "Deconstructing the Map," In Trevor J. Barnes and James S. Duncan, eds., *Writing Worlds: Discourse, Text and Metaphor in the Representation of Landscape* (London: Routledge, 1992), p. 242.

6. Lewis Mumford, *Technic and Civilization* (London: Routledge and Kegan Paul, 1962), p. 338.

7. *National Geographic,* July 1976, p. 140. As the article notes, "Landsat does not use photographic cameras but an ingenious instrument called a multi-spectral scanner, or MSS. The device uses an oscillating mirror that scans the earth and a telescope that focuses visible and near infrared light waves reflected from the earth into the satellite's radiation detectors, which measure the light intensities of 1.1-acre picture elements, or 'pixels,' in four different spectral bands. These values are converted into computer-digestible numbers and transmitted back to earth at the rate of 15 million units per second."

8. In 1930, Walter Benjamin reviewed a collection of essays edited by the conservative revolutionary Ernst Junger and entitled *War and Warrior.* Noting its contributors avid romanticization of the technology of death and the total mobilization of the masses, he warned that it was 'nothing other than an uninhibited translation of the principles of *l'art pour l'art* to war itself.'" Martin Jay, "'The Aesthetic Ideology' as Ideology; or, What Does It Mean to Aestheticize Politics?" *Cultural Critique* 21 (Spring 1992), p. 41.

9. James Lovelock, "Gaia: A Model for Planetary and Cellular Dynamics," In William Irwin Thompson, ed., *Gaia: A Way of Knowing. Political Implications of the New Biology* (Great Barrington, MA: Lindisfarne Press, 1987).

10. Langdon Winner, *Autonomous Technology: Technics Out-of-Control as a Theme in Political Thought* (Cambridge, MA: MIT Press, 1986).

11. Doris H. Jelly, *Canada: 25 Years in Space* (Montreal: Polyscience Publications, in cooperation with the National Museum of Science and Technology/National Museums of Canada, 1988).

12. Strategist Sun Tzu, sixth Century BC, quoted by Charles Bates and John Fuller, *America's Weather Warriors 1814–1985* (College Station: Texas A&M University Press, 1986), p 249.

13. Martin Spence, "Lost in Space," *Capital & Class* 52, Spring 1994, p. 60.

14. *Canada's Strategies for Space: A Paradox of Opportunity* ed. Brian MacDonald (Toronto: CISS, 1983), p. 7.

15. *Ibid.*, p. 20.

16. *Ibid.*, pp. 18, 19.

17. *Ibid.*, p. 7.

18. George Lindsey and Gordon Sharpe. *Surveillance over Canada*, Working Paper 31 (Department of National Defense, 1990).

19. *Ibid.*, pp. 55, 56.

20. See Derek Gregory, *Geographical Imaginations* (Cambridge: Basil Blackwell, 1994).

# 8

# The Bomb's-Eye View:
# Smart Weapons and Military T.V.

*John Broughton*

## Exterminating Angels

The New World Order, first outlined by Eisenhower in 1959 and later promised to U.S. citizens as the prize for winning the Gulf War, failed to materialize in Bosnia, and was mercilessly parodied in Somalia. It eventually found its inception in the proposed mission to save Haiti.

A funny thing happened on the way through Clinton's presidential address to the people on September 15th, 1994, in which he made the case for invasion. The camera suddenly switched away from the president's face to a series of three computer-generated still shots of Port-au-Prince, aerial maps of rapidly decreasing scale. This simple, vertical triplet—a syncopated tracking shot reminiscent of Hitchcock's in *The Birds*[1]—prefigured and promoted the vertical descent of American military might on the heads of the Haitians. Exploiting the nightmarish potential of dream dynamics, this tiny device managed to condense penetration, power, and domination in a single cinematic euphemism.

The formal structure of this dramatic televisual trope concretized the threat to the Haitian "dictators": in addition to evoking the recent memory of Saddam's humiliating defeat, it also alluded iconically to the trajectory of a smart bomb. This clearly did not amount to a literal threat of bombing, or even a brandishing of the lethal new technologies of indiscriminate destruction in the U.S. arsenal. Rather, it was an indirect reminder of overall military clout

and the particular authority it has assumed in the new global order.

The depiction of accelerated vertical descent served as a mnemonic for the previous U.S. military action, which supposedly gave birth to that order. The autobiographical nose-cam video shot of the guided missile descending to its dramatic rendezvous with a supposed enemy installation was the most popular icon of the Gulf "war." During the confrontation, the bomb's-eye view was replayed, in different variations, with astonishing frequency, across a wide range of channels. It was a case study in hyper-publicity invading the modular privacy of domestic space. This particular image, reprised to bolster the fragile Haiti initiative, played a major role in the waging of the Gulf campaign by recruiting participation at the hearth of virtually every American living room. In one fell swoop, scopic violence was both announced as a crucial feature of the new order and employed as a means of soliciting the perceptual complicity of the viewing citizenry.

## Functions of the Smart Bomb: Missile of Mercy

The culmination of the energetic foreign policy and sophisticated diplomacy of the Reagan-Bush era was the announcement that the successful Gulf campaign had cleared the way for the New World Order. The smart-bomb video clip rapidly established itelf as the insignia of that ordering. In the Romantic iconography of the Gulf altercation, the smart bomb was the light-ning bolt that "Desert Storm" promised.[2] In a flash, by courtesy of a military-civilian televisual process, the whole vision of new world ordinance was tele-scoped into a single, moving image.

For what reasons did this particular, relatively simple, visual sequence undergo such an apotheosis into the primary signifier of the new order of war and of resuscitated American militarism? It has already been suggested above that the bomb's-eye view was not intended primarily to terrify the enemy, who had their own, unmediated experience of the air war to deal with. Although the bomb certainly did damage, and was seen as contributing to the pacification of a tyrant on the rampage, its mediated, broadcast version was used as a way to mobilize the civilian population on the home front (Cumings, 1992).

Postman (1988) has pointed to the significance of how missiles are christened. The official name of the chief smart bomb in the Gulf War was Tomahawk (Klare, 1992)—a Freudian slip revealing and reviving primitive fears of alien races. As Kovel (1994) has documented, there is a tendency in the U.S. for the "enemy" to be linked unconsciously to the eradicated Native American

population, which provides a model for genocidal threats and actions outside the U.S. However, the name Tomahawk, in recalling the frontier mythology of cowboys and Indians (*cf.* Slotkin, 1973), and the concrete image of a Native American weapon in actual use, also suggests that the smart bomb is felt as a threat within the U.S.,[3] and especially as a fantasized attack on the white mainstream of the population.

More central to the campaign of psychological warfare against the American people was the attempt to install the medical mythology of "surgical strikes," in order to create the public impression of a hygienic war. The vertiginous video clip was a key rhetorical device for the military-government alliance in persuading U.S. citizens and the rest of the world that only military targets were being bombed, and that "collateral damage" was being strictly minimized.

Matters of "high" principle were at stake: clearly (and visibly), the U.S. would not sink to the level of needlessly imperiling the lives of innocent citizens. To the contrary, as President Bush announced at the start of the war, armed confrontation was being pursued in order to liberate those hapless Iraqi victims from the tyrannical dictator controlling their country by force. The battle was for ethical territory, for an elevated vantage point (Aksoy and Robins, 1991; Churchill, 1992; Broughton, 1995).

In the public eye, holding to this moral high ground came to be associated with the smart-bomb video imagery. Accuracy was transformed into a sign of noble intention (Ronell, 1992; Levidow, 1994). The spiritual elevation latent in the "high" of high-tech was suddenly realized. Sanctions reinforced the superiority of the celestial perspective. The punitive impacts of munitions, like salvos of harsh condemnation, exemplified the force of conviction behind the moral judgment. When it came to blows, this explosive discipline was seen not only to announce its own legitimacy but also to use violence self-consciously to engender law.[4] The bombardment was presented as performative juridical founding of the New World Order. The home movies, with their sound tracks of holy silence, dramatized the ritual of sanctification.

War technologies, not content with legal and religious imprimaturs, offer in addition the healing promise of a medicinal state: the "surgical" precision of smart weapons provided direct evidence of institutionally backed care and control. One half of M.A.S.H.—the military as a savior devoted to the Hippocratic oath—is severed from the other—the military as a warmonger caring little for life or limb. The upgraded missile seemed to fulfill the prediction of the advance publicity broadcast by the *Newsweek* cover story in the winter of 1990 entitled "How the New High Tech Weapons Will Save Lives." What a P.R. coup: doctoring the media to portray the bomb as Mother Teresa.

# John Broughton

## Functions of the Smart Bomb:
## Agent of Accuracy and Autonomy

The notion of objectively scientific, rationally controlled, relatively decent, virtually harmless assault served an important purpose in offsetting the possible impression of indiscriminate destruction and slaughter (Carroll and La Roque, 1991; Broughton, 1991a). But the image from on high turned out to be entirely misleading. The catastrophic dimension of the actual destruction was, according to a UN report, "near-apocalyptic" (Druckrey, 1991: 18; Cumings, 1992: 126). The predominant strategy was actually "saturation" bombing; the supposed precision targeting was only successful in a minority of cases; and the claimed limitations on "collateral damage" were neither achieved nor systematically pursued.[5]

Surprisingly, accuracy has not been a major concern in high-technology weapons research; it has only become so in the domain of ballistic missiles for social and political reasons having to do with the image of the U.S. as the dominant world power (MacKenzie, 1989; cf. Street, 1992). Nevertheless, the Gulf War provided a sharp escalation of the missile rationales for defense funding that dated back to 1980 (Fallows, 1981). It was the stage for flaunting the performance of antitactical ballistic missile systems such as the Patriot, and cruise missiles such as the Tomahawk, some of which had the added *frisson* of terminal guidance by televisual data link (cf. Carus, 1992). The war foregrounded "a bomb that was simultaneously image, warfare, news, spectacle, and advertisement for the Pentagon . . . a video press-release" (Cumings, 1992: 122).

Another factor sustaining the impression of a qualitative lurch forward in military power is automation. It has been made to seem as though the smart bomb announces the imminent emergence of expert systems that will power "fully autonomous" robotic weapons, self-regulating predatory machines such as "pilotless aircraft . . . 'intelligent' enough to be able to select and destroy their own targets" (De Landa, 1991: 1).

Despite the lurid appeal of this threat, the touted advances in Artificial Intelligence simply have not taken place. If anything, the whole research domain has been in the doldrums.[6] Even in the instance of intelligent weapons in the Gulf War, autonomy was greatly exaggerated. In the domain of bombing, "smart" implies autonomous in the sense of precise self-guidance. Yet many of the bombs called smart were actually laser-guided (cf. Ross, 1992), an arcane procedure in which the "dumb" bomber requires a second aircraft to point out the target—a vastly inefficient process, even by military standards. What "smart" means here, as in the case of the televisually guided missile, is doing what you are told by somebody else.

Thus the touted breakthrough represented by the smart bomb is more the socially engineered product of impression management than of specific technological advances. Such P.R. was especially valuable during the Gulf campaign in order to cover up the failure of much high-tech apparatus (for instance, helicopters), the embarrassing inaccuracies in the many cases of "friendly fire," and the overall dependence on low-tech communications such as telephone and radio. Even the precision of the nose-cam video relay was suprisingly poor (Mellencamp, 1992), especially in the context of a sophisticated audience used to much higher definition in their video—the tech of the state seemed to fall far short of the state of the art.

Accuracy and autonomy are more reasonably interpreted as the liberal virtues of bureaucratic rationalization, facilitating identification with the bomb on the part of the influential, professional, middle class and perhaps, conversely, permitting an increment in the militarization of civil bureaucracy. Thus smart bombs may be representative not just of weapons trends, or of changes in the military, or even of the deadly potential of high technology, but also of our broader cultural orientation (*cf.* Penley and Ross, 1991). It is perhaps no coincidence that on the cover of Baudrillard's recent cultural critique, *The Transparency of Evil*, we find the eerily menacing image of a single, unexploded bomb. The degree to which the precipitous descent of smart bombs proved able

> to mobilize the popular imagination should tell us that they are more than anecdotal occurrences in an irrational world. The fact is that they contain within them the whole logic of our system: these events are merely the spectacular expression of that system. (Baudrillard, 1993: 67)

## Bombing as Communication: Stories and Messages

Our system claims to function logically, according to the natural laws of systems theory—the same cybernetic vision that was bequeathed to us by the military after World War II. In truth, however, our system requires a massive public relations program, a persistent campaign of psychological warfare, to sustain it. A major part of this general assault on the domestic audience is fostering the emergence of communications and entertainment hardware and software for showing and telling it the way it is.

Despite the crassly concrete nature of explosive bombardment, the absolute, unambiguous quality of killing, and the scientific, factual status of

munitions, there is still a complex narrating of war. Moreover, war itself is a form of narrating. This perhaps explains why war is such a surprisingly effective medium for storytelling.[7]

Smart bombing was imbedded in a complex rhetorical machinery of mediation, manipulating imagery, and discourse to achieve the impression of simple, scientific observation of technology at work. Typically, the bombing was presented in isolation, as though it were a contingent or even incidental feature of the war, but this was false modesty:

> The abstract image provided for television by the remote, robotic sensors of a "smart bomb," then, is not just an accidental feature of the way this war was fought, but a crucial element in its overall narrative construction. (Mitchell, 1994: 402).

The tales told by war have moral, metaphysical, and even cosmological implications. For example,

> Vietnam was what we might call an interactive or "intersubjective" war, a story with a dilated beginning, middle and end, in which both we and the enemy came to know each other as human beings, locked in a highly mismatched and uneven contest over incommensurable goals. (Cumings 1992: 122)

In contrast, insofar as intelligent weapons encapsulated the Gulf War story, they dismissively squashed the personal enemy and the discursive confrontation into a series of terrifying, punitive blows. The cyclical broadcast of the smart-bomb video provided in miniature one of those "apocalyptic narratives . . . (that) accumulate climaxes . . . , deemphasize beginnings and middles and allow the entire narrative space to become a repetition of climactic moments" (Bersani and Dutoit, 1985: 51). So, in spite of Baudrillard's comments, cited above, we could reasonably conclude that the logic of the system *is* a function of anecdotes.

At least since Antonioni's *Blow Up*, and with the help of Scott's *Blade Runner*, the visual representation of technology homing in on the target has connoted the detective procedure of closing in on the clue, the crime, and eventually the guilty suspect. Crime is about an approach, an approximation—desired yet perhaps feared by the agent of the law, and dreaded, yet perhaps yearned for by the criminal (*cf.* Black, 1991). The police story spatializes and temporalizes our ambivalence, our need to split the idealized hero from the vilified villain, to be sought after by the angel of justice, and to combat the evil demon. The projectile allows a more abstract, indirect, and dispassionate version of the tale, an attenuated policing.

Derrida, in his *tour de force*, "No apocalypse, not now: full speed ahead, seven missiles, seven missives" (1984a), has analyzed the semiotic structure of the projectile. All messages have a ballistic aspect, and qualify, from the point of view of the sender, as "things with which I am bombarding you" (*ibid.*, p.3). One cannot "touch on" a subject matter without "touching" the addressee. In Lyotard's (1981) words, "To speak is to fight as in a game, and the acts of language represent a general antagonistic. Social links are created through blows of language" (p. 8).

Bombardment is not simply a physical act of destruction or a goal-directed behavior. Rather, it implicates a subject in relation to another subject, albeit in the context of complex sets of social conventions. It is an instrument of mediation operating within a complex military exchange—not only a tool carrying a material impact, but also a sign expressing or connoting a specific intention or meaning, whether it be rage, indignation, condemnation, intimidation, punishment, revenge, redemption, intransigence, potency, persuasion, provocation, or simply announcement of one's existence.

We are familiar with the stereotype of the "mad" bomber, whose act is apparently deprived of any hidden significance by virtue of attributing insanity to the actor (Haynal, Molnar, and de Puymege, 1982). But the bomber is rarely insane: he or she exploits the potential, in the bombing deed, to *tell* and to *show*, as well as simply to *do*. Even terrorist acts require a performative competence, one which may involve reinterpreting and rejuvenating a tradition or announcing and demonstrating an identity (Brown and Merrill, 1993; *cf.* Crapanzano, 1990). Force and meaning are not mutually exclusive, but rather operate in a variety of combinations (Ricoeur, 1970).

All communications, however mediated, are attempts to make contact with an other. They are irreversible actions with particular properties: the "missive" is sent, launched on a trajectory, marked with an intended destination, delivered, and possessed of a certain effect upon arrival (*cf.* Lacan, 1972; Žižek, 1992). Even when the precise addressee is unknown, this transporting arc remains in place, and the receiver still "gets the message":

> Despite the fact that I do not know you or can barely see you while addressing myself to you, and that you hardly know me, what I have been saying is, as of a moment ago, reaching you—regardless of the trajectories and translations of signs that we address to each other in this twilight. What I have been saying comes at you, to encounter and make contact with you. Up to a certain point it becomes intelligible to you. The "things" that I throw, eject, project, or cast in your direction to come across to you, fall, often and well enough, upon you, at least upon certain of those among you. (Derrida, 1984b, p.3)

# John Broughton

Projectile weapons, therefore, can be subsumed as a special case under the more general category of directed messages—the "logic of the dispatch" (Derrida, 1984b: p. 7). The launching and guiding of weapons to their targets is a caricature of the way normative communication impinges on the other. How else can "the missile . . . living in isolated and great remove from others . . . 'send out' its expressions in order to have an impact on others?" (Mazis, 1993: 84).

> Again we follow the model
> of a violent beginning . . .
> faint and racing to infinity,
> picked up on instruments . . .
> a bomb knocking at the roof,
> the door, saying hello,
> goodbye, saying
> this is who we are.
>
> (Bowers, 1991)

Destructive acts may seem the absolute antithesis of communication. We commonly hear of "random" violence, "senseless" brutality, or the "madness" of war. Typically, if any meaning is attributed to an act of destruction it is, at best, restricted to an instrumental purpose: the achievement of some goal, such as the acquisition of territory, the monopolization of a valued resource, or perhaps just the distancing of self from other. Nevertheless, violence—however "antisocial"—possesses no less meaning than any "social" act. If anything, its destructiveness may witness a surplus of meaning (Bataille, 1988a), a spilling-over not of formless aggression but of pointed, poignant emotion, stemming from excessive loss, idealized ambitions, extreme guilt, or even an overly acute sense of justice (Klein, 1977a). From this point of view, the trajectories of munitions reinstate—in however abstract, stereotyped, or dangerous a manner—the desire for communicative contact.

## Military-Civilian Mimesis

Nevertheless, over and above the communicative nature of war there is the question of the *identities* of the various participants. The focus on video, in particular, brings us back to the roles of perception, visual imagination, and

physiognomic imitation, which do not always fall neatly under the rubric of the social constructions of discourse (cf. Taussig, 1993).

Modernity has fostered, via the new, visually mediated technologies and the mass production of imagery, a burgeoning not only of communication but also of the mimetic faculty—the "powerful compulsion to become and behave like something else" (Benjamin, 1978b). It is not so much that we learn, in Kubrick's words, to *love* the bomb, but that we learn to *identify* with it.

The vanishing of human bodies through media censorship may have interrupted processes of empathic identification with Iraqi civilians, but it cleared the way for identification with the only body offered: the tubular torso of the heroic missile. Identification with the missile may have been enhanced by dubbing it "smart" (an old trick from the advertising world). Yet identification is a defense mechanism. It involves deference to authority, and implies a certain coercive quality to the authoritative figure. We identify with the aggressor. When the aggressor is a cinematic presence, that mimesis is vastly empowered by its contact with the optical unconscious.[8]

Critical to the flux between the cultural and individual forms of the optical unconscious is the continuity established between household and state along the vector of video technology. Television is the institutionalization of video, the TV screen providing a video terminal within the home. This allows a reverse mimesis—attempts on the part of social institutions like the military to mimic the home video enthusiast. Both the system containing the nose-cone camera and the official playback at a military briefing imitate the increasingly common consumer who has a video camera and VCR. As a consequence of a complicated series of decisions about design, development, and sales strategies, "the market is currently being swamped by combined video camera cassette recorders aimed primarily at the home-movie maker. . . . More and more people have had the opportunity to put together their own electronic images" (Keen, 1987: 8; cf. Halleck, 1991).

Thus the military is compelled to model itself on everyday household activities. The impoverished, low-resolution video clips shown at briefings and released to the networks (Mellencamp, 1992) helped to sustain the domestic outreach. By denying itself the higher-definition, color video broadcasts (the technology for which was largely a military invention), and going instead with grainy black and white, the Gulf War was not only stamped as a "black and white" affair, but was also linked directly to the consumer's own range of familiar video activities. Conversely, the home video enthusiast confronted with the smart-bomb clip was virtually promoted on the spot to the level of military general. Home video replay acquired the world-historical importance and urgency of a wartime military briefing.

# John Broughton

## Information Technologies and the Crisis of the Self

Many commentators on the televisual coverage of the Gulf War (Wark, 1991; Taussig, 1992; Druckrey, 1991; Levidow, 1994) commented on the seduction of the viewer through the device of the bomb's-eye view, suggesting that the TV audience was sucked into a virtual identification with the missile on the way to its rendezvous with destiny.

Such identifications not only are common in the domain of technology, but they appear to be particularly exhilarating in high technology (Barglow, 1994). Barglow's research suggests that a society founded on high technology fosters an especially problematic type of identification, not unrelated to the fact that this kind of technology itself objectifies aspects of profoundly unconscious subjectivity. The requirements of technoscientific production—intellectual creativity, imaginative ingenuity and just plain physical labor—all seem more or less conscious processes, and the producers have a heavy investment in preserving the entirely rational appearance of this process. However, intellect, imagination, and work depend on and are fueled by deeper emotions, anxieties, and impulses, as research findings have already documented (Turkle, 1984; Honey, 1985; Broughton, 1990).

Information technologies, in particular, reify in material form defense mechanisms like isolation and intellectualization that require gross deformations of the truth. It is not the case, then, that an exploitive technocracy or an ignorant populace distorts the meaning and purpose of technology, but that the form of high technology itself is forged in the image of deception (Broughton, 1985a).

Since technology is already a crystallization of selfhood—of the constitutive, transcendental framework of subjectivity itself—identification with it is not just a discovery but a rediscovery. This refinding thus mimics the propaedeutic experience of acquiring the object of desire, which psychoanalysis shows us is always a return to an earlier, lost object—what Lacan (following Propp) calls the *"objet à."*

Small wonder, then, that the relationship to high technology can take the form of such intense and driven attachments. The new technologies are geared precisely to this compulsive aspect of unconscious subjectivity (Solomonides and Levidow, 1985). Intimate connection to such technologies frequently reevokes pathological aspects of childhood and even infantile dependencies (Faber, 1984; *cf.* Rieber, 1994). The regressive pull jeopardizes the crucial process of individuation and identity formation that occurs subsequent to childhood. In documenting such phenomena, Barglow (1994) suggests that the unresolved emotional dilemmas and identity problems of the

individual, brought out by and capitalized on by the compulsive technologies, reflect a much more general "crisis of the self."

## Identification and High Tech

Cinematic viewing has heightened our awareness of the paradoxical distance of the viewer, who is simultaneously a spectator—interpreting, constructing, and making sense out of the scenes—and yet also a barely separate being—phenomenally absorbed into the fictive activity (Merleau-Ponty, 1964). According to the pop psychology of film critics, this duplicity is to be explained in terms of the vicissitudes of "identification" of the viewer with the fictional characters—a virtually literal merger with protagonist and antagonist, rather than a symbolic engagement. Thus, under congenial circumstances, the viewer is supposed to align himself or herself with this or that character on the screen.

It is this alignment that is at the root of the psychodynamic convolutions in high technology that Turkle, Barglow, Honey, and Faber have identified. Unfortunately, popular discussions of the "addiction" to high technology and the "compulsive" pathology that it tends to draw out tend to misrecognize and even legitimize these phenomena as the efforts of a rational, adaptive agent bent upon "mastery."

In Freud's original use of the term, "identification" involved a submission, including a taking on of characteristics of the other. However, the concept has become vulgarized. Now the idea that we "identify" with the other suggests that we nullify its otherness, virtually assimilating it to the sphere of the self (Broughton, 1985b). In Turkle's account, for example, high technology functions as a screen onto which we project our interior life, and so the electronic object becomes our "second self" (Turkle, 1984). Such an identification could be said to reflect imperial tendencies in the self that encourage us to deny the alterity of the other, concealing the alienation of technology from human life.

The voluntarism, idealism, and individualism of such an imperial "ego" psychology conspire to obscure the contribution of the means of communication. "Identification" as suggestive of an outgoing, active process works against the awareness of the ways in which technology changes us. It is as though our desire to master technology, to reduce it to a tool (Broughton, 1985a), makes it necessary for us to remain unchanged by it. However, all kinds of evidence suggest that such a "take it or leave it" relationship, in which technology and user remain external to each other in the process of interaction, does not and cannot obtain (Ihde, 1990; Barglow, 1994).

# John Broughton

Such a desire both secretly rejects what technologies are and overlooks the transformational effects which are necessarily tied to human-technological relations. (Ihde 1990: 75)

The transformational effect is not just the Enlightenment benefit of skill or information. It is a matter of formal restructuring, even to the point of a constitutive alteration of subjectivity (Bukatman, 1993).

## Identifying with the Bomb

In the case of the video generation, such transformation is facilitated by the fact that television is a dynamic form of organization. Its narrative devices inspire and regulate the viewing public. As Bersani and Dutoit (1985: p. 41) suggest, with certain kinds of technically sophisticated, frenzied narratives, audience members "are excited out of themselves into new identities."

In the domain of violence, television operates actively to isolate and fixate the specific acts of war, facilitating the alignment of viewers with those acts: "The immobilization of a violent event invites a pleasurable identification with its enactment. . . . Stabilized images stimulate the mimetic impulse" (*ibid.*, p. 52). The constraints imposed by televisual broadcast provoke a self-displacement into another agent, while the focus and framing of camera and screen limit and concentrate the vicarious participation of the viewer:

(P)rivileging of the subject of violence encourages a mimetic excitement focused on the very scene of violence. The atrophied relation of that scene to adjacent (but background) activities blocks our own relations to those activities and limits the mobility of our attention and interest. (*ibid.*)

"Television" here should be taken to include the directorial effort required to command the viewer's attention: the way in which what is portrayed and the manner in which it is shown are precisely devices that have to be sophisticated enough to hail and recruit the spectator plausibly and persuasively. When a cinematic scene works, it engages the audience not only as a denotation but also as an *interpellation*, one of those "utterances whereby the subject, by recognizing itself in their call, becomes what they purport it to be" (Žižek, 1992, p. 32). The subject does not so much lend itself to the filmic episode, but responds to a request for incorporation. "Going to" the movies is also "coming to" the movies, being drawn in. The subjectivity of the viewer, then, is not as voluntaristic as it might appear. Even the choices that the subject

seems to make are implicated in the rhetorical structure of the situation.

Nevertheless, the viewer is not some mindless zombie transfixed by the magical power of the screen. The subject does not simply blend into the celluloid landscape, as movie fantasies from *Hellzapoppin*, via *The Purple Rose of Cairo*, to *Last Action Hero* would indicate. Rather, it tends to take up a specific position, or positions, as a function of the interpellative structure of the imagery and narrative (Clover, 1987). Assuming and shifting such positions involves a versatile maneuvering that requires a skilled complicity, which in turn presupposes a complex perceptual socialization into the psychopolitics of viewing conventions.

Such experiences are as enormously popular as they are, not just on account of the so-called entertainment value, but because a paradoxical integrity arises from social participation in a fictive construction:

> The dialectic at work here is that of a symbolic mandate: insisting on a false mask brings us nearer to a true, authentic subjective position than throwing off the mask and displaying our "true face" . . . (A) mask is never simply "just a mask" since it determines the actual place we occupy in the intersubjective symbolic network. . . . (W)earing a mask actually *makes us* what we feign to be. . . . (T)he only authenticity at our disposal is that of impersonation, of "taking our act (posture) seriously." (Žižek, 1992, pp. 33–34).

## Body as Missile

We take up our place or places in the social order not just as disembodied minds, but as corporeal beings. The concept of "identification" often inclines us toward thinking exclusively of a cognitive process, a feat of imagination. However, the mimetic propensity activated by conflict and aggravated by television is an ontological matter, involving the physical presence as much as, if not more than, ideation.

Even in the material form, identification needs the assistance of particular models. The massification of armed forces involved in the Gulf War and the absence of face-to-face combat helped to obscure the particulars, rendering problematic any coherent acts of identification other than a blind patriotism. During the war, the aggressivity of the overall social order became accentuated and linked to the massive mechanical mobility of the whole. It was left largely to the missile to provide a model of individuation. The viewer, falling under the thrall of the smart-bomb video, took up a specific, symbolic position, not as abstract, transcendental subject but as concrete, material body.

# John Broughton

"Armies win wars, not lone heroes. In real wars, Rambos die quick" (Sterling, 1993: 91). Nevertheless, even though we are rationally aware of this truism, we still tend to imagine warring in terms of the individual heroism of soldiers (Griffin, 1992: 316). We still cling to the hope of "some semblance of satisfaction from speed, explosion, blood-flow, and blackout in military action" (Theweleit, 1989: 207). The vision of the soldier's Utopia of a

> steel figure . . . with his ability to "subdue instincts" with his durable body armor . . . represent(ing) the possibility of guaranteed emotional control: in its most extreme form it was devoid of all feelings. (*ibid.*, pp. 206–207)

The figure of steel was in fantasy identified with the ballistic destructiveness of its own projectile weaponry:

> (W)e know what really became of these men. They went flying across the landscape like shrapnel from a machine blown apart at the seams, ripping to pieces whatever they encountered. (*ibid.*, p. 207)

The image here seems to be that of becoming dangerous and injurious to the other by being part of a unified metallic apparatus that then acquires velocity and the power to damage by being blown to pieces. Klein's studies of infantile ideation have shown how the multiplicative splitting of psychic wholes into part-objects can, in fantasy, give those bits and pieces a greatly amplified hostility and penetrating power.[9]

## Oblivion

The heroic steel figure is not a solitary unit. Each element rocketing along is a part of a vast metallic swarm—the "silver locusts," in Arthur C. Clarke's argot. Given that the subject projectively identifies with these flying splinters, the only drawback to such a scenario is the shattering realization that such projectiles have an uncertain future. One of the disadvantages of identifying with a falling bomb, as even a gung ho participant like Slim Pickens discovered, is that it risks the precipitous foreclosure of one's existence. The thrill is short-lived; the nirvana is Kurt Cobain's.

In the missile videos, the bodies were edited out. At the point of impact, not the gratifying B-movie splatter, but the censors' delicate truncation —a blackout. Any empathy for the victims, the invisible Iraqi targets, was forestalled. If any tendency of identification survived, the only figure left over to identify with was the bomb itself. After all, this shiny fuselage was a model of

nationalistic devotion—not only hastening to its own demise, but staunchly unwavering in its heroic act of self-sacrifice. The blackout at the end of the video is the dark valor of "speed, explosion, blood-flow and blackout." This syntagmatic chain of the oblivious "steel figure" in Theweleit's account of the romantic soldier-hero culminates in an exhilarating swoon:

> Identification is sexualized by the ecstatic loss of the appropriated identity. The confrontational nature of object relations is perhaps less the result of the subject's insanely blaming the object for its own inescapable self-alienation than the precondition for that masochistic "sympathy" in which the subject will recreate the *jouissance* of self-loss. (Bersani and Dutoit 1993: 156)

In the imagery of smart bombardment lurks an eschatology of scintillating, celestial objects, in brief, luminous motion, dying anonymously in passage through televisual-satellite space. Such motifs embody the currently fused ethics and aesthetics of the transient object:

> Good is no longer the opposite of evil. . . . Just as each particle follows its own trajectory, each value or fragment of value shines for a moment in the heavens of simulation, then disappears into the void along a crooked path that only rarely happens to intersect with other such paths. This is the pattern of the fractal—and hence the current pattern of our culture. (Baudrillard, 1993: 6)

It is not only the object that does not survive, but the subject, too. To the extent that there is symbolic identification between the viewing subject and the missile, the subject can die together with the object. There is a brief encounter, a passionate interlude, however foreshortened, followed by the classic and dramatic *Liebestod* that is so much a part of the American narrative tradition (Fiedler, 1960). At least the romantic vision of the suicidal impulse makes us seem more than just stupidly self-destructive.

We are used to the notion of the armored warrior body as a false unity protesting against an underlying fragmentation (Jaanus, 1989; Mazis, 1994; Broughton, in press[c]). Yet the converse has its appeal too: retreat from the ballistic whole to the disintegrated shrapnel state can serve as an avoidance. The sadistic quality of the metallic body does not have to be referred back to some violent essence. Instead, the offence can be seen as a dynamic defence, a hyperbole of courage that conceals a deeper cowardice. The stress of sustaining lives, the responsibility of difference, the strain of relating, the sorrow of parting, the guilt about damage done, the possibility of death—all these can be circumvented, or at least suspended, if only living can be dismantled (Fornari, 1975; Benjamin, 1980). If realising the unalienated creativity of

species being could be said to heal a wound, then bodily splintering and physical destruction could be seen as resistance to creative life itself.

## The Vertigo of the Real

The scenography of vertical obliteration carries an ontological and a psychological message about the peculiarity of the real.

Reality is not the positivist fiction of objectively neutral laws of nature, but a systematically social domain, the realm of the symbolic order. However, as dystopian exposés from *The Trial* to *Brazil* testify, this realm is repeatedly perforated by unresolvable antagonisms—unsymbolizable, traumatic elements (Žižek, 1989). These resistant lacunae of the so-far-uninterpretible represent "impossible" places, negative *loci* of the raw and unprocessed, like the grotto in *Alien* (see below), where the ruthless reproductive system lurks. They attach themselves to zeros, like the infinitely enigmatic letter "O" on the matchbook of Roger O. Thornhill in *North by Northwest* that, like the pseudonym "Kaplan" that starts the film or the dark opening of the tunnel that ends it, signifies nothing.

Desire is structured around the vacuoles left by the traumatic objects and events. When fantasy is not busy exorcizing the damage by injuring the other, it attempts to neutralize the threat of rupture, bridging those gaps, healing the gashes. Such attempts personalize the desire to fill out the social fabric, to preserve the illusion of its seamless continuity, consistency, and completeness, to protect us all from the vertiginous anxiety that facing up to the fractures would evoke (Žižek, 1991). A large part of the collective, ritual, Durkheimian effort is that required to sustain the flawless opacity of the emperor's clothes. Our sense of coherent identity and our daily enjoyment derive from the pursuit of these symptomatic acts (Žižek, 1992).

We feel that reality (that is, the social order) holds itself together, but this is only "the unreal unity proclaimed by the spectacle" (Debord, 1970: sec. 72). The integrity of the real is actually dependent upon collective fantasy (*cf.* de Mause, 1982). As the cracks in the conventional symbolic order become more salient, such fantasy becomes both more necessary and more pronounced. At the extreme, violence tends to become the predominant fantasy—abuse at home (for instance, *Twin Peaks*), revenge in the city (*The Crow*), and deadly combat abroad (*Black Rain*). Violence is seen as a supercharged vehicle for passage through chaos to rebirth (de Mause, in press; *cf.* Slotkin, 1973). In war, we express our desperate disavowal of our own residual trauma, throwing those wounds onto the other, attempting to destroy the aliens' national fantasy. The injury of bodies, then, is not the ultimate goal that Scarry (1985) presumes. It is only a signifier diverting us from the massive attack on the social fabric of the other's identity (Salecl, 1994).

The traumatic residues of the symbolic order appear in the deep-seated and archaic strata of subjectivity as intrapsychic "black holes" (Eigen, 1992; Kovel, 1994). Contrary to the therapeutic imaginary, and despite our efforts to metabolize these zones of negativity, they remain "fundamentally mysterious, unresolvable, incomprehensible: in a word, vertiginous" (Freedman, 1991: 17). Unless disowned through projection, these distributed, decentralized, dark nuclei exert their threat from within (Jaanus, 1989). It is around such abysmal holes that our understanding of danger, excitement, deceit, and bodily being is articulated.[10]

As Hitchcock's *Vertigo* shows, and *Robocop* or *In the Line of Fire* echoes, what repeatedly destroys us is the Icarus moment of self-inflation, when we perceptually blow ourselves up into omnipotent, almost divine bladerunners. In Magritte's *Domain of Arnheim*, the frozen bird-mountain still peeks with its eagle eye at the precariously perched nest eggs, reminding us that in the tragic couplet hubris serves to prefigure nemesis. The exit iconography

of *Psycho* (see right) fleshes it out: in a flush of guilt about her flight, the heroine watches the shredded evidence swirling down the toilet, and ends up a single, still eye. The camera homes in on the empty blankness of her pupil, which dissolves, in turn, into the vortex of her blood, draining away into a tubular blackness.

Psychic grandiosity is, paradoxically, a fragile defense against our phobia of the dark, satanic mills. In our counterphobic zeal, like Solness in *The Master Builder*, or the protagonists in *Grand Canyon, Priscilla, Cliff-hanger*, and even *Butch Cassidy*, we rush to precarious pinnacles, expecting a sublime release. Alas, such vantage points not only afford the sublime, but also position us on the brink of the ridiculous: the fantasy of plunging headlong into the gulf, as though by volunteering for vertigo, we could abolish the abyss. The exhilaration of climbing, as we escape from the humdrum of the tedious everyday below, is a figuration predicting the unexpected fulfilment of another, more profound escape, in which the scope of what we leave behind is suddenly and breathtakingly widened:

> In this free movement, independent of all consciousness, the elevated bodies strain towards an absence of limits which stops one's breath. . . . No limit, no measure can be given to the violence of those who are liberated by a vertigo experienced before the vault of the sky. (Bataille, 1988b: 77, 190)

When Thelma and Louise ignore the benign agent of the symbolic order, and gun it toward the edge of the canyon, they choose fantasy over the Real—which even Ridley Scott seems to acknowledge by freezing the car in mid-flight, suspended above the gulf.

The imagery of the apex and the vortex, the summit and the final summation, is a revealing vision of the hubris of power. It captures the false optimism with which we ascend heights, deceiving ourselves that motion in a direction called "up" is the only trajectory that cannot possibly reach a dead end. "High" technology is well equipped to function as the epitome of this *cul de sac*, and high-technology bombs suggest an ingenious way out.

Technology reciprocates: it is precisely the transformation of humanity by its own productivity that realizes the situation of absolute danger. When the relation to the world of creative discovery is reduced to finding new and better implements, human work itself is reduced to domination. The illusion of control and safety that the managerial attitude brings is delusional; bureaucratizing and instrumentalizing existence actually brings the living to the verge of nonexistence:

> (P)recisely through the successes (of technology) the danger can remain that in the midst of all that is correct the true will withdraw. The destining of revealing is in itself not just any danger, but danger as such. . . . As soon as what is unconcealed no longer concerns man even as object, but does so, rather, exclusively as standing-reserve, and man in the midst of objectlessness is nothing but the orderer of the standing-reserve, then he comes to the brink of a precipitous fall. (Heidegger, 1955: 26–27)

The dizzying abyss opens up as a function of the attempt at vertical escape, a "line of flight" (Deleuze and Guattari, 1987) from the negativity expressed in production:

> The negation of Nature accomplished by man—rising above a Nothingness which is his work—sends one back directly to vertigo, to the fall into the void of the sky. The very movement in which man negates Mother Earth who gave birth to him, opens the path to subjugation. (Bataille, 1985: 145)

The smart bomb may be a symptom of our decline and fall, but it is not a sign of an escape route. The explosive obliteration of the enemy is an act of desperation. If it has a Dionysian moment, it is the optical celebration of a fresh technical subjection looming into view.

# John Broughton

## Notes

Raymond Barglow, Ingrid Gerstmann, John Lenzi, and Mark Sammons took aim at this manuscript, and their friendly fire was always on target. Ricardo Hornos, Mick Taussig, and Michael Watts supplied valuable bibliographic materiel. Carissa Bozzo and Richard Cheney conducted expert library reconnaissance and provided reliable delivery systems. Thanks also to Susan Christopherson, Arch Dotson, and Esther Dotson, who provided a theater of operations for the writing. Jen Burns, Jim Feast, Chris Higgins, Alison Matika, Katie McMillan, and John Ruttner gave invaluable moral support on the battlefield.

1. On this shot in particular, see Nichols (1981), and on the "murderous gaze" in Hitchcock's total oeuvre, see Rothman (1982).

2. Elsewhere, I have attempted to draw out the many uses in the Gulf campaign of the Romantic "sublime"—its naturalist metaphors of landscape, meteorology, scale, and strife (Broughton, 1993, 1994).

3. The domestic orientation of New World Order ideology is highlighted in Peters (1992).

4. On the significance of violence in the generation of supervening law, see Benjamin (1978a) and Derrida (1990).

5. Regarding these three issues see, repectively: Leonard (1991) and Klare (1992); Fox (1991), Walker (1992), Hooglund (1992), Schmitt (1993), and Friedman (1993); Gellman (1991), Kempton (1991), Sklar (1991), and Hiro (1992).

6. On the decline and fall of artifical intelligence, see Dreyfus and Dreyfus 1986, Noble 1991, and Broughton (in press[a]).

7. On the narrating of war, see Ronell (1992) and Salecl (1994). On war itself as narrative, see Stone (1991). On war stories, see Silverman (1992) and Broughton (in press[b]).

8. On the optical unconscious, see Taussig (1992) and Krauss (1993). The connection between imagery and aggression has a long history, and is not confined to the psychological domain. Rather, it has involved a complex and convoluted intervention by technology (Virilio, 1989).

9. On the psychological basis of explosive fragmentation, see Redfearn (1992) and Mazis (1994). On the fantasied power of fragments, see Klein (1977b), Skirrow (1986), and Broughton (1991b).

10. The vertiginous descent into the traumatic nucleus is portrayed as double drama in a number of science fiction movies, such as *Fantastic Voyage* and *The Black Hole*, in which the personal interiority of the trauma is played out on shipboard while the fuselage itself encounters the Real as external threat, and takes a nosedive into it.

## Works Cited

Aksoy, Asu and Robins, Kevin (1991). "Exterminating Angels: Morality, Technology and Violence in the Gulf War." *Science as Culture*, 12, 332–37.

Barglow, Raymond (1994). *The Crisis of the Self in the Age of Information.* London and New York: Routledge.

Barnaby, Frank (1986). *The Automated Battlefield.* London: Sidgwick & Jackson.

Bataille, Georges (1985). *Visions of Excess.* Minneapolis: University of Minnesota Press.

———(1988a). *The Accursed Share.* New York: Zone.

———(1988b). *Inner Experience.* Albany: State University of New York Press.

Baudrillard, Jean (1993). *The Transparency of Evil: Essays on Extreme Phenomena.* New York: Verso.

Benjamin, Jessica (1980). "The Bonds of Love: Rational Violence and Erotic Domination." *Feminist Studies*, 6(1), 144–74.

Benjamin, Walter (1978a). "Critique of Violence," in *Reflections*, pp. 277–300. New York: Harcourt, Brace, Jovanovich.

———(1978b). "On the mimetic faculty," in *Reflections*, pp. 333–36. New York: Harcourt, Brace, Jovanovich.

Bersani, Leo (1977). *Baudelaire and Freud.* Berkeley, CA: University of California Press.
Bersani, Leo and Dutoit, Ulysse (1985). *The Forms of Violence.* New York: Schocken Books.

———(1993). *Arts of Impoverishment: Beckett, Rothko, Resnais.* Cambridge, MA: Harvard University Press.

Binkley, T. (1989). "Camera Fantasia." *Millenium Film Journal*, 20/21, pp. 6–43.

Black, Joel (1991). *The Aesthetics of Murder.* Baltimore: Johns Hopkins University Press.

Bowers, Neal (1991). Unpublished poem.

# John Broughton

Broughton, John M. (1985a). "The Surrender of Control: Computer Literacy as Political Socialization," in D. Sloan, ed., *The Computer in the School*. New York: Teachers College Press.

———(1985b). "The Genesis of Moral Domination," in Sohan Modgil and Celia Modgil, eds., *Lawrence Kohlberg: Consensus and Controversy*. Philadelphia: Falmer/Taylor & Francis.

———(1990). "Machine Dreams: Computer Fantasies of Young Adults," in Robert Rieber, ed., *Individual, Communication and Society: Festschrift for Gregory Bateson*. New York: Cambridge University Press.

———(1991a). "High Technology Fantasies in the Gulf War." Paper presented at the Conference on the Social Imaginary, University of Puerto Rico, February 14th.

———(1991b). "Babes in Arms: Object Relations and Fantasies of Annihilation," in Robert Rieber, ed., *The Psychology of War and Peace: Images of the Enemy*. New York: Plenum.

———(1993). "The Pleasures of the Gulf War," in Hendrikus Stam, and Bernard Kaplan, eds., *Recent Trends in Theoretical Psychology*, Vol. 3. New York: Springer.

———(1994). "The Bomb in the Bathroom," in Ian Lubek, Gail Pheterson and Charles Tolman, eds., *Recent Trends in Theoretical Psychology*, Vol. 4. New York: Springer.

———(1995). "U.S. over Iraq: High Technology and Low Culture in the Gulf Conflict," in Michael Flynn and Charles Strozier eds., *Festschrift for Robert Lifton*. New York: de Gruyten.

———(in press[a]). "Artificial Intelligence and Smart Weapons," in Iain Boal and James Brook, eds., *Unwired*. San Francisco: City Lights.

———(in press[b]). "Dialogues of Violence: Imaginary or Real?" in Marcella Tarozzi Goldsmith, C. Edward Robins and Samuel Wortzel, eds., *Lacan and War*. New York: Nomos.

Brown, David & Merrill, Robert, eds., (1993). *Violent Persuasions: The Politics and Imagery of Terrorism*. Seattle WA: Bay Press.

Carroll, Eugene J. and La Roque, Gene R. (1991). "Victory in the Desert: Superior Technology or Brute Force?" in V.Brittain, ed., *The Gulf Between Us: The Gulf War and Beyond*. London: Virago.

Carus, Seth (1992). *Cruise Missile Proliferation in the 1990s*. New York: Praeger.

Churchill, Ward (1992). "On gaining 'Moral High Ground'," in Cynthia Peters, ed., *Collateral Damage: The "New World Order" at Home and Abroad*. Boston MA: South End Press.

Clover, Carol (1987). "Her Body, Himself: Gender in the Slasher Film." *Representations*, 20, 187-228.

Crapanzano, Vincent (1990). "On Self-Characterization," in J. Stigler, R. Shweder and G.Herdt, eds., *Cultural Psychology*, pp. 179–206. New York: Cambridge University Press.

Cumings, Bruce (1992). *War and Television*. New York: Verso.

Debord, Guy (1970). *The Society of the Spectacle*. Detroit: Black & Red.

De Landa, Manuel (1991). *War in the Age of Intelligent Machines*. New York: Zone.

Deleuze, Gilles & Guattari, Felix (1987). *A Thousand Plateaus*. Minneapolis: University of Minnesota Press.

DeMause, Lloyd (1982). *Foundations of Psychohistory*. New York: Creative Roots.

———(in press). "The Group-Fantasy of Rebirth through Violence." *Journal of Psychohistory*, 1994.

Derrida, Jacques (1984a). "No Apocalypse, Not Now: Full Speed Ahead, Seven Missiles, Seven Missives." *Diacritics*, 14(2), 20–31.

———(1984b). "My Chances/Mes chances," in Joseph Smith and William Kerrigan, eds., *Taking Chances: Derrida, Psychoanalysis and Literature*. Baltimore: Johns Hopkin's University Press.

———(1990). "Force of law: the 'Mystical Foundation of Authority.'" *Cardozo Law Review*, 5–6, 919–1045.

Dreyfus, Hubert and Dreyfus, Stuart (1986). *Mind Over Machine*. New York: Free Press.

Druckrey, T. (1991). "Deadly Representations." *Ten.8*, 2(2), pp. 16–27.

Eigen, Michael (1986). *The Psychotic Core*. Northvale, NJ: Jason Aronson.

Faber, Mel (1984). "The Computer, the Technological Order, and Psycho-analysis." *Psychoanalytic Review*, 71(2),pp. 263–77.

Fallows, James (1981). "The Culture of Procurement," in *National Defense*. New York: Random House.

Fiedler, Leslie (1960). *Love and Death in the American Novel*. New York: Criterion Books.

Fornari, Franco (1975). *The Psychoanalysis of War*. Bloomington, IN: Indiana University Press.

Fox, Thomas (1991). "Bombs Falling Slowly," in *Iraq: Military Victory, Moral Defeat*, pp. 145–63. Kansas City, MO: Sheed & Ward.

Freedman, Jonathan (1991). "From *Spellbound* to *Vertigo*: Alfred Hitchcock and Therapeutic Culture in America." Unpublished manuscript.

Friedman, Thomas (1993). "US Leads Further Attacks on Iraqi Antiaircraft sites; Admits its Missile Hit Hotel." *New York Times*, Jan. 19, A1/A8.

Gellman, B. (1991). "Allies Sought Wide Damage in Air War." *Guardian Weekly*, June 30, p. 18.

Griffin, Susan (1992). *A Chorus of Stones: The Private Life of War*. New York: Doubleday.

Halleck, Didi (1991). "Watch out Dick Tracy! Popular Video in the Wake of the 'Exxon Valdez'," in Constance Penley and Andrew Ross, eds., *Technoculture*, pp. 211–30. Minneapolis, MN: University of Minnesota Press.

Haynal, Andre, Molnar, Miklos, and de Puymege, Gerard (1982). "Hatchets and Bombs: Anarchist Terrorists," in *Fanaticism: A Historical and Psychoanalytic Study*, pp. 165–94. New York: Schocken Books.

Heidegger, Martin (1955). *The Question Concerning Technology*. New York: Harper.

Hiro, Dilip (1992). *Desert Shield to Desert Storm: The Second Gulf War*. New York: Routledge.

Honey, Margaret (1988). "Play in the Phallic Universe: Adolescents' Involvement with a Fantasy Role-Playing Computer Game." Unpublished Ph.D. dissertation, Teachers College, Columbia University.

Hooglund, Eric (1992). "The Other Face of War," in Cynthia Peters, ed., *Collateral Damage: The "New World Order" at Home and Abroad*. Boston MA: South End Press.

Ihde, Don (1990). *Technology and the Lifeworld*. Bloomington, IN: Indiana University Press.

Jaanus, Maire (1989). "Viivi Luik: War and Peace; Body and Genotext in Her Novel, 'Seitsmes Rahukevad'," *JBS*, 20(3), 265–82.

Keen, Ben (1987). "'Play it again Sony': The Double Life of Home Video Technology." *Science as Culture*, 1, 7–42.

Kempton, Murray (1991). "The Wake of the Storm." *New York Review of Books*, July 18, 45.

Klare, Michael T. (1992). "High-Death Weapons," in Mordecai Briemberg, ed., *It Was, It Was Not: Essays and Art on the War Against Iraq*. Vancouver BC: New Star Books.

Klein, Melanie (1977a). *Love, Guilt and Reparation*. New York: Dell.

———(1977b). "Notes on Some Schizoid Mechanisms" (1946), in *Envy and Gratitude*. New York: Dell.

Kovel, Joel (1994). *Red Hunting in the Promised Land*. New York: Basic.

Krauss, Rosalind E. (1993). *The Optical Unconscious*. Cambridge MA: MIT Press.

Lacan, Jacques (1972). "Seminar on 'The Purloined Letter'," *Yale French Studies*, 48, 39–72.

Leonard, Thomas (1991). *On the Mass Bombing of Iraq and Kuwait, Commonly Known as "The Gulf war."* Stirling, Scotland: AK Press.

Levidow, Les (1994). "The Gulf Massacre as Paranoid Rationality," *Psychoculture*, 1(1), 7–10.

Lyotard, Jean-François (1981). *Discours/figure*. Paris: Klincksieck.

MacKenzie, Donald (1989). "Missile Accuracy: A Case Study in the Social Process of Technological Change," in Wiebe Bijker, Thomas Hughes, and Trevor Pinch, eds., *The Social Construction of Technological Systems*, pp. 195–222. Cambridge, MA: MIT Press.

Mazis, Glen A. (1993). *The Trickster, Magician, and Grieving Man*. Santa Fe, NM: Bear & Co.

Mazis, Glen A. (1994). "Male Gender Identity Beyond the Plato-to-Hegel Tradition; From High-Altitude Living, Tank Bodies, and Missile Sexuality to Flesh." Paper presented at the International Human Science Conference, St. Joseph's College, Hartford CT.

Mellencamp, Patricia (1992). *High Anxiety: Catastrophe, Scandal, Age, and Comedy*. Bloomington, IN: Indiana University Press.

Merleau-Ponty, Maurice (1964). "The Film and the New Psychology," in *Sense and Non-Sense*. Evanston, IL: Northwestern University Press.

Mitchell, W.J.T. (1994). "Pictures and the Public Sphere," in *Picture Theory*. Chicago: University of Chicago Press.

Nichols, Bill (1981). *Ideology and the Image: Social Representation in the Cinema and Other Media*. Bloomington, IN: Indiana University Press.

# John Broughton

Noble, D. (1991). *The Classroom Arsenal: Military Research, Information Technology and Public Education*. Bristol, PA: Taylor & Francis.

Penley, Constance and Andrew Ross, eds. (1991) *Technoculture*. Minneapolis, MN: University of Minnesota Press.

Peters, Cynthia, ed., (1992). *Collateral Damage: The "New World Order" at Home and Abroad*. Boston MA: South End Press.

Postman, Neil (1988). "The Naming of Missiles," in *Conscientious Objections: Stirring up Trouble about Language, Technology and Education*. New York: Knopf.

Redfearn, John (1992). *The Exploding Self*. Wilmette, IL: Chiron.

Ricoeur, Paul (1970). *Freud and Philosophy*. New Haven: Yale University Press.

———(1974). *The Conflict of Interpretations: Essays in Hermeneutics*. Evanston, IL: Northwestern University Press.

Rieber, Robert W. (1994). "Social Distress and the New Psychopath,"in Ian Lubek, Gail Pheterson, and Charles Tolman, eds., *Recent Trends in Theoretical Psychology*, Vol. 4. New York: Springer.

Ronell, Avital (1992). "Support our Tropes," in Nancy Peters, ed., *War after War*. San Francisco: City Lights.

Ross, Andrew (1992). "The Ecology of Images," in Nydza Correa De Jesus, Heidei Figueroa Sarriera, and Maria Millagros Lopez, eds., *Coloquio Internacional sobre el Imaginario Social Contemporaneo*, pp. 153–60. Rio Piedras, PR: Universidad de Puerto Rico.

Rothman, William (1982). *Hitchcock: The Murderous Gaze*. Cambridge: Harvard University Press.

Salecl, Renata (1994). *The Spoils of Freedom*. New York: Routledge.

Scarry, Elaine (1985). *The Body in Pain*. New York: Oxford University Press.

Schmitt, Eric (1993). "Path of US Missiles Brings Debate about Their Ability.," *New York Times*, January 19, A8.

Silverman, Kaja (1992). *Male Subjectivity at the Margins*. New York: Routledge.

Sklar, H. (1991). "Brave New World Order," *Z Magazine*, 4(5), 29–34.

Skirrow, Gillian (1986). "Hellivision: An Analysis of Video Games," in

Colin MacCabe, ed., *High Theory, Low Culture*. Manchester, UK: Manchester University Press.

Slotkin, Richard (1973). *Regeneration Through Violence*. Wesleyan University Press.

Solomonides, Tony and Levidow, Les (1985). *Compulsive Technology*. London, UK: Free Association Books.

Sterling, Bruce (1993). "War is Virtual Hell," *Wired*, 1(1), 46–51, 94–99.

Stone, Lynne (1991). "Theseus and the Minotaur," in John M. Broughton, ed., *Friendly Fire: Psychosocial Commentary on the Gulf War*. Teachers College, Columbia University.

Street, John (1992). *Politics and Technology*. New York: Guilford.

Taussig, Michael (1992). "Physiognomic Aspects of Visual Worlds," *Visual Anthropology Review*, 8(1), 36–48.

———(1993). *Mimesis and Alterity*. New York: Routledge.

Theweleit, Klaus (1989). *Male Fantasies*, Vol 2. Minneapolis, MN: University of Minnesota Press.

Turkle, Sherry (1984). *The Second Self*. New York: Basic.

Virilio, Paul (1989). *War and Cinema*. New York: Verso.

Walker, P. (1992). "The Myth of Surgical Bombing in the Gulf War," in Ramsey Clark, ed., *War Crimes: A Report on U.S. War Crimes against Iraq*. Washington DC: Maisonneuve.

Wark, MacKenzie (1991). "News Bites: War TV in the Gulf," *Meanjin*, 50(1), 5-18.

Žižek, Slavoj (1989). *The Sublime Object of Ideology*. New York: Verso.

———(1991). *Looking Awry*. Cambridge MA: MIT Press.

———(1992). *Enjoy Your Symptom*. New York: Routledge.

# IV

## Markets and the Future of Work

# 9

# Virtual Capitalism

*Arthur Kroker*

## Wired Shut

*Wired* intends to profit from the Internet. And so do a lot of others. "People are going to have to realize that the Net is another medium, and it has to be sponsored commercially and it has to play by the rules of the market-place," says John Battelle, *Wired*'s 28-year-old managing editor. "You're still going to have sponsorship, advertising, the rules of the game, because it's just necessary to make commerce work."

> "I think that a lot of what some of the original Net god-utopians were thinking," continued Battelle, "is that there was just going to be this sort of huge anarchist, utopian, bliss medium, where there are no rules and everything is just sort of open. That's a great thought, but it's not going to work. And when the Time Warners get on the Net in a hard fashion it's going to be the people who first create the commerce and the environment, like Wired, that will be the market leaders."
>
> —Andrew Leonard, "Hot-Wired," *The Bay Guardian*

The twentieth century ends with the growth of cyberauthoritarianism, a stridently pro-technotopia movement, particularly in the mass media, typified by an obsession to the point of hysteria with emergent technologies, and

with a consistent and very deliberate attempt to shut down, silence, and exclude any perspectives critical of technotopia. Not a wired culture, but a virtual culture that is wired shut: compulsively fixated on digital technology as a source of salvation from the reality of a lonely culture and radical social disconnection from everyday life, and determined to exclude from public debate any perspective that is not a cheerleader for the coming-to-be of the fully realized technological society. The virtual class is populated by would-be astronauts who never got the chance to go to the moon, and they do not easily accept criticism of this new Apollo project for the body telematic.

This is unfortunate, since it is less a matter of being pro- or anti-technology, but of developing a critical perspective on the ethics of virtuality. When technology mutates into virtuality, the direction of political debate becomes clarified. If we cannot escape the hard-wiring of (our) bodies into wireless culture, then how can we inscribe primary ethical concerns onto the will to virtuality? How can we turn the virtual horizon in the direction of substantive human values: aesthetic creativity, social solidarity, democratic discourse, and economic justice? To link the relentless drive to cyberspace with ethical concerns is, of course, to give the lie to technological liberalism. To insist, that is, that the coming-to-be of the will to virtuality, and with it the emergence of our doubled fate as either body dumps or hypertexted bodies, virtualizers or data trash, does not relax the traditional human injunction to give primacy to the ethical ends of the technological purposes we choose (or the will to virtuality that chooses us).

Privileging the question of ethics via virtuality lays bare the impulse to nihilism that is central to the virtual class. For it, the drive to planetary mastery represented by the will to virtuality relegates the ethical suasion to the electronic trash can. Claiming with monumental hubris to be already beyond good and evil, it assumes perfect equivalency between the will to virtuality and the will to the (virtual) good. If the good is equivalent to the disintegration of experience into cybernetic interactivity or to the disappearance of memory and solitary reflection into massive sun-stations of archived information, then the virtual class is the leading exponent of the era of telematic ethics. Far from having abandoned ethical concerns, the virtual class has patched a coherent, dynamic, and comprehensive system of ethics onto the hard-line processors of the will to virtuality. Against economic justice, the virtual class practices a mixture of predatory capitalism and gung ho technocratic rationalizations for laying waste to social concerns for employment, with insistent demands for "restructing economies," "public policies of labor adjustment," and "deficit-cutting," all aimed at maximal profitability. Against democratic discourse, the virtual class institutes anew the authoritarian mind, projecting its class interests

onto cyberspace from which vantage-point it crushes any and all dissent against the prevailing orthodoxies of technotopia. For the virtual class, politics is about absolute control over intellectual property by means of warlike strategies of communication, control, and command. Against social solidarity, the virtual class promotes a grisly form of raw social materialism, whereby social experience is reduced to its prosthetic aftereffects: the body becomes a passive archive to be processed, entertained, and stockpiled by the seduction-appertures of the virtual reality complex. And finally, against aesthetic creativity, the virtual class promotes the value of pattern-maintenance (of its own choosing), whereby human intelligence is reduced to a circulating medium of cybernetic exchange floating in the interfaces of the cultural animation machines. Key to the success of the virtual class is its promotion of a radically diminished vision of human experience and of a disintegrated conception of the human good: for virtualizers, the good is ultimately that which disappears human subjectivity, substituting the war machine of cyberspace for the data trash of experience. Beyond this, the virtual class can achieve dominance today because its reduced vision of human experience consists of a digital super-highway, a fatal scene of circulation and gridlock, which corresponds to how the late twentieth-century mind likes to see itself. *Reverse nihilism*: not the nihilistic will as projected outwards onto an external object, but the nihilistic will turned inwards, decomposing subjectivity, reducing the self to an object of conscience- and body-vivisectioning. What does it mean when the body is virtualized without a sustaining ethical vision? Can anyone be strong enough for this? What results is rage against the body: a hatred of existence so true and so sharp that it can only be satisfied by an abandonment of flesh and subjectivity and, with it, a flight into virtuality. Virtuality without ethics is a primal scene of social suicide: a site of mass cyrogenics where bodies are quick-frozen for future resequencing by the archived data networks. The virtual class can be this dynamic because it is already the aftershock of the living dead: body vivisectionists and early (mind) abandoners surfing the Net on a road trip to the virtual inferno.

## Adapt, or You're Toast

The virtual class has driven to global power along the digital super-highway. Representing perfectly the expansionary interests of the recombinant commodity-form, the virtual class has seized the imagination of contemporary culture by conceiving a technotopian, high-speed, cybernetic grid for traveling

across the electronic frontier. In this mythology of the new technological frontier, contemporary society either is equipped for fast travel down the main arterial lanes of the information highway, or it simply ceases to exist as a functioning member of technotopia. As the CEOs and the specialist consultants of the virtual class triumphantly proclaim: "Adapt, or you're toast."

We now live in the age of dead information, dead (electronic) space, and dead (cybernetic) rhetoric. *Dead information?* That is our co-optation as servomechanisms of the cybernetic grid (the digital superhighway) that swallows bodies, and even whole societies, into the dynamic momentum of its telematic logic. Always working on the basis of the illusion of enhanced interactivity, the digital superhighway is really about the full immersion of the flesh into its virtual double. As *dead (electronic) space*, the digital superhighway is a big real estate venture in cybernetic form, where competing claims to intellectual property rights in an array of multimedia technologies of communication are at stake. No longer capitalism under the doubled sign of consumer and production models, the digital superhighway represents the disappearance of capitalism into colonized virtual space. And *dead (cybernetic) rhetoric?* That's the Internet's subordination to the predatory business interests of a virtual class, which might pay virtual lip service to the growth of electronic communities on a global basis, but which is devoted in actuality to shutting down the anarchy of the Net in favor of virtualized (commercial) exchange. Like a mirrored reflection in reverse, the digital superhighway always means its opposite: not an open telematic autoroute for fast circulation across the electronic galaxy, but an immensely seductive harvesting machine for delivering bodies, culture, and labor to virtualization. The information highway is paved with (our) flesh. So consequently, *the theory of the virtual class*: cultural accomodation to technotopia is its goal, political consolidation (around the aims of the virtual class), its method, multimedia nervous systems its relay, and (our) disappearance into pure virtualities—its ecstatic destiny.

That there is an inherent political contradiction between the attempt by the virtual class to liquidate the sprawling web of the Internet in favor of the smooth telematic vision of the digital superhighway is apparent. The information highway is the antithesis of the Net, in much the same way as the virtual class must destroy the *public dimension* of the Internet for its own survival. The informational technology of the Internet as a new *force* of virtual production provides the social conditions necessary for instituting fundamentally new *relations* of electronic creation. Spontaneously, and certainly against the long-range interests of the virtual class, the Internet has been swamped by demands for meaning. Newly screenradiated scholars dream up visions of a Virtual University, the population of Amsterdam goes on-line as Digital City,

environmentalists become web weavers as they form a global, Green, cybernetic, informational grid, and a new generation of fiction writers develops forms of telematic writing that mirror the crystalline structures and multiphasal connections of hypertext.

But, of course, for the virtual class, content slows the speed of virtualized exchange, and meaning becomes the antagonistic contradiction of data. Accordingly, demands for meaning must be immediately denied as just another roadkill along the virtual highway. As such, the virtual class exercises its intense obsessive-compulsive drive to subordinate society to the telematic mythology of the digital superhighway. The democratic possibilities of the Internet, with its imminent appeal to new forms of global communication, might have been the seduction strategy appropriated for the construction of the digital superhighway, but now that the cybernetic grid is firmly in control, the virtual class must move to liquidate the Internet. It is an old scenario, repeated this time in virtual form. Marx understood this first: every technology releases opposing possibilities towards emancipation and domination. Like its early bourgeois predecessors at the birth of capitalism, the virtual class christens the birth of technotopia by suppressing the potentially emancipatory relations of production released by the Internet in favor of the traditionally predatory force of production signified by the digital superhighway. Data is the antivirus of meaning—telematic information refuses to be slowed down by the drag-weight of content. And the virtual class seeks to exterminate the *social* possibilities of the Internet. These are the first lessons of the theory of the virtual class.

## The Virtual Class

The *universal* interests of the recombinant commodity are carried forward by the *particular* interests of the technological class. Itself a virtual class because its historical interests are linked to hyperspace and its economic relations are (globally) coextensive with the world network of technocratic elites rather than bounded in local space, the technological class fuses with the high-speed backbone of the Net. Its expression as the emergent class of posthistory is coterminous with the sovereignty of the recombinant commodity.

Having no *social* origins, the technological class is a bionic product of that vast, and demonstrably successful, experiment in *economic eugenics* that has been unleashed by the merger of technology and biology in the posthistorical form of the will to virtuality. A mutant class, born at that instant when technology acquired organicity and became a living species, the technological class

is itself a product of combinatorial logic. It stands as the first, self-conscious class expression of the universal net of posthuman bodies. Alternatively therapeutic in its cultural outlook, because it believes fervently in technology as coeval with the life-principle itself, and vicious in its defense of the political interests of the will to virtuality, this class uniformly, globally and at the same historical moment flees the closed boundaries of the nation-state, going over to the side of a new eschatology: the interfacing of cybernetics and flesh as the (post)human good. In its bitter struggle to break free of the fetters of local politics, and to differentiate its universal (virtual) interests from the particular interests of the disappearing working class and inertial public sector bureaucracies, the technological class must mobilize on behalf of the ontological claims of the will to virtuality. Consequently, its *political* aim: the virtualization of economic space with the abandonment of products, and the sovereignty of process economy. Its *territorial* ambitions: to colonize hyperspace as voyagers exploring the stellar regions of the electronic frontier. Its really existent *community*: corelational and coextensive networks of cyberneticized knowledge. And its prevailing *ideology*: an ambivalent, but no less enthusiastic, doubled rhetoric of technological fetishism and technological determinism.

Not a passive class, but aggressive and predatory, the technological class has an immanently global strategy for its swift coronation as the leading class of postcapitalism. The Virtual Manifesto, with its associated war strategy, proceeds as follows.

## 1. *Tactical Envelopment*

On a global basis, the logic of tactical envelopment functions by installing supranational trading blocs (EC, NAFTA, the newly emergent South-East Asia Economic Co-Prosperity Zone). This function consists of a political strategy for undermining state sovereignty and freeing up the speed of virtual economy from the gravitational pressure of local regulatory "circuit breakers." These circuit breakers include local state subsidies for particular class interests in the production economy, environmental standards, tariff barriers to the unfettered movement of the process economy and nationalist coalitions mobilized around social agendas of labor and its representative political parties. Here, suborned, technocratic, state elites work hand in hand with the virtual class to ensure, by law and trade agreements, the unhampered movement and statutory protection of "intellectual property" (relational networks of cybernetic knowledge) through the permeable walls of local political space.[1]

## 2. The Disappearing State

Under cover of the Gatt negotiations, with their ideological recuperation of the obsolete dogma of "free trade" (itself a *mise-en-scène* for the disappearance of merchandise capitalism), a struggle is waged to destroy the internal integrity of the interventionist state and to free up labor as a fully mobile, fungible, and, hence, virtualizable commodity.[2] Here, the liberal-democratic compromise of the "welfare state" is swiftly and decisively pushed aside in the interests of the virtualization of economic space. The state that cannot plan in the interests of its own social economy, and that cannot act on behalf of its own political economy, is also the disappearing state. It is a perfect subordination, therefore, to the manufacturing phase of capitalism before the transnational interests of process economy, to (local) property before relational knowledge and of bounded political sovereignty before the primogeniture of the recombinant commodity.

## 3. A Definition of the Virtual Situation

Resequence the ruling rhetoric of particular political communities according to the global ideology of technological liberalism: that political consensus that holds that the dynamic and unimpeded expansion of the will to virtuality is the *superordinate aim and justificatory condition* for the state policy-making apparatus. Witness the evangelical appeals for a "high-speed digital superhighway" across the United States as both the aim of a technologically renewed America and its ethical *raison d'être* (for a technocratic U.S. "capable of competing on an even playing-field with the rest of the world"). Construction of a new high-tech transportation infrastructure (the famous "Chunnel," the modelling of the "new Europe" on the superquick network of the French TVA) mimics the construction of the Canadian National Railway across the Canadian frontier as a vaunted act of "nation-building" (long before Western Europe was "Canadianized" by technological liberalism). This was akin to the downloading of Tokyo, floating airport and all, into a virtual cyberspace, complete with neon libidos and pulsing video screens on every (telematic) street corner. In each of the above cases, it is a different country, but the ideology of technological liberalism is the same. The will to virtuality is both the aim and justificatory condition for the territorial expansion of the space of the political (state).

173

# Arthur Kroker

## 4. Ideological Delegitimation

Finally, through concerted public policies that speak the language of technological necessitarianism, there is a struggle to delegitimate unions and their political defense of the working class. Under the onslaught of technocratic elites occupying the heights of right-wing governments across the Organization for Economic Cooperation and Development (OECD), union leaderships and their working-class membership are continuously ridiculed as nostalgic defenders of an already superseded economic order. The unemployed are also targeted for abuse. In Canada, federal and provincial governments enact socially sadistic policies towards the jobless and the homeless because, from the moral viewpoint of the technological class, these are fully surplus bodies, accidental spillover from a virtual system that must result in growing social inequalities and the creation of a permanent underclass. With its inherently religious commitment to virtualization, the technological class would find it irrational, and thus immoral, to speak to social issues that are endemic to production. As in David Cronenberg's film, *Dead Ringers*, the bodies of the technological class may look normal on the outside, but on the inside something has gone terribly wrong. They are mutants: half flesh, half wired, fetishists in virtual guise who work to liquidate, by absentee mindlessness, the working class, the homeless and the powerless. And, of course, if "benign neglect" does not work, then there is always recourse to the deterrence-violence of the security state. In the United States, employment in the security business is a growth industry.

As David Cook states, in a reflection on Thurow, Galbraith, and Reich as emblematic signs of the recline of the American mind:

> With the satisfaction of desire (contentment) comes the growth of the military and the private security industry. The controlling mood is one of violence and force. . . . In America there are no longer, if there ever were, "Good Americans," or "Toquevillean citizens," or the "fortunate" who are going to look into the future. America is in the process of disappearing, dispersed across the world in a continuing sacrificial spiral. America now is reengineering itself via technological processes that create the culture, work, competition and self that is no longer "made in America" or made anywhere other than in technological space and whose future may well be played out in the only realm where America still holds the edge—violence both inside and outside the nation.[3]

## Virtual Class War

The technological (virtual) class must liquidate the working class. It does so through alliances forged with political representatives of the global technocratic class. The working class is grounded in localized space; the technocratic class wills itself to float away in the virtual zone of hyperspace. The working class has an objective interest in maintaining steady state employment in the production machine of capitalism; the technological class has a subjective interest in transcending the rhetoric of employment to "creative participation" in virtual reality as an ascendant life-form. The working class depends for its very existence on shielding itself from the turbulence of the nomadic vector of the recombinant commodity by securing its political foundations in the sovereignty of the nation-state; the technological class, politically loyal only to the virtual state, thrives on the violent passage of the recombinant commodity. The working class, grounded in social economy, demands the sustenance of the "social welfare net"; the technological class flees the inertial drag of taxes on its disposable income by projecting itself onto the virtual matrix.

Deeply antagonistic and with immanently warring interests, the working and technological classes are the emblematic historical signs of the beginning and the ending of the twentieth century. The modern century might have begun with the great historical struggles of the working class, sometimes revolutionary (Marxist-Leninism) and sometimes reformist (the welfare state, with its trade and business unionism), but it certainly ends with the political victory of the technological class, and with the global retreat of the working class, like a tide running out to the postmodern sea. Lenin and capitalism in ruins are the mirrored signs of the disappearing working class, and the triumphant ascendancy of the technological class as the posthistorical embodiment of the will to virtuality. Hence, the collective gloating of the technological class and the diffusion everywhere of virtual reality as the implacable horizon that welcomes us to the twenty-first century.

What of the relationship of the technological and capitalist classes? They are not the same, since the capitalist class has an interest in an old value-form of production (surplus-value), and the technological class has its interest in a new relation of process economy (virtualized exchange). The capitalist class seeks to ride the whirlwind of virtual economy via quick translations of process into products (consumer electronics); the technological class parasites surplus-value as a way of actualizing the virtualized body. The capitalist class desperately seeks new digital technologies as investment strategies for conquering the mediascape, and with it, all the welcoming orifices of the

electronic body; the technological class puts its research at the behest of capital accumulation, while it awaits the inevitable vanishing of capitalism into the will to virtuality. Refusing in the end to accede to its own historical liquidation at the hands of (an already obsolescent) fealty to the production machine, the capitalist class goes over to the side of the processed world of virtual economy. It puts capitalism in the service of the will to technology. In return for providing the material conditions necessary for allowing the machines to speak and to have (cybernetic) sex, the virtual world responds by rewarding this new class of virtual capitalists beyond its most feverish dreams: the robber barons of primitive capitalism are replaced at the end of the century by the pinhead egos of software barons. Capital is virtualized. Property remains in place and workers are sequestered, but resources are virtualized and redistributed from the virtual population to the elite. But, of course, capital has always been virtualized, always a matter of transforming material reality into a floating world of surplus-exchange. This process of alchemical transmogrification of nature and social nature finds its most abstract, and essential, expression in virtual reality. Virtual economy is a way of finally coming home for the liquid, circulating rhythms of the recombinant commodity.

Consequently, our actual situation is this: the state remains behind to sequester those who cannot, or will not, achieve escape velocity into hyperspace—wage-earning workers, salaried employees, broad sectors of the old middle class. The political model here is simply, "If in doubt, tax," because the Carceral State energizes its fading energies by randomly selecting among the virtualized population objects of abuse value. And the territorially imprisoned virtual population responds in kind: it initiates a form of popular counterterrorism by transforming all political leaders into liquid targets for the pleasures of abuse. Abuse and counterabuse, then, as the doubled codes of territorially bounded space and its sequestered virtual population.

As for the technocrats? They have long ago blasted off into hyperspace, filled with sad, but no less ecstatic, dreams of a telematic history that will never be theirs to code. An evangelical class, schooled in the combinatorial logic of virtual reality and motivated by missionary consciousness, the technological class is already descending into the spiralling depths of the subhuman. It wills itself to be the will to virtuality. In return for this act of monumental hubris, it will be ejected as surplus matter by the gods of virtuality, once its servofunction has been digitally reproduced. In Dante's new version of the circling rings of virtual reality, this class operates under the sign of an ancient curse: it is wrong, just because it is so right. For not understanding virtual hubris, it is condemned to eternal repetition of the same data byte.

## Slaved-Functions:
## The Political Economy of Virtual Colonialism

Virtualized capitalism is about cynical power, not profitability. Here, the virtual order of capitalist exchange is a global grid for the terminal division of the world into the shifting order of sadism. The truth-sayer of virtual capitalism as power is to be found in those dispossessed countries and regions that are fully surplus to the telematic requirements of the will to technology. Residual spaces outside the operating system of the recombinant commodity, the surplus economies scattered around the globe are preserved as sites of pleasureful abuse value and as potential sources of surplus flesh, doubled scenes of what might happen to us if we fail the will to virtuality. If the electronic body is neither a privileged citizen of the dialectic of technology (the spiralling network of programmers/consumers across the neural network of hardware, software, and wetware economies), nor a cursor in a clonal economy (the "five tigers") for quick simulations of the telematic order, then it can only be a "slaved-function": a detrital site of surplus body parts for the fatigued organic bodies of the "master-functions" as they await processing into virtualized nervous systems. Master-functions, slaved-functions, and clonal economies, therefore, are the classificatory power grid of virtualized capitalism.

Consider, for example, India, Haiti, Bangladesh, or the continent of Africa. These countries have slaved-economies that are maintained as standing reserve for the "master-functions" of the ruling sim/porium of Japan, Western Europe, and North America. Not really part of a global welfare system administered by the UN/U.S., but surplus nations that are sites of novel experiments in body-vivisectioning and vampirism in its late-capitalist phase: a whole underground global trade, then, in body parts (livers, hearts, blood) that are surgically cut out of the surplus flesh of the virtualized population of slaved-nations. And how could it be otherwise? The organic body knows that it will die before it can be morphed into a virtualized state, and so it desperately scans slaved-bodies, particularly those of the young, for the elixir of life: kidneys, pancreas, eyes, and hearts. And why not scenes of mass innoculation as first-cut film scripts for the future of the body-electronic? That is, the mass injection of the AIDS virus into the bloodstreams of Africans, before an officially approved and hypercharged AIDS virus under the cover of a "hepatitis vaccine," could be downloaded into the bodies of gay men in New York and San Francisco. Slaved-nations also function as marketing sites for the chronic diseases expelled from the aestheticized culture of North America: the aggressive promotion of cigarettes to the citizens of slaved-nations, under the always

seductive sign of the "Marlboro economy," provides symbolic, if not actual, membership in the master android cultures. Or, for that matter, why not copy the discarded cultural kitsch of America (Disney World) to the modernist cultures of Western and Eastern Europe as symbols of their clonal status in the lead societies of virtualized capitalism? No longer, then, do we have the division of political economy into First and Third Worlds, but a more grisly dissolution of the virtualized globe into a sadistic table of sacrificial value: *master-functions, clones, and slave-functions.* When capitalism disappears into a power grid, then economy remains only as an illusional space, disguising the more sadistic ruse of technology as abuse value.

Virtual colonialism is the endgame of postcapitalism. Just when we thought that the age of European colonialism had finally come to an end, suddenly we are copied into the second age of virtual colonialism: a reinvigorated recolonization of planetary reality that reduces human and nonhuman matter to a spreading wake of a cosmic dust trail in the deepest space of the blazing comet of virtual capitalism. A recolonization of everything is in progress, including the virtualization of labor, as jobs in the productive sector are downloaded around the globe to a slaved-workforce; the virtualization of culture, as the planetary neosphere, from Canada, to Romania, to China, is caught up in the deep-space drift net of CNN and MTV, which beam out the pulsar code of America to the clonal cultures of the world. The virtualization of fashion is also part of the body program as, for example, designers resequence the (recombinant) color and style of clothing into a high-fashion Internet. "Soft fashion" produces surplus-virtualized exchange (for itself) by transforming the culture of fashion into a digital sequencer, linking child labor in slaved-nations with the high-intensity market setting in the master triad (Japan, Europe, and America). And virtualized transportation, too, as transnational automobile producers flip into process economy: robotizing production by copying and pasting parts manufacturing to pools of cheap labor, while maintaining virtualized populations as holding pens for (ad) stimulated desire.

If there could be such a fantastic display of publicity about 1992 as being five hundred years after the conquest of (aboriginal) America by Europeans, it is probably because 1993 was Year One of the reconquest of the world by virtual capitalism.

# Notes

This is an excerpt from Arthur Kroker and Michael Weinstein, Data Trash: The Theory of the Virtual Class, (New York: St. Martin's Press, forthcoming 1994).

1. In addition to the study of the political strategy of the Trilateral Commission and the deciphering of the (side)texts of the Canada/US "Free Trade" Agreement and NAFTA, there is also an excellent analysis of the International Business Roundtable circulating on the Canada-L BBS of the Internet, posted by Dale Wharton, June 8, 1993. While this text does not draw out the implications for the technological class of politicized "trade" agreements nor situate the analysis in light of the recombinant commodity-form, it focuses critically on the fungibility of the international labor market and the undermining of local state sovereignty by a resurgent American empire. Here, the politics of "free trade" are forced to the surface of the seemingly transparent background of international economics.

2. *Ibid.*

3. David Cook, "Farewells to American Culture, Work and Competition," *Canadian Journal of Political and Social Theory*, 16 (1–3),1993, p. 5. In this review article, Cook argues eloquently, and convincingly, that Lester Thurow (*Head to Head*), Robert B. Reich (*The Work of Nations*), and John Kenneth Galbraith (*The Culture of Contentment*) are the leading representatives of the recline of the American mind. While Reich focuses on the spatial recovery of the disappeared working class (at the behest of the "technological class") and Thurow talks about engineering the new "European beast," Galbraith closes his eyes to the brilliant sun of Crash America.

# 10

# Markets and Antimarkets in the World Economy

*Manuel De Landa*

One of the most significant epistemological events in recent years is the growing importance of historical questions in the ongoing reconceptualization of the hard sciences. I believe it is not an exaggeration to say that, in the last two or three decades, history has almost completely infiltrated physics, chemistry, and biology. It is true that nineteenth-century thermodynamics had already introduced an arrow of time into physics from which arose the idea of irreversible historical processes. It is also true that the theory of evolution had already shown that animals and plants were not embodiments of eternal essences but piecemeal historical constructions, slow accumulations of adaptive traits cemented together via reproductive isolation. The classical versions of these two theories, however, incorporated a rather weak notion of history into their conceptual machinery: both thermodynamics and Darwinism admitted only one possible historical outcome, the reaching of thermal equilibrium or of the fittest design. In both cases, once this point was reached, historical processes ceased to count. For these theories, optimal design or optimal distribution of energy represented, in a sense, an end of history.

It should come as no surprise that the current penetration of science by history has been the result of advances in these two disciplines. Ilya Prigogine revolutionized thermodynamics in the 1960s by showing that the classical results were only valid for closed systems where the overall amounts

of energy are always conserved. If one allows energy to flow in and out of a system, the number and type of possible historical outcomes greatly increases. Instead of a unique and simple equilibrium, we now have multiple ones of varying complexity (static, periodic, and chaotic atractors); and moreover, when a system switches from one to another form of stability (at a so-called bifurcation), minor fluctuations can be crucial in deciding the actual form of the outcome. When we study a given physical system, we need to know the specific nature of the fluctuations that have been present at each of its bifurcations. In other words, we need to know its exact history to understand its current dynamical form (Prigogine and Stengers, 1984: 169).

And what is true of physical systems is all the more true for biological ones. Atractors and bifurcations are features of any system in which the dynamics are nonlinear, that is, where there are strong interactions between variables. As biology begins to include these nonlinear dynamical phenomena in its models (as in the case of evolutionary arms races between predators and prey) the notion of a "fittest design" loses its meaning. In an arms race, there is no optimal solution fixed once and for all, since the criterion of fitness itself changes with the dynamics. This is also true for any adaptive trait whose value depends on how frequently it occurs in a given population, as well as in cases like migration, where animal behavior interacts nonlinearly with selection pressures. As the belief in a fixed criterion of optimality disappears from biology, real historical processes come to reassert themselves once more (Kauffman, 1988: 280).

Computers have played a crucial role in this process of infiltration. The nonlinear equations that go into these new historical models cannot be solved by analytical methods alone, and so scientists need computers to perform numerical simulations to and discover the behavior of the resulting solutions. But perhaps the most crucial role of digital technology has been to allow a switch from a purely analytic, top-down style of modeling, to a more synthetic, bottom-up approach. In the growing discipline of Artificial Life (AI), for instance, an ecosystem is not modeled starting from the whole and dissecting it into its component parts, but the other way around: one begins at the bottom, with a population of virtual animals and plants and their local interactions, and the ecosystem needs to emerge spontaneously from these local dynamics. The basic idea is that the systematic properties of an ecosystem arise from the interactions between its animal and plant components, so that when one dissects the whole into parts the first thing one loses is any property due to these interactions. Analytical techniques, by their very nature, tend to kill emergent properties, that is, properties of the whole that are more than the sum of its parts. Hence the need for a more synthetic approach, in which

everything systematic about a given whole is modeled as a historically emergent result of local interactions (Langton, 1989: 2).

These new ideas are all the more important when we move on to the social sciences, particularly economics. In this discipline, we tend uncritically to assume systematicity, as when one talks of the "capitalist system," instead of showing exactly how such systematic properties of the whole emerge from concrete historical processes. We then tend to reify such unaccounted-for systematicity by ascribing all kinds of causal powers to capitalism, to the extent that a clever writer can make it seem as if anything at all (from nonlinear dynamics itself to postmodernism or cyberculture) is the product of late capitalism. Such indiscriminate reification is, I believe, a major obstacle to a correct understanding of the nature of economic power, and is partly the result of the purely top-down, analytical style that has dominated economic modeling from the eighteenth century. Both macroeconomics, which begins at the top with concepts like gross national product, as well as microeconomics, in which a system of preferences guides individual choice, are purely analytical in approach. Neither the properties of a national economy nor the ranked preferences of consumers are shown to emerge from historical dynamics. Marxism added to these models intermediate scale phenomena, like class struggle, and with it, conflictive dynamics. But the specific way in which it introduced conflict, via the labor theory of value, has now been shown by Shraffa to be redundant, added from the top, so to speak, and not emerging from the bottom, from real struggles over wages, or the length of the working day, or for control over the production process (Hodgsen, 1981: 93).

What we need here is a return to the actual details of economic history that utilizes a synthetic approach, as is happening, for instance, in the evolutionary economics of Nelson and Winter, where their emphasis is on populations of organizations interacting nonlinearly. Much has been learned in recent decades about these details, thanks to the work of materialist historians like Fernand Braudel, and it is to this historical data that we must turn to know what we need to model synthetically. Nowhere is this need for real history more evident than in the subject of the dynamics of economic power, defined as the capability to manipulate the prices of inputs and outputs of the production process as well as their supply and demand. In a peasant market, or even in a small-town, local market, everybody involved is a price-taker: one shows up with merchandise and sells it at the going prices, which reflect demand and supply. But monopolies and oligopolies are price-setters: the prices of their products need not reflect demand/supply dynamics, but rather their own power to control a given market share (Galbraith, 1978: 24).

# Manuel De Landa

When approaching the subject of economic power, one can safely ignore the entire field of linear mathematical economics (so-called competitive equilibrium economics), since these fields basically ignore monopolies and oligopolies. Indeed, Herbert Simon, economist and Artificial Intelligence guru, called this lack of concern for power the scandal of modern economics. Yet even those thinkers like Mandel or Galbraith who make economic power the center of their models, introduce it in a way that ignores historical facts. Authors writing in the Marxist tradition place real history in a straitjacket by subordinating it to a model of a progressive succession of modes of production. Capitalism itself is seen as maturing through a series of stages, the latest one of which is the monopolistic stage in this century. Even non-Marxist economists like Galbraith agree that capitalism began as a competitive pursuit, stayed that way until the end of the nineteenth century, and only then reached the monopolistic stage, at which point a planning system replaced market dynamics.

However, Fernand Braudel has recently shown, with a wealth of historical data, that this picture is inherently wrong. Capitalism was, from its beginnings in the Italy of the thirteenth century, always monopolistic and oligopolistic. That is to say, the power of capitalism has always been associated with large enterprises, large that is, relative to the size of the markets where they operate (Braudel, 1982, 2: 229). Also, it has always been associated with the ability to plan economic strategies and to control market dynamics, and therefore, with a certain degree of centralization and hierarchy. Within the limits of this article, I will not be able to review the historical evidence that supports this extremely important hypothesis, but allow me at least to extract some of the consequences that would follow if it turns out to be true.

First of all, if capitalism has always relied on noncompetitive practices, if the prices for its commodities have never been objectively set by demand/supply dynamics, but imposed from above by powerful economic decision-makers, then capitalism and the market have always been different entities. To use a term introduced by Braudel, capitalism has always been an "antimarket." Such a reconceptualization would seem to go against the very meaning of the word "capitalism," regardless of whether the word is used by Karl Marx or Ronald Reagan. For both nineteenth-century radicals and twentieth-century conservatives, capitalism is identified with an economy driven by market forces, whether one finds this desirable or not. Today, for example, one speaks of the former Soviet Union's "transition to a market economy," even though what was really supposed to happen was a transition to an anti-market—to large-scale enterprises with several layers of managerial strata in which prices are set. This conceptual confusion is so entrenched that I believe

the only solution is to abandon the term "capitalism" completely, and to begin speaking of markets and antimarkets and their dynamics.

Utilizing this new terminology would have the added advantage of allowing us to get rid of historical theories framed in terms of stages of progress and to recognize the fact that antimarkets could have arisen anywhere. Theoretically, antimarkets can arise the moment the flows of goods through markets reach a certain critical level of intensity, so that organizations bent on manipulating these flows can emerge. Hence, the birth of antimarkets in Europe has absolutely nothing to do with a peculiarly European trait, such as rationality or a religious ethic of thrift. As is well known today, Europe borrowed most of its economic and accounting techniques, those techniques that are supposed to distinguish her as uniquely rational, from Islam (Braudel, 1982, 2: 559–61). Many of the technological inventions that allowed her economy to take off came from China. What needs explaining is not that antimarkets were born in Europe, but that they did not emerge in the economies of China or Islam, even though the volume of trade there was intense enough. Several historians explain this situation by invoking the repressive power of their respective states, which made large-scale accumulation of capital impossible (McNeill, 1982: 49).

Finally, and before we take a look at what a synthetic, bottom-up approach to the study of economic dynamics would be like, let me meet a possible objection to these remarks: the idea that "real" capitalism did not emerge until the nineteenth-century Industrial Revolution, and that it could not have arisen anywhere else where these specific conditions did not exist. To criticize this position, Fernand Braudel has also shown that the idea that capitalism goes through stages, first commercial, then industrial, and finally financial, is not supported by the available historical evidence. Venice in the fourteenth century and Amsterdam in the seventeenth, to cite only two examples, already showed the coexistence of the three modes of capital in interaction. Moreover, other historians have recently shown that the specific form of industrial production which we tend to identify as "truly capitalist," that is, assembly line mass production, was not born in economic organizations, but in military ones, beginning in France in the eighteenth century, and then in the United States in the nineteenth century. It was military arsenals and armories that gave birth to these particularly oppressive control techniques of the production process, at least a hundred years before Henry Ford and his Model T cars. (Smith, 1987: 47). This largely ignored military component of large-scale enterprises is, I believe, another good reason to replace the term "capitalism" with a neologism like "the antimarket," since we can simply build this military component right into our definition of the term.

# Manuel De Landa

Besides conceptual clarification of its terms, economics needs novel approaches to modeling in order to complement analysis of its concepts with synthesis of the emergent properties of the phenomena with which it concerns itself. What would the models created by a bottom-up approach to the evolution of economics look like? A convenient starting point for a description of such a complex simulation is provided by the work of Nelson and Winter on evolutionary economics. In their work, they begin at the bottom, at the level of the individual firm. Why not even lower, at the level of human individuals? Because one important insight of their research is that large organizations, having developed routine procedures to handle many decisions, strongly constrain the choices of individual decision-makers, at least in most of the daily operations of the firm. These routines function as an "organizational memory" that maintains the identity of the firm from day to day. When a firm opens up a branch, for example, it moves some of its staff to that branch and a more-or-less accurate copy of this memory is transferred with them (Nelson and Winter, 1982: 98). Hence, the large firms that make up the antimarket can be seen as replicators, much as animals and plants are. And in populations of such replicators, we should be able to observe the emergence of the different commercial forms, from the family firm, to the limited liability partnership, to the joint stock company. These three forms, which had already emerged by the fifteenth century, must be seen as arising, like those of animals and plants, from slow accumulations of traits that later become consolidated into more-or-less permanent structures, and not, of course, as manifestations of some preexisting essence. In short, both animal and plant species as well as "institutional species" are historical constructions, the emergence of which bottom-up models can help us study.

It is important to emphasize that we are not only dealing with biological metaphors here. Any kind of replicating system that produces variable copies of itself when coupled with any kind of sorting device is capable of evolving new forms. This basic insight is now exploited technologically in the so-called "genetic algorithm," which allows programmers to breed computer software instead of painstakingly coding it by hand. A population of computer programs is allowed to reproduce with some variation, and the programmer plays the role of a sorting device, steering the population towards the desired form. The same idea is what makes AL (Artificial Life) projects work. Hence, when we say that the various forms the antimarket has taken are evolved historical constructions, we do not mean to limit our analysis to suggesting a simple metaphorical likeness to organic forms. Indeed, we argue that the divergent manifestations of the antimarket are produced by a process that embodies the same engineering diagram as the one that generates organic

forms. Another example may help to clarify this. When one says, as leftists used to say, that "class struggle is the motor of history," one is using the word "motor" in a metaphorical way. On the other hand, to say that a hurricane is a steam motor is not to use the term metaphorically, but literally: one is saying that the hurricane embodies the same engineering diagram as a steam motor: it uses a reservoir of heat, and operates via differences of temperature circulated through a Carnot cycle. The same is true of the genetic algorithm. Anything that replicates, such as patterns of behavior transmitted by imitation, or rules and norms transmitted by enforced repetition can give rise to novel forms when populations of them are subjected to selection pressures. And the traits that are thus accumulated can become consolidated into a permanent structure by codification, as when informal routines become written rules (Dawkins, 1989).

In this case, we have the diagram of a process that generates hierarchical structures, whether large institutions rigidly controlled by their rules or organic structures rigidly controlled by their genes. There are, however, other structure-generating processes that result in decentralized assemblages of heterogeneous components. Unlike a species, an ecosystem is not controlled by a genetic program; it integrates a variety of animals and plants in a food web by interlocking them together into what has been called a "meshwork structure." The dynamics of such meshworks are currently under intense investigation, and something like their abstract diagram is beginning to emerge (Kaufmann, 1988). From this research, it is becoming increasingly clear that small markets, that is, local markets without too many middlemen, embody this diagram; they allow the assemblage of human beings by interlocking complementary demands. These markets are self-organized, decentralized structures: they arise spontaneously without the need for central planning. As dynamic entities they have absolutely nothing to do with an "invisible hand," since models based on Adam Smith's concept operate in a frictionless environment in which agents have perfect rationality and all information flows freely. Yet, by eliminating nonlinearities, these models preclude the spontaneous emergence of order, which depends crucially on friction: delays, bottlenecks, imperfect decision-making, and so on.

The concept of a meshwork can be applied not only to the area of exchange, but also to that of industrial production. Jane Jacobs has created a theory of the dynamics of networks of small producers meshed together by their interdependent functions, and has collected some historical evidence to support her claims. The basic idea is that certain relatively backward cities in the past—Venice when it was still subordinated to Byzantium, or the network New York-Boston-Philadelphia when still a supply zone for the British empire—

engaged in what she calls "import-substitution dynamics." Because of their subordinated position, they must import most manufactured products, and export raw materials. Yet meshworks of small producers within the city, by interlocking their skills, can begin to replace those imports with local production, and these imports can then be exchanged with other backward cities. In the process, new skills and new knowledge are generated, new products begin to be imported that become the raw materials for a new round of import-substitution. Nonlinear computer simulations of this process have been created, and they confirm Jacobs's intuition: a growing meshwork of skills is a necessary condition for urban morphodynamics. The meshwork as a whole is decentralized, and it does not grow by planning, but by a kind of creative drift (Jacobs, 1984: 133).

Of course, this dichotomy between command hierarchies and meshworks should not be taken too rigidly; in reality, once a market grows beyond a certain size, it spontaneously generates a hierarchy of exchange, with prestige goods at the top and elementary goods, like food, at the bottom. Command structures, in turn, generate meshworks, as when hierarchical organizations created the automobile, and then a meshwork of services (repair shops, gas stations, motels, and so on) grew around it.[1] More importantly, one should not romantically identify meshworks with that which is "desirable" or "revolutionary," since there are situations where they increase the power of hierarchies. For instance, oligopolistic competition between large firms is sometimes kept away from price wars by the system of interlocking directorates, in which representatives of large banks or insurance companies sit on the boards of directors of these oligopolies. In this case, a meshwork of hierarchies is almost equivalent to a monopoly (Munkirs and Sturgeon, 1989: 343). And yet, however complex the interaction between hierarchies and meshworks, the distinction is real; the former create structures out of elements sorted out into homogenous ranks, the latter articulate heterogeneous elements as such, without homogenization. A bottom-up approach to economic modeling should represent institutions as varying mixtures of command and market components, perhaps in the form of combinations of negative feedback loops, which are homogenizing, and positive feedback, which generates heterogeneity.

What would one expect to emerge from such populations of more-or-less centralized organizations and more-or-less decentralized markets? The answer is, a world-economy, or a large zone of economic coherence.[2] The term, which should not be confused with that of a global economy, was later adapted by Braudel so as not to depend on a conception of history in terms of a unilineal progression of modes of production. Braudel takes the spatial definition of a world-economy from Wallerstein, and defines it as an economically

autonomous portion of the planet—perhaps coexisting with other such regions—with a definite geographical structure. It is composed of a core of cities that dominate it and that are surrounded by yet other economically active cities, subordinated to the core and forming a middle zone, and finally a periphery of completely exploited supply zones. The role of European world-economy's core has been historically played out by several cities: first Venice in the fourteenth century, followed by Antwerp and Genoa in the fifteenth and sixteenth. Amsterdam then dominated it for the next two centuries, followed by London and then New York. Today, we may be witnessing the end of American supremacy, and the role of core seems to be moving to Tokyo (Braudel, 1982, 3: 25–38).

Interestingly, those cities that play the role of core seem to generate very few large firms. For instance, when Venice played this role, no large organizations emerged in it, even though they already existed in nearby Florence. Does this absence of large-scale firms contradict the thesis that capitalism has always been monopolistic? I think not. What happens is that, in this case, Venice as a whole played the role of a monopoly: it completely controlled access to the spice and luxury markets in the Levant. Within Venice, everything seemed like "free competition," and yet its rich merchants enjoyed tremendous advantages over any foreign rival, whatever its size. Perhaps the impression classical economists had of a competitive stage of capitalism comes from the fact that the Dutch or the British advocated "free competition" internally precisely when their cities as a whole held a virtual monopoly on world trade.

World-economies, then, present a pattern of concentric circles around a center, defined by relations of subordination. To this spatial structure, Wallerstein and Braudel add a temporal one: a world-economy expands and contracts in a variety of rhythms of different lengths: from short-term business cycles to longer-term Kondratiev cycles, which last approximately fifty years. While the domination by core cities gives a world-economy its spatial unity, these cycles give it a temporal coherence: prices and wages move in unison over the entire area. Prices are, of course, much higher at the center than at the periphery, and this fact makes everything flow towards the core: Venice, Amsterdam, London, and New York, as they took their turn as dominant centers, became "universal warehouses" where one could find any product from anywhere in the world. And yet, while respecting these differences, all prices moved up and down following these nonlinear rhythms, affecting even those firms belonging to the antimarket, firms that needed to consider those fluctuations when setting their own prices.

These patterns—self-organized in time and space—which define world-economies were first discovered in analytical studies of historical data.

# Manuel De Landa

The next step is to use synthetic techniques, and create the conditions under which they can emerge in our models. In fact, bottom-up computer simulations of urban economics, where spatial and temporal patterns spontaneously emerge, already exist. For example, Peter Allen has created simulations of nonlinear urban dynamics as meshworks of interdependent economic functions. Unlike earlier mathematical models of the distribution of urban centers, which assumed perfect rationality on the part of economic agents, and where spatial patterns resulted from the optimal use of some resource such as transportation, here patterns emerge from a dynamic of conflict and cooperation. As the flows of goods, services and people in and out of these cities change, some urban centers grow, while others decay. Stable patterns of coexisting centers arise as bifurcations occur in the growing city networks taking them from attractor to attractor (Allen, 1982: 136).

According to Braudel, something like Allen's approach would be useful to model one of the two things that stitch world-economies together—trade circuits. To generate the actual spatial patterns that we observe in the history of Europe, however, we need to include the creation of chains of subordination among these cities, of hierarchies of dependencies besides the meshworks of interdependencies. This would require the inclusion of monopolies and oligopolies, growing out of each city's meshworks of small producers and traders. We would also need to model the extensive networks of merchants and bankers (through which dominant cities invaded their surrounding urban centers) by converting them into a middle zone at the service of the core. A dynamical system of trade circuits, animated by import-substitution dynamics within each city, and networks of merchants extending the reach of large firms of each city may be able to give us some insight into the real historical dynamics of the European economy (Braudel, 1982, 3: 140–67).

Bottom-up economic models that generate temporal patterns have also been created. One of the most complex simulations in this area is the Systems Dynamics National Model at MIT. Unlike econometric simulations, where one begins at the macroeconomic level, this one is built up from the operating structure within corporations. Production processes within each industrial sector are modeled in detail. The decision-making behind price-setting, for instance, is modeled using the know-how of real managers. The model includes many nonlinearities normally dismissed in classical economic models, such as delays, bottlenecks, and the inevitable friction due to bounded rationality. The simulation was not created with the purpose of confirming the existence of the Kondratiev wave, the fifty-two-year cycle that can be observed in the history of wholesale prices for at least two centuries. In fact, the designers of the model were unaware of the literature on the subject. Yet, when the

simulation began to unfold, it reached a bifurcation and a periodic attractor emerged in the system, which began pulsing to a fifty-year beat. The crucial element in this dynamics seems to be the capital goods sector, the part of the industry that creates the machines that the rest of the economy uses. Whenever an intense rise in global demand occurs, firms need to expand and then to order new machines. But when the capital goods sector, in turn, expands to meet this demand, it needs to order from itself. This creates a positive feedback loop that pushes the system towards a bifurcation (Sterman, 1989).

Insights coming from running simulations like these can, in turn, be used to build other simulations, and to suggest directions for historical research to follow. In the near future we will be able to imagine parallel computers running simulations combining all the insights from the ones we just discussed: spatial networks of cities, breathing at different rhythms and housing evolving populations of organizations and meshworks of interdependent skills. If power relations are included, monopolies and oligopolies will emerge, and we will be able to explore the genesis and evolution of the antimarket. If we include the interactions between different forms of organizations, then the relationships between economic and military institutions may be studied. As Galbraith has pointed out, in today's economy nothing goes against the market, nothing is a better representative of the planning system, as he calls it, than the military-industrial complex (Galbraith, 1978: 321). But we would be wrong in thinking that this is a modern phenomenon, something caused by "late capitalism."

In the first core of the European world-economy, thirteenth-century Venice, the alliance between monopoly power and military might was already in evidence. The Venetian arsenal, where all the merchant ships were built, was the largest industrial complex of its time. We can think of these ships as the fixed capital, the productive machinery of Venice, since they were used to do all the trade that kept her powerful; but at the same time, they were military machines, used to enforce her monopolistic practices (Braudel, 1982, 2: 444). When Amsterdam and London came to be the core, the famous companies of India with which they conquered the Asian world-economy, transforming it into a periphery of Europe, were also hybrid military-economic institutions. We have already mentioned the role that French armories and arsenals, in the eighteenth century, and American ones, in the nineteenth century, played in the birth of mass-production techniques. Frederick Taylor, the creator of the modern system for the control of the labor process, learned his craft in military arsenals. That nineteenth century radical economists did not understand this hybrid nature of the antimarket can be seen from the fact that Lenin himself welcomed Taylorism into revolutionary Russia as a progressive force, instead of seeing for what it was: the imposition of a rigid command-hierarchy on the workplace.

# Manuel De Landa

Unlike these thinkers, to correctly model the hybrid economic-military structure of the antimarket, we should include in our simulations all the institutional interactions that historians have uncovered. Perhaps by using these synthetic models as tools of exploration, as intuition synthesizers, so to speak, we will also be able to study the feasibility of counteracting the growth of the antimarket by a proliferation of meshworks of small producers. Multinational corporations, according to the influential theory of "transaction costs," grow by swallowing up meshworks, by internalizing markets either through vertical or horizontal integration (Hennart, 1991). They can do this because of their enormous economic power (most of them are oligopolies) and their access to intense economies of scale. However, meshworks of small producers interconnected via computer networks could have access to different, but just as intense, economies of scale. A well-studied example is the symbiotic collection of small textile firms that has emerged in an Italian region between Bologna and Venice. The operation of a few centralized textile corporations was broken down into a decentralized network of firms, in which entrepreneurs replaced managers, and short runs of specialized products replaced large runs of mass-produced ones. Computer networks allowed these small firms to react flexibly to sudden shifts in demand, so that no firm became overloaded while others sat idly with spare capacity (Malone and Rockart, 1991, 131; Jacobs, 1984: 40; Braudel, 1982, 3: 630).

But more importantly, a growing pool of skills is thereby created, and because this pool has not been internalized by a large corporation, it can not be taken away. Therefore, this region will not suffer the fate of so many American company towns, which die after the corporation that feeds them moves elsewhere. These self-organized reservoirs of skills also explain why economic development cannot be exported to the Third World via large transfers of capital invested in dams or other large structures. Economic development must emerge from within as meshworks of skills grow and proliferate (Jacobs, 1984: 148). Computer networks are an important element here, since the savings in coordination costs that multinational corporations achieve by internalizing markets can be enjoyed by small firms through the use of decentralizing technology. Computers may also help us to create a new approach to control within these small firms. The management approach used by large corporations was in fact developed during World War II under the name of Operations Research. In much the same way as mass-production techniques effected a transfer of a command-hierarchy from military arsenals to civilian factories, management practices based on linear analysis carry with them the centralizing tendencies of the military institutions where they were born. Nonlinear scientists are now developing fresh approaches to these questions

in which the role of managers is not to impose preconceived plans on workers, but to catalyze the emergence of meshworks of decision-making processes among them (Malik and Probst, 1984: 113). Computers, in the form of embedded intelligence in the buildings that house small firms, can aid this catalytic process, allowing the firms' members to reach some measure of self-organization. Although these efforts are in their infancy, they may one day play a crucial role in adding some heterogeneity to a world-economy that is becoming increasingly homogenized.

## Notes

1. The dichotomy meshwork/hierarchy is a special case of what Deleuze and Guatteri call Smooth/Striated or Rhizome/Tree.

2. The term "world-economy" is a neologism of Immanuel Wallerstein.

## Works Cited

Allen, Peter M (1982). "Self-Organization in the Urban System," in *Self-Organization and Dissipative Structures: Applications in the Physical and Social Sciences*. William C. Schieve and P.M. Allen, eds. Austin: University of Texas Press.

Braudel, Fernand (1982). *Civilization and Capitalism: Fifteenth- to Eighteenth-Century*. New York: Harper and Row.

Dawkins, Richard (1989). *The Selfish Gene*. New York: Oxford University Press.

Deleuze, Gilles and Felix Guatteri (1987). "1440: The Smooth and the Striated," in *A Thousand Plateaus*. Minneapolis, MN: University of Minnesota Press.

Galbraith, John Kenneth (1978). *The New Industrial State*. Boston: Houghton Mifflin.

Hennart, Jean-Francois (1991). "The Transaction Cost Theory of the MultiNational Enterprise," in *The Nature of the Transnational Firm*. Chistos Pitelis and Roger Sudgen, eds. London: Routledge.

Hodgson, Geoff (1981) "Critique of Wright I: Labour and Profits," in *The Value Controversy*. Ian Steedman, ed. London: Verso.

Jacobs, Jane (1984). *Cities and the Wealth of Nations*. New York: Random House, Inc.

Kauffman, Stuart (1993). *The Origins of Order: Self-Organization and Selection in Evolution*. New York: Oxford University Press.

———(1988). "The Evolution of Economic Webs," in *The Economy as an Evolving Complex System*. Philip Anderson, Kenneth Arrow, and David Pines, eds. New York: Addison-Wesley.

Langton, Christopher G (1989). "Artificial Life," in *Artificial Life*. C.G. Langton, ed. New York: Addison-Wesley.

Malik, F. and G. Probst (1984). "Evolutionary Management," in *Self-Organization and the Management of Social Systems*. H. Ulrich and G. Probst, eds. Berlin: Springer Verlag.

Malone, Thomas W. and John F. Rockart (1991). "Computers, Networks and the Corporation," *Scientific American* September 265 (3).

McNeill, William H (1982). *The Pursuit of Power*. Chicago: University of Chicago Press.

Munkirs, John R. and James I. Sturgeon (1989). "Oligopolistic Cooperation: Conceptual and Empirical Evidence of Market Structure Evolution," in *The Economy as a System of Power*. Marc R. Tool and Warren J. Samuels, eds. New Brunswick, NJ: Transaction Press.

Nelson, Richard and Sidney Winter (1982). *An Evolutionary Theory of Economic Change*. Cambridge, MA: Belknap Press.

Prigogine, Ilya and Isabelle Stengers (1984). *Order Out of Chaos*. New York: Bantam Books.

Smith, Merrit Roe (1987). "Army Ordnance and the 'American System' of Manufacturing, 1815-1861," in *Military Enterprise and Technological Change*. M.R. Smith, ed. Cambridge: MIT Press.

Sterman, J.D. (1989). "Nonlinear Dynamics in the World Economy: The Economic Long Wave," in *Structure, Coherence and Chaos in Dynamical Systems*. Peter Christiansen and R.D. Parmentier, eds. Manchester: Manchester University Press.

# 11

# Technoscience and the Labor Process

*William DiFazio*

I am going to tell a few stories of work and nonwork in postindustrial, postmodern, now-Clintonesque America. And I am going to point in some directions that I believe intellectual activists should move in. These directions can, at this point, be only provisional, because the labor process, transformed by technoscience, has changed the world of work and the social and cultural relations that are part of the world of work.

This presentation consists of fragmented and incomplete narratives, which I call stories, that describe a world of work that is increasingly "up for grabs." So far all of the grabbing has been on the terms of those who own and control the technoscience-based labor process.

## The First Story: Empty Piers

Longshoremen on the Guaranteed Annual Income (GAI) are paid even after their work is technologically redundant. The GAI came about as a result of technological changes within the shipping industry. The union's premise was that the cost of technological changes should not rest entirely upon the employees in the industry. The longshoremen are guaranteed work or income; containerization of cargo might eliminate their jobs, but it would not eliminate their incomes.

# William DiFazio

The GAI has been in effect since 1966. Longshoremen are guaranteed a full year's salary (2080 hours) at $45,000 a year.

In the 1950s, the New York-New Jersey docks were being worked by 48,000 men, who worked a total of 46,000,000 man-hours, and moved a total of 22,000,000 tons of general cargo. At the time, the work was concentrated on the Manhattan and Brooklyn docks. Italian and black longshoremen moved cargo on the Brooklyn waterfront, while Irish and Slavic longshoremen worked the Manhattan docks.

All this has changed. Work has almost completely disppeared from the westside Manhattan piers and there are 15,000 fewer workers on the Brooklyn docks. By the mid-seventies, 12,000 longshoremen were working 22,000,000 man-hours, and moving 27,000,000 tons of cargo. In short, one-fourth of the men now move more cargo tonnage. Longshoremen have increased their productivity by four-hundred percent in twenty years. In the past two decades, there has been a continuous decline in longshore job opportunities. The work has moved out of New York City to the modern container facilities in New Jersey. But no new job creation is occurring in New Jersey. In 1985, 10,100 laborers still worked the port of New York-New Jersey. three-thousand of these men on the GAI, with high seniority, who have been displaced by container technology, rarely work but receive a full salary. Even with the GAI, this is a very profitable industry, generating $14 billion in economic activity and $2.3 billion in business income.

Faced with the technological elimination of their jobs, Brooklyn longshoremen attached themselves to a nonproductivist ideology. They collectively struggled for wages without work and for free time as opposed to work time. No longer is their well-being attached to hard work, as it was in the past. Now it is attached to managing their own time away from work. They rightly perceive that productivity in the workplace is opposed to their interests. The economists who argue the opposite do not represent them, and they know it. Productivity means increased profits for the shipping industry, and the elimination of the longshoremen's livelihood. In this fight against productivity, they successfully avoid work. Their time is increasingly their own, and aimed in pursuit of their own needs. The longshoremen's struggle is one for repossession of their own time.

Time has always been a contested terrain in the clash between labor and capital. In the past, the assumption that a hard day's work was both necessary and a moral obligation undermined efforts to reduce the workday. The struggle of longshoremen confronts this assumption with skepticism. In the workplace of computer-mediated production, robotics, and information systems, the work ethic is challenged, and labor time is disrupted. If unions are to survive

in today's workplace they must struggle to make both technology and time negotiable issues.

But the longshoremen did not go far enough. Their struggle was shortsighted; they struggled only for their own, immediate needs. They did not understand that universal featherbedding is the only way to guarantee jobs at the wage and benefit levels they had achieved. And so, because they did not struggle for a guaranteed permanent workforce in the port of New York-New Jersey, nor for work-sharing, nor for a shorter workday without a decrease in pay, longshoring is an increasingly redundant occupation.[1]

## The Second Story:
## White Juvenile Delinquents in Greenpoint, Brooklyn

In 1979 to 1980, I was hired by Terry Williams and William Kornblum to do a study of violent, white juvenile delinquents that became part of their book, *Growing Up Poor*.[2] I studied white, male teenagers who were raised to be factory workers in the small- to medium-sized factories in Greenpoint and Williamsburg, Brooklyn, and Long Island City, Queens. But the factories had closed, or had left New York to hire nonunion workers at lower wages in the South and out of the country. The factories that remained paid low wages, and teenagers preferred to sell drugs, rob, and murder rather than work for those wages. By 1994, two-thirds of these teenagers, now adults, were in prison, were career criminals, heavy drug users, or dead.

In the United States, from 1979 to 1984, 1.7 million manufacturing jobs were lost. From 1988 to 1992, another 1.4 million manufacturing jobs were lost. Now my twenty-two-year-old, middle-class daughter, her friends, and my students compete for jobs in a market that hardly guarantees them the standard of living of their parents. Yet they do not take to the streets like the French students in 1968.

## The Third Story:
## White Male from the Soup Kitchen

A white man, forty years old, a middle class, warehouse manager with twenty years experience, has not worked in a year:

You should see the people I have to compete with. I'm waiting for a job interview in a moving company. A beautiful operation. They liked me but they said they didn't want to train me. It's not because I'm obese, at least not this time. It's a computerized operation, and I would have to be trained on the computer. But I'm sitting waiting for the interview, the other guy waiting to be interviewed is an MBA, also my age. Knows how to use the computer. Laid off from Wall Street, eighty-thousand dollar-a-year job. He's competing with me. I told him I just applied for a warehouse job at Bush Terminal. He asks me for the information and if I mind that he'll apply for the job. I have all on-the-job experience and only a two-year college degree. How can I compete for warehouse jobs with MBAs? And it happens all the time.

Hossein, the Director of the Bread and Life Soup Kitchen at St. John the Baptist Church in Bedford Stuyvesant, Brooklyn, is trying to get him a job. They have five job counselors, and they cannot find him a job.

## The Fourth Story:
## Angela and Flexible Specialization in the Garment Industry

Angela is a floor-girl, on Seventh Avenue in New York's garment district:

I check the operators' work. I've worked here for thirty-eight years. It's very bad here now. The work is all done outside of the United States and then we put it together here, and then we say it's made in the USA. We do very little in the New York area. Everything is done outside. You pick up a blouse and it's made in China. And they pay them terrible wages, fifty cents an hour, how can you live on those wages? And you know who sets them up all over the world? We do—American manufacturers—all of the shops, all over the world. We only assemble them here. They have kids in Chinatown, nine and ten years old, nonunionized, terrible. You can't survive on those wages. You can't be a garment worker and have a decent life; at one time you could, but not anymore.

Now more and more of the work is made by machine. The machines do everything—rolling, piping, felling. They put a gadget on the machine, like a funnel, and it rolls and stitches at the same time. Now piping, we used to call it French piping, now it's done by machines. We used to do bottoms by hand and now the machines do the felling. We used to do everything by hand, but now it's like an assembly line. In the old days it was all custom-made, we did everything by hand, now everything is by machine. They call it progress, they used to have twenty people do the work, all by hand. Now they have three people doing the same work and it's all by machine.

The only new work they create are the sweatshops in Chinatown, Greenpoint, Brighton Beach. I don't know what we're going to do. These people work for peanuts. They can't collect unemployment, they have no benefits, and they work harder than we did. People need to make a living, a wage, people got to live. But its always the same baloney. The immigrants are afraid and everybody else wears blinkers.[3]

## The Fifth Story:
## José and Bea in the Soup Kitchen

I sit down with José at the soup kitchen. I know that he is a single man on public assistance, and that I can ask him some questions about welfare. I ask him to explain check day.

Well, today is SSI (Social Security) check day. You get SSI on the first of the month. That's why there's fewer people here than usual. On Tuesday, it's emergency food stamps. On Thursday, a lot of people will be getting welfare checks and regular food stamps. But its all different. Even the days are different. But SSI always comes on the first of the month.

I ask him: "What are your benefits?" José responds:

I get a hundred dollars every two weeks, that's welfare. I don't get SSI. I get ninety dollars once a month, food stamps. And I get a housing check, a rent check. I endorse it and give it to the superintendent, he deposits it. I can't cash it. Only the landlord can cash it. I think the maximum rent that they'll give for a single man is two-hundred and fifteen dollars. Not much.

But different people get different amounts. My buddy here gets a hundred and eleven in food stamps but no welfare. Everyone's different. I try to eat here as much as possible, and then save thirty dollars a month of my food stamps. All the bodegas around here will buy them. They give you seven dollars cash for ten dollars of food stamps. It gives me some freedom. Yeah, some buy drugs and alcohol, but you don't really make enough and you need necessities. A shirt, cigarettes, go to a movie. I also will use them to go to restaurants. Get bacon and eggs for breakfast. I love that. And then I save them so, at the end of the month, I always save at least thirty dollars, I can go to the A & P and pig out. Cake and chocolate milk, some luxuries.

I sit down with Bea. She lives in the housing projects across the street from the soup kitchen. She has lived there all her life. Even though there is

crime, and it is dangerous at night, she says, "everyone knows me and I feel safe there." In general the projects are the best housing that the area offers. There are some well-kept and more expensive homes, where middle- and working-class blacks and Latinos live. Still, the projects are better than most of the housing in the neighborhood.

Bea says:

> We have a five-and-a-half room apartment in the projects. There are four of us, my sister and her son and my son. I get forty-eight dollars and fifty cents in public assistance every two weeks. My son gets SSI because he's disabled. He's blind. The rent is 217 dollars per month, and we get 196 dollars food stamps per month. That's hard. Things are expensive. I baby-sit and clean house and I make seventy-five dollars more a week. [This is not allowed, and technically Bea is a welfare cheat]. That helps, but what we live on is really nothing.

I ask her about selling food stamps. She answers:

> I don't think the system is fair—they don't give you enough to live on. But I think it's wrong to trade them in and not buy food. That's unfair. Food stamps is how I survive. They're like gold to me. I may have no money, but I always have food. Like now, it's the first of the month, I'm going to buy my meat. I buy a case of chicken, a loin of pork chops, big shell steak, chopped meat, rice and noodles, and I'll eat my lunches here at least a few days a week. And I get to see my friends and talk, and Sr. Bernadette (the nun who runs the soup kitchen) is just beautiful. But again, I think it's wrong to sell food stamps to buy cigarettes, clothes, crack, or OTB [Off Track Betting]. Even though it's not much money and we don't have much, its wrong.

## The Sixth Story:
## Computer Aided Design and the Decentering of Skill

In 1984, Stanley Aronowitz and I started our studies of Computer Aided Design (CAD) use in the New York City Department of Environmental Protection and the Transit Authority. CAD had just been introduced, and only a few architects and engineers were working on the machines. We observed that the architects, engineers, and drafters who were doing manual design work always looked busy. They were at their boards, continuously drawing. Those few engineers and architects who were working on CAD never looked as if they were working. They were sitting, staring at the screen of their machine,

using their mouse and continually staring. They were not drawing, they were thinking—a major change, from continuous drawing to continuous conceptualization.

Over the last ten years, we have studied architects and engineers in New York and New Jersey, in the public and private sector. We have observed the transformation of these architects and engineers who do design work with CAD. Drawing, the physical skill in doing design, has become secondary to the knowledge component. Conceptualization has become primary. Engineers and architects using CAD have significantly changed the object produced. There is much evidence that the departments are doing more work, with fewer workers, and with greater accuracy and more creativity. The notion of productivity itself is changing. How can you talk about productivity when the product itself is changing, and different from what it was in the past. Thus Mickey, an architect for the Department of Environmental Protection, says: "With CAD we can build a functional and beautiful city." For him, any notion of productivity would have to include not only cost and function, but aesthetic considerations as well.[4]

## The Seventh Story:
## Theoretical Biophysics—Theory Is Not Skill

A theoretical biophysicist describes his research:

My research is entirely theoretical. I used to have an experimental component to my research, but that has closed off. I have left this to colleagues, and my research is entirely theoretical. It is molecular biophysics. It is an exploration of the molecular basis of biological mechanisms. And it is an exploration that is based on physics, mathematics and theoretical chemistry, and it is performed with computer simulations. What I'm interested in are the most basic mechanisms of life, if you want, or biological structure. I work on the structure of DNA, the regulation of gene expression that is the interaction between DNA and protein, the structure of protein, the structure and function of protein, and then research that. My oldest roots are in research on neurotransmitter receptors—again, from the point of view of the structure of neurotransmitter receptors that allows them to perform the signaling process, and more recently, because it's become available from experiments, is the structure of the receptors that recognize those neurotransmitters and transduce the signals. And so it covers in fact an enormous amount of cellular and molecular biology. It covers most of the physiological mechanisms that are understood at the molecular level. But it deals with all of this computationally

through simulation, and theoretically, there is a difference between theory and simulation. . . . I call "theory" things that are based on laws which then are extrapolated either numerically or analytically to formulations, to specific formulations. "Simulations" is taking specific formulations, equations that govern a certain process, and propagating them as if you were the system, and accumulating the knowledge of the behavior of the system within a given formulation. To come up with a formulation you do theory. To make this formulation work and give you data on how the system evolves you do computational simulation. And one is purely theoretical and is close to theoretical physics, and theoretical chemistry, and theoretical geology, and theoretical astrophysics, all of those things. And the other is closer to experiment, in fact, but its a computational experiment. Because you design a system, although it's theoretical, and then you make it work, and observe it, and try to measure things on it.[5]

There is an increasing dependency by practitioners in the biomedical fields on scientists doing basic research. The scientists are unable to communicate this complex knowledge to the practitioners. Medical doctors rely on this knowledge, but must take it on almost religious faith, because they do not have the scientific background to understand it. This is the same contradiction that exists for the engineers and architects who use Computer Aided Design in which theoretical knowledge increasingly replaces the skilled knowledge of the old engineers and architects. In this sense, medical doctors are like craft workers; though still highly rewarded, they are being displaced by theoretical scientific knowledge and by technoscience.

## Conclusions:

1. In general, new, high-tech, production regimes are labor-destroying. As a result, increasing numbers of workers are becoming permanently redundant. The wave of the future is more workers in a global labor market with fewer opportunities. Workers "of all collars" are increasingly forced into greater competition with each other. In light of this situation, the struggle of longshoremen on the Guaranteed Annual Income has to become the struggle of all workers in all labor processes: manual, skilled, and intellectual. That is the struggle for income independent of work.

2. Technological and scientific knowledge have become the principal productive forces in late-industrial societies. Not only has manual work been displaced, but skilled work has been displaced as well. In the new workplaces,

technoscience is dominant, and skilled work is moved to the margins of production. Both skilled and industrial unionism face an increasing dilemma in view of these developments. Unions must reconceptualize their organizing strategies, with an increasing emphasis on knowledge work. This is already beginning to occur.

3. With more and more workers faced with the technological elimination of their work, we have at least two problems. First, the work ethic is no longer a central organizing priciple for social life; and second, there is a general decline in wages. In order to address these problems, we must actively participate in the creation of a new public ethic of social responsibility around which life can now be organized. Second, the struggle for the decommodification of medicine, housing, education, food, and so on has to be initiated. We must all be involved in these struggles.

## Notes

1. William DiFazio, *Longshoremen: Community and Resistance on the Brooklyn Waterfront* (Massachusetts: Bergin & Garvey Publishers, 1985).

2. Terry M. Williams and William Kornblum, *Growing Up Poor* (Lexington, MA: Lexington Books, 1983).

3. Stanley Aronowitz and William DiFazio, *The Jobless Future: SciTech and the Dogma of Work* (Minneapolis: University of Minnesota Press, 1994).

4. Aronowitz and DiFazio, *The Jobless Future.*

5. Aronowitz and DiFazio, *The Jobless Future.*

# U

## Bioethics

# 12

# Genetic Services, Social Context, and Public Priorities

*Philip Boyle*

Genetic technology, touted as being one of the great revolutions in medicine—and salvation to many who suffer from intractable disease—is well on its way to a clinic near you. Thanks to rapid private-sector advances in molecular biology, and fueled by a three-billion-dollar federal Human Genome Project that is mapping and sequencing the genetic makeup of humans, a plethora of genetic population screens, diagnostic tests, and therapies will be available—perhaps commonplace—in the next decade. But the cure might be worse than the disease. The avalanche of genetic services has the potential to cripple an already sick health care system. It is not unreasonable, therefore, to wonder whether there is a sensible way to distribute this onslaught of services. And what public policy matters must society pay attention to if there is to be any chance of reaching some sensible distribution of these services?

Genetic services could be both a blessing and a curse. Genetic testing will offer the opportunity to would-be parents to preselect which of their embryos to implant, and which to abort due to undesirable characteristics, such as the wrong hair color, or body weight. Complicating these choices, society will need to recognize that information provided by genetic testing will not always be as accurate as expected. People will be tested for a condition that might never fully express itself as a disease, or might express itself only in a mild form of a disease. Take for example, fragile-X—the most common form

of mental retardation, affecting one in every twenty-five hundred live births. Nearly twenty percent of persons who carry the gene for fragile-X will never express any form of mental retardation; however, knowing that their child carries the gene might lead parents to treat these unaffected children as mentally disabled persons. Other genetic markers that will be tested for will provide information about multifactorial conditions—conditions caused by the environment, by other genes or both. Genetic testing may not be the magic fount of information that society wished for.

In addition to the quality of the information, the number of potential abuses of the information should trigger caution. With the present laws permitting preexisting conditions to serve as a reason to deny health care insurance, insurers might begin refusing coverage to people who have a gene for a late-onset disorder, such as adult kidney polycystic disorder or Huntington's chorea. Recent studies suggest that employers are becoming interested in using genetic information about employees when the capability arises.[1] Perhaps the most pressing of all the daunting moral questions presented by genetic screening is whether society should make all of the potential technologies available.

The number of genetic technologies—screens, tests, and therapies—will, at minimum, present difficult choices for public policy makers and health planners, especially in the climate of health care reform. Regardless of whether reform succeeds at the federal level, the restructuring of health services along the lines of managed health care will force the issues of what services will be made available, to whom, and on what basis. The philosophy of managed care that attempts to manage resource utilization by controlling costs and quality of care will in a sense "call the question" about what services to make available. Reform—private or public—will likely force society to determine what health services to make available. The most obvious questions that must be addressed are: By what criteria shall we make these genetic technologies available? And who will make the decision? The rub in trying to answer these questions is not only that the present mechanisms for any rational health care planning are hopelessly inadequate. It is also that any plan for coherent reform will fail unless it pays attention to the social context—the obvious and less obvious social influences that exist and will prevail over any attempt to set priorities for genetic services.

It is the purpose of this paper not only to lay out what criteria are being proposed for an equitable distribution of genetic services, but also to show how the social context is critically important to understanding and planning for such a distribution, particularly when what is distributed is as tremendously powerful a set of health services as genetics.

# Genetic Services, Social Context, and Public Priorities

Genetic services can serve as a case study for the larger health care arena, where coherent theories of distributional equity must also entail a fine-grained understanding of social context. Genetics is perhaps different only in the sheer number of genetic services—according to low estimates, some fifty thousand gene markers will be developed as a result of molecular biology. These gene markers will be used for direct testing, to develop easy-to-employ biochemical assays, and to produce new drugs and therapies. The sheer numbers involved will dwarf other new health care technologies, but like other technologies, there will be a tension between wanting to offer some benefit, and not having tested the technology sufficiently.

Discussions of setting priorities for genetic services often proceed on the assumption that genetic services can be easily defined, which they cannot. Services that offer advances provided for by molecular analysis, such as polymerase chain reaction (PCR), perhaps have the greatest claim to being called genetic because they uses molecular biology's tools to identify gene markers. Even here what counts as genetic is confusing. For example, should cardiology services that utilize molecular techniques to confirm an ailment called Marfan's syndrome be considered genetic? The situation becomes murkier when you consider that many neonatal services that are offered under the rubric of genetics, such as maternal alpha-fetoprotein screening, are not strictly genetic services because the screen itself is a biochemical assay, not a molecular test. In the public policy debate over what genetic services we ought to make available, the issue of what counts as genetic becomes a political problem. Those who seek special funding for certain conditions (for instance, cancers) at times find it more advantageous to call the condition genetic, even though its causes might not be strictly genetic, but multifactorial.

A downside exists even to asking whether it is possible to set priorities for genetic services. This is a question that genetic researchers resist, because they fear a backlash against the advance of medicine. They reason that if many genetic services remain of unproven benefit—and it might take years to develop sufficient proof of a genetic service's effectiveness—then stalling will stifle all advance in research, and populations in need of genetic services will experience a long delay in getting them. This concern is fair enough, so I want to be clear that the present discussion about genetic services is not an attempt to single out genetics. All health services should be put to the same analysis that occurs here. So much for the throat-clearing. Now on to business.

# Philip Boyle

## How Have Genetic Technologies Become a Priority?

The history of how priorities for genetic technologies have been set in the past is useful for the present and future debate.[2] The story of phenylketonuria (PKU), a form of mental retardation, is an instructive case because it shows many of the strengths and defects of proposed screening programs for other conditions such as cystic fibrosis or fragile-X, or for multiplex testing (where one test serves to identify several problems).

Out of three million live births in the United States each year, PKU affects four hundred infants, or one case per fourteen thousand live births. The presence of phenylketonuria in the blood is an indication that an infant will develop mental retardation unless his or her diet is immediately regulated and restricted. Yet the prevalence of this condition is a medical rarity that most physicians would not see in a lifetime of practice. The low prevalence of the condition might be a reason to wonder what motivated making newborn PKU testing a public health priority that spurred an entirely new, universal, newborn screening program in the 1950s. Why did PKU become a priority target of state legislation across the country, and why was a multimillion dollar public health campaign for its detection and treatment launched?

To understand how PKU testing became a priority, we have to put the actors in their social context. A Norwegian physician, Alfred Folling, discovered in 1934 that PKU could be detected, but it was not until twenty years later that a way was found to control the condition. In the 1950s, it was thought that the damage done by PKU might be modified by placing patients on a phenylalanine-restricted diet. At the same time a physician-researcher whose son and niece both suffered from the condition spotted a correlation between the PKU levels and mental retardation.

For the biochemists, PKU testing was a confirmation of their work. As an inherited enzyme deficiency that could cause progressive neurologic damage and mental retardation, PKU was the best argument for funding biochemical genetics research. For the clinicians, PKU served as the first instance of a condition allowing mental retardation to be understood in medical terms. For the parents, treatment for PKU offered a chance of success in efforts to deinstitutionalize their progeny. Finally, for the government, PKU testing and treatment were the first tangible progress in efforts to control mental retardation—the scourge of the decade. In the 1950s, then, a number of factors coalesced to make large-scale screening for PKU acceptable to the public. One was heightened public concern with mental retardation; another was the discovery of a link between PKU levels and retardation; and a third was the development of a strategy for responding to the condition before the affected person suffered

retardation from it. PKU still occured only once in 14,000 live births but this chance combination of events including the personal connection of the researcher, reflects the symbolic significance it held in the agendas of various interest groups—parents, scientists, clinicians, bureaucrats, and legislators.The case of PKU demonstrated that the forces that press the priority of health services can have much less to do with rational planning than with discoveries, happenstances, and preoccupations at work in the social context. The history of other "genetic" conditions, such as cystic fibrosis and maternal alpha-fetoprotein screening bear out this story.

## Public Priorities Today and Tomorrow

Public policy about genetic services is made in the private sector as well as in the public sector. Federal research dollars affect what gets studied; federal monies, through the Bureau of Maternal-Child Health, fund networks of services to providers for genetic services. Perhaps the greatest coordination of the largest number of services occurs at the state level. However, the private sector is equally important, with insurers and managed care offering a host of services that could broadly be considered genetic. While the influence on public policy of the private sector's priorities is undeniable, telling that story is well outside the scope of this paper.

So how are public decisions reached about what genetic services will be made available? There is no one formula for how services are selected to be a priority—it varies from state to state and institution to institution, depending on funding streams, organizational patterns, institutional commitment, and populations served. Regardless of the heterogeneity in the particular details of how priorities are set, one constant remains: some variation of a cost-benefit analysis is used to determine which services will be provided and which will not. Typically, public policy-makers turn to experts in the field to identify the resources that should be made available. These experts frequently look to the severity and prevalence of a condition, balancing those against the effectiveness and cost of proposed genetic services as compared to alternative treatments for the same condition. Although expert health researchers take these measures as the obvious starting place, ethicists have pointed out how deeply imbued the measures are with social biases.

For example, take a rather common method for determining how to set priorities. A general intuition exists that if you have two patients with the same disease, and under circumstances of limited resources a choice must be made as to which one to treat, if one of the patients will likely survive five years

longer than the other and have a better quality of life, then our intuitions seem to favor that patient, because she will gain the greater benefit. Yet the person who does not get the treatment because she will benefit only a little could easily complain that she has been discriminated against—she is losing out on a treatment that would make a very large difference to her. The point is that individuals and society value life differently. For the person who does not receive the service, three months of life are of inestimable value. To society, however—or the policy makers acting on its behalf—those three months might seem insignificant. The measures we use are deeply imbued with other cultural biases as well, such as the one favoring the able-bodied. Persons with disabilities are likely to be the long-term losers, because health measures as they presently stand favor full recovery over the limited benefit of living with a disability. I am not suggesting that society should set side all scientific measures. Rather, I want to suggest that society should not overlook the fact that the measures we use to set priorities, whether in genetic services or elsewhere, are culturally bound. Practically speaking, this might require that society should make some adjustment in favor of those individuals who have historically been discriminated against by these measures. At the very least, society needs to be much more skeptical about the measures that are used to distribute limited societal health resources.

A second question that must be explored in setting priorities for genetic services is also culture-bound: Who should make the decisions? The large majority of choices about what health services should be made available has been made by the experts. However, because the nature of health measurements is so deeply imbued with cultural assumptions, it is not clear why the experts should be given the decisions. Experts might have expertise in a particular science, but that does not qualify them as experts about the values of the population, much less about the values the population *ought* to have. At minimum, the ranks of decision-makers ought at least to include those who are going to be most affected by the service. People other than experts need to participate in the decision-making as well, and the entire process must be democratized. It would be politically infeasible for everyone who is affected by a service to join in the priority-setting process. However, there ought to be representatives of the public on the group that must decide how to prioritize services, and public preferences should be integrated into the measures used. Finally, some sort of appeals process ought to be established, so that those who did not participate directly might have a chance to appeal, especially when services that could benefit them have been given low initial priority.

## Conclusions

Priorities for genetics services, as for other health services, have been set in a less than orderly way. In genetics, as in other areas of health planning, the rational goals of public policy-makers have not been met, because so many unexpected social forces have intervened. Therefore, whatever equitable measures and process are developed will be for naught if they do not take a realist assessment of social context and political feasibility.

## Notes

1.  Elaine Draper, *Risky Business: Genetic Testing and Exclusionary Practices in the Hazardous Workplace* (New York: Cambridge University Press, 1991).

2.  Benjamin Wilfond and Kathleen Nolan "National Policy Development for the Clinical Application of Genetic Diagnostic Technologies: Lesson from Cystic Fibrosis" JAMA V. 270 #24, Dec. 22-29, 1993, pp. 2948–2954; and Ellen Wright Clayton "What are the Law's Priorities about the Dispersion of Genetic Technologies?" in *Priorities in Genetic Services*, ed. Philip Boyle (Washington DC: Georgetown University Press, 1995).

# 13

# Genetics in Public Health: Implications of Genetic Screening and Counseling in Rural and Culturally Diverse Populations

*Ralph W. Trottier*

## Introduction

The Human Genome Project (HGP) began in 1990 under dual administrative responsibility of the National Institutes of Health (NIH) and the Department of Energy (DoE). This fifteen-year, estimated three-billion-dollar research study is part of a broader international initiative to produce a genetic and physical map of the entire human genome as well as the genomes of various other biological species. The goals of the human genome studies effort are to locate the estimated fifty to a hundred thousand genes along each somatic and germ cell chromosome, to determine the exact DNA molecular sequence of each gene, and, eventually, to define the role of genes in health and disease. The enormity and social impact of this scientific endeavor have been likened to the Manhattan Project and the Apollo Moon Project; but attention is quickly drawn to the fact that although the Manhattan and Apollo projects were certainly monumental, their emphasis was not human identity. Some experts have opined that human genome technology will play a role in medicine and society that is analogous to other, now plebeian-technology, such as the X ray machine. The scientific pace of the genetic mapping goal is well ahead of the originally planned first five-year schedule. Disease-causing gene isolation is expected to proceed at an ever increasing rate. The growth of

more than eleven hundred U.S. biotechnology companies since 1970 bears witness to a commercial climate ripe to market new biotechnological products.

The information to be gained from a better scientific understanding of human genetic function holds a lot of promise for science, medicine, and society, but casts many shadows of caution and concern as well. New, fast-paced methods in science will be by-products of HGP research; the practice of medicine as we now know it will change as a result of HGP technology; and we will be forced to revisit human relationships in terms of genetic families, communities, and cultures. There is a broad spectrum of thought or camps regarding genetic research at the level represented by the HGP (and even at minor levels, such as in plant or domestic animal genetic research). On the one extreme, there are those who believe that such research activity is dangerous and deterministic, and that it should be abandoned, while the other extreme proclaims that new genetics will be the wellspring of options and opportunities heretofore not thought of, and that moral responsibility will prevail over any evil designs. Of course, as anticipated, there is plenty of middle ground, and there is also a watchdog of sorts.

In an unprecedented move, unlike any other past or present big science projects, the HGP divisions within the NIH and the DoE included a special research endeavor to anticipate and address ethical, legal, and social implications (ELSI) of consequences likely to arise as the result of scientific and technological advances made by HGP research. Since the inception of the HGP, the NIH and the DoE have awarded approximately ten million dollars in support of ELSI research and various educational activities. This unique program provides an opportunity for diverse professional interests to examine the responsibility and impact of publicly sponsored science before or during the time scientific investigations reach the stage of application. The products of ELSI research provide insights that will shape the development of social and professional policies guiding the role of genetics in society and health care. Policy options take into consideration the fact that rapidly evolving technology in genetics will result in the ability to discover precise genetic causation, *presymptomatically*, of conditions for which there are currently no cures and perhaps only marginally palliative medical management (two such conditions that come to mind are neurofibromatosis and Huntington's chorea).

## Research and Analysis
## of State-Sponsored Medical Genetic Services

Our research, focused on the systems of public genetic medical services in Florida and Georgia, was conducted to address the following objectives:

Analysis of the statutory schemes and services provided by the newborn screening (NBS) programs to include the development of the programs and their present-day operations as well as to profile personnel responsible for various services provided. Comparisons along the lines of intrastate geographical regions of minority populations and access to services were also a part of the research plan.

Identification of issues involving confidentiality both within and outside of family contexts and to categorize situations likely to create conflicts between index persons or families and third parties who may claim a need to know sensitive information.

Assessment of the impact of early intervention programs on genetic consultative services.

This work was accomplished primarily by in-depth study of state laws and regulations governing the provision of NBS and other genetic services within the states' public health departments, and also extensive interviews with key administrative personnel as well as medical service providers (geneticists, genetic outreach nurses, and genetic counselors) and early intervention program operatives. The data, in various stages of analysis, are of the nature of thick descriptions of qualitative information.

As our investigations proceeded, we asked ourselves some basic questions that we believed would help us to understand the historical perspective of genetics as a public health issue, allow us to challenge the original purpose of state involvement in genetic services, and to forecast, by informed speculation, the potential future of genetics in the public health arena. Running through the entire fabric of our research was the question of how the HGP may impact upon public health genetic services. This, of course, seemed to beg another question—to what extent are states aware of or anticipating such an impact? Starting with the leading question: Why and how did states become involved in genetics? We did not entirely ignore the socially repugnant movements of eugenics and legally sanctioned sterilization laws in the early part of the century. Taking even that era into consideration, the answer seemed clear that the most benevolent rationale was to foster sound mental health and productive citizenry. Moving toward the mid-century, more progressive thinking was applied to matters regarding causation and prevention of mental retardation. The seminal finding from which modern-day NBS programs sprang was the discovery, in the early 1950s, that appropriate dietary management, instituted as soon as possible following birth, prevented much of the sequelae of mental retardation in newborns with phenylalanine hydroxylase

deficiency (the phenylketonuria [PKU] story). However, it was not until the early 1960's that broad population-based screening for PKU became practical. Shortly thereafter, nearly every state in the U.S. passed legislation to require all newborns to be screened for this condition. A key question arising from this case, if taken as a model, is: Should the availability of a "cure" or effective treatment be a condition precedent to testing for the presence of any genetic abnormality? As shall be seen by our analysis, an answer to this question is far from settled. The PKU story and the eugenics-era antics serve as examples of how states exercise a legal power known as *parens patriae* whereby the state assumes the role of "superparent" of its citizens and acts on their behalf, for their own good, with essentially no need for their consent to do so.

The next question examined whether states had deviated from the original purpose of initiating NBS programs. It was obvious that the first-step NBS programs were targeted toward detecting hormonal (for example, thyroid) and enzyme deficiencies that, left untreated, result in mental retardation. Within the approximate thirty-year operational span of NBS programs, conditions not associated with mental retardation began to be added to the list of routine NBS profiles. It is now not uncommon to see conditions such as congenital adrenal hyperplasia (CAH), sickle cell disease (SCD) and other hemoglobinopathies, and cystic fibrosis (CF) appearing on NBS program descriptions. These three examples are of interest for a variety of implications. First, each of these conditions has a particular ethnic prevalence. CAH has its highest incidence in Yupik Eskimos, SCD occurs most frequently in populations of African origin, while CF affects primarily populations of European derivation. As to the rationale that an effective treatment should be available before broad population-based screening is warranted, these conditions do not universally support that notion. CAH has an low-cost effective treatment (corticosteroid pharmacotherapy). There is no specific, currently available or recommended treatment that prevents the onset or reverses the consequences of episodes of SCD; however, it has been demonstrated that appropriately administered, prophylactic, antibiotic therapy in children with SCD prevents infectious complications. In the case of cystic fibrosis there is a new and expensive targeted gene therapy which is not a cure, but which may prevent complications. Carrier status testing in families or individuals is a possibility for each of these conditions.

Early into our studies, we learned that NBS was only one aspect of state-sponsored genetic services. Both Florida and Georgia, through state contracts with tertiary care centers, provide genetic outreach services to sectors of the population that would otherwise find it inconvenient or impossible to obtain these services. Differing somewhat in the means through which these

services are rendered, the states have established, in their respective public health departments, systems that provide periodic, on-site, genetic medical services to defined catchment areas. For purposes of this discussion, the Georgia system will be used as the primary example. An attending medical geneticist, from an academically based institution, travels to an outreach site, conducts examinations, orders necessary tests, renders a diagnosis, and develops or suggests a treatment plan to be transmitted to the referring physician in the community. In Georgia, this activity is coordinated by on-site, specially trained, genetic outreach nurses. These nurses provide a stationary base for clinic management and a contact person for patients, and they conduct extensive pre- and post-clinic activities. How busy are these sites, considering that genetic diseases are thought to be "rare"? During fiscal year 1992, 2,693 patients received services through the nine genetic outreach clinics located throughout the state. The population served by these nine clinics represents forty percent of Georgia's total population. The majority of those served is considered to be rural. The racial composition of these districts is twenty-seven percent black and seventy percent white with the remainder described as "other." As of the 1990 census, Georgia did not break down the category of "other" into specific ethnic designations. It is not difficult to conclude, however, that this category is comprised mainly of Hispanic and Asian populations. The pattern of racial/ethnic distribution described above is generally reflective of the pattern throughout the state; but, this can be deceptive, in that Georgia has 159 counties. It is not unusual to find adjacent counties with an obvious imbalance of racial diversity.

On first impression, the system of genetic outreach services appears to serve all rural areas equitably. A closer look, however, reveals some interesting findings. Georgia is divided into ten health districts. The larger districts are divided further into subdistricts. Each district and subdistrict has its own health director. Health directors have unilateral authority to prioritize the public health needs of their districts and how funds will be spent to meet those needs. The genetic outreach program is not under legislative mandate, and competes with other health care programs for its survival in the system. A district or subdistrict health care director may choose not to provide for a genetic outreach clinic. This appears to be the case in two districts in Georgia, the implications of which are under study. These two areas represent a combined estimate of six hundred thousand people, approximately ninety thousand of whom are black and six thousand of whom are of racial/ethnic origin other than black or white. Virtually all of this population is rural. Interestingly, these two districts are located at the northwestern tip and the southern central

regions of the state. We have been informed that citizens from these regions are not able to travel to adjacent districts to obtain the genetic medical services provided in those districts. We argue that, in some sense, this void in the state-sponsored genetic outreach services raises issues of distributive justice. This is not at issue in the Florida system.

## Potential Implications for the Future

Our third question, regarding the future role of genetics in the public health arena, was essentially phrased as: What evidence indicates that genetics may assume a greater role in public health care and management? To answer this question, we offer two possibilities. First, Public Law 99–457 is a federal mandate directing states to establish comprehensive integrated systems for the purposes of detecting children at risk of developmental delay and formulating a plan to maximize their transition into the school years. Basically, this is known as the Early Intervention Program (EIP). In Georgia, it is called "Babies Can't Wait." Clearly, this program is preventive in nature, and public health programs are about prevention. It is also "interventive" in nature, in that EIPs call for specific plans to be designed by the family and various service providers that outline the goals and objectives for maximizing the child's transition into the school years. The EIPs in Florida and Georgia are administered by the states' public health departments. We are familiar with one location in Georgia where the genetic outreach nurse is also the EIP coordinator. We argue that sophistication in genetic diagnostics would logically provide the tools to predict developmental delays. Second, advances in medical genetics will continue to have an impact on diagnosis and treatment of the genetic basis of multifactorial disorders of primary public health interest. It is also predictable that advances arising from HGP research will translate to usefulness in the diagnosis and treatment of cardiovascular, neoplastic, and perhaps behavioral disorders.

Some experts speculate that the GHP will forge the future for nationalized health care reform, and that the predictive power of risk calculation will tilt the balance from the treatment side to the prevention side. Perhaps the final question we will raise is: "Will health care reform plans in the future of all cultures be determined by a personal ultimate bar code scanned at or prior to birth?"

## Acknowledgments

On behalf of my many research colleagues, I gratefully acknowledge support for this research from the cooperative funding agreement of the DoE and the NIH for Grant #DE–FG02–61396, administered by the U.S. Department of Energy, Office of Energy Research; and for funds received from the Morehouse School of Medicine, Research Centers in Minority Institutions Grant #RR 03034. We thank The Center for Cultural Studies at the City University of New York for the opportunity and support to attend the conference from which this volume was developed and to present our research.

# VI

## Risky Reading, Writing, and Other Unsafe Practices

# 14

# Boundary Violations

*Peter Lamborn Wilson*

There exist historians of the eighteenth century who refuse to deal with Freemasonry. Their "reasoning" seems to run as follows: "The masons believed in mumbo jumbo. I do not believe in mumbo jumbo. Therefore the masons are unimportant—indeed, virtually nonexistent." The eye in the pyramid stares out of everyone's pocket, yet still these historians refuse to admit that masonry has any *historical significance*. Nowadays, thousands are afflicted with alien encounters, and UFO sexual molestations occur by the hundreds; countless others are afflicted with memories of satanic abuse. But according to serious science, neither Satan nor UFOs exist, *therefore* the abduction hysteria has no historical significance and can scarcely be said to exist. Right? No, wrong. Obviously UFOs and UFO hysteria can be considered as two different things, lacking all ontological codependency. That is, UFOs may or may not "exist," *but they need not exist* (except perhaps as an "archetype") in order to arouse the interest of historians in the *hysteria* and induce them to attempt to *interpret* it. The hysteria is real and important,—"history in the making" as the newsreels used to squawk—but its significance remains buried because "science" has mistaken the *content* of hysteria for its *inner structure*.

Now that Freud has been defenestrated—along with the Unconscious —modern psychotherapy can offer an all-purpose etiology for all UFO and/or Satanic "memories"—child abuse. In a recent statement on the subject, the

# Peter Lamborn Wilson

American Psychiatric Association (APA) cautioned that the falsity of certain "memories" should not be used as an excuse to ignore the underlying trauma, or deep inner structure of the "memory," which is assumed to be "real" abuse. The idea that *repressed sexuality* in childhood might cause false memories to arise as defense mechanisms in later life has been junked; the "seduction theory" has been revived, and transformed into the "abuse theory." This theory presupposes the nonexistence of "infant and childhood sexuality" (in Freudian terms), and in a broader sense, the nonexistence of childhood *desire*. A tendency arises to regard the child as an erotic blank, incapable of any authentic con-sensuality. Therefore, all points of contiguity between the concept "childhood" and the concept "sexuality" can be subsumed into one new and exhaustive concept: "abuse."

The APA offers an interesting paraphrase of the abuse concept when it mentions "conditions that are associated with boundary violations in [the patient's] past." New professional jargon always provides the semanticist/sociologist a golden opportunity to unpack hidden political and psychological content from telltale words and phrases, and *boundary violation* is a veritable trick suitcase—a richness of embarrassments. We would need a whole monograph to dump all the items jammed into this little portmanteau.

The metaphor of nationalism springs to mind first of all—boundaries are borders, violations are invasions. The individual is hypostasized not as a sovereign monarch (who might, after all, mingle and mate with other monarchs) but as a closed-off area surrounded by an abstract grid of map lines, political separations and all other manner of *exclusions*. A border crossing here is a violation, not an act of trade, or love, or harmonious association. The border is not a skin which can be caressed, it is a barrier. In relation to the inviolate body, all "others" are simply potential "wetbacks," illegal immigrants, terrorists traveling on forged documents.

The next obvious metaphor is the immune system. In fact, we can mix metaphors here, like the Iranian scholar M. Rahnema who "has compared the effects of developmental aid with the effect of the illness AIDS": the meddling of capital in the "Third" World has a viral effect—it breaks down immune systems made up of traditionally scaled economies and values, and replaces them only with diseased "growth."[1] This is true, but the use of the metaphor is even more interesting, further giving an air of hysteria and hopelessness to the argument. After all, there is a "cure" for capitalism, but it does not involve non-contact among peoples; on the contrary, in a sense, capitalism creates *separation* as a vicious parody, if you like, or grotesque exaggeration of the "natural" immune systems of peoples and cultures. It imposes uniformity but denies contact. The other, the "different," is perceived as viral and threatening. The

222

cure for this "condition" might well be to deny uniformity but to *make contact*. Ultimately, it is not the "immune system" which is at stake, but life itself.

The metaphor of AIDS has been a godsend to crypto-ideologues like the APA, who can make use of its semantic effluvia in terms like "boundary violation" to hint obliquely at the underlying agenda of their therapeutic control paradigm—that is, to erase the concept "childhood desire," and replace it with the concept "abuse." If all sex is dirty and causes death, then *everyone* must be "protected." Children here serve as metaphors for "everyone." To "protect children" is to protect the spiritual values of civilization itself against the threat of desire, the otherness of the body. No doubt the APA remains unconscious of these meanings; but then the APA has jettisoned *the* unconscious, so it is only appropriate that they should be among the first to fall victim to its surreptitious return. The unconscious—banished safely to the realms of advertising and disinformation, or so we fondly imagined—has come back to haunt us with Godzilla-like vengeance—raped by aliens and satanists! Our boundaries are being invaded, and we are urged to "believe the victim." The APA warns us that "abusers come from all walks of life. There is no uniform 'profile' . . . ," etc. Anyone may be an abuser, just as anyone may have been abused. Abuse is universal. There is *only* abuse. Of course, the APA does not believe in UFOs, but quite clearly it does believe that pleasure is evil.

Some extremists in the "deep" ecology movements joined certain Christian bigots in hailing AIDS as God's plan (for overpopulation, not immorality), and went on to suggest building a wall between the U.S. and Mexico to keep out the teeming billions of the angry South. Cut down to few million healthy heteros, America could restore its "wilderness"—which the deep ecolo's seem to envision as something like the Ayatollah Khomeini's idea of heaven: clean, pure, Aryan . . . well, maybe more like the SS's idea of heaven. "Ethnic cleansing" is yet another panic reaction to the sensation of "boundary violation." Abusers are, above all, "aliens"—even though (as the APA palpitatingly insinuates) they might look like you and me! The Other is the focus of all forbidden desire, which we ourselves must deny and hence project onto the unknown. But of course, that is Freudianism—or even Reichianism! We have no desires. *We* are the victims of abuse. Q.E.D.

The new catchphrase "multiculturalism" simply hides a form of ethnic-cultural cleansing under a semantic mask of liberal pluralism. Multiculturalism is a means of *separating* one culture from another, for avoiding all possibility of cross-cultural synergy or mutuality or communicativeness. At best, multiculturalism provides the consensus with an excuse to commit a bit of cultural pillaging—"appropriation"—to add some sanitized version of otherness to its own dreary, uniform boredom, through tourism, or vapid

academic curricula based on "respect and dignity." But the underlying deep structure of multiculturalism is *fear of penetration*, of infection, of mutation, of inextricable involvement with otherness—of becoming the other. Again, there is a cure for tourism—but it does not involve everyone staying home and watching TV. It necessitates a simultaneous attack on uniformity and a breaking down of borders. It demands both a genuine pluralism and a genuine camaraderie or solidarity. It demands conviviality.

Knowledge itself can be seen as a kind of virus. On the psychological level, this perception manifested recently as a panic about "computer viruses," and more generally about computer hacking—boundary violations in cyberspace, so to speak. The government wants access to all computer cyphercodes in order to control the "Net" (Internet), which might otherwise spread everywhere, transmitting secrets, even secrets about "abuse" and kiddy porn—as if *the Net* were a disease, rather than simply a *free exchange* of information. America's immune system can't take "too much knowing" (or whatever T.S. Eliot's lame-ass phrase was); America must be "protected" from penetration by foreign chaos cabals of evil hackers (who might look just like you and me). Borders must be imposed.

Cyberspace itself, however, involves a curious form of *disembodiment,* in which each participant becomes a perceptual monad, a concept rather than a physical presence. Cyberspace parodies the gnostic demand for transcendence of the body, which is literally "left behind" like a prison of meat as one enters the pleroma of conceptual space. Ultimately, one wishes to "download the consciousness" and achieve purity, cleanliness, immortality. Cyberspace proposes that life is not "in" the body, but in the spirit. And the spirit is . . . inviolate.

A preview of this paradise can be attained through phone-sex. Videophones never caught on because too many people hate their own offices (that is, bodies) and do not want others to see them (too much boundary violation). So, until cybersex is perfected, the un-cyberspace of telephone-land—a soundscape of bodiless voices—must be invested with all the sexuality we cannot share with other bodies, or with "real-time" persons with real personalities and desires. The deep purpose of phone-sex is probably not really the client's masturbation or his credit card number, but the actual ectoplasmic meeting of two ghosts in the "other" world of sheer nothingness, a poor parodic rendering of the phone company's slogan, "Reach out and touch someone," which is so sadly, so finally, what we *cannot* do in cyberspace.

Of course, the phone company, and everyone else, knows very well that you cannot reach out and touch someone over a phone. What the slogan really says is: Don't reach out and touch someone—that's a boundary violation—

pay us instead to mediate between you and the very sense of touch itself. The phone will save you from *being touched*.

Why then use the slogan, "Reach out and touch"? Ah, there is the secret of desire, Benjamin's "Utopian trace" still embedded in the commodity.[2] We *want* to reach out and touch, but we also fear the invasion of sensation it would entail; by using the phone, we scratch an itch that we secretly know will never go away. We will never be "satisfied" by all this spookiness, but at least we will be . . . distracted.

Protectionism becomes the one true philosophy of any culture based on mass anxiety about border violation; "safety" and "survival" become its shibboleths and highest values. The "security state" emerges like an abstract constellation figured against a random patterning of stars—each star representing a threatened job, "dysfunctional" family, "crime-ridden" neighborhood, black hole of boredom. Power in the security state emerges out of fear, and depends on fear for its rule. In the society of safety, *all* jobs are threatened, all families are dysfunctional, all crime is universal, and boredom is god. You may read the signs of this power not only in the texts of the media which define it, but even more clearly in the very landscape which "embodies" it. The pomo architecture of paranoid urbanism complements the already picturesque decay of the modern, the haunted emptiness of industrial ruins and abandoned farms. The aesthetic history of capitalism maps out a process of *retreat*, a withdrawal into the psychic fortress, the "drug-free-zone," the mall, the planned community, the electronic highway. We design for a *life without immunity*, believing that only capital can save us from infection. As we watch "history" unfold for us in the media, including the media of cultural and political representation, we become voluntary trance-victims of "terrorism" (the secret inner structure of "protectionism"). Consequently, our political acts (such as architecture) can express no higher vision than fear. The design of private space is based on the easiest antidote to fear, which is boredom.

Ideally, capital would like to discorporate entirely and retreat into the cyberspace of electronic wealth (and electronics *as* wealth) of power, speed, pure representation. The infinite "growth" which is capital's concept of immortality will indeed exceed all limits once economics becomes a matter of digitized data or spiritualized knowledge or "gnosis." Not long ago, the glaciers of capital covered the whole landscape, now the "ice" (William Gibson's sci-fi slang for "data") is withdrawing from physical space and retreating toward the pole, the mathematical point of abstraction, where a new and spiritualized topology of pure informational space will open up for us, like that "heaven of glass" with which the gnostic Demiurge attempted to con the angels of the Lord. And we shall be saved, safe at last, beyond all corruption—gone beyond.

# Peter Lamborn Wilson

Of course, as you know, very few will actually be taken up in this Rapture. Actually, you have probably already been disqualified. As capital withdraws (like an army fleeing from phantoms, or phantoms fleeing an army), a great deal of *social triage* will have to be practiced. As the no-go-zones are created and the wounded are left behind, entire new populations of *outsiders* will be created. Too bad you will have to miss that last helicopter out of town.

"Homelessness" constitutes such a zone, a kind of antiarchitecture, a shell from which all services and utilities have been withdrawn, leaving only a television blaring in a bare and empty room, broadcasting cop shows and messages of multiculturalism and dignity. That is, the spectacle of power remains, while the "advantages" of control have disappeared. Any overt symptoms of autonomy amongst the "victims" can be smashed by the last interface between power and nothingness: Robocop, Manuel de Landa's "artificial intelligence" or war-automaton, the violence of a society turned against itself.

As the map is infolded, certain privileged zones vanish into the "higher" topology of virtual reality, while certain other spaces are sacrificed to the world of decay, P.K. Dick's *Ubik*, the universal greyness of social and biological meltdown. In such a scenario, how can we play any role other than victim? We have already lost, because we have defined ourselves in relation to a situation of *loss*, and to a space of disappearance. In our fear of all boundary invasion, we discover that we ourselves have been reclassified and categorized as viral. This time the abuser/terrorist does not just *look* like you and me—*it is* you and me. The "homeless are criminal"; those who are not "taken up" have clearly "sinned."

Of course, it remains entirely within our power to construct an altogether different interpretation of "homelessness" and the no-go zone. We could use terms like *psychic nomadism*, and even *nomadosophy* to fortify ourselves for a revaluation of values in which our chances of autonomy would seem to increase in proportion to the actual withdrawal of power into the simulo-spectacle of too-late capitalism. We could try to envision situations in *which* the "value" of homelessness would mutate into the value of "aimless wandering" (as Chung Tzu expressed it)—situations in which we could organize everyday life into a *de facto* field of struggle for "empirical" freedoms, palpable pleasures, festal arrangements.

For the "utopian socialist" Charles Fourier, "God is the enemy of Uniformity." The true blight of civilization is uniformity, not union. The individual is realized not as the mass-produced monad of civilization's alienating social atomism, but as a living star in a constellation of sexualized stars. In fact, the Phalancterian orgy is, for Fourier, the ultimate emblem of the social, its heraldic device, so to speak, as well as its clearest manifestation. Think of those

226

pornographic eighteenth-century engravings showing dozens and dozens of naked randy aristos, a bit of flagellation, a bowl of flaming punch, an aesthetic dance of multiple and ambiguous copulations. This is Fourier's political program, a template for the ideal society—Harmonial Association. The body has not disappeared, nor has it become the body without organs; it has become the *infinitely penetrable body*.

Physicist Nick Herbert likes to point out that for life here in the "mesosphere" (that is, between stars and quarks), here where we actually live, *juice and slime* play an indispensable biospheric morphic role. Juice and slime are the ultimate free-form connective and penetrative tissues of living systems. Life clearly has no interest in the antibiotic hermeticism implied in such phrases as "boundary violations." Life uses and violates borders, and life constructs media of its own to fill up the extra spaces. The amoeba and the fertilized egg are both sacs of juice and slime—one grows by splitting itself, the other by being split. Viral-like DNA is "freely exchanged" in gushes of juice and slime—liquid with paradoxical form—the very liminality of form itself, secret secretions, the viscous slippery in-betweenness of the organic; the placental wetness of becoming.

The appropriate architectural form for a society based on radical conviviality might best be characterized as *grotesque*—that is, in the original sense of the word: the cave. Since the Paleolithic, ritual space has always been envisioned as a *hollow earth*, and in Mao Shan Taoism, for example, heaven itself is honeycombed with countless grottoes of faeries and Immortals, dripping with cinnabar and sprouting with magic mushrooms. As an aesthetic term, *grotesque* refers to the organic-looking forms of stalagmites, to the curving spiralling line of flesh and vegetation, which reappears underground and is transformed into the crystal of architectural space, without losing its snaky, flowery curviness, or it's matrix-like, slick wetness, or even its colors. For the Gothic and the Baroque, "grotesque" serves as a term of aesthetic appreciation; for the neoclassical and the protoindustrial, with their mania for straight lines, "grotesque" becomes an insult.

The grotto serves to house the "grotesque body," as Bakhtin calls it. In his writings on carnival, Bakhtin maintains that one of its most salient characteristics is its use of imagery involving what he calls the "grotesque body."

Contrary to modern canons, the grotesque body is not separated from the rest of the world. It is not a closed, completed unit; it is unfinished, outgrows itself, transgresses its own limits. The stress is laid on those parts of the body

that are open to the outside world, that is, the parts through which the world enters the body or emerges from it, or through which the body itself goes out to meet the world. This means that the emphasis is on the apertures or the convexities, or on various ramifications and offshoots—the open mouth, the genital organs, the breasts, the phallus, the potbelly, the nose. The body discloses its essence as a principle of growth which exceeds its own limits only in copulation, pregnancy, childbirth, the throes of death, eating, drinking, or defecation. This is the ever unfinished, ever creating body, the link in the chain of genetic development, or more correctly speaking, two links shown at the point where they enter into each other.

This describes what has been called Bakhtin's "principle of permeable boundaries."

Folklore is permeated with the carnivalesque/grotesque, with the Rabelaisean/utopian landscape of Rock Candy Mountains, houses of cream and bacon, seas of lemonade—geography of excess which found its theorist in Fourier (who actually predicted that the oceans would turn to "something like lemonade once humanity had converted itself into Passional Series") as well as in Rabelais, who drew more directly on the folkloric sea of story. But folklore itself appears as a phenomenon of permeable boundaries. Stories go everywhere, arriving long before anyone "notices" them, and embed themselves at a level of culture that, perhaps more than any other human project, represents the possibility of *unity without uniformity*. The Omnivorous Ogre and the Giant's Bride exercise an almost universal "archetypal" appeal because they express certain basics of the body—and the social body. But in each culture the Dragon-slayer and the Ash-girl find new names, costumes, dialects—even different meanings—without losing their recognizable selves and invariable fates. The worldwide dispersion of folklore is the most striking accomplishment of the grotesque social body and its principle of permeable boundaries: the creation of a carnivalesque narrative which resonates in every land, uniting humanity on the level of shared pleasure even while it expresses the infinitude of archetypal variations. The motifs of folklore act in a sense as *memes* and bundles of memes, which in turn, have been compared with viruses; they carry meanings from one society to another. The transportation of a folktale is a movement of meaning, but the meaning is never assigned (by an author[ity] or "tradition"), the meaning is *given* and *received*. Imagination here acquires the function of morphogenetic mutuality, or social "cocreation." This definition serves us better than the term virus with its connotations of disease and terror. But let us be clear: If we are forced to choose between "the viral" and the civilization of safety, we'll choose the viral. If we must be crude about it, we shall have to declare *in favor* of "boundary violations." We are not just

describing the "grotesque" social body, we are buying it.

Invariably, however, this rather existentialist commitment involves a *caveat*: that the proposal here is not directed by some sort of "high-risk" nihilism or Armageddonism. The real doomsayers are the proponents of order and progress, whose world view reduces them to a hystereisis of rigidity and body-slander. But the proponents of a Feyerabendian "chaos" (an *antitheory*) are in fact the true biophiles, the party of celebration. We suggest that the grotesque body is at one and the same time the *magical individual*, the free spirit, the fully realized self of the fairy tale's dénouement, and also the infinitely permeable body, the body of Fourier's "Museum Orgy"—the body that is desired. This paradox can only be resolved in the *festal body*; thus it is the festival (with its zero work and "promiscuity") that functions as the crucial insurrectionary praxis or principle of social mutability—the creation of festal space, the creation of carnival to fill the festal space—the creation of the temporary autonomous zone within the no-go zone—festival as resistance and as uprising, perhaps in a single form, in a single hour of pleasure; festival as the very meaning or deep inner structure of our autonomy.

## Notes

1. Quoted by Paul Feyerabend in *Farewell to Reason*, New York: Verso, 1977, p. 298.

2. Walter Benjamin, "The Work of Art in the Age of Mechanical Reproduction" in *Illuminations: Essays and Reflections*, New York: Schocken Books, 1969.

# 15

# The Possibility of Agency
# for Photographic Subjects

*Barbara Martinsons*

*Subject* is the fulcrum in all of this. Are the doorways and iron balconies Atget's subjects, his choices, the manifest expression of him as active *subject*, thinking, willing, intending, creating? Or are they simply (although there is nothing simple in this) *subjects*. . . .

——Rosalind Krauss, "Photography's Discursive Space"
in *The Originality of the Avant Garde and Other
Modernist Myths*, p. 149

For philosophy and poetics alone are considered capable, in our time, of bearing witness to the irreducible otherness inhabiting every system. . . . Lyotard suggests that the function of literature and philosophy is both to disclose the activity of the intractable thing and to signal the oppressive and potentially genocidal consequences of thinking that it has a face. . . .

——Winifred Woodhull, *Transfigurations of the Maghreb*,
pp. xii, xvi

# Barbara Martinsons

## I. Preliminary Thoughts
## Technologies of Vision/Visions of the Subject

Photography has been regarded from its inception as a technology that can be considered only in tandem with its content. Increases in film speed, the development of the handheld camera, explorations in paper and plate emulsions and the like are inevitably discussed in terms of the visual results, the *content* that was suddenly possible. Lewis Hine could not have taken the pictures of the "men at work" building the Empire State Building without the recently developed, smaller, hand-held camera. Edward Weston, who prided himself on never retouching or cropping his pictures, developed a visual philosophy of "shades of gray" that depended on constancy of both film and paper emulsions.

Even the ways in which photographic content was evaluated was—and is—often determined by the existing technology. Daguerre's silver iodide-coated copper plate developed with mercury (1839) resulted in clarity and detail that was perceived by its nineteenth-century audience, with delight, as "reality." This perfect replication of exact detail that was true even under a magnifying glass was regarded as the height of artistic perfection. The aesthetic was challenged almost immediately, however, when coated paper was substituted for Daguerre's copper plate by William Henry Fox Talbot, who developed his "paper plates" into the negative-positive process, called the calotype (1839). While the calotype lacked the brilliant precision and the sharpness of the daguerreotype, the softer, vaguer images produced by the process developed an aesthetic of their own, and were much admired as portraying the spirit of reality in landscapes and in Talbot's scenes of his family's everyday domestic life. In 1851, visual styles altered again when glass plates and collodian or "the wet plate process" was developed by another Englishman, Frederic Scott Archer. 1851 was also the year of the Great Exhibition in London, with its best-remembered building, the Crystal Palace. Phillip Henry Delamotte was hired to photograph the rebuilding of the Crystal Palace after the fair was over. Using the new collodian process, he was forced to work quickly, because the plates dried fast. His documentarylike shots of men at work, including the collapse of a section of scaffolding in which twelve men were killed, resulted in yet another aesthetic ideal for the contents of photographs. Now, instead of either sharp detail or vague impressionism, the rapidly grabbed, unposed picture, in which figures were sometimes blurred by movement, gained adherents who argued that *this* was the photographic style that portrayed reality.

Over the roughly hundred-and-fifty-year history of photography, "the real," has been constructed, at one time or another, according to various

discourses. Only since Barthes, however, have we started to accept the slippery and unstable connection between the trace and its meaning; only since Bakhtin have we begun to realize that hearing only a single voice is a weak and faulty reading; and only since Foucault have we become able to query the politics of the attributed meanings and judgments attached to photographs. We understand that, as Allan Sekula observes:

> If we are to listen to, and act in solidarity with, the polyphonic testimony of the oppressed and exploited, we should recognize that some of this testimony . . . will take the ambiguous form of visual documents, documents of the microphysics of barbarism. These documents can easily fall into the hands of the police or their intellectual apologists. Our problem, as artists and intellectuals living near but not at the center of a global system of power, will be to help prevent the cancellation of that testimony by more authoritative and official texts. (Sekula, 1981: p. 379)

We have learned that the results of the technology of visualization, including photographs, may cancel or distort the testimony of the subject; we understand that there is always the danger that the photograph will position "a legislative power on one side and an obedient subject on the other" (Foucault, 1980: I, 85). With this knowledge—since we may be unable to keep the photographs from "falling into the hands of the police"—how are we to safeguard subjecthood from this technology?

Since Heidegger, it has become clear that technology is not, necessarily, the enemy, and that (like cholesterol) there is good enframing and destructive enframing. Enframing can, after all, result in two different kinds of revealing: first, [and most obviously] there is the "enframing. . . which holds sway in the essence of modern technology" which is "in the mode of ordering" (Heidegger, 1977: 20); "where this ordering holds sway, it drives out every other possibility of revealing" (p. 27). This is enframing that represents being in a way that "pursues and entraps" and "sets nature up to exhibit itself" (p. 21); this is enframing that makes being exposed, vulnerable, manipulable. "Enframing blocks the shining-forth and holding-sway of truth" (p. 28). "Thus, where Enframing reigns there is danger in the highest sense"(p. 28). This is enframing as villain, and it is typical of technology.

Then, unexpectedly, Heidegger throws poetry at us—two lines from Hölderlin:

# Barbara Martinsons

> But where danger is, grows
> The saving power also

and he repeats the lines a few pages later. What is this about? Heidegger has given a broad hint a few pages earlier:

> The word *stellen* [to set upon] in the name *Ge-stell* [Enframing] not only means challenging. At the same time it should preserve the suggestion of another *Stellen* from which it stems, namely, that producing and presenting [*Her-* und *Dar-stellen*] which, in the sense of *poiesis*, lets what presences come forth—e.g., the erecting of a statue in the temple precinct—and the challenging ordering now under consideration are indeed fundamentally different. . . . (Heidegger, 1977: 21)

This sense of *poiesis*, which Heidegger tells us he borrows from Plato in the *Symposium*, (p. 10) is bringing-forth in this second, different sense: "that revealing which holds complete sway in all the fine arts, in poetry, and in everything poetical that obtained *poiesis* as its proper name" (p. 34). It is in art, and only there, that *poiesis* and *aletheia*, fundamentally different from the essence of technology given earlier, may "foster the growth of the saving power" (p. 35). Art—the "statue in the temple" of philosophy—may under certain circumstances combine with technology to "summon us to hope" (p. 33). "There was a time when it was not technology alone that bore the name *techne*. And the *poiesis* of the fine arts also was called *techne*. . . . It was a single manifold revealing . . . yielding to the holding-sway and the safekeeping of truth" (p. 34). But the presence of both *techne* and *poiesis* in art is the answer only on one condition:

> if reflection on art . . . does not shut its eyes to the constellation of truth after which we are questioning. . . . The more questioningly we ponder the essence of technology, the more mysterious the essence of art become. The closer we come to the danger, the more brightly do the ways into the saving power begin to shine and the more questioning we become. (p. 35)

While Heidegger's suggestion that art can bring us hope, even in (or after) the modern technological age, is not unproblematic, it suggests, I believe, along with the insights of Barthes and Foucault and Bakhtin, a joint strategic move of great importance.

The possibility of multiple meanings and multiple voices must be maintained. To act "in solidarity with the polyphonic testimony" of the people who produce photographs that are art and the people who are pictured in

# The Possibility of Agency for Photographic Subjects

photographs that are art is part of the strategy. And it must be noticed and acknowledged *in the photograph* that the subject is never single. There is no possibility of transcendental subjectivity in photographs (or anywhere else). No individual stands alone in the center of the arena of knowledge and discourse. We are, as subjects, dislodged by what Schürmann, describing Heidegger's view, calls "the economies of presence" (Schürmann, 1990: 46). This change from "subject" to "economies of presence" is one of the markers, set up by Nietzsche, that denotes the turning away from the modern epoch. If it is true that "the modern cognitive project consists in establishing the subject as the unshakable, indubitable foundation of knowledge," then closure of the modern is under way, and this is no longer true of the Heideggerian project. In Heidegger, thinking, now emancipated from knowing, is central; there is "an imperative for thinking" rather than for knowing (p. 58); thinking culminates in the convergence between flux and form, between becoming and being (p. 49). Thinking has to do with "coming forth. For thinking, and incipient with the closure, origination means *multiple presencing*" (p. 51, my italics). Being is always being-with-others—or, as Schürmann puts it, "involvement with things and with others" (p. 70). Even in Heidegger's sense, in which subjectivity, the last of the epochal principles of the modern, withers away, there remains an "I." It is a multiple self, capable of transformative discourse, able to create new space for itself. While it is not a self in the old sense of transcendental essence, it is, "Nevertheless, . . . still a matter of coming back to ourselves in order to invent conditions of possibility" (p. 70).

We have lost hold of the subject in the old sense of one who is an actor in history. The collectivity of each multiple self "no longer accomplishes it" but "receives its destiny," unfolds into it (p.74). In the unfolding, *being there* requires being there manifoldly. The "there" in the case of a photograph acquires particular significance: it is the space, including the contained objects and people ("the ground of beings as a whole") (Heidegger, 1977: 18) that is enclosed within the frame of the picture. This "there" is the ground as the space of what matters. The viewer of a photograph must be able "to attain a relation to the ground" by "extending our thinking toward the manner in which the ground includes us in its essence" (p. 16). "When we have grasped something we also say that something has opened up to us. This means . . . that we have been transported into what has opened up and remain determined by it from now on." The space of the photograph surrounds the viewer(s) and "embraces us into itself" and "speaks to us" (p. 18). It discloses itself to us and requires disclosure of us.

This will be a discussion of the human subjects of photographs and of photography as a technology that represents human subjects. Photography

235

is a technology of representation; for this very reason, questions of the [un]-representability of photographic subjects are explored. Is it true, as Lyotard suggests, that the subject is unrepresentable? Is it also true, as Heidegger holds, that the essence of all technology is a revealing of being, making being available for appropriation, vulnerable to manipulation? Or in Schürmann's language "The categorical transition from 'unconcealment' to 'event of appropriation' is datable; it occurs with contemporary technology" (Schürmann, 1990: 218). Finally, is "the gaze" always that of the panopticon (or of the Marquis de Sade)? Can there be, after Nietzsche, a photographic subject with agency? And what is the connection between the organic subject of a photograph and its synthetic technological trace? To invert Krauss's question about Atget: To what degree might the people portrayed in photographs be "manifest expressions of each as active subject, thinking, willing, intending, creating?"

In the following, I will approach the question of the agency of photographic subjects twice: First, I will discuss my reading of a picture by Todd Webb. Then, I will discuss the possibilities of agency of the subjects in a series of pictures with common "subject" matter. In the final sections, I will discuss the possibility of agency for photographic subjects, and photography as a technology of visibility.

## II. Suffolk Street at Hester Street — New York 1946 by Todd Webb

# The Possibility of Agency for Photographic Subjects

This is a picture of the Lower East Side, a point in time as well as a place. It is a picture of that most ordinary of everyday activities, buying (and selling) food for the day's meal. This is not a wealthy neighborhood. The gutters are made of paving stone bricks, the curb of the same roughly cut granite. The stores and stalls are not abundantly stocked; in the window decorated with two 7-Up decals there is a single unwrapped loaf of locally baked bread, two loaves of packaged Taystee bread and a few other commercially produced loaves. Fruit is for sale on this corner; we see cherries and apples in a honeydew crate. A discarded pineapple top lies on the grate to the drain. Probably vegetables are sold as well. They were usually sold together, and there is a sign for sauerkraut. One building over is a fish store with the owner's name, "A. Perlin," a picture of a fish and the words "fish market" in English and Yiddish. In case there was any doubt, this is a Jewish neighborhood.

The shoppers, with two exceptions, are women, probably Jewish, but judging by their hair and their clothing, not Orthodox. The sellers, most noticeably the pushcart vendor in undershirt and rolled up trousers in the foreground, are all men. They have set up a passage between the two-wheeled pushcart in the gutter, at one edge of the sidewalk, and the stalls and boxes against the building edge. The shoppers pass through this channeled space with their lumpy bundles and heavy shopping bags. All of the people are immigrants or children of immigrants, during the summer after the war, on the brink, perhaps, of making it in America.

The scene is framed by the strong horizontal lines of the curb, the bed of the pushcart, the awnings and the building trim above them and the "one way" arrow, and the vertical of the lamppost/call box. The shoppers and sellers are lined up with the horizontal sidewalk space. The only person who has escaped the horizontal channel and the seller/buyer dichotomy is the little girl standing near the lamppost and fire call box at the edge of the sidewalk. Someone has brushed her hair up, to keep it off her face in the heat, and tied a ribbon into it. Someone has washed and ironed her white blouse and jumper. Someone who is shopping in this neighborhood of immigrants has provided the rather elegant doll carriage and the doll, and has struggled down the stairs with them so that the little girl could have her doll along on today's shopping trip (and so that the shopping bags would be easier to manage). Was it her grandmother, in a white dress, facing the pushcart (and the camera), or her mother, in a similar white blouse, choosing apples with her back to the street? Or is her mother the other woman in a white blouse, half turned to the produce, on the other side of the "grandmother" figure? We do not know. The three women shoppers form a triangle that, with the pushcart vender, is the stable center of the picture. The selling and shopping activity converges on

them; they are the hub of the activity here. These women, and the pushcart vendor in his white undershirt, are also in sharpest focus and, in their white clothes, are the focus of the most light. But the child, in softer focus, and only partly dressed in white, looking toward the shopping activity, frames the scene, both physically and metaphorically. She is not lined up with the others in the frame. She is at the edge, disturbing the symmetry of the center. The viewer's attention is displaced from the center to the margin. This child, watching the adults, is part of the scene, of the neighborhood, and, at the same time, apart from it. For she will partake of a very different culture from that of the adults at the center of this life, this photograph. She will know only *stories* of the shtetl, of the old country village, of the journey, if, indeed, she listens at all. She will play jacks, and read comics, and go to summer camp, and set her hair. She is the subject of this picture, and possesses her own meaning and her own future, in which she will be "the active *subject*, thinking, willing, intending, creating." She brings clarity and temporality to the photograph, beyond the daily task of shopping for dinner.

This is not a photograph of the "immigrant other" (although without the child it might have been). Nor is the little girl Lewis Hine's exploited child-as-symbol (and much more) of what's wrong with society. She is not exquisitely defined, picturesque or particularly well wrought as a photographic subject. She is not all that the technology of photography in the mid-1940s might have made of her. She is a bit out of focus at the edge of the frame. And she is a real child, who *is* first, and *means* second.

True, I have hindsight on my side in this reading. It is also true that in 1946 I was about the age of this little girl, the granddaughter of Jewish immigrants who lived not too far from the corner of Suffolk and Hester. But as I read this photograph, my personal context comes last. First are the less personal mechanisms of meaning: the physical arrangement of people and things within the frame; the people or objects highlighted due to light or placement or pattern; the use of semantics (meanings of the elements of the picture) and semiotics (the sign system of the elements); the rhetorical stance (the argument the photographer is making); and finally, the discursive (where, in the discussion between my reading of the work and the work itself, my subjectivity and the subjectivities I construct of those in the picture come into play). Then there is the reassembling of this grammar of meaning and the moment of Barthes's "punctum" occurs—or it does not.

This photograph, as Beaumont Newhall says about Stieglitz's "The Terminal" is "more than a record of a vanished scene. . . . " Stieglitz wrote about his own work (Trachtenberg, 1989: 176): "My New York is the New York of transition—The old gradually passing into the new. . . ." In this picture, it is

the inclusion of the child that marks the transition. This is a picture of the discontinuity between the lives of an immigrant generation of Jews and the lives of their children who sometimes rejected and sometimes embraced their parent's culture, but who all moved away from Suffolk and Hester Streets.

"Only by its embeddedness in a concrete discourse situation can the photograph yield a clear and semantic outcome" (Sekula, 1981: 457). I have known the child who watches the shoppers and the peddlers; I have been that child; I am that child. Whatever horizon she and I share allows me into the picture, allows that sense of recognition that Barthes calls the punctum. Here the technical and the theoretical, the aesthetic and the social, the diachronic and the synchronic come together. The art cannot be separated from the document, for the picture is both. There is no "bogus subjecthood" (p. 457) here, no passive victim, no abstract humanity. Instead, a very real and immediate six-year-old girl allows me to understand her present and, perhaps, her future. And allows me to read this photograph within the context of my own cultural experience, and within the cultural context of all who share or have shared this experience.

But an unavoidable question intrudes: could it be that the the only "readable" photographs, the only "empowered" subjects, are those with whom we are intimate, or those that are ourselves? Is agency only possible for a "known," recognized subject?

In order to explore this question, I will consider a series of pictures in which the subjects are not "me" or known to me; indeed, they are barely recognizable, for they are, to one degree or another, hidden from the camera and thus, literally, inscrutable. The subjects in the pictures that I will consider in this section are veiled. I have chosen pictures of veiled or covered figures as an extreme case—the "unseen" and thus unknown and "unexplainable" subject—in which to reconsider the question of the possibility of agency for photographic subjects.

I am a recipient of the stereotyping Western idea that the veil is the symbol of the oppression of women in Muslim (and some other) societies; but I also understand that neither women nor cultures are monolithic; and that the intertwining of patriarchal and colonial power yields a varied series of practices that can only be oversimplified by substituting "the veil" as the reductive metonymation of the lives of women in certain "Other" cultures. It is true that for me, at this moment of writing, the increase of Islamic fundamentalism/nationalism since the Iranian Revolution is more repressive than positive, and that, in this context, "choosing" to be veiled can imply repression as well as volition. The shrouded figure nevertheless raises questions for us of the forbidden Other, of desire and the hiding of desire, of personal space and

of ownership, of sensuality, of status, of identity and of tradition. The veil might even, as Frantz Fanon suggests, have dual and opposite meanings: "The veil was worn because tradition demanded a rigid separation of the sexes, but also because the occupier *was bent on unveiling Algeria*" (Fanon, 1965: 63). The veil has been worn as Fanon and Woodhull point out, as a strategy (Woodhull, 1993: 4). But first the veil raises the issue of gender. In all cases, the veiled figures, Muslim and non-Muslim, are generally (almost exclusively) women.

## III. Photographs of Veiled Subjects

If photography is a technology of the making visible, the veil may be considered a technology of concealing. What is the outcome when the two technologies are combined? Does being a subject require a face? And do the conditions of the concealing veil-edness matter? The veiled people in photographs seem to me to fall (for the moment) into three categories: first, there are pictures of those who are veiled by the photographer *for* the photograph—those who would not ordinarily wear a veil during daily life. This is often a figure intended to add a sense of enigma to a landscape or other setting. This is subject as body, but as body in the sense of corpus, of bulk. It is a body without gender (unless, by definition, almost all draped and veiled figures are women) and thus with neither desire nor desirability. It is not merely that the draped figure could be of either gender, but that it has no discernable gender.

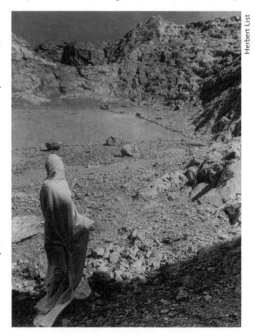

Herbert List

In this first example, the figure does not even have a clear front and back: it is

human, and seems to be adult, but that is about as much as one can see. It has, it appears, been draped and placed by the photographer to emphasize the jagged, rock-strewn landscape, much as the carefully and mysteriously cleared rectangle behind the draped figure emphasizes the craggy and uneven surrounding terrain. The possibility of this covered figure having volition or desire of its own seems as preposterous as imagining that the cleared rectangle of ground has needs or desires. Each has been provided by the photographer to provide mystery and contrast. The picture is called "The Spirit of Lycabettos 2, Athens Greece." The landscape, inhospitable and arid, filled with sharp stones and steep mountains, is no place for people. The sky is flat and featureless above the mountains. But this is a picture about mystery: a person without features stands here, only the fingers of one hand revealed, (thus indicating that this is probably not a statue, but a living person) at the edge of a shadow. Also at the edge of the shadow is a small pile of slightly larger rocks, probably not randomly deposited there, but collected, and placed. The only exposed part of the draped figure, the fingers, seem to lead the viewer's eye toward the rocks. And a perfect rectangle has been cleared of stones and boulders between the figure and the mountains. This landscape has been manipulated, and part of the manipulation has been the placing and draping of a figure.

The depth of field is also something of a mystery, with the rocks in the extreme foreground as sharply defined as the rocky mountains in the background. In this perfectly and carefully shot and arranged photograph, the landscape is enhanced by a person without personality and without power. This is a person as an embellishment for a landscape. The discourse is of mood, of mystery, of contrast, perhaps of beauty. It is the space of the aesthetic, in which the veiled figure serves a purpose that has nothing to do with personhood. It is a discourse in which the humanity of the veiled figure counts for nothing. The person behind the veil, positioned to enhance the mood or the landscape, without volition of any kind, has been nullified. [The work, made in 1937, is by Herbert List, (1903–1975)].

In the second category are pictures of those who are veiled during their daily lives for cultural reasons—those who wear veils because the society in which they live expects or requires it. While it is hard, if not impossible, to assess such a subject's ease or unease with her tradition, her social role or her position in her culture, it is hard for me *not* to imagine a sheathed, cloth-enclosed life as inhibiting, as subaltern. But even here, I see *degrees* of "veiled-ness."

# Barbara Martinsons

Liz Gilbert/NYT Pictures

In the photograph of a woman drawing water from a well in Burkina Faso (*New York Times*, June 19, 1994, section 1, p. 10) by Liz Gilbert, the veiled figure knows what she is about; she has a job and she is doing it. But the reality of everyday life in these clothes, the work of drawing water and carrying it back over the parched looking earth to the family for washing, drinking, cooking, is daunting. The veiled woman at the bleak hole-in-the-ground well probably does not live a life of comfort. Nevertheless, she is surrounded, as if secured, by a circle of trees; her shrouded head stands out boldly against a hot, white sky. She will undoubtedly look proud and picturesque once she gets the water jug balanced on her head, and starts home. Why, then, am I so troubled by the picture? Maybe because the strength and drama of the photograph belies the imagined life of the woman. It robs both the woman in the picture and the viewer of the reality of what little I know of the lives of poor women in Africa. It makes the woman noble. Maybe she is. Undoubtedly, on some level, she is.

# The Possibility of Agency for Photographic Subjects

But the balance and strength of the image—the apparently powerful figure, shot from below so that her head is higher than the trees, emphasizing both the drama of the black form against the background and the vertical bisection of the landscape—reaches for an aesthetic that is in opposition to the picture's content. This content is implied by the black veils, the dry earth, the distance of the well from the woman's village, and the daily life of a woman in that village, without plumbing, or, in all likelihood, electricity. While this photograph is not of a figure posed against an artificial and neutral background, the "real" earth and "real" circle of trees aestheticize the draped figure in the same distorting way. This photograph, dramatic though it is, fails as ethnography; it also fails aesthetically, because it artificially enables this woman and her life. But this picture was shot neither as ethnography nor as an art photograph. This picture is photojournalism. The reporter, shooting "for the *New York Times*" and selling her work to the *Times*, implies that this is a picture of a real woman, living her real life. And of course it is. Photographs, as John Berger has pointed out, are records of things seen. This photograph has been selected from a large number of pictures by a photo editor (I assume) and printed as such, as part of a long piece on "Want and Misery" and AIDS in Africa. The caption, probably written by still another person, is about the failures of living standards, health, agriculture, and education. The text of the article is about "poverty, misery and despair: the deadly legacy of decline." And yet we see this picture of coping under duress, the single foot revealed by the robes lending a note of poignancy to the powerful figure in black.

In the third category are pictures of those who have *veiled themselves* for the photograph—because modesty requires it, or because the photographic process is otherwise intrusive. These are women who have chosen to be veiled, either for this occasion or for their lives. The first series of questions is about the woman herself: Why would such a subject want to avoid the camera, to be "not seen?" What is being chosen here? The second set of questions is about the interaction between the photographer and the subject of such a (potential) picture. Where does the power lie? What is the negotiation? Foucault writes: "Renounce yourself or suffer the penalty of being repressed; do not appear if you do not want to disappear. Your existence will be maintained only at the cost of your nullification" (Foucault, 1980: 84). And Heidegger initially considered all technology as a way of revealing, of representing and regulating being, as "that kind of revealing which is an ordering. Where ordering holds sway, it drives out every other possibility of revealing" and which is the "extreme danger," for it "blocks the shining-forth and the holding-sway of truth" (Heidegger, 1977: 27,28).

# Barbara Martinsons

But the subject of this picture, a woman who was walking on the street, or waiting, has not obeyed, has not disappeared, and has not been manipulated or nullified by the taking of the photograph or by her inclusion in the photograph itself. In fact she objects to the taking of her picture—and has raised her arms, lifting her robes to almost cover her face.

Mary Ellen Mark/Library

The roughly finished clay or stucco wall in front of which this woman stands is graffiti-scrawled. The woman has clutched the ends of her robe in her hands and has raised the robe over her head, leaving only enough space to watch the photographer warily, with one uncovered eye. The white fabric at the opening forms a line like an inner defense or lip between the semi-distinct face, recessed within the cloth and deeply shadowed, and the flowing folds of the dark robe hanging from the woman's raised arms. The opening, surrounded by outer robe and inner robe, is elongated, its form emphasized by the concentric folds of fabric that repeat the shape. The contrast between the trowel-marked and scribbled-upon wall and the inner, partly hidden face of the woman is sharp. It is hard for me, in this picture of inner and outer, world outside and world within, not to notice the shapes and spaces and folds as reminiscent of stylized vaginal forms and openings. The woman's reluctance to be nullified, seen and thus obliterated, in Foucault's sense, is also, for me, quintessentially female. So is her refusal to accept "utter availability." While she seems to understand the danger of the camera's penetrating gaze, she seems also to know that she can make herself impervious; and by covering only part of her face she risks satisfying her curiosity about the Western woman who is taking her picture, giving explicit or tacit permission for the photograph.

The photographer, for her part, focuses not on the woman's withdrawn face, but on the draping of her robe. The face, shadowed and hidden, is in soft-focus; the camera registers the light of the sun on the folds of cloth and does not

244

attempt to clarify the face. The folds of the fabric are, in contrast, in exquisite focus, and perfectly exposed. The very weave and weight of the cloth is apparent. Perhaps the photographer, Mary Ellen Mark, who shot this around 1970 in Pakistan, understood the woman's dilemma and her choice. There may even be complicity between the subject and the photographer. This is a real and singular woman who makes choices and acts in the world, even if the vaginal shapes of the raised robe imply everywoman. It is not that she is exotic, or different that arrested the attention of the photographer, as much as the textures and the play of light, the rapport with her subject, the shadows on the wall. This picture is not, in spite of its "foreign" setting, part of the ethnographic discourse or the discourse of sociology. It partakes of the aesthetic, but I would suggest that the work is part of the realms of ontology and archaeology—the production and possession of meaning, the existence and personification of meaning, revealed through the reflection on the discourses into which the picture enters. The photographer has used her technology to make her own choices. She has accepted the woman's reticence and has chosen not to invade it. Neither woman has sole power here. Each empowers the other in small ways. Foucault again: "Confronted by a power that is law, the subject that is constituted as subject—who is 'subjected'—is he who obeys. . . . A legislative power on one side and an obedient subject on the other" (p. 85). There is no power here that is law, no legislation, no obedient subject. Only two very different women, each curious about and interested in the other. The Other. Or Others. . . .

In this more or less familiar scene, on an early spring day a small group of people are resting and reading in front of a mighty building. They

have little connection with each other, and each, typically, has left as much surrounding space-as-buffer as possible. The building in the background, decorated with a huge urn and fluted columns, is clearly an important one that required a great deal of money to build. The steps are of marble, and the area in front of the steps is patterned in a combination of stone and brick—not the most economical way to construct public space, but varied, and aesthetically pleasing. The fret-and-flower trim at the base of the building, too, was clearly a luxurious, if tastefully restrained, decorative touch. The concentric rectangular fountains at the left of the picture, topped by carved stone that seems to have a motif of fruit, also reflect an aesthetic of restrained largess, some nineteenth-century, public-spirited gentleman's idea of public grandeur, temperate and tasteful, but certainly an important and grandly conceived building. (The trash basket appears to be of a later and more frugal time.)

In front of this fine pubic building there are six people: one obscured by the urn and its pedestal, three reading, one resting, and one, in the foreground, completely veiled, sitting hunched over next to a shopping bag. The veiled figure (once again: a man? a woman? it is impossible to tell, unless it is true that veiled figures are always women. . .) is not avoiding the intrusion of the camera, any more than the others are. They all, including the veiled figure, seem unaware of the camera's presence. The veiled person may have wanted darkness, or privacy, or to shut out the world—but is not veiled against the intrusion of the camera. Given what I know of the setting—it is early in the morning in New York, in the nineties, on the steps of the forty-second Street Library—the veiled person is probably homeless, and may be asleep after a sleepless night in a shelter or, more likely, on the street. In whatever ways this person, like all of New York's "homeless," has been manipulated or abused by urban life under late-twentieth-century capitalism, he or she seems neither more or less available, legislated or manipulated than the other people in the picture, which is to say, not much. The veiled figure, unlike the others, has no visible face; but the veiled figure, together with the rest of the homeless people of the city, is the subject of this photograph. This homeless person and "homelessness" of all homeless people are the subjects. I am certain that this person (or any homeless person) did not choose to be homeless. But it is equally clear that this person chose to be entirely veiled. His or her options are limited; yet he or she has seized what little control of her/his environment is possible. This person is not without resources, and in spite of the very obvious limitations, not without agency.

The photographer, Per Brandin, seems to understand that, while none of us are in total control of things, any more than the readers and resters on

the library steps are in total control, each of us makes efforts to act on our own behalf, and that these efforts have value. The veiled figure here is not inquisitive and bold, like the woman in the Mary Ellen Mark photograph; but there is a clear vision of volition and the ability to exercise it, even in a city that seems not to care. Here the emphasis is not on the fabric or the form of the veil. It is on the setting, the context of this particular veil-edness. It is within this context, and the viewer's understanding of it, that the agency of the figure veiled in black becomes apparent.

And, after all, there is a fourth category: these are pictures of veils and robes without discernable women (or men). In these pictures the subject is not merely reduced to a body—for there is no clear indication that a body is present.

Some of Clerambault's photographs, taken between 1914 and his death in 1934, fall into this category. He took pictures of robes and veils on hangers and manikins; he took pictures of robes and veils worn by women; and, in the pictures I am considering here he took pictures of robes and veils within which I cannot tell whether living women are present or not. As Joan Copjec points out (Copjec, 1989: 56–95) in her comments on Clerambault's forty thousand photographs of draped Moroccan costumes, the veiling and draping in these pictures (particularly, it seems to me, when the clothes seem all but uninhabited), restore some part of the auratic quality, the space, "the unique manifestation of a distance" that is usually destroyed by the

Clerambault/Musée de L'Homme, Paris

mechanical reproduction inherent in photographs. There is something both magic and terrible about these all-but-empty robes and veils. The reminder that a person inhabits them is frightening; and it is equally frightening to imagine that no one does.

Triggered by Benjamin's comments about the sense that crimes have occurred in Atget's photographs of "empty" Paris streets, streets that are obviously without evidence of crime and thus, empty also of evidence, yet do not allay our suspicion, Copjec writes: "It is not the evidence of suspense

247

but the suspension of evidence that grips us in these photographs" (p. 84). Somehow, these robes that are seemingly uninhabited and somehow sinister are all the more terrible for their lack of evidence. The possible implications, the possible meanings, of this unexplained and shifting but always threatening picture are the stuff of which nightmares are made. I know what it is, but I do not know what it is *about*. The connection between the trace and its meaning is really gone this time. It is not some deconstructive, theoretical metaphor; it is actual, and immediate, and very disturbing.

Perhaps all veiled figures are, in this sense, filled with this lack of connection between the trace and its "meaning," with this suspension of evidence: there is little that is evident to the observer in the robes that may or may not be draped over a human figure. The space for the aura reasserts itself in the same way that it does in Atget's empty streets. But this is not the positive aura of Benjamin's unique work of art or beautiful landscape. This is the frightening aura of unintelligible domination. It is the obliteration of the totally negative, the desperation of an abused child, a battered wife, a black man facing a white mob. It is the acceptance of the status of subaltern, of other. It is the suspension of evidence that a human life is at stake. Somehow, the act of taking these photographs is collaborative. This is not merely the act of an innocent bystander, but the involved participation of a perpetrator.

Power, then, is what is centrally at issue here: the forms and relations of power which are brought to bear on practices of representation or constitute their conditions of existence, but also the power effects that representational practices themselves engender—the interlacing of these power fields, but also their interference patterns, their differences, their irreducibility one to another (Tagg, 1993: 21).

# III. Concluding Thoughts

## A.

Quite unexpectedly, something has happened. During the course of writing this I have met a friend whom I have not seen in several years. She is from Ecuador, and we worked together on an ethnographic project about Latino identity in New York. Today, in the library, she is veiled. She tells me that she has become Muslim—Islamic—I do not even know the right words. She tells me that, if it would not call attention, she would be completely veiled; as it is, only her hair, her forehead down to her eyebrows and her throat are covered now by black veils. Teasing me, she draws the filmy material that covers

her shoulders across the lower part of her face, leaving only her eyes uncovered. For the rest, she wears a tunic and pants, caught at the ankles. She looks slightly exotic and very beautiful; but she was always beautiful.

She tells me, using phrases from the Koran, about how important Islam is to her, and that she is secure and private within her semi-veiled garb as she has never been. She tells of privacy, of an expanded sense of her own space, of protection in a hostile world. And she talks of no longer worrying about some of the things we used to talk about, because her life is now in the hands of Allah. In spite of our very different lives and places of origin, this friend and I once had much in common—studies, families, clothes, interest in architecture, in ethnographic issues, and in life in the city. She listens patiently, as I try to explain my very Western, American voice and vision about veil-edness; my floundering description falters as I realize that my horror at the Clerambault images is not shared by my friend. Suddenly I do not know her.

## B.

Let us assume, with Heidegger, that the being of the people in these pictures has been enframed by the metaphysics of photographic technology. Their essences have been contained by the gaze (worldview) of the photographer/camera. They have been represented, and each has been "denied the possibility of presencing itself"—thereby entailing "in a certain manner a loss of being" (Heidegger, 1977: 129). By being chosen/valued/pictured, the being of these photographic subjects has been, according to this view, encroached upon and denigrated.

Is this the necessary outcome? Might these photographic subjects be rescued from the state of perpetually standing in reserve, ready to be, but able only to *be represented* by the image, the trace?

In the picture of the Pakistani woman against the graffitied wall, and in the picture on the library steps, the hermeneutical flash of recognition, the unstated dialogue, seems to have occurred on some level between the photographer and the veiled figure, and is evoked again in the picture so that I, the viewer of the photograph, have access to the plurality of *Weltanschauungen* that constitute any photograph.

So it can happen, even if the Other is not Me. Or to put the same thing differently, many of the Others are, given our multiple selves, Me. I construct photographs according to the set of discourses that I am familiar with, am drawn by, feel connections to; I use who I am, my several selves, to construct and to enter into dialogue about and with an image: "an image [that can

# Barbara Martinsons

be] . . . seen as a composit of signs. . . . Its meanings are multiple, concrete and, most important, *constructed"* (Tagg, 1993: 187). It is, first, a question of how I construct the image of the other and second, a question of how I construct myself: "we recognize that a condition of modern culture is that indeed all effective heritages have to be constructed, and that the dialogues provoked by this necessity are not encompassed within any monological horizon" (Brenkman, 1987: 55). Finally, it is a question of the way in which first the photographer, and then I, construct a discourse, without denying or doing damage to the differences, between the many selves of the others and my many selves.

It seems that the question of the agency of the subject with which I started becomes instead the question about the possibility of the unvoiced, multivocal discussion between myself (selves) and the other(s). And, at the same time, I am forced to reconsider, again, Heidegger's idea of technology as a way of revealing, in the sense of ordering and making vulnerable, of totalizing what is only an aspect of being. It becomes clear, as I look at these photographs, that there is no essential being, just as there are no unitary texts or discussions. "My hypothesis: the subject as multiplicity" (Nietzsche, cited by Schürmann, 1990: 49).

Agency may be constructed by the photographer and the subject(s) in a joint dialogue; and it may be reconstructed by the viewer and the trace of the photographic subject in a second dialogic exchange. (All agency, like all meaning, is inscribed by power and must be invoked with dialogue, incantation, discussion, myth, story, and other constructed narrations.) The auratic in the photograph or the *oeuvre* lies here—in the space between the subject and the representation, between the work and the viewer formed, wrought, constructed, fabricated, by the narratives of possible—and plural—agency. Gayatri Spivak's important distinction between "representation as 'speaking for,' as in politics; and representation as 're-presentation,' as in art or philosophy" (Spivak, 1988: 275) is crucial here. Neither the photographer nor the viewer "speak for" the photographic subject. The subject of the photograph, like the little girl on the corner of Hester and Grand streets, must have the ontological status to speak for her/himself and for a host of others.

This disclosure implies completeness—including having and acknowledging a face—on the part of both the viewer of the photograph, and the photographic subject. In the Heideggerian notions of "grasping" (to grasp: *Be-greifen*) and "ground" there is an implicit imperative for mutuality, a joint "being embraced into" for both viewer and subject.

"Subjectification is never without a black hole in which it lodges its consciousness, passion and redundancies. . . . The face digs the hole that subjectification needs in order to break through; it constitutes the black hole of

subjectivity as consciousness or passion, the camera, the third eye" (Deleuze and Guattari, 1987: 167–68). So the subject does and must have a face; it is the face that allows the photographic subject to "break through" as Deleuze and Guattari put it; it is the face that allows one to enter into and emerge from discourse, to manifest feeling, to look back at the viewer, to return the camera's gaze.

## Acknowledgments

My thanks and appreciation to Michael Menser for the many discussions of these topics, not all of which had to do with philosophy; and to Jennifer Rich for sensitive editorial help. I also thank my father, Alexander E. Racolin, for encouragement of many kinds.

# Barbara Martinsons

## Works Cited

Alloula, Malek (1986). *The Colonial Harem,* trans. Myrna and Wlad Godzich. Minneapolis: University of Minnesota Press.

Barthes, Roland (1981). *Camera Lucida: Reflections on Photography.* New York: Hill and Wang/Noonday Press.

Benjamin, Walter (1969). "The Work of Art in the Age of Mechanical Reproduction" in *Illuminations.* New York: Schocken Books.

Brenkman, John (1987). *Culture and Domination.* Ithaca, NY: Cornell University Press.

Copjec, Joan (1989). "The Sartorial Superego," *October* 50, Fall.

Deleuze, Gilles and Felix Guattari (1987). *A Thousand Plateaus: Capitalism and Schizophrenia,* Vol. II. trans. Brian Massumi. Minneapolis: University of Minnesota Press.

Fanon, Frantz (1965). *A Dying Colonialism,* trans. Haakon Chevalier. New York: Basic Books.

Foucault, Michel (1980). *The History of Sexuality, Vol. 1.* New York: Vintage Books.

Goldberg, Vicki, ed. (1981). *Photography In Print : Writings from 1816 to the Present.* Albuquerque: The University of New Mexico.

Goldberg, Vicki (1991/1993). *The Power of Photography: How Photographs Changed Our Lives.* New York: Abbeville Publishing Group.

Heidegger, Martin (1993). *Basic Concepts,* trans. Gary E. Aylesworth. Bloomington: Indiana University Press.

Heidegger, Martin (1977). *The Question Concerning Technology and Other Essays,* trans. William Lovitt. New York: Harper & Row,

Krauss, Rosalind E. (1986/1993). *The Originality of the Avant-Garde and Other Modernist Myths.* Cambridge: MIT Press.

Rosaldo, Renato (1989). *Culture and Truth: The Remaking of Social Analysis.* Boston: Beacon Press.

Schürmann, Reiner (1990).*Heidegger On Being and Acting: from Principles to Anarchy.* Bloomington: Indiana University Press.

Sekula, Allan (1981). "On the Invention of Photographic Meaning," in Vicki Goldberg, ed. *Photography in Print.* Albuquerque: University of New Mexico Press.

# The Possibility of Agency for Photographic Subjects

Sekula, Allan (1989/1993). "The Body and the Archive," in Richard Bolton, ed., *The Contest of Meaning: Critical Histories of Photography*. Cambridge: MIT Press, (also in *October* 39, Winter 1986).

Solomon-Godeau, Abigail (1991). "Who is Speaking Thus," in *Photography at the Dock: Essays on Photographic History, Institutions, and Practices*. Minneapolis: University of Minnesota Press.

Spivak, Gayatri (1988). "Can the Subaltern Speak?" in *Marxism and the Interpretation of Culture*, eds. Nelson and Grossberg, Urbana, IL: University of Illinois Press.

Tagg, John (1993). *The Burden of Representation: Essays on Photographs and Histories*. Minneapolis: University of Minnesota Press.

Trachtenberg, Allan (1989). "Camera Work/Social Work" in *Reading American Photographs*. New York: Hill and Wang.

Woodhull, Winnifred (1993). *Transfigurations of the Maghreb*. Minneapolis: University of Minnesota Press.

# 16

# Remarks on Narrative and Technology, or Poetry and Truth

*Samuel R. Delany*

1. Science and Poetry are my concerns here. I do not mean the poetry of science. Still less do I mean some mistily envisioned science of poetry.

Poetry and Science.

But we must approach the topics cautiously, even circuitously.

It is customary to say, in a presentation such as this, that the following remarks are not systematic. They are not. But I would like to specify here—and narrativize—the nature of their asystematicity: I suspect many readers will see all sorts of relationships among them, some interesting, some troubling. But the status of many of those relationships is—I feel, as someone who has considered them at some length and with some care—highly problematic.

2. Some months ago, my university press publisher informed me (I paraphrase): "It's our house style not to use *i.e.* (for *id est*), or indeed to use any other abbreviations of Latin phrases, such as *et al.* (for *et alia*), *e.g.* (for *exempli gracia*), *viz.* (for *videlicet*), *id.* (for *idem*), *ibid.* (for *ibidem*), *cf.* (for *conferre*), or *n.b.* (for *nota bene*). Our only exception is *etc.*—which we don't italicize—for *et cetera*." The lack of italics indicates, presumably, that it has been absorbed into English and is now considered an English term.

"But what," I asked, "if the writer wants to use them?"

# Samuel R. Delany

"We explain to him—or her—that it violates house style. As far as we're concerned, using them in scholarly writing is no longer correct."

"Do you know where this house style comes from?" I asked.

"I imagine it's just that we don't want to appear too pedantic and court lots of people not knowing what the writer is talking about."

"But you know what those Latin phrases mean," I said. "And so do I. And most large dictionaries will give you a list of such frequently used phrases and many more besides—should one of them escape you. And there's always Mary-Claire Van Leunen's *Handbook for Scholars*."

"They don't present any practical stumbling blocks. Besides, your acknowledged audience for the sort of works in which such abbreviations might appear is overwhelmingly academic. That means—at least in the humanities—these works will be read by people used to researching in scholarly texts written before World War II, which means they have to know such Latin tags as a matter of course."

There was a moment's silence. "Well," said the voice from the editorial office, that, whatever else one might say of it, was certainly from someone ten to fifteen years younger than I, "that's just not the way we do it."

"I suspect you do it," I said (I paraphrase freely), "as a holdover from the resurgence in the movement just after World War II to remove ancient languages, Latin and Greek, from the High School curriculum in order to accommodate the returning soldiers, for whom it was clearly a barrier to graduation—that whole movement itself was a revitalization of the movement just after World War I to democratize higher education by making Latin and Greek take a back seat to the study of English language texts, such as the English novel, which, for the first time had been brought into the purview of university studies via the academic establishment of such then-new disciplines as English literature. All of this, including, in many ways, the Great War itself, was a response to the rising population and to the growing amount of printed matter that begin in the 1880s, when people began to take seriously the recommendations of Matthew Arnold and other educational reformers to bring 'sweetness and light' to the common man.

"But that same rise in printed matter—" (I now paraphrase wildly) "while certainly Latin and Greek literacy has not kept up with it, has also obviated the need for such retro-pedantic gestures as forbidding scholarly abbreviations in scholarly texts."

My friend on the other end of the phone laughed. "In other words," she said, "it's not very modern at all."

"It's quite modern," I said, "for 1888 is the year Arnold died, the year the *New York Tribune* first began using the linotype, and the year the English

decided to make their spelling look more sophisticated and up-to-date by Francophizing it, while leaving the earlier and older spelling forms in the first editions of such authors as Dickens and George Eliot—and to the barbaric, backwards United States."

After another moment, there was a sigh. "If you really want to write '*i.e.*,' I suppose you can."

"Thank you," I said. "I've been doing it for years. It's part of my language. It would be as difficult for me to excise it from my writing and thought as it would be for me to start writing 'different than' for 'different from,' or putting commas before restrictive clauses."

"What's wrong with 'different than'?"

"Today, nothing. But thirty-five years ago, when I was in high school, 'different from' was considered correct, while 'different than' was considered a solecism—and you were marked "wrong" for it on any English test. Twenty-five years before that, when my mother was in high school, you were marked wrong if you wrote 'X is not as good as Y.' The proper positive form was 'as good as.' But the proper negative form was, 'not so good as.' If you confused them, you were mistaken—though, by the time I was in school, 'not as good as' had become acceptable."

"Now what's a 'solecism', again?"

"A barbarism considered unacceptable among educated people."

3. I pause here to consider my parenthetical comments: when, in the conversation above, I said "I paraphrase" (or "I paraphrase freely," or "wildly"), in what way did my words model the situation they purported to describe? In what way was I rewriting or revising the incident (or incidents) I am presumably describing? Well, to begin with, it was not just one conversation that yielded the above, but several—one of which was with someone not involved with the press at all. But my paraphrase involves considerable shortening, as well as condensing the conversations into one. The young woman on the other end of the phone in the major conversation certainly did not have a handle on all the abbreviations I have included—nor, indeed, did I. (I will let you guess in what scholar's handbook I looked them up.) But the anecdote seemed more effective when I cited a somewhat greater number of abbreviations than we had actually first mentioned. And though the outcome of the several conversations was more or less as I have recounted, rest assured that I was nowhere near as eloquent or succinct in my historical rundown, the first time I had to marshal it.

My reason for such revisions?

The historical insight that I took from the situation—and even dare to call its "truth"—is more strongly foregrounded in the more (I confess)

imaginative version of the narrative, even though, knowingly and with intent, I violated the letter of the versions one might have retrieved from tape recordings of the contributing incidents, had such tapes been made. And I wanted to stress and give a narrative articulation to relations that, now and again, had been only implicit, and whose status—while they were happening—I was not so sure of; though, with thought, I am surer of that status now. Again: I have called it "truth." Perhaps more to the point, while the parent incidents were occurring, it was a "truth" I intuited and articulated rather clumsily; in the narrated version, it is a "truth" stated—narrated—as such.

(Now even though it holds a place in our title, we will not mention this "truth" again; hold on, then, if you can, to the slippery, imaginative, and generally problematic notion of it presented in the paragraph above.)

It is interesting that such violation is traditionally referred to as "poetic license," rather than, say, "narrative license."

4. In 1882, Ottmar Mergenthaler patented the linotype that was to revolutionize printing in both Europe and America. Ten years earlier, the Remington & Sons Fire Arms Company took its considerably refined ballistics technology and applied it to a new machine, the Remington typewriter. Along with other technological developments in everything from transportation to papermaking, these were to mean that, by the end of the eighties, something like five times as much material was being printed as had been printed at the beginning of that decade.

The upsurge in printed material in the 1880s has been historicized by many scholars. In her historical study, *The Origins of Totalitarianism*, Hannah Arendt attributes to this astonishing growth—coupled with the rise of population—the modern forms of both anti-Semitism and (South African and Rhodesian) racism: while both racist and anti-Semitic rhetoric had stayed pretty much the same between the sixteenth and the twentieth century, including the decade of the 1880s, Arendt points out that the referents for this rhetoric changed their form so totally during the 1880s that one could say anti-Semitism was "invented" in that decade. Before the 1880s, incidents of anti-Semitism were small, local phenomena. While, indeed, pogroms, stonings, and virulent social prejudice existed, *vis-à-vis* what was to come, they were comparatively rare, with comparatively low death rates and damages. Anti-Semitism was the largely theoretical hobbyhorse of a number of eccentric intellectuals such as Wagner, who, throughout the 1870s, even as he wrote and argued heatedly for his belief in the decadence and racial degeneration of the Jews, was nevertheless friends with Jews, entertained them—sometimes royally, as in the case of Hermann Levi, with whom he pleaded—and finally won over

to conduct the premier of *Parsifal*. But when—even at the beginning of the 1880s, it was clear that forces were in place that were changing anti-Semitism from a "theoretical" question into a political movement—Wagner wrote that the Jews were "the only free people in Europe," and wrote to his friend, the conductor Angelo Neumann, himself a Jew, in February 1881:

> I wholly dissociate myself from the present "anti-Semitic" movement: An article by me, soon to appear in the *Bayreuther Blätter* [Wagner's own, often self-authored newspaper], will proclaim this in such a way that it should be impossible for persons of intelligence to associate me with that movement.

Arendt argues that it was the growth of print that was to raise anti-Semitism from an eccentric social anxiety, with occasional violent outbreaks, to a major plank in the political platforms of several political parties (not just National Socialism), all with major, material, aggressive plans for action. The quote above is not to excuse Wagner for his anti- Semitism, but simply to point out that changes in the nature of the beast (that Arendt cites, largely in pamphlets and newspapers) were apparent and troublesome—even to someone like Wagner—as far back as the first year of that decade in which the technological revolution that was to exacerbate the situation really got under way. By the middle of 1890s (a dozen years after Wagner's death in February of 1883), that movement was to take up and disseminate the Dreyfus Affair, which would polarize the West. Modern comparisons of the Dreyfus Affair with Watergate do not even suggest how pervasive that political scandal was during the years between 1896 and 1900. While it is arguable that the working classes were not deeply affected by the Dreyfus Affair (*viz.* the French peasant who, when questioned at the height of the affair, is supposed to have answered, "*Dreyfus, qui ça?*"), nevertheless the middle classes were exercised over it throughout Europe: not only were there Dreyfus pamphlets, posters, banners, and books (the best remembered among them, Emile Zola's *J'Accuse*); there were Dreyfus (and anti-Dreyfus) paperweights, letter openers, vases, beer mugs, scarves, furniture, and china service!

5. The rise in the amount of printed material also produced a change, if not a crisis, in the realm of the literary as well: How to organize so much new writing, how to store it, how to treat it both physically and conceptually? The trace of that change can be retrieved from the shift over time in the meaning of the word "literature" itself.

In the eighteenth century, "literature" functioned largely as a companion term for "literacy." Someone who had "literacy" knew how to read and write. Someone who had "literature" had used that knowledge and read broadly over

the whole range of what had been written and published. Literature meant an acquaintance with what had been written in the language. In short, literature was a species of knowledge. In the eighteenth century, someone "had broad literature," while someone else "had no literature at all." By the nineteenth century, the word had come to mean the "profession of writing." Someone might be "in literature," in the same way that someone might be "in law," or "in medicine."

It is only after we get well into that groundswell of printed material in the 1880s that we find what had formerly been a secondary or even tertiary meaning of "literature" coming to the fore and suppressing these other meanings: literature as a set of texts of a certain order of value.

This rise to primacy of an until-now secondary definition has its underside: the conceptual creation of a vast reservoir of texts outside literature that has come to be called, in recent years, "paraliterature," *i.e.*, centering on the concept of those texts not of that order of value.

Simply in the area of fiction, in order to deal with the growth in the amount of it, categories of fictions—genres—became far more important than they had been before: penny dreadfuls, dime novels, mysteries, Westerns, children's books, adventures, scientific romances, ghost stories, poetry, and literature *per se*.

Literature was, of course, the privileged genre (or genre collection). Meanwhile, other genres were dismissed out of hand: nor is it innocent happenstance that those genres dismissed tended to be those most popular with working people—the adventure, the Western, the mystery. Nor is it an accident that the genres that actually made it into the category of literature were those that accrued to themselves a certain cachet among the middle classes and their extension, the intellectual classes of the day—the genres that are finally valorized as "literary" *per se*: the novel, the short story, the drama, the history, the epic, and the lyric.

Just as the technological revolution in printing was a cause of the political alignments of the Great War, similarly, it was a cause in the creation of literature as we know it, during and just after that war. In his survey, *Literary Theory, An Introduction*, Terry Eagleton quotes from the inaugural lecture of Professor Gordon, the first professor of English Literature at Oxford, who was appointed to his chair just after World War I:

> England is sick, and . . . English Literature must save it. The Churches (as I understand it) having failed, and social remedies being slow, English Literature has now a triple function: still, I suppose to delight and instruct us, but also, and above all, to save our souls and heal the State.

And healing the state, in the first decades of the twentieth century, when these words were spoken, meant specifically proofing the state against the sort of workers' revolutions that had already erupted in Russia in 1906 and 1908, and would explode against in 1917.

6. Reading widely on a daily basis, in the eighteenth century, a Doctor Johnson could consider himself familiar with the range of what had been written in the English language until that time. Nor did he have any need of high genres or low.

Reading widely on a daily basis, in the twentieth century, a Harold Bloom, who claims (however playfully) a Johnsonian range to his reading, must have recourse to the modern concept of literature (and by extension, that which is not literature), as well as—to use terms he has put forward in his most influential book, *The Anxiety of Influence*—"strong poets" and "weak poets." A "strong poet" is a poet to whom we must pay attention; a "weak poet" is one there is no necessity to bother with, even though we may dip into his or her work, and even find pleasure there, now and again. "Strong poets" rewrite the works of earlier "strong poets" in ways that produce new and interesting reading experiences; "weak poets" simply do the same things previous poets have done, however well or skillfully. I do not doubt for a minute that, in the range of the texts he has encountered, Bloom finds criteria sufficient to justify these categories. But the condition of their necessity—what makes them indispensable—is simply that there is too much to read. (Even on first hearing the terms, does anyone need to be told that there are far fewer strong poets than there are weak ones?) Without these categories there would be no way to decide what to read at all, and even more important, to justify what not to read.

While the ostensible purpose of the categories "strong poets" and "weak poets" is to judge an aspect of critical interest (call it quality), its necessity is simply that there are too many poets today for any one critic possibly to give the careful and considered reading to their complete works that is finally and actually what is required to make the quality judgment that "strong" and "weak" imply. And a reader or two away from Bloom, "strong" and "weak" dissolve back into the same unlocatable, rather arbitrary social consensus that constitutes "important" and "unimportant" writers, at least among the writers of today, and more and more among the writers of yesterday.

7. Two metaphors—at least—contest for primacy in describing the humanities' encounter with itself and the world. They contest today. They have contested for years, at least at the rhetorical level. One sees the world as a

series of narratives: linear, systematic, more or less rational, more or less negotiable. Technology itself is one conceptual area that is easily represented as a set of highly operationalized narratives about materiality. The operations are called science. Their material fallout is the artifacts of technology.

8. When, in his essay, *"Epic and the Novel,"* Mikhail Bakhtin wrote: "By 1900, all genres had become novelized," he was responding to the historical situation of the rise in primacy of the narrative model for generally organizing our experience—and its settling into place by 1900.

9. The metaphor that contests with the narrative model, however, sees the world as a series of poems. This metaphor has never been the dominant one in our culture. But it has never been completely suppressed, either. And there are certain periods when it is far more forcefully in evidence than in others. In the 1890s, again in the 1920s, and arguably in the 1960s, this marginal model moved forward in the general consciousness, and commanded more intelligent attention than it has at other times.

To take the twenties as the most arbitrary of examples, one thinks— at one end of the spectrum—of Cocteau's perhaps glib categorization of all the arts as a species of poetry—*poesie du roman, poesie du musique, poesie du cinema, etc.*—and, at the other end (scholars of the period will realize there is a much closer connection than there is an opposition) Heidegger's enterprise of the period to repoeticize the modern world.

American literature's Beat Generation movement of the fifties and sixties, with its concomitant foregrounding of the poetry first of the Black Mountain School and then of the San Francisco Renaissance, as well as its privileging of spontaneity in art (with the novels of Kerouac, typed out in the first draft on endless paper rolls) can be looked back on as an appeal to the poem as the privileged model with which to encounter life, rather than the more acceptable and recognizable systematicity of the narrative.

When the poet Charles Olson said, in the first of his trio of 1967 Beloit Poetry Lectures, which shares my subtitle with Goethe's 1809 autobiography, "poetry . . . especially by or in our language . . . is so different from the assumptions that poetry has had in our language. . ." he was citing the fact that the *chose poetique*—what poetry is—has shifted mightily from the 1890s. Yet the assumptions about what poetry is have remained remarkably stable, which has resulted in Olson's difference.

10. A critical assessment that looked at the relation between Goethe's *Dichtung und Wahrheit*, Olson's lecture trio, "Poetry and Truth," and, say, this

current paper, and proceeded on the assumption that all the relations ascertained by the critics were signs of a movement through time and of an influential status—with Goethe influencing Olson and Olson influencing Delany (with any influences from Goethe on Delany having to have been filtered through Olson)—would more than likely be controlled by a fundamentally narrative model. A critical consideration that looked for relations between Goethe and Olson, between Olson and Delany, but equally between Goethe and Delany, and that assumed that any and all of these relations could run either forward in time or backward in time, and that the determination of their status was problematic, would, most likely, be controlled by a fundamentally poetic model.

I must say "most likely," rather than "definitely," because it is not the idea of a unidirectional temporal linearity that defines the narrative model, and distinguishes it from the poetic. Rather it is the idea of the problematic status of the relations that defines the poetic model, and distinguishes it from the narrative.

Many critical studies cite relations in which the status of the relations is presumed to be known, even though it is never stated in the critique. Similarly, in many studies the status is presumed to be problematic, even when that status is not stated. Thus, it is often possible to read narrative critiques as poetic—or indeed, to read poetic critiques as narrative.

11. Longinus's *On the Sublime* (the περι υψοζ) from third-century Greece, whose author was educated in Alexandria, then taught at Athens, and was finally executed (it is widely presumed) by order of the Roman Emperor Aurelian in 273 for having acted as aid and advisor to the rebellious Queen Zenobia of Palmyra, is a critical treatise in which a great many critical relations are foregrounded among a number of texts (Demosthenes, Plato, Sappho, *The Iliad*, Herodotus . . .), and in which the status of those various relations is left more or less tacit. (Are they merely descriptive? Are they fictive? Do they imply influence? Or are they assumed to be at some other level of causality?) It is possible that, at the time Longinus wrote that address to Postumius Terentianus critiquing Caecilleus's monograph of the same name, the status of all such relationships was presumed common knowledge among the intelligentsia; thus there was no need to specify. But because we do not have such knowledge today (nor have we had it at least since the 18th Century when Longinus first became widely read), we read and traditionally have read Longinus's as the most poetic of critiques.

12. A kind of countercanon of works runs parallel to the canon we traditionally think of as the literary. Often its works are ones for which a more

or less massive critical attempt was mounted to enter them at a respectable places in the traditional canon, and usually, most literary historians would have to say that, for whatever reasons (usually because other critics resisted), the attempts have failed.

These works are in a very different position from those that, for a season or even a decade or more, achieve a general public popularity because the authors are well spoken and because there is nothing in the works so aesthetically offensive that literary critics feel called upon actively to denounce them. Often those works would appear to have joined the ranks of the immortals, only to be forgotten after still another decade or so, when their simple banality finally subverts all actual critical interest: one thinks of Archibald MacLeish's silly play *J.B.* (1958), Robinson Jeffers's mawkish redaction (another wildly free paraphrase, from Euripides this time) of *Medea* (1946), or even Tony Kushner's AIDS fairy tale *Angels in America, Parts I and II* (1993). All three have been declared, in their moments, icons of culture, but, stripped of the artful performances that briefly enlivened them, all three are less than memorable.

Works in the countercanon retain their interest, however. They are constantly being rediscovered. The 1890s is famous for a whole string of such works, though, indeed, to limit the ones associated with the nineties to that decade in any strict way would be far too absolute. It must go back at least as far as 1881, when twenty-six-year-old Olive Schreiner decided to leave South Africa with the just completed manuscript of her mystical—in the best sense—novel, *The Story of an African Farm*. The book was published in England in 1883, when she was twenty-eight. But during the nineties it was the most talked-about novel of the decade, at least among the poets of the Rhymers' Club—and rightly so. Now one stumbles across excited encomia about it in the letters of Ernest Dowson, now one uncovers an account of Arthur Symons, some few years before his final breakdown in Italy, enthusiastically urging it on the author of *Marius the Epicurean*, Walter Pater. Indeed we might even want to extend this line back to James Thomson's *City of Dreadful Night*, which appeared over four numbers of the *National Reformer* between March and May of 1874—a work that grows from the same failure of organized Christianity that produced Schreiner's account of her characters' moral ordeals (with its uncanny, transvestial ending) on another continent in the year before Thomson died from tuberculosis in London, complicated by advanced dipsomania, on June 2nd of 1882.

The poems of Dowson (*Verses*, 1896; *The Pierrot of the Minute*, 1897; and the posthumous volume *Decorations*), with their unarguable verbal beauties, belong to this same line of works—if not the equally delicate tales he produced and published in the volume *Dilemmas: Stories and Studies in Sentiments*

(1895) and in *The Yellow Book*. So do the more demanding—for the modern reader: because of their religious weight—poems of Lionel Pigot Johnson and Francis Thompson, if not the work of Alice Meynell. Indeed, the "productions of the nineties" continue on at least through 1904, when "Frederick, Baron Corvo" published his extraordinary novel, *Hadrian the Seventh*, a year after Samuel Butler's novel *The Way of All Flesh* saw posthumous publication in 1903. Indeed, Butler's novel, which he began in 1873 and completed in 1884, is a work contemporary with Schreiner's novel. Butler's novel, with its iconoclastic satire, was taken into the canon almost immediately, while Corvo's, with its far more conservative politics, its wildly erudite religious superstructure, and its barely suppressed fantasy—the writing is simply gorgeous—has led a far more problematic life at the margins of the literary, despite the praise of everyone from D. H. Lawrence to W. H. Auden.

Looking at the range of such counterworks, one notices first the catastrophic lives their writers tended to live: the artists who produced them do not lend themselves to any easy version of the literary myth that art ennobles the artist's life—at least not in any nonironic and socially evident manner. If anything, they suggest that art is a bitch goddess who ravages the creator and leaves a distressing, pathetic ruin behind. It would seem that the canon can absorb a bit of such pathos, but in nowhere near the amounts that predominate in the range of highly talented creators; and it is rare that (with a lot of posthumous critical help) a John Keats, a Percy Shelley, an Edgar Allan Poe, or a Hart Crane makes it across the canonical border. And in terms of the reception of all of these, all are poets who, at one time or another, verged on being confined to the countercanon. (How interesting it is to observe the posthumous critical reduction currently going on of W. H. Auden from the poetic giant he was during the last thirty years of his life to a "more or less interesting poet," for no other reason that I can discern—in the half-dozen recent studies and biographies of him I have read—than that [it does not even seem to be his homosexuality] he occasionally neglected his clothing, his St. Mark's Place apartment was a mess, and he drank.) As a group, however, the countercanon poets tend toward a brilliance of surface that suggests an excess of aesthetic relations in their texts constituting both their enjoyment and the permanence of their esthetic interest despite their regular canonical exclusion.

This is why the American writer Stephen Crane joins them. Crane's *Red Badge of Courage* was briefly popular, first in its 1896 newspaper serialization, then in volume form from Appleton over the following year. But by the year Crane died, aged twenty-eight, in 1900, it had been all but forgotten. Despite the fact that, in his final trip to England, he became a friend of James, Wells, and Conrad, Crane was not taken into the canon—nor did he come anywhere

near it—until Thomas Beer's (wildly fanciful!—though the extent of that fancy has only come to light in recent years) biography became a bestseller at the start of the next poetic decade, in 1923.

12. Now, to say that science is the theory of technology is not to say very much until we have clarified some assumptions about the relation of theory to the situation it is presumed to be the theory of.

The question is: Is science a set of immutable rules, laws, and universal facts, of which any specific experiment or observation is only a particular manifestation, and often a fallen or inexact manifestation, at that? (Think of all those times in Chem. Lab when our experimental results were so far off textbook prediction.) Or is science a kind of averaged description of experiments and observations that at any moment may be catastrophically revised by unexpected experimental results not fundamentally different from our lab student anomalies? (Think of Einstein's General Theory of Relativity, confirmed by the anomaly of Mercury's inevitably early appearance from behind the sun—finally explained by the idea of the sun's gravity actually bending the light waves of which the image was composed, rather than the sun's considerable atmosphere deflecting those rays—which, till then, had been the traditional, but finally mathematically inadequate, answer.) Indeed, to glance at examples like the ones in parentheses here suggests that science partakes of both. In practical terms, certainly, that is the working assumption most practicing scientists go on—in hope that they will not mistake evidence of a fundamental paradigm shift for a simple measurement inaccuracy (or, perhaps, more embarrassingly, vice versa).

I hold that science is aestheticized technology. However, it is also and at the same time the political aspect of technology—as it is the theoretical aspect. The working part of this suggestion is that science bears the same relation to things in the world as an aspect bears to an object. Thus, though it may be represented as a rule or set of rules governing objects, strictly speaking it is not the rules that constitute science but the explanations for those rules— nor is science, speaking equally strictly, a reduction of an object. (As with an aspect of an object, a representation of that aspect cannot totalize the object, by definition, the way science is presumed to totalize technology.) Thus the relation between science and technology is very different from either of the ones suggested above, even as it explains particular effects or appearances of that relation.

But, yes, the status of that relation is and always has always been problematic.

13. Aspects of objects depend mightily on human biology. It is absurd (*i.e.*, away from reason towards stupidity) to speak of colors that are not

colors we or some living creature can see; or of notes and harmonies that, similarly, cannot be heard. That is to say, such concepts do not easily fit into most current logical narratives about the world. (Should we speak of such sounds or colors, because we will be in the realm of metaphor, the status of the relation between word and world will be thrown into question.) And colors and sounds are aspects of objects par excellence. Aspects are the ability of objects to excite the biological subject in a particular way.

Science, then, might be called the ability of the object world to excite explanations in the reasoning body that, through their coherence and iterability, allow (or suggest) a greater and greater control over the object world.

14. The object world, controlled or uncontrolled, maneuvered or unmaneuvered, is technology. To pull an apple from a tree and eat it is as much a technology as to hunt through a garbage can, find half a hot dog, and eat it. And there is a science to both.

15. Aspects, to speak figuratively, tend to sit on the surface of objects. That is to say, they are the first things about the objects that interact with us. In a cultural field given over to essentialism, we are very likely to assume that the aspect represents some sort of essence of the object.

I hold that poetry is an aspect of narrative.

I hold that science is an aspect of technology.

But the fact that aspects have perceptual priority explains why it seems to so many of us (including me) that poetry precedes the functional use of language: clearly, in language, relationships whose status we are not sure of (relationships whose signification/status is unknown or problematic) must precede relationships whose status we believe we know (relationships whose signification/status we can follow). A little thought will show that this makes the historical question: Which came first, poetry or narrative? a chicken-and-egg question. But in terms of the history of any given individual, from infancy to adulthood, poetry must come first.

16. But let us switch topics once again: to narrative and narrativity. Narrative exists as an extraordinary complex of expectations. As soon as we write, "The marquis went out at five o'clock . . ." the problem is not then that we do not know what to write next. Rather, we have an immense choice of things we can follow it with. But there is an equally immense or even greater number of things that would produce a tiny, almost minuscule feeling of upset, violation, and the unexpected: "An anvil fell on his head from the roof and killed him." Or: "At that moment the Titanic sank." To the extent that a narrative is supposed to produce various sorts of pleasure, the sense of

expectations violated can be just as pleasurable, or even more so, than the sense of expectations fulfilled. And as soon as one choice is made (whether the writer goes with fulfillment or with violation), a new set of expectations opens before the reader/writer. Which will the writer—say, the writer of what we usually call "narrative fiction"—choose to develop: the sense of violation or the sense of fulfillment? But, like a tree-search lying in front of every writer (and reader), at the beginning (and all throughout, unto the closing sentence) of every tale, the expectations are always there. That tree underlies every text. Any text represents only a specific path through it.

One argument posed by people who claim genre fictions are aesthetically valueless *per se* is that, to be recognizably of a genre—science fiction, Western, horror, mystery—the text must fulfill so many expectations that there is no room for the necessary violations that characterize great literary works. The counterargument is that, first, literary fiction entails just as much a set of expectations as any other genre, and requires just as much conformity to expectations to write it. (People who argue against this often see mundane fiction as simply "mirroring the world," rather than negotiating a complex set of writerly expectations in the same way genre fiction does.) Second, the greater emphasis on expectations fulfilled that indeed characterizes what we traditionally call genre fiction means that, when violations are worked into traditional genre tales, they register more forcefully on the reader than similar violations in tales belonging to the literary genres. Conversely, literary modernism, with its emphasis on violation of expectation, has produced an expectational field where violation is so expected that the differences in effect between expectation met and expectation violated are minimal. Thus, as an effective field, modernism (and by extension, postmodernist writing) is affectively moribund. Well, I believe both arguments underestimate just how rich, complex and vast the expectational field actually is. They are confining their view to the tiny range of expectations we call "plot," "character," "style," "theme," and "setting." The fact is that there have always been moribund spots at every level: they're called clichés, and they have been with us at least since French printers coined the term in the seventeenth century. (The original "cliché," which means "clamp," was a length of preset type of frequently used words and phrases, held in a clamp and stored on a special shelf, that the seventeenth-century printer could slide into his type tray, instead of having to set that length of text letter by letter.) But the dismissal of entire genres as cliché rests on a blindness to the complexities of what it takes to ignite a genre and make it take life in the first place.

In any genre, literary or paraliterary, texts that go along merely fulfilling expectations register as moderately good or mediocre fiction: the sort one reads, more or less enjoys, and forgets. What strikes us as extraordinary,

excellent, or superb fiction must fulfill some of those expectations, and at the same time violate others. It is a very fancy dance of fulfillment and violation that produces the "Wow!" of wonder that greets a truly first-rate piece of writing—the inarguably wonderful story—no matter the genre it occurs in. The expectations I am talking of cover everything from the progression of incidents that, in the course of the story, registers as plot, to the progression of sounds that, in the course of its sentences, register as euphony. Such expectations occur at the level of metaphor and form, just as they occur at the level of character and motivation, and at many, many other levels besides.

The notion that plot (or character) exhausts what we can say about expectations across the whole range of narrative fiction, among all the various genres, literary and paraliterary, is about the same as the notion that, in music, the most expected note is always a fifth, fourth, or tonic up or down within the same scale; thirds and sixths are also expected notes; seconds and sevenths are less expected; and notes that lie outside the scale are unexpected. Now, with that as our only principle, we must create a rich subject for a Bach fugue, a pleasing melody for a Verdi aria, a satisfying row for a Schoenberg chamber symphony.

Taking off from Pater's formalist dictum, "All art aspires to the condition of music," philosophers like Rorty and Davidson are showing us that language is not less complex than music, but more so.

17. Whether fulfilled or violated, each expectation citable in a narrative is the sign of a relationship between what comes before it and what comes after it. Not all of these relationships are necessarily consecutive, nor do they all run only from the past to the future. Something happening on page ten of a text may charge or recharge with meaning something we read on page two. And this can happen at any level. In short, we do not know the critical status of every narrative relation. Often these relations are pleasurable simply in themselves. But what we are doing here is recomplicating narrative itself into a poetic model.

From here on, I am going to try to achieve another level of narrative clarity on top of my fundamentally poetic model of narrative.

18. It is easy to get too caught up in the notion of a tree-search. As early as 1957, in his ground-breaking little book *Syntactic Structures*, Noam Chomsky showed that the "end-stopped" (really, just another name for a "tree search") model of language was simply inadequate to generate all the well-formed sentences in a language. To counter this model, Chomsky produced the model of "deep grammar," where complex sentences were generated on

the surface of layers of vertical development. In terms of current computers, that means a tree-search with a whole lot of loops, flags, go-tos, and recursive features. But the fact is that we still do not have computers that, in a free dialogue situation, can generate original sentences of the range and complexity your average six-year-old speaks easily. That suggests that even the deep grammer model is not adequate to language.

Indeed, it is the notion of language as "well formed" that seems to be the problem. While a lucky few of us may write using only well-formed sentences more or less exclusively, none of us speaks only using well-formed sentences. In ordinary speech, some of us may come up, now and then, with three or four well-formed sentences in a row. But most of us, in actual dialogue situations, generate far more fragments and run-ons than we do well- formed sentences, with disagreements between verbs and nouns and incorrect tense progressions the norm rather than the rule, even though, if one of our ill-formed sentences is pulled out of context and we are asked to examine it carefully, we can usually tell something or other is wrong with it—and often even what it is. "Grammar," even the most carefully constructed spoken grammar, as put together by the most careful linguists, is, in most actual speech situations, something that actual language aspires to, something that it approximates, but that actual language is always falling short of, rather than something that controls language in some masterful way. And that goes for the language of "competent speakers" as well as for people just learning it. (Of course the mistakes competent speakers make routinely are very different from the mistakes new learners make. But that is another topic.) Another way of saying the same thing is: a grammar can never be a complete description of an actual language but must always be a reduction of it. One might go so far as to say: if you have a complete description of it, "it" is probably not a language at all but rather a much simpler communication object—a code. Still another way of saying much the same is: it is only after we have an algorithm that can generate both well-formed and ill-formed sentences that we can likely develop a superalgorithm from that earlier algorithm that can distinguish between them (i.e., a grammar); for, contrary to much linguistic speculation, a grammar is not something that, on some ideal or Platonic level, is prior to language, and can be recovered by an examination of specific language situations. If we ask a native informant what another native speaker means by a particular utterance, we will be given some translative paraphrase, or possibly be told, "I don't know." If we ask, "Did the second speaker say what she or he said correctly?" we will be told, "Yes," "No," or, "I'm not sure." It is from the second set of questions, or from the assumption that we know that the speaker was not making a mistake, that we put together our grammar. But it is the

idea of grammar that brings the idea of correctness and incorrectness to the language; the language is not founded on this idea. And the native interpreter will be able to paraphrase—that is, to tell us the meaning of—many more utterances than those that, to a later question, he or she may deem correctly uttered: the interpreter will be able to give us at least some of the meanings of the pregrammatical requests of little children, the slurred demands of the drunk, and the heated boasts or the enthusiastic gossip of those speaking too quickly to care about fine points of expression. The ability to understand a great deal of ill-formed language is not the accidental fallout of linguistic competence (*i.e.*, the ability to speak in well-formed language), but is rather the anterior state necessary to have any concept of the well-formed at all. Rather, grammar always follows language and is generated as an always partial description of what is actually there (*i.e.*, a description of the parts there that are particularly useful in ways the concept of grammar defines). Thus, by extension, an algorithm that can generate only well-formed sentences but cannot generate both comprehensible (and incomprehensible) ill-formed sentences is simply not a complete language algorithm.

(In terms of science: the ability to generate incorrect explanations necessarily precedes the ability to operationalize our way into correct ones.)

I may not be able to give you an immediate paraphrase of the meaning of these lines from Hart Crane's "Atlantis," which closes his poetic sequence *The Bridge*:

Swift peal of secular light, intrinsic Myth

Whose fell unshadow is death's utter wound,—

O River-throated—iridescently upborne

Through the bright drench and fabric of our veins . . .

But to ask whether, as a sentence, it is well-formed or ill-formed—whether it is "correct," or contains any mistakes of grammar, syntax, or diction—is simply hopeless. And it is still poetry. More to our point, it is certainly still language, and language at a high and (and to me and many other readers) pleasurable level of expectational violation. Indeed, the only way to begin talking about it productively as poetry is to read carefully the precise ways in which the language resists the fulfillment of expectations: "Swift peal of. . ." makes us expect, of course, "thunder," thunder being the mythic mode in which the god Zeus traditionally demonstrated his sacred, religious power. But

rather than religious thunder, instead we get "secular light." And it is precisely the difference between the expected "thunder" and the violational "secular light" that starts to make the line, and, indeed, other words and phrases in the lines, signify, as it allows us to experience the specific play of differences that is Crane's vision.

An even more extreme example, however, might be taken from Crane's friend, black writer Jean Toomer, who, at the start of the twenties, experimented by writing a poem organized around a single letter ("Poem in C"):

Go and see Carlowitz the Carthusian,

Then pray bring the cartouche and place it

On this cashmire, while I tell a story.

The steaming casserole passed my way

While I reclined beneath Castelay,

Dreaming, ye gods, of caster oil . . .

Toomer also wrote, in a wholly invented language, "Sound Poem (I)":

Mon sa me el karimoor,

Ve dice kor, korrand ve deer,

Leet vire or sand vite,

Re sive tas tor;

Tu tas tire or re sim bire,

Razan dire ras to por tantor,

Dorozire, soron,

Bas ber vind can sor, gosham,

Mon sa me el, a som on oor.

To argue whether the first of these is well-formed or not, or whether the second is actually language, is to miss the point: there is no way we can respond to them other than as language. (In "Sound Poem (I)" there is no way

to avoid hearing "wind" in the Germanic "vind," the French forms "mon" (my), "tire" (pulls), and "dir" (to say) in "Mon," "tire," "dire," and "dice," the Latin "basia" (kisses) in "bas," and Spanish and French "el" (the) and "tasse d'or" (cup of gold) in "el" and "tas tor." The English "paramour" and the French "raison" linger behind "karrimoor" and "Razon," as well as dozens of other semantic conceptions.) No, we can establish easy narrative relations here neither in Toomer nor in Crane. But that is what both Crane's and Toomer's poems have been carefully crafted to do. And they do it not by avoiding language but my maneuvering—in all cases—fundamental language elements.

In all three cases, it is language expectations that are being violated to highlight various poetic effects.

Much linguistic work in the past has occurred within a paradigm that sees well-formed sentences as language but ill-formed sentences as, somehow, outside language (work that would certainly place Toomer's "Sound Poems," if not much of Crane, beyond the linguistic border); it sees them as some sort of non-language, when, on the one hand, the most cursory observation of actual language as it is spoken (or, with a poet such as Crane as a prime example, written) reveals that ill-formed sentences are just as much "within-language" as are well formed sentences, and are equally a part of the language process; while, on the other hand, the meticulous and careful readings by deconstructive critics of written language (writing: that bastion of the well-formed!) reveal that the ideal derived from (but on which, rather, we mistakenly tend to ground) the whole notion of the "well-formed"—the sentence whose logic and clarity precludes all ambiguity, all semantic slippage—is itself an impossibility: that, indeed, if such an ideal were achieved, rather than producing the phantasm of a perfect and mastered meaning, immediately present both to sender and to addressee, it would bring the communication process to a dead halt. The slippages, the ambiguities, the mistakes, finally, are what make language function in the first place. But even with this much of an overview of the ubiquity and utility of "mistakes," some will see that we are back at that very important notion of violation of expectations, purposeful mistakes, if you will, that must reside in higher-level narrative grammars (even as slippages and ambiguities reside in well-formed sentences), if the narratives are to be in any way richly satisfying.

The much beleaguered project of deconstruction can be looked at as a way of foregrounding the necessary and unavoidable "mistakes" (read: ambiguities, slippages) that reside in even the most well-formed sentences— and that must reside there if those sentence are to exist in time--and are to communicate anything at all over the time it takes to utter them.

With the acknowledged failure both of the end-stopped (or tree-search) model of grammar, as well as the deep (or vertical) model of grammar,

it seems clear that, to describe actual language more precisely, we need another model. More to the point, we need another *sort* of model—one that is looser, more flexible, that allows us to retain the insights of the previous models until someone generates a better technical description, even while our new order of model acknowledges that the way of talking about those insights, from both earlier models, are now metaphors and, as such and despite their insights, are themselves violations of an expected, more exact model, a more poetic model, *i.e.*, an expectation as yet unfulfilled . . .

But to return to our topic of fictive narrative: no one sits down and teaches you what fictive expectations are, much less which ones to conform to and which ones to violate.

Rarely have I been in a creative writing class that has even mentioned them, much less talked about them at any length.

We learn them from reading other fiction—other truly good fiction; and equally, or possibly even more, from reading bad fiction.

Because violation has as much to do with success as does fulfillment, there can never be one "great work," or even a group of ideal "great works," that can teach you all the expectations at once. The artist, T. S. Eliot wrote in "Tradition and the Individual Talent" (1919), must "familiarize himself with the tradition." In today's computer oriented world, we might put it (metaphorically): the artist (along with the critic) must, though broad exposure, become familiar with the overall structure of the possibilities of the tree. And the tree (or the tradition), remember, produces not only the good pieces but the bad pieces as well.

We learn those expectations not as a set of rules to follow or break—though after a while, some writers may actually be able to list a number of them in that form. Rather, we learn them the way we learn a language when we live in another country—We learn its grammar and syntax; we learn what is expected of a competent speaker of that language.

And just to up the ante, languages change, including the language of fiction. What was perceived as a violation yesterday is today a sedimented expectation. What was once an expectation is now honored only in the breach—or people just giggle. The language of fiction is not quite the same today as it was eighteen or twenty-five years ago. It is certainly not the same as it was sixty or seventy-five years ago. And it is almost entirely different from what it was a hundred or a hundred-fifty years ago. So while it is always good to know the history of the language you are speaking, and while that history will often tell you the reason why certain expectations are (or are not) still in place today—where, in effect, those expectations started out—the great stories of the past hold the key to writing the great stories of today no more than

an oration by Cicero will tell a modern politician the specifics of what to mention in his next sound-bite, even when Cicero and the modern politician can be seen as having similar problems.

All we can ever learn is what the language—of fiction, say-—has been in the past. But every time we sit down to write a new text, we become involved, however blindly, in transforming the language into what it will become.

19. As science is an aspect of technology, poetry is an aspect of narrative: it is such an evident aspect of narrative that, from time to time, it has been foregrounded and highlighted and hypostasized, at least on the social level, into a thing in itself, just as, in the same manner, science has been so hypostasized.

20. When poetry is separated from narrative, as it is in much language poetry, *i.e.*, where the coherent narrative units (as in, say, the works of Silliman or Hejinian) are kept down to a sentence or less, the poetic relations foregrounded are much quieter, subtler, and—for the reader used to taking his or her poetry with greater dollops of "argument"—more difficult, at least for a while, to recognize. Yes, it is a reduced esthetic field that such poets are asking us to concentrate on: but the reduction also represents an esthetic refinement.

And the fact is, there is simply no way to experience those particular poetic effects (read: verbal relationships of a problematic status) at such an intensity and purity in a more narratively saturated field.

21. The hypostasization of aspects into (conceptual) states that, at least socially and linguistically, are treated as though they were actual objects in themselves would seem to be a constant function of language. We not only talk of "yellowness," "largeness," "smallness" (even "size"), "heat," or "cold" as though they were actual things (rather than aspects of things), but by treating them thus verbally, we allow ourselves to study them and to create explanatory models of them, models that are counterintuitive precisely to the extent that they deny their object status and return them to their aspective states.

It is arguable that such hypostasization is a poetic function of language, and one that, we can easily see, makes science (which is, after all, a similar hypostasization of aspects) possible.

Poetry is cut off too rigorously and permanently from all narrative, in that it represents another such hypostasization, and may lay out a locus for esthetic abuse. (At least every time, usually at those historical moments that the poetic model itself has come to the foreground, and poetry itself has taken

the occasion to make another lurch away from traditional narrative in order to repurify itself, there have always been critics standing about to shout "Abuse! Abuse!") So can science, when it forgets the complex material world, the technology, if you will, of which it is an aspect, also lay out such areas, and for the same reasons. But I do not think that such hypostasizations are necessarily abusive in themselves, for if they were, we would have to dismiss both science and poetry out of hand. And, myself, I would rather see more of both, conducted at a high and refined level, than less.

## Works Cited

Arendt, Hannah (1951). *The Origins of Totalitarianism*. New York: Harcourt, Brace, Javonovich.

Bahktin, Mikhail (1981). "Epic and the Novel," in *The Dialogic Imagination*, ed. Michael Holquist, trans. Caryl Emerson and Michael Holquist. Austin: University of Texas Press.

Butler, Samuel (1964). *Ernest Pontifex, or The Way of All Flesh*, ed. with intro. by Daniel F. Howard. Boston: Houghton Mifflin Riverside Editions.

Chomsky, Noam (1957). *Syntactic Structures*. The Hague: Mouton & Co., N.V., Publishers.

Crane, Hart (1986). *The Complete Poems of Hart Crane*, ed. Marc Simon. New York: Liveright.

Dowson, Ernest (1919). *The Poems if Ernest Dowson*, with a memoir by Arthur Symons. New York: The John Lane Company Ltd.

————(1947). *The Stories of Ernest Dowson*, ed. Mark Longaker. Philadelphia: University of Pennsylvania Press.

————(1967). *The Letters of Ernest Dowson*, eds. Desmond Flower and Henry Mass. London: Cassell & Company Ltd.

Eagleton, Terry (1983). *Literary Theory: An Introduction*. Minneapolis: University of Minnesota Press.

Gregor-Dellin, Martin (1963). *Richard Wagner, His Life, His Work, His Century*, trans. J. Maxwell Brownjohn. New York: Harcourt, Brace, Jovanovich.

Johnson, Lionel (1982). *The Collected Poems of Lionel Johnson*, Second and Revised Edition, ed. Ian Fletcher. New York: Garland Publishing, Inc.,

Leunen, Mary-Claire van (1979). *Handbook for Scholars*. New York: Knopf.

Longinus (1991). *On Great Writing (On the Sublime)*, trans. with intro. by G. M. A. Grube. Indianapolis: Hackett Publishing Co.

Olson, Charles (1979). "Poetry & Truth," in *Muthologos, The Collected Lectures and Interviews*, Vol. II, ed. George Butterick, Bolinas: Four Seasons Foundation.

Pater, Walter (1986). *Marius the Epicurean, His Sensations and Ideas*, ed. with intro. by Ian Small. First published 1885. Reprinted New York: Oxford Univeristy Press.

Schreiner, Olive (1939). *The Story of an African Farm*, intro. by Dan Jacobson. First published 1883. Republished London: Penguin Books.

Toomer, Jean (1988). *The Collected Poems of Jean Toomer*, eds. Robert B. Jones and Maregery Toomer Latimer, intro. by Robert B. Jones. Chapel Hill: The University of North Carolina.

# VII

## Visualizing and Producing
## Anarchic Spaces

# 17

# The Question of Space

*Lebbeus Woods*

In the realm of the social sciences, space is usually discussed in terms of human presences within it. In the field of architecture, however, it is the abstract qualities of space that are stressed, for an understandable if not altogether forgivable reason—architects are specialists in the formation of these qualities. One of the clichés derived from this approach is that space is designed to be functional, meaning, in the jargon of the architects, that each designed space has been shaped to follow a "program" for human use.

This, of course, is nonsense. Architects usually design rectilinear volumes of space, following Cartesian rules of geometry, and anyone can observe that such spaces are no better suited to being used for office work than as a bedroom or a butcher shop. All designed space is, in fact, pure abstraction, truer to a mathematical system than to any human "function." While architects speak of designing space that satisfies human needs, it is actually human needs that are being shaped to satisfy designed space and the abstract systems of thought and organization on which design is based. In the case of Cartesian space, these systems include not only Descartes's mind-body duality, but also Newton's cause-effect determinism, Aristotle's laws of logic, and other theoretical constructs that the prevailing political and social powers-that-be require. Design is a means of controlling human behavior, and of maintaining this control into the future. The architect is a functionary in a

chain of command whose most important task (from the standpoint of social institutions) is to label otherwise abstract and "meaningless" spaces with "functions," that are actually instructions to people as to how they must behave at a particular place and time.[1] The network of designed spaces, the city, is an intricate behavioral plan proscribing social interactions of every kind, and proscribing, therefore, the thoughts and, if possible, the feelings of individuals.[2]

A rectilinear volume of space labeled "lecture hall" requires that people who occupy this space behave either as lecturer or as listener. If anyone violates this order of behavior, say by deciding to sing during the prescribed lecturing/listening behavior, because the space has good acoustics, perfect for singing, then pressure to silence the violator will be brought to bear by the audience of obedient listeners, or by the lecturer or, if the violator persists, by the police. Or, to take a less blatant example, if one of the listeners asks (during the usual, prescribed question/answer period following the lecture) too long a question, the audience of obedient questioners will try to heckle into silence the violator of the space's proscribed behavior. In certain cases, asking a question with a "wrong," unproscribed, uncontrolled, ideological slant will bring the same result. In extreme cases, it will bring the police.

The justification for the suppression of violators of the behavior proscribed for the occupation of designed space is clear enough. Social order must be maintained, so that individual freedom (which is largely the freedom to conform to social norms) can be maintained. Think of the poor lecturer, who no doubt has something important to say, interrupted by the spontaneous singer, the too-long questioner who is actually usurping the lecturer's role, or the thinker whose heretical views upset the carefully controlled balance of the lecture and the listening! If, or so the argument goes, the "function of the space" is violated, and this violation is tolerated, it may set a precedent, become more widespread, threatening the whole mechanism of society. Anarchy. Chaos. It cannot be allowed.[3]

Of all these conditions, of course, the hapless architects are hardly aware. Isolated in a specialized task, praised by higher authorities (clients, awards panels, social agencies of one sort or another) for their excellence in manipulating the abstract qualities of space and its defining forms, and at the same time for fulfilling the needs of people (enforcing the proscribed behavior), architects can live under the illusion that they are first and foremost artists, who shape space and its qualities for an appreciative (obedient) audience of users. Consequently, in the thinking and discourse of architects, formal qualities of space take precedence over its human content, which is merely assumed. In the case of the lecture hall, architects will discuss the subtleties

of the space's proportions, its lighting, use of materials, the sight lines from audience to stage, its use of color or a dozen other, almost entirely visual qualities. They may refer to its acoustical characteristics by way of alluding to its "function," but they will never question the premises of the "program" for the space, the concept of "lecture."

A great architect, such as Mies van der Rohe, is able to elevate this precedence to a plane of philosophical principle. He was fond of saying that the greatest historical works of architecture were the temples of the ancient world, the interior spaces of which had little or no human function at all. They were pure architecture, architecture as religion. His concept of "universal space," which led to some of the best modern buildings (by him) and the worst (by his imitators) also had religious overtones. Architecture was something above life, or at least beyond the messiness of lives lived within it.[4] People come and go, ways of living change, but architecture endures, an idealization of living. Architectural thinking in the past twenty years, even though it has paid much lip-service to cultural context, including history, local conditions and the like, has changed the discourse of architecture very little.[5] Even an architecture that plays with changes of fashion and fashions of change still places the medium over the message.

On the other hand, one cannot complain too loudly. It would only be repeating certain historical disasters to subjugate architecture to social conditions as they are or, even worse, to social theories, of whatever kind. Anyone who visits modern cities that were transformed by architectural and urban planning dictated by a particular ideology will understand how one-dimensional such landscapes can be. Architects who recall the "design methodology"[6] and "advocacy planning"[7] movements that dominated architectural education in the late sixties and early seventies will also understand how the best of social intentions can go terribly wrong. In the name of egalitarian principles, the attempt was made to directly apply to the process of architectural design sociological techniques such as statistical analysis, but with results that rival the most pedestrian socialist architecture of the Eastern Bloc countries in mind-grinding blandness. Architecture, in the end, is not a branch of the social sciences any more than a mere instrument of a particular public policy, or a chiefly aesthetic manifestation. At the same time, it is also not merely a combination of these admittedly important aspects of practice and production. The question of space raised by the design of architecture leads in a very different direction, one that could, until the present period, remain safely concealed behind historically sanctioned appeals to science and to art.

When Nietzsche wrote that people would rather have meaning in the void, than a void of meaning, he made an almost painfully apt critique of the

present, postmodern situation, and in perfectly postmodern, concretely spatial terms. For in fact, space is a void, an emptiness that people have a powerful need to fill with the content of their own presence. This filling can be mental or physical, or both, but if a space exists in consciousness that cannot be filled (or shall we say, more simply, is not filled) it represents an "unknown." In other words, it represents something intolerable. In earlier epochs, these unknowns were usually geographical, and existed as continuously receding frontiers that had to be crossed, settled, inhabited, if for no other reason, so that new frontiers might be revealed. Yet even those dominions inaccessible to a physical human presence, the ones that appeared in dreams or the imagination, were populated by gods and angels. For most of human history, there was meaning in the void. But then something began to happen. Nietzsche commented on that, as well.

Decrying the devaluation of those primordial sites that gave rise to the rituals and myths that "help the man to interpret his life and struggles," he inveighed against modern "abstract man" and a modern culture that "is doomed to exhaust all possibilities and to nourish itself wretchedly on all other cultures." They are the products of "Socratism" and its incessant questioning of everything that inevitably destroys myths. "Only a horizon defined by myths completes and unifies a whole cultural movement," and imparts, therefore, to shared experiences mutually held values and meanings. "And now," he concludes with desperate sincerity:

> the mythless man stands eternally hungry, surrounded by all past ages, and digs and grubs for roots, even if he has to dig for them among the remotest antiquities. Let us ask ourselves whether the feverish and uncanny excitement of this culture is anything but the greedy seizing and snatching at food of a hungry man—and who would care to contribute anything at all to a culture that cannot be satisfied no matter how much it consumes, and at whose contact the most vigorous and wholesome nourishment is changed into "history and criticism?"[8]

This is not the place to discuss Nietzsche's prophetic powers, the extent to which he anticipated the disintegrating character of the twentieth century, the coming preeminence of psychology and anthropology in his own field of philosophy, the radical changes in the deterministic character of the hard sciences,[9] and technologies that have had the effect of turning whole populations into voyeurs and tourists grubbing for roots, even though it is among the remotest antiquities, and who are never satisfied, no matter how much they consume. Nevertheless, we can read today what he called his "revaluation of all values" as the first wave of what has essentially been a full-scale "devaluation"

of all values that has continued nonstop since his death. Now people find themselves with an infinitude of space—from the atom to the cosmos, from cyberspace to outer space, from suburban living rooms to the vacant acres of the South Bronx—that cannot be filled with meaning by the traditional productions or contemporary products of science or art. No matter how much is pumped in, through mass media or consumer culture, through academic discourse or political peroration, it seems to fill the space less and less. It is fair to say that there is a growing skepticism among people, an erosion of their belief, not simply in the productions of culture, which are understood as transitory, but in belief itself, which, like Mies's temples, has always transcended the processes of change, and lent coherence to them. The "devaluation of all values" is today eroding the concept of value itself.

The chief agents of the process of devaluation are the mass media.[10] Dominated by television and made global in scope by satellite technology, these media owe their existence to fundamental epistemological changes that made their first appearance in physics. Particle-wave duality begat the uncertainty principle, which begat quantum theory, which begat solid-state physics, which begat the transistor, digital computation, the microchip, the credit card. These developments have resulted in a communications revolution that has flooded space not with human presence so much as raw data that is, phenomenologically speaking, indiscriminate and undifferentiated. The effect of this flood is a chaotic one, in the presently understood sense of the term. That is, a landscape of psychological dimensions is created in which it becomes increasingly difficult to make distinctions between discrete things and events (they are homogenized in the "mass"), and in which flows, tendencies, trends, fashions are the primary features. The very lack of discreteness in these features and the indeterminacy and lack of predictability of their structures have within a single generation deprived the term "meaning" of its former meaning. Meaning itself is no longer something inherent in things and events, much less placed in them by its authors, but something open to personal interpretation or, in mass-cultural terms, something pliable and subject to endless manipulation, in other words, "history and criticism."

There is, for the first time in history and criticism, the prospect of a general void of meaning. This is not only because meaning itself no longer has a common meaning, but also because the means of its codification—art and science, religion and philosophy—have themselves became voids. It is they that are the unknown spaces whose emptiness is intolerable, and that beg to be filled with human presence. Yet, without meaning of the sort Nietzsche believed essential to interpretation, they will remain (ontologically speaking) empty. While the alienation of people within ambivalent data flows is manifest

# Lebbeus Woods

in existential angst or postmodern languor, fundamentalist revivals or knee-jerk nationalism, it is becoming clearer that the emptiness of space formerly filled with a certain kind of meaning cannot be filled today by anxiety, or apathy, or frenetic consumption, or even by a determined nostalgia for values or ideologies that have been irredeemably lost. These are all "negatives," which can only expand the emptiness. The lack of new "positives" foments a cultural, perhaps a civilizational crisis that is seen most clearly in the various struggles going on now not simply to occupy, but to fill space, to complete space, and to be completed and made whole by it.

It is true that space of the more mundane sort, that which is designed by architects for everyday use, seems as full as ever of human presence, but it is so in precisely the same way that everyday life, in its increasing consumption is more full than ever, yet at the same time more empty. Office buildings, hotels, condominiums, schools, airports, cinemas, spas, private houses, and shopping centers are bristling with human activity, but the purpose of this activity, its "meaning," is becoming less and less certain. Increasingly, the design of space is today spoken of in terms of "flexibility." Even spaces in existing buildings must be considered for their possible "adaptive re-use." The lecture space might become a space for song recitals, after all. But only "might." No one knows for sure. Flexibility and mutltifunctionalism are euphemisms for uncertainty.

Though few are willing to say it openly, it is clear that the most important program for the design of space today is uncertainty. To admit being uncertain, however, to be lacking in determination, is, for most people, and especially architects, anathema. Even if they were willing to face this condition directly, architects are ill-equipped to design for a program of uncertainty. They are trained as positivists, and their entire education and practice has been aimed at affirming explicit cultural contents dictated by their clients, which they believe must be invested, as they always have been, in the discrete things that are both the subjects and objects of design. But as discreteness itself has dissolved in the turbulences of information exchange, architects have reacted much the same as other people, that is, by clinging with greater or lesser desperation to the very conceptions of their activities that are slipping most quickly beneath the waves.

An obvious example is the postmodernist movement in architecture of the past twenty-five years, which has reaffirmed the importance of architectural history and attempted to "reinterpret" the old, "classical" typologies, sometimes with ironical self-mockery, but most often not. The revivifying of various symbols and signs is somewhere a part of this "greedy seizing and snatching" at meaning in the void. However, in a landscape in which distinct

features are effaced by the redundancy and repetition of mass consumption, attempts to resurrect the "thing-in-itself" at extremities of symbolic or typological representation is hopeless.

Architects today display the least humor when iconic forms or spatial ideas from the "heroic" phase of early modernist architecture[11] are invoked. This particular history is resurrected in the hope that its credos still might have, as they once did, the potential for evoking a new set of canonical meanings, or that "the unfinished modern project," is not merely a pretentious disguise for nostalgia. High-tech architects fall into a similar trap, hoping that mechanistic analogies might still hold, that determinism, at least in the cultural sphere, is not dead, or at least that McLuhan was right when he said that a superseded technology is ripe for being transformed into art. Perhaps it is, but by being so, today it can only slip into the flow, increasing the emptiness of culture, without in any way contributing to a culture of emptiness.

The time has come for architects to accept the essential emptiness of space, its voided meanings, its indeterminacy and uncertainty. This might not mean simply jumping into the wayward wagon of the mass media and their continuing devaluation of values and of value, and travelling further into the unchartable fluid-dynamic terrain of the Internet and virtual reality—though it might. Even a cathartic, Dionysian ecstasy in terms of the design of space today is preferable to the desperation of architects, especially young ones, grasping at the conceptual straws of the past. Far better that they simply play, without a conscious plan or preconception in their heads, with their pencils or computers, taking what comes. At least they will manifest the virtues of courage and candor, indispensable for confronting unknowns. But perhaps there is another way.

Perhaps the old logical chains can be dragged a bit further. Perhaps, as the sciences in this century of change have already shown, the foundations of the old systems of thought can be expanded and revised enough to make new virtues out of former sins. This will require the embracing of what was formerly considered paradoxical and self-contradictory, therefore illogical, even irrational. But if concepts such as self-referentiality and chaotic motion— which were, less than a century ago, outside the reach of respectable science[12] —have been successfully incorporated into traditional logical systems, and have even yielded important practical results, then there is no reason why not only the recognition but also the design of the paradoxical space of uncertainty cannot be dealt with "logically" as well.

The concept of "freespace" was introduced in the Berlin Free-Zone project in 1990.[13] At the outset this conception differed from the "universal space" posited by Mies van der Rohe, in that the latter suggested a purely aesthetic *raison d'être*, albeit disguised as (multi)functionalism. Freespace has no

# Lebbeus Woods

function that can be identified in advance, but only a set of potentials for occupation arising from material conditions. Also, the freespaces proposed for the reunited Berlin (and particularly its center, formerly in East Berlin) were conceived outside any known building typologies—historical monuments, museums, state buildings, among others—that the restoration of the symbolic center of modern German culture would inevitably bring. The creation of cultural theme parks, whose purpose is the codification of an older order of authority as well as a lure to the masses now liberated by technology and market capital to become eternal tourists, digging and grubbing for roots, even among the remotest antiquities, who are never satisfied no matter how much they consume, is anathema to present conditions and potentials.

    The Berlin Free-Zone project proposes the construction of a hidden city within the one now being shaped. The hidden city is composed of a series of interior landscapes joined only by the electronic instrumentation of speed-of-

Freespace Structure, Zagreb [1991]
Lebbeus Woods, Architect

light communications, in ever-changing interactions with one another and with a community of inhabitants created only through the vagaries of dialogue. This hidden city is called a free-zone, because it provides unlimited free access to communications and to other, more esoteric, networks at present reserved for the major institutions of government and commerce—but also because interaction and dialogue are unrestricted by conventions of behavior enforced by these institutions.

    The spatial forms of freespaces render them unsuited for the conventional, and demand instead the invention of new ways of occupying space, even new types of activities; hence they are free in a deeper sense, as well—free of predetermined meaning and purpose. A subtle and dynamic relationship between the material realm of architecture and the dematerialized realm of electronic instrumentation is in this way established. This relationship becomes cybernetic in the continuous act of inventing reality.[14]

# The Question of Space

Freespaces are not invested with prescriptions for behavior. Strictly speaking, they are useless and meaningless spaces. The physical difficulties of occupation resulting from the eccentricity and complexity of their spatial configurations (the opposite of an easily assumed neutrality) require occupation to be of a forceful, even adversarial kind. Freespaces create extreme conditions, within which living and working are engaged with a disparate range of phenomena.

Zagreb Free-Zone [1991] Lebbeus Woods, Architect

Within each freespace are located instrument stations. These are electronic nodes containing computers and telecommunications devices for interaction with other freespaces and locations in the world, and with other inhabitants. At the same time, freespaces also include instrumentation for exploring the extrahuman world at every scale, insuring that telecommunity encounters the elements and forces of a wider nature.

Until now, the principal task of architecture has been to valorize social institutions by making them symbols of an urban hierarchy of authority. Today, even though hierarchies necessarily remain, a new type of order, the heterarchy, an order without symbols, is ascendant.

The heterarchy[15] is a self-organizing system of order comprised of self-inventing and self-sustaining individuals, the structure of which changes continually according to changing needs and conditions. In theory, representative forms of government tend towards hierarchy, as do free-market economic systems, although both are today severely compromised by vestigial hierarchies.[16]

Freedom of thought and action are the basis for any heterarchical system, guaranteeing the autonomy of individuals and the changeability and

# Lebbeus Woods

fluidity of the system itself. Heterarchical urban forms are invented in response to increasing emphasis in the present culture on the idea of "the individual," coupled with recent technological developments, such as the personal computer and systems of communication that simultaneously weaken the established hierarchies by accessing the information formerly controlled by them, and strengthen the autonomy of individuals. These technological developments have been based on revisions to conceptions of nature expressed first in relativity and quantum theories, then in systems and information theories, and today in theories of cognition and "chaos." From these emerges a mathematics that feeds directly back into the operation of free and indeterminate ways of conceiving all the sciences and the arts, creating a working understanding of the space of uncertainty.

Berlin Free-Zone section through freespace
Lebbeus Woods, Architect

The manifestation of heterarchies in contemporary cities is largely hidden, because it emerges from within private spaces of work and living. These heterarchies cannot be valorized in the traditional sense of fixed patterns and forms, even though individual habitations remain fixed. Instead, the heterarchies of contemporary community exist as elusive, ephemeral, and continually changing patterns of free communativity.

The Free-Zone in Berlin presents a new matrix of potentialities and possibilities. Built on the free dialogue of self-inventing individuals, nurtured by their continual spontaneity and play, the Free-Zone is a parallel culture by definition, parallel to one of conformity and predictability. But it will be tolerated only so long as it can remain hidden. It will survive in the new, commercialized center of Berlin only so long as its inhabitants maintain their wit and quickness, so long as they are free performers in a self-organizing and secret circus, a cybernetic circus.[17]

The freespaces in Berlin are not overtly aggressive or subversive. Because they are hidden within existing buildings, they are not imposed, but

288

must be discovered by chance or deliberately searched for by people who want to find them. For those who make the choice, these spaces allow, encourage, enable, or demand a confrontation with "a void of meaning," the contemporary condition *par excellence*. They do this by establishing a *terra incognita*, or what is perhaps better called a *terra nova*, a new ground of experience that is not *a priori* encoded with meanings that, for those who can confront the implications of their own freedom, have ceased to have meaning and remain only signs of empty authority, which is the most desperate, the most dangerous kind.

The idea of freespace is nothing new in itself. All designed space, as has already been noted, is abstract and self-referential, following rules that

Reconstruction of an Apartment Building Sarajevo [1993] Lebbeus Woods, Architect; Chris Otterbine, model

underpin particular systems of order. What is new in Berlin (and subsequently in the Zagreb Free-Zone[18] and Sarajevo projects[19]) is the public exposure of this fact, and a subsequently critical position regarding the design of space generally.

All space is freespace.

What is new in its assertion in "the new Berlin" is its attempt to make a virtue out of the former sin of "emptiness," a positive out of a negative, thereby provoking a human presence that may, in its paradoxical way, fill the void of value with the void of space. If this "filling" is not exactly of the former kind, which is to say by a set of mutually held beliefs and commonly agreed upon meanings, then it is by their mutual loss, and the mutual responsibility their loss demands of anyone willing to confront it. The concept of freespace

# Lebbeus Woods

is an assertion that "emptiness" is just another word for "freedom." In free-space, what is lost is the familiarity of architectural and social norms, the reassurance of control by stable authority, and of predictability, certainty, and the routinization of behavior. What is gained is not an answer to the perpetual question of space, but simply a clear articulation of its potential. From this, everything else flows.

# Notes

1. This is the reason that architects must receive a license from the state in order to design public buildings. Their role is to "protect the public health, safety and welfare."

2. The control of behavior is easier than the control of thoughts, although habitual or routinized action tends to routinize thought, as well. Emotions, however, are harder to control. In relatively liberal social systems, they are dealt with therapeutically, at the level either of the family or optional medical care. In more rigid social systems, professional medical care becomes more aggressive, even punitive, as in the psychiatric hospitals of the Soviet Gulag.

3. This argument precludes the possibility of an "anarchic" order, of a society organized on principles of spontaneous behavior and interaction. Perhaps this is understandable, as no society has been organized on these principles to date.

4. His 860 Lake Shore Drive towers (Chicago, 1954?) are two black, steel-and-glass rectilinear prisms, for which he specified that there be only grey drapes at the large, glass windows, in order to preserve the buildings' monolithic appearance; behind these, tenants could put any color and style of drapery they chose.

5. See Tom Wolfe *From Bauhaus to Our House*, (New York: Farrar Strauss and Giroux, 1981).

6. The basic idea is to establish a rigorous analytical process (method) that leads, step by step, to a finished building. The canonical text of this approach was Christopher Alexander and Serge Chermayeff, *Community and Privacy*, (MIT Press, 1967). The assumption is that if one asks the right questions, one will get the right answers.

7. This approach insists that the architect is only the advocate of a particular community of people he or she is trying to serve. The design of any particular building should be determined by the direct input of members of the community for whom it is designed. See Robert Venturi and Denise Scott-Brown *Learning from Las Vegas*, (MIT Press, 1972).

8. Cf. Friedrich Nietzsche, *The Birth of Tragedy*, trans. Walter Kaufmann (Random House, 1967). When Nietzsche speaks of myths, he is being literal. Yet he is also referring to a state of innocence, exemplified by myth, which is essential for belief in anything wholistic, that is, beyond the fragmentary nature of experience.

9. His "eternal recurrence"—to cite one example—anticipates not only a universe that astrophysicists now describe as locked into interminable Big Bang-Big Crunch cycles, but the ontological dilemma posed by such a prospect.

10. The principal effect of the mass media is the destruction of innocence through the continual propogation of undifferentiated information. While the mass media are not "Socratism" in the strict sense that Nietzsche defined it, they are the stepchildren (like all technology) of the ever-questioning sciences.

11. This phase is epitomized in the work of the Bauhaus, between 1919 and 1933.

12. Bertrand Russell's "theory of types" was wrecked on the shoals of the statement "I am a liar." Einstein's paper on "Brownian motion" was about as far as physics (and differential calculus) could go into describing "nonlinear" phenomena.

13. This project has been published in several monographs, including Lebbeus Woods *Terra Nova* (Tokyo: A+U Publishing Co. Ltd., 1991).

14. For a concise discussion of the relationship between the concepts of invention and reality, see Heinz von Foerster, "On Constructing a Reality," in *The Invented Reality*, (New York and London: W. W. Norton, 1979), pp. 41-60. Von Foerster is one of the founders of cybernetics and a proponent (together with Humberto Marturana, Francesco Varela, Ernst von Glaserfeld, and others) of the branch of this field known as "radical constructivism," which has "invented" such concepts as self-organization, circularity, and autopoiesis.

15. *Hieros*: the holy. *Heteros*: the other. Hierarchy is a system of order based on the authority of the whole, which is invested in "one," a leader, an elite, an ideology. Hierarchies produce monologues, pronouncements that issue from a single source, radiating throughout and dominating a system. Heterarchy is based on the authority of many. It differs from so-called collective authority in that only "one" exercises authority at any moment, and thus assumes sole responsibility not only for one's self, but also for others (see Jean-Paul Sartre's *Existentialism and Human Emotions*, (New York: Philosophical Library, 1957) for further exposition on responsibility). At another moment, an "other" exercises authority and responsibility. And so on. Heterarchy subsumes hierarchy. However, it becomes a landscape of continually shifting authority. Thus, heterarchy is always dialogical.

16. As Manuel De Landa argues in his forthcoming book, today's free markets are dominated by anything-but-free monopolies.

17. Circus is used here in both senses of the term: a literal circus, or circular construct implying "feedback," and a setting for performances of a particular, self-referential kind.

18. See Lebbeus Woods, *Anarchitecture: Architecture is a Political Act*, (London: Academy Editions, 1992), pp. 110-27.

19. See Lebbeus Woods, "War and Architecture: Tactics and Strategies," in *Architecture and Urbanism* (A+U), Tokyo, No. 281, (February 1994), pp. 8-33.

# 18

# Becoming-Heterarch: On Technocultural Theory, Minor Science, and the Production of Space[1]

*Michael Menser*

## 1. Introduction: the Technological *Assemblage* and its Cultural Space

The prefix "techno" and its cohort "cyber" have racked up an enormous amount of discursive "frequent-flyer mileage," thanks to their ever rampant employment by critics, academics, and advertisers.[2] With the rapid entrenchment, reproduction, and dissemination of this discourse, one might get the impression that its referent also has no "limit." From genetics and athletic shoes to jet-set academics and TV evangelists, technology has been and continues to be (re)inserted into nearly every cultural field, whether high or low, marginal or elite and regardless of class. Despite all-too-obvious "unequal developments" in terms of various groups' ability to access or acquire more "advanced" technologies, these machines and systems still seem to be everywhere. Even if there are no material apparati in place, the place itself is inevitably affected (as in the case of isolated regions that are polluted) and/or permeated (phenomenologically, perceptually, or semiotically) by technological apparati located elsewhere. Yet it is with this latter set of claims that theory's tendencies towards "totalization" manifest themselves, in spite of the supposed "postmodern condition" of partiality, fragmentation and local, "situated" critiques.[3] In the influential case of Heidegger-brand

phenomenology, the claim is even stronger: we are all placed within this hypertechnological age, whether scientist or farmer, itinerant woodsman or philosopher.[4] According to this view, technology is metaphysics, and unfolds *itself* while it "*enframes*" everything else. The "weaker" version of this argument claims that, although technology is not an "in itself," it is still monolithic and operates "one way," hegemonically "progressing." While this may not be totalization, it invokes its kissing cousin, determinism.

Technology's insertion into the spaces and practices of "private" homes, "corporate" workplaces, "public" spheres, and laboratories, does, however, warrant the hybrid terms, "technoscience" and "cyberculture." These hybrids propose that the technosocial-cultural terrain and its objects are ontologically *complex.*[5] Thus, there is nothing clearly and distinctly describable as science or culture or technology. If one adopts this position, all theories of "monoliths" or an "in-itself" become impossible, as does talk of all-encompassing totalities, unavoidable determinism and global-present universals.

In this essay, we aim to shift the questioning of technology through cartographical investigation of its material-social place. For us, technology is not metaphysics, or hegemony pure and simple, but refers to those technical apparati constructed in a geographical material-social space. We call this space "culture," and (following such theorists and Latour and Haraway[6]), intend to eradicate any fixed and determinate ("clear and distinct") separation between nature and culture—additionally, we do claim that human beings are not the only beings that are "social" and have "agency."[7] Through an appropriation of the work of Deleuze and his collaborations with Guattari,[8] we construct a political-critical ontology designed to make possible a theoretical and material production of space. This is our politics. Our claims are as follows: (1) there is nontrivial heterogeneity among cybercultural and technoscientific practices, and *complexity* within and around their objects. Following Deleuze and Guattari—and *contra*, for example, Heidegger—the lineages of technological development are knotted and linked within historically specific *assemblages.*[9] What is of particular interest in this essay is (2) the significance of the material-social "production of space" that locates these assemblages and their technical apparati (technologies). Therefore, (3) the chief site of our analysis is architecture, and its dependence upon "major" science's organization of labor and materials, which in turn requires the state's production of "striated spaces." It is at this architectural site where we take on state space production and the theories and practices of major science through a counter theory of "heterarchies" and "freespaces," following the work of architect Lebbeus Woods.

## 2. On the State Apparatus

The state is established and reproduced/expanded by way of a two-poled apparatus which, first, *binds* the people and their territory together on a *semiotic-ideological plane*. Operations which bind make reference to the "social contract," nationalism, the myth of the "founding fathers," and so forth (Deleuze and Guattari, 1987, 351–52). Second—and more significant for our considerations—the state *organ-izes* on the *material plane* of persons and bodies. This involves the organization of groups so as to establish and reproduce institutions (akin to Althusser's "Ideological State Apparatuses") and departments on the political-legal-bureaucratic level: police, courts, legislators, educators, military; and on the social level[10]: intellectual and manual labor, owners and workers, employed and unemployed, citizens and non-citizens, private and public, and so on. (Recall, legally, corporations have the status of "persons".) The state's institutional distribution of functions organizes bodies and groups in order to further facilitate dependency among the various divisions, thereby insuring the necessity of the state as an organizing principle. In this sense, the state is what Deleuze and Guattari refer to as an "apparatus of capture." Central to this "capturing" is the principle of *gravitas*. As we shall see in the following two sections, by increasing its mass and density, the state is able to capture bodies (goods, persons, and others) "as"[11] a planet is able to capture a body and make it a satellite. No one group is independent, though one may possess more status and power than others.

## 3. The Ontology of Work

In the seventeenth and eighteenth centuries, Europe was in the midst of establishing itself as the place of civilization *par excellence* via its industrial revolutions and the rise of French, English, Italian, Spanish, and Portuguese imperialism and later of English, French, and German state formations. Central to these ascendancies—which, indeed, produced the "world stage"—was the wedding and rise of the "family" of science and philosophy (fresh from its messy divorce from the Church) whose "offspring" architecture was "instrumental" in the actual building of these states which, of course, made use of a specific (sub)set of technoscientific advances.[12] One of the more fundamental techniques was stone-cutting, crucial to the construction of large churches, bridges, roads, homes, and public buildings. Of particular notice was the construction of Gothic churches, which were born of the will to build churches higher and longer than the Romanesque.[13] In order to "hold together"

the materials necessary to create such large structures, alternative means for cutting stone were employed. This meant that the geometry used for cutting had to change. Under the old Euclidean scheme:

> stonecutting is inseparable from, on the one hand, a plane of projection at ground level, which functions as a plane limit, and, on the other hand, a series of successive approximations (squaring), or placings-in-variation of voluminous stones (Deleuze and Guattari, 1987: 364).

What theoretically "grounded" this process was the quite literal employment of Euclidean mathematics, of flat planes and fixed points seemingly perfect for the practices of stonecutting.[14] However, because of the scale of the buildings, and the weight and size of the stones needed, Euclidean geometry could not "cut it" (and was less effective structurally). Too much stone was involved, the pieces were too large to be cut perfectly square, the technologies were not available to produce such pieces. A switch was made—usually credited to the monk-mason Garin de Troyes (Deleuze and Guattari, 1987: 364)—to a geometry which constructed according to a "theoretical perception" of the cathedral as a variable movement of expressive stone to be followed through space, rather than a structure (pre)conceived as a "form to be filled." The move from "pre-conception" to the variability of "on site construction" indicates an acceptance of both "indeterminacy" in terms of foreground knowledge and receptivity of material's expressiveness (Deleuze and Guattari 1987: 387).[15] In a theory which considers materials to be expressive, properties (e.g., strength, resistance) can be said to inhere in the objects. Indeed the artisan's role is to bring out these properties, allowing for their expression.

This way of building is not less "scientific"; rather, this "[minor] science is characterized less by the absence of equations than by the very different role they play: instead of being good forms absolutely that organize matter, they are "generated" as "forces of thrust" (*poussees*) by the material, in a qualitative calculus of the optimum" (Deleuze and Guattari 1987: 364–65) This mode of building is made possible by what Deleuze and Guattari call "minor science." Through the examination of the division of labor and "treatment" of materials, the cases of minor or "nomad" science violate the discrete sanctity of the castles of technoscience, and, as we shall later see, the state production of space.

## 4. The Matter(s) of Major and Minor Science

There is another plane which comprises the institutions and modes of (re)production and semiotic codings, exchanges, and simulations: the plane of

material-social organ-ization. As we saw in the previous section, major science *homogenizes* matter in order to "prepare" it for instantiation in a form. The possibility of these formations requires the state's consecration of major science's physical and social laws. In the case of physical science, "It is the idea of the law that assures the model's coherence, since laws are what sub-mit matter to this or that form, and conversely, realize in matter a given prop-erty *deduced from the form*" [my emphasis] (Deleuze and Guattari 1987: 369).[16] If a building is sturdy, this is, according to major science, *due to its design*. The property of strength *is assigned by* the form created by the architect, which is "filled in" by builders. If they carry out the plan "properly" (in accordance with the *arché*), then the building will be sturdy. In this sense, architecture, as the literal form of the term suggests, is the construction (actualization) of an *arché* or principle.[17] As we shall later see, this *arché* demands a design that organizes bodies in accordance with functional needs but that is also subordi-nated not to efficacious production in itself, but to the *arché* of the state. Furthermore, the ontology of major science has more to do with the needs of State social organization than any kind of productive efficiency (corporate or otherwise).

Material-social organization crucially requires the production of spaces for the organization of bodies: *major science homogenizes matter and "fixes" its expression through the production of "striated spaces."* Expression is the social-material arrangement of matter in which emergent properties are understood as functional effects. These properties are not derived from form —they are not created through the imposition of human constructions—but inhere in material organization, and emerge through a construction apparati that "treats them" as such. In the case of the Gothic cathedrals, the journey-men participated in the expression of matter in order to build a structure whose size outstripped the Euclidean forms (and the laws they presuppose) of major science. Gothic architecture marks the (local-historical) triumph of a material's expressive power, whereas "prefab," suburban, track housing marks the (local-historical) triumph of architectural forms to subordinate homoge-nized materials which enable a reproduction of the form regardless of the (absence of) properties of these materials.[18]

## 5. On the Gravitational Space of the State

In order for states and major science to organ-ize the social body and properly "prepare" (homogenize) the field of matter, a specific kind of space must be created or utilized.[19] According to Deleuze and Guattari, the

# Michael Menser

state constructs spaces which have a kind of gravitational effect, thereby making it the central organizational organism which attempts to *regulate* (not always successfully) the movements of persons and goods within and through its borders. These movements are made up of the motions of bodies moving from point to point in well-traveled, relatively rigid pathways. This 'laminar' motion requires a space that is segmented, broken up into distinct parts for motion and rest and regulates the size of the movements among these points. (Deleuze and Guattari, 1987: 370). For example, certain trucks are too heavy for certain roads, thus the regulatory "weigh station" run by the State police. Also, one can (legally) sleep in designated campsites but not in public parks or unused buildings. One can ride a bicycle on a city street but not on an inter-state—regardless of whether the proper speed could be maintained. State space is "striated" or gridlike (could there be government without gridlock? Is Ross Perot president?), a Euclidean *metric* which regulates number ($x$ number of persons may ride in an elevator or dwell in an apartment) and motion ($x$ miles per hour is permissible on the "freeway").[20]

The state exerts a gravitational pull both "over" (as with the binding but detached God's-eye at the top of the pyramid on the one-dollar bill) and "under" the bodies within its bounds as well as those going in and out of it (the S.E.C. exerts a gravitational pull on flows of money in financial trading both within the U.S. and overseas). The state's principle abstract machine is *gravitas* and is *real*, not metaphorical (as was noted earlier). The state is a massive, dense, and stratified structure: "in other words, it forms a vertical, hierarchized aggregate that spans the horizontal lines in a dimension of depth" (Deleuze and Guattari, 1987: 433), which binds and regulates bodies by pulling them into and/or pushing them through or out of educational institutions, regulatory agencies, prisons, infrastructural systems, and networks. According to this critical-political ontology, Marx is "Spinoza-ized" to such a degree that he is "surpassed" via a "digging under," through a more radical materialism which "define[s] social formations by *machinic processes* and not by modes of production (*these on the contrary depend on the processes*)" [my emphasis] (Deleuze and Guattari, 1987: 435).[21] What the *gravitas* is opposed to is the Heraclitean hydraulic force (more fully elucidated by "atomists" Democritus and Lucretius (Deleuze and Guattari, 1987: 489–90)). The state *arché* "subordinate[s] hydraulic force to conduits, pipes, embankments," to bridges, tunnels, and interstates, "which prevent turbulence, which constrain movement to go from one point to another" as in the "laminar" motions briefly spoken of above. Furthermore, and just as fundamental, "space itself [is] to be striated and measured, which [then] makes the fluid depend on the solid, and flows proceed by parallel, laminar layers" (Deleuze and Guattari, 1987: 363).

The state also possesses the means to free other bodies from these systems: "unrestricted" (that is, permitted) immigration from Nicaragua, but not El Salvador, in the 1980s; mass-ive flows of venture capital from the US. to Brazil, Peru, and Argentina coordinated by banks but *made possible by* the Reagan Administration and the heads of those countries. Yes, immigrants sometimes "sneak in" ("illegals" from Ireland, Eastern Europe, and Mexico) and capital "escapes," (secret bank accounts). In any case, it is crucial to note the involvement of state apparati in coordination with international capital (NAFTA, GATT, the EC). But, again, we have traveled too far and wide. Let us come closer to home, to everyday technolife, to a site which brilliantly exemplifies the convergences and divergences of the material-social and semiotic-ideological planes and between the nomadic-hydraulic and state-striated. Let us examine the field of ideological materialism and social planning in the enterprise of architecture and the *hieros* of its plane.

## 6. Architecture as State Metaphysics

> There are three straight sides to a triangle—the most stable geometric form—according to Euclid, and a triangular basis to the pyramid, the archetype of all hierarchical architecture, because it is the most perfect hierarchical form. In the pyramid, the apex dominates the base, no matter how large the pyramid, no matter how broad the base. Authority, whether of an intellectual, spiritual or political kind, is invested in this apex, and may be said to flow downward, by a kind of gravity, from it—when it flows at all.
>
> ——(Woods, 1992: 46)

Architect Lebbeus Woods, like Deleuze and Guattari, recognizes architecture's role in the propagation of the state-form and the production—and "castle"-like restriction—of knowledge, the division of labor in material production (intellectual and manual) and the homogenizing of spaces, materials, and, most crucially, the inhabitants and users of these structures.

State science, with its principal of *gravitas*, governs the governed via a systematic and hierarchical "settling" of its constituents into its striated spaces. Within its systems of laminar channels and metric sites, a specific division of labor is (en)forced which forges a codependency that not only makes the architectural "plan" (usually devised off-site) possible, but also makes it dependent upon a corps of workers who *will* actualize the plan and not bring their own plans or ideas to the work site (unlike the Gothic journeymen cited above, who could not be characterized as either "workers" or "architects"). Architecture,

299

which we had previously defined as the actualization of the *arché*, requires the striating of space into a laminar metric, in order to situate the building within this preexisting structuring characteristic of the state.

*What are the conditions of possibility for architecture?* The possibility of the plan and the work-corps presupposes the metric space of the state, with its division of intellectual and manual labor, and the homogenizing preparation of materials. Our next question is: *What are the characteristics of the arché?* First is the formation of an inside. The conditions of possibility are connected to the creation of an interior, and the possibility that human beings and their pets and machines will be able to in-habit this interior (which interestingly requires the "formation" of the habit of being-inside. Surely televisual mass media, VCRs, video games, the proverbial "home entertainment center," and computer technologies have furthered the entrenchment of the privatized inte riorization of the public sphere, and consecrated the position of architecture as the actualizer of the near "monadic" televisual dwelling). As such, there needs to be a source of lighting (natural or artificial, more often than not only the latter is required) and many more things depending upon the function of the building: electrical wiring with a specific power potential, pipes for water and sewage, telephone lines, passageways for entry and exit within and without, and so on. *Can this state architecture be countered?* Yes. It always has been, but the task of producing this counter is as difficult as recognizing it, especially with the so-called poststructuralist theory's inability to elude the grasp of Hegel.[22]

## 7. On Lebbeus Woods' *Anarchitecture*

> "A thing has as many meanings as there are forces capable of seizing it."
> —(Deleuze 1963: 4)

In Lebbeus Woods's "anarchitecture," the *arché* and its organ-functions are literally ripped up or thrown "outside," placed on or along what was once an exterior. Pipes for plumbing or heating or even passageways or storage facilities link together (interior) rooms by traveling along the exterior, popping in and out of windows. Also, seemingly random lines are drawn through the middle of buildings which penetrate walls, (see Woods fig. #3) or travel to other buildings. In these drawings, architecture is not done away with; such a program would be fascistically futile. Rather, it has been dis-placed and destratified. Woods's structures exhibit this displacement through the construction and deployment of patchworks and projections that are propelled by

"lines of flight"[23] out of the sacred sites of form (interior compartments, externalizing surfaces) and function that are based upon some usability index which presupposes the distinction between architectural knowledge-producer and -user (which follows from the previous state distinction between governor and governed).

Woods's structures are two-sided. One is *arché*-ic and organized, the other a *rhizomatic body without organs*. These two do not compose a dialectic of particulars in need of sublation-reconciliation, but instead propose lines of flight that flee the interiorizing organ-functions of the *arché*. Here there is a *"body without organs*, which is continually," and *continuously*, "dismantling the organism"—in this case the architectural site—and producing "asignifying particles or pure intensities to pass or circulate, and attributing to itself subjects that it leaves with nothing more than a name as the trace of an intensity" (Deleuze and Guattari, 1987: 4). As Woods says of his "Aerial Paris" drawings, the "inhabitants of aerial houses have names, but these do not refer to past-future continuities or identities; rather they are expressions of affection, curiosity, disgust, delight" (Woods, 1992: 65). Identity construction *takes place on* the material plane of the event and is not ideally designed or ascribed (Woods, 1992: 64), but instead emerges in the second aspect of the *assemblage*, the plane of enunciation, as an effect or "incorporeal transformation"[24] that is not "abstract" or "transcendental" but emerges indeterministically from a body-space (Deleuze and Guattari, 1987: 108) that recognizes "naturing nature" in the continuum. One's "identity" is no longer identical to itself—the body is not identical to the expressive effects that emerge; instead, the emergent transformations shift as the individual shifts spaces.

Indeed, identity and its politics are undercut. All that is left are *bodies without meanings* (expressive articulations rather than functional organizations) locatable in terms of spatiotemporal positions (which can be either, relatively stationary or in continuous variation), names of affects or effects, but without "definition" in terms of an "overcoding" structure of meaning (signification).[25] The subject, no longer a self-enclosed "I = I" is neither a "fractured" self (the self was never "one"), nor a collection of selves.[26] Rather, the names that dwell in these "heterarchical" spaces refer to individuals who are always dependent upon (that is they always "fall back on"), but are not determined by,[27] a material-space and its objects and vectors. The individuals are defined by spatially situated bodies and their effects, not by regimes of signification that are atemporal (synchronic) or "transcendentally" historical (diachronic).[28] These individuals are becomings, their time is *haeccity*, event or *Aion*, "the floating, nonpulsed time . . . of the pure event or of becoming which *articulates* [my emphasis] relative speeds and slownesses independently of the chronometric

or chronological values that time assumes in other modes" [the time of strat-ified, accumulative, layered and gravitational "Chronos."][29]. This is not the time of subjectification or signification[30] but of becoming, of the individual's dwelling in "smooth space." These individuals are really neither "users" nor "tenants"—both of these terms imply the old division of labor split. Let us call these individuals who think-act-construct smooth spaces "heterarchs," the "other" of the monarch.[31]

## 8. On the Production of Free (Smooth) Spaces and the Buildings of *Bodies without Meaning or Organs*

The architecture that Woods assails is *principally meaningful* because of its functionality (what it is used for) and/or its monumental stature (aesthetic, ideological, semiotic). Woods's countermovements are spelled out in his proposals for "*heterarchitecture*" and "*freespaces*" that call for spaces that are "inherently" meaningless. All that inheres in these patchworks is differ-ence. Meaning must be produced in an incorporeal transformation *conducted* by (as certain materials "conduct" electrical currents and others do not) the heterarchs, not assigned by planners to users and inhabitants. What charac-terizes nearly all of Woods's drawings—from "Berlin Free-Zone" to "Aerial Paris"—is the production of possibilities. Buildings are no longer fixed monuments of function, but "*injections*" into an in-between, perhaps most overt-ly exemplified by those spaces and structures that have been destroyed or aban-doned. For Woods, freespaces do not enforce a unity of meaning and material, but instead "offer a dense matrix of new conditions, as an armature for living as fully as possible in the present, for living experimentally."[32] Freespaces employ matrices rather than metrics. Matrix relations are forged in the time of the event (what Woods calls the "present"): temporality not typology.

## 9. Possibility, not Progress

Heterarchic spaces are projective rather than progress-ive. Progress presupposes the metric space of the grid, of the measurability of lack and accumulation. "We once had $x$ amount, now we have $x + 5$. That is progress, indisputably." Projective space is heterogeneous, not striated-metrical, and what lies within it cannot be "added up." Smooth space is composed of inten-sities that do not "add up" though they may be counted. For example, if one

has two liquids of different temperatures—the first is 60 degrees Fahrenheit, the second 55 degrees—the combining of the two does not produce a liquid that is 135 degrees. However, in the striated space of a quantitative scale, if one has two gallons of water and combines it with four gallons of water, they do add up, and produce a six-gallon mixture. Heterogeneous spaces, such as Woods's projective structures spanning the city street, are not metrical, they are patchworks, composed of materials of different densities or intensities that produce variable conditions within the structure. Yet they also make possible the expansion, detraction, or contraction of the structure because of its patchwork heterogeneity.

## 10. The Space of Difference is Difficult: Against all Commercial-State Prepackaged, User Friendly Multiculturalism[33]

> If someone chooses to live out in the freezing cold and chop wood every day, why should he be forced to go into a flat, have a telephone, pay electricity, rent, water bills? He doesn't want that—all he wants is to be left in peace."
> —(From an interview with a "British" squatter)[34]

Since the water has been shut off and the upper floors of buildings are more vulnerable to shelling and sniper fire, the people of Sarajevo "under siege" have adapted by more intimately and less dangerously dwelling closer to the ground (also because the transportation of water up several flights of stairs, day after day, is rather daunting).

> These buildings were designed not so much for their inhabitants as much as for the social order that sponsored them, an order based on predictability and central planning. Now that this order has collapsed, the buildings are useless, except as monuments to the death not only of certainty, but of its enforcement through the promulgation of large-scale plans. The real scale of life in Sarajevo today is rather small and, in a very tactile sense, intimate. (Woods A+U 1994: 08, Tokyo).

The "perspective" of these buildings was bureaucratic-centralized and the possibility of their functionality and meaning was based upon the construction, maintenance, and defence of a metrical grid of power, water, and phone lines. Once these apparati fail, the buildings fail—even if they remain structurally

intact (lucky enough to avoid shelling)—because the conditions of their possibility (*arché*-ic social order) failed. Even though the building may continue to stand soundly, the *arché* has vanished, and with it, a certain functional capability of that building.

We now have two seemingly "extreme" cases involving the possibility of architecture and its essential link to institutional social order (the state). The cases of the siege and of the squatter stand at opposite ends: one involves unpredictability and collapse, and the other sees sedentarity and wants unpredictability, and in many cases "chooses." Britain is waging a war against the squatters with its proposal of the 1994 Criminal Justice Bill that, on the surface, denies freedom of assembly, but more pervasively, aims to striate the unpredictability of "event-spaces":

> If a police officer "reasonably believes" that ten or more people are waiting for or setting up a rave—defined as 100 or more people playing amplified music characterized by "a succession of repetitive beats"—they can be ordered to disperse; if they refuse they're each liable for up to three months prison or a 2,500 fine [in pounds] even if the event has the permission of the landowner. The police can also turn away anyone who comes within *five miles* of the potential "rave."[35]

The assumption here is that, given a group of *x* amount of persons with certain, all-too-available technologies, smooth space will be produced. In practice, "rave" technoculture has forged an *assemblage* with the squatter culture—which is seemingly, nostalgically antitechnology—largely because each was involved in the nomadic production of space, the irruptive event, a "Temporary Autonomous Zone"[36] that escapingly flees the metric. Although these events are not characterized by violence, there is a production of freespace culture that has been deemed offensive by the British "establishment" (the term's connotation of institutionally entrenched spatiality is crucial in this context precisely because they are productive spatially, if not "economically"). As Woods is engaged in the production of freespaces, the ravers and squatters demonstrate possible social organizations that are too irruptive and nomadic to ever "settle" into a stratified social formation.

Whether the in the case of the dissolution (Sarajevo) or the refusal (squatters) of the *arché*, because these spaces are not prepackaged, they are considered "difficult" by contemporary standards since they "require inventiveness in everyday living in order to become inhabitable" (Woods, 1993: 21). They are not "ready made," "prepackaged," or "user-friendly." Freespaces are for heterarchs, not users. As Deleuze and Guattari warn us, the popular rhetoric that advocates more and better "usability" actually points to a

postuser subordination network that is the latest in the line of postindustrial commercial-social programs for "machinic enslavement," and is perhaps best exemplified by television;

> But one is enslaved by TV as a human machine insofar as the television view-ers are no longer consumers or users, nor even subjects who supposedly "make" it, but intrinsic component pieces, "input" and "output," feedback or recurrences that are no longer connected to the machine in such a way as to produce or use it. In machinic enslavement, there is nothing but transfor-mations and exchanges of information, some of which are mechanical, oth-ers human. (Deleuze and Guattari, 1987: 458)

Much contemporary architecture (especially that of "urban planning") engages the same integrationist, commercial-state, social machines as televi-sion. The heterarch does not "inhabit," but is able to *produce space*, rather than simply plug into the *hieros* edifice of architecture entrenched in the striated metrics of state space. Heterarchs are not "integrated circuits" constructed to process data, they are situated bodies engaged in expressive activity that "press out" effects rather than "processing" data already instituted in (or plugged in to) some regime of truth. As such, *"It is essential that freespaces are, at their inception, useless and meaningless spaces. They become useful and acquire meaning only as they are inhabited by particular people"* [my emphasis] (Woods, 1993: 21). (On this note, the "information suckerhighway" appears as a striat-ed metric for the machinic enslavement of integrationist circuits. It might be said that the Internet's becoming superhighway is directly related to the recent interest in cyberspace's "usability" from a corporate-state perspective and the incorporeal transformation that "takes place" through the deployment of the term "information superhighway.")

## 11. On the Relation of Freespaces to State Architectural Space and the Role of "Minor" Theory and Praxis

As we have emphasized, neither Woods nor Deleuze and Guattari are advocating the eradication or sublation of signification, architecture, or state striated spaces. What they are all attempting is to establish a relational posi-tion to these "structures" that allows for a perception and appropriation that takes advantage of an already existing "outside" (this outside must also be produced, however; it is not given now and forever). Even if we were to grant

# Michael Menser

that theory is (sadly) separated from practice, it is essential for the former to chart and produce these freespaces on its own plane by creating and employing "cartography, pragmatics, rhizomatics, schizoanalysis"—and I would add Haraway's "situated knowledge" and borderland phenomenology[37] (and there are certainly more)—so that these spaces may be perceived as not just possibilities but existent. Furthermore, given our position that major science and theory must literally "prepare the ground" (the striation of space and the homogenization of material) for the institution, consecration, and reproduction of their practices, it is essential that minor science and theory "mix it up" and counter the hordes of blindly totalizing state bureaucrats, neo-Hegelians, "flaccid" (as Haraway call them) genealogists, and deconstructionists who understand difference as lack or loss, and structuralist pessimist-skeptics who confine legitimacy/authenticity to the "powerless" margins.[38] Artisans, heterarchs, nomads, and "minor" theorists all play crucial roles in the construal of arché-ic spaces as permeable and appropriatable, which are produced depending on the material-social needs of individuals not fulfilled (either semiotically or materially as in the case of squatters or victims of a siege). We must recognize and produce the conditions made possible in the matrix (not metric); the expressive, irruptive material-space of the event.

## 12. Further Remarks on Heterarchy

Heterarchy is not "many arché's" but refers to the other (heteros) of the arché. The other can be understood as a movement (not an object) made that forms a dialogic relationship with both materials and human beings, with organic and inorganic life, like Haraway's cyborg and Deleuze and Guattari's artisan who "begins by looking around him- or herself, into all the milieus, but does so in order to grasp the trace of creation, of naturing nature in natured nature; then adopting an 'earthbound position'"(Deleuze and Guattari, 1987: 486). Heterarchy constructs spaces that make possible effects or emergent properties instead of signification bound to an abstract regime of overcoding characteristic of the state and its cohorts.[39] This is not to say that signification must be "overthrown"; rather it is dis-placed—literally robbed of its place—as the individual follows a line of flight along a material-social plane that traverses the divides between nature/culture, human/technological, and organic/inorganic life. This also could be characterized as the much-discussed "return to the body," but one that does not consider the body to be a tabula rasa, ripe for textualization (the signifying kind of incorporeal transformation), but rather a

kind of "creature": a Spinozist "naturing nature" that is creative of itself (expressive), in which properties are not "attributed" by the consecrated subjects and stratified formal institutions of human history, but emerge geographically-materially-socially in events.[40]

In Woods's work, specific sections of buildings are separated from the rest of the larger structures, and linked to other structures standing in or across from the street. Sometimes they are even suspended in the air, as in the Zagreb Free-Zone series (Woods, 1992: 114), as projective patchwork structures assembled on site by local heterarchs employing whatever materials are available. Through the utilization of that which had lost its meaningfulness and functionality (scrap metals or otherwise unused objects or refuse), a structure is assembled "on site," situated within the time of Aion. Thus, meaning is produced as space is produced: by heterarchs through a dialogue among people and materials (as heterarchs and materials vary, so does the meaning). There is nothing "fixed" about these structures: "Complete in themselves, they do not make an exact fit, but exist as spaces within spaces, making no attempt to reconcile the gaps between what is new and old, between two radically different systems of spatial order and thought." (Woods, 1993: 21) This is antidialectical space!

In order to meet the needs for housing or storage space, existing structures are not torn down and then rebuilt. (This requires extraordinary amounts of Chronic time, "major" capital investment, and involves the whole regulatory aspect of the state that aims to reinforce the distinction between governed and governor, and intellectual and manual labor. "If you need a new housing structure you must apply for a permit and contact a licensed architect" who is usually off-site). But is *this* (clearly referent) possible? Could people really do this? Who has the "time," talent, and materials? It is already being done, though perhaps less often (or less recognizably) in this televisual age of postuser viewing, where much of the thinking and activity of human beings resembles the processing of integrated circuits. These "kinds" of structures are built in all kinds of scenarios, in refigured apartments (the construction of a loft) or houses (the transformed garage or "add-on" room) by people of all classes as well as by "homeless" persons who construct sometimes-elaborate structures of scrap metal, plastic, and, all too often, cardboard or plywood.[41] These structures are anti-teleological, always complete and endless, and varying with the needs of the inhabitants, but beyond fixed-use, "user-friendly" functionalism: "architecture writhing, twisted, rising, and pinioned to the unpredictable moment."[42]

# Michael Menser

## 13. Conclusion: On the Practice of Heterarchical Thinking

If technical apparati are assembled within *assemblages*, technology cannot be monolithic. Two points must be made here: although technologies have been developed in many different material-social contexts, those most dominant and pervasive today seem to have sprung from but a few *assemblages*: military and commercial-industrial. While more independent invention still occurs—especially (perhaps?) in the computer industry—it seems that these technologies are somehow "made" or appropriated to serve commercial or military purposes. It is here that the question of space and its relation to the state fully emerges. It is not that technologies in themselves determine a certain usage, but, as Deleuze and Guattari claim, (1) *assemblages* produce technical apparati whose functional capability is largely shaped by the arrangement of material-social production (as we argued, modes of production are derived from these underlying "machinic processes"); and (2) the social production and the kinds of appropriation that follow are made possible by the imposition and reproduction of specifically geographic material-social space(s). Although the reception and functional utilization of technical apparati cannot be determined, the *assemblages* and the spaces in which they operate do "fix" their utilization, although as soon as a spatial shift occurs, the functionality may shift with it. *The primary producer of spaces in our contemporary technocultural landscape is architecture which is largely defined through the arché of the nation-state.* It is not that the state is the great developer of technologies, indeed (extrastate) nomadic groups such as the Mongols were expert in the development of technologies. Rather, the state, through its production of space and organization of bodies, attempts to establish a strict employment of technologies to further the principals (*arché*) that it possesses. Central to the actualization of this *arché* is the ideological practice of architecture.

What the heterarch discerns is the irruptive potential in a material-space; natured nature is revealed to contain or be part of a continuum of "naturing nature." Difference inheres in substance, and produces possibility provided that the "proper" mode of thinking-being is engaged. Woods's project is projective, it is about thinking that makes possible a heterarchic everyday life where meaning is made intimately, in an event of individuals (both organic and inorganic). In the language of "complexity theory," the heterarchical assemblage is a "self-organizing system," in which properties emerge from the formation of new relations and distributions (densities). Properties are not attributed to individuals through the imposition of some form.[43] In the architecture of social order, individuals are homogenized in social-material and semiotic strata; they become subordinated inhabitants of the interior without

meaning. In war there is "loss of meaning," but the collapse of the *arché* makes possible possibility. In the case of the abandoned buildings seized by squatters, meaning is produced by these heterarchs, as the space is transformed through the assembly of scrap materials that make a different kind of living possible. As Woods says of his "Aerial Paris" drawings, *"Antigravity refers to the struggle, tension, anxiety and a restless assertion of the kinetic and animate against stasis"* (Woods, 1992: 64) The utopia of consensus is the ally of gravity. Aerial houses—or squatter-dwellings or rave sites—are like the individuals who inhabit them: "extremely expansive and three-dimensional, striving always for plasticity, freedom of movement and a continuous victory over gravity" (Woods, 1992: 64) and *gravitas*.

In Woods's drawings, the spaces are always indefinite, projective, never clearly demarcated, "finished" or finite. They are momentary, not monumental. The spaces are smooth patchworks of continuous variations, which resemble the heterogeneous communities and materials that bring them about. The links are tactile and intimate, yet temporary (as are those in a siege). Striated "integrity" and identity are born of the homogenizing metric's divisive grid, and are rejected. These ideal divisions are undercut by squatting on the material plane of nomadic movements-projections and events. How could squatters be considered to be part of Heidegger's "standing-reserve"? Even amidst the striated environs of Britain, they have produced smooth spaces. The imposition of state space is never automatic; it requires struggle and *gravitas*. It requires not only the enforcement and development of legal apparati, but also the consecration of a mode of thinking which denies difference and possibility. Some may look at Woods's "Aerial Paris" drawings and exclaim, "This is not possible! There are buildings in the sky, for crying out loud! He ignores gravity." However, *gravitas* is not a given for always and everywhere (there are no universals), but is enforced in a struggle. The state constantly struggles to striate the hydraulic flows of illegal immigrants, squatters, the homeless in the streets or the river overflowing its laminar banks. We cannot stress how important Woods's heterarchitecture is as a demonstration of the inhering relation between thinking and acting-building. That is why we have chosen to dwell in the space of architecture, in the site where thinking appears as both ground and effect, reciprocally related to the production of space (architecture), yet oriented within the state space that entrenches and makes possible architecture; but it also fails, despite itself, to make heterarchitecture impossible. There are two positions at issue here; one, of the architect who becomes artist-heterarchitect; and two, of the inhabitant who becomes artist-artisan (heterarch).

The task of heterarchitect is "to inscribe space and time with the paradoxical dimensions of a relativistic 'I', which is situated on the material plane

of the event and its individuals. "The architect is a designer of space, not of living. The spirit of invention demanded by the perpetual war of change thrives best in space shaped by invention"(Woods, A+U 1994: 02, Tokyo; 16). The heterarchitect produces smooth space, the space of naturing nature that has no terminus or end, but instead offers connectivities and possibility. Here we have a conflation that smoothes over the intellectual/manual labor split, and makes the governed into governors, into deactualizers of the *arché* who institute the time of the event, of naturing, of following the paths of assembly, of building towers in the street, of squatting in buildings abandoned by the homogenized tenants who were unable to appropriate *arché*-space. The heterarchitect creates freespaces not for work, but for "free action":

> Work is a motor cause that meets resistances, operates upon the exterior, is consumed or spent in its effect, and must be renewed from one moment to the next. Free action is also a motor cause, but one that has no resistance to overcome, operates only upon the mobile body itself, is not consumed in its effect, and continues from one moment to the next. (Deleuze and Guattari, 1987: 397)

Woods's freespaces are material constructions that do not fill some metrical space, but are projective, producing, and appropriating their own spaces. These projections produce temporary bodies, *"perpetuum mobile,"* which do not involve linear displacement from point to point, but escape the gravitational metric "to occupy absolutely a nonpunctuated space" (Deleuze and Guattari, 1987: 397). Buildings become weapons that violate without violence: heterarchitecture "must learn to transform the violence, even as the violence (of wars, the Criminal Justice Bill and sieges) knows how to transform the architecture" (Woods, 1993: 24). Here minor science and theory follow heterarchitecture in order to become a situated war machine that violates the metric with its recognition and production of smooth projections and injections, yet avoids the all-too-often inconsequential and vulgar violence of the battle, since it never aims to "hold" or "capture." It is not defensive but elusive, producing its own spaces for slippage; *to give possibility (heterogeneity) to technologies we must become engaged in the production of spaces*—dwellings and "Untimely Meditations" at the *fin de siècle*.

## Notes

1. I would like to thank Stanley Aronowitz, Barbara Martinsons, Mike Roberts, and Jenny Rich for their editorial help. Additional credit goes to Paul Mittleman, Wayne Van Sertima, Lebbeus Woods, and Robert Eggert for the many engaging discussions concerning architecture, technology, and philosophy.

2. The figure who somewhat embodies all three of these is, strangely enough, author William S. Burroughs, whose archives are institutionalized at Kansas University and who now does Nike commercials. From Dr. Benway to Air Jordan and Bo Jackson. . . .

3. It is fascinating to note that as much "postmodern" theory struggles to retreat from totalization and universals, technology moves forward.

4. Much of this essay can be seen as an implicit critique of Heidegger's position that technology is metaphysics and its essence is *Gestell* ("enframing"), especially insofar as the anti-totalizing terms "*assemblage*" and "smooth and striated spaces" are employed.

5. See Aronowitz and Menser, this volume.

6. In *We Have Never Been Modern* Bruno Latour's theory "quasi-objects" attempts to posit such complexity: "Quasi-objects are in between and below the two poles, at the very place around which dualism and dialectics had turned endlessly without being able to come to terms with them. Quasi-objects are much more social, much more fabricated, much more collective than the "hard" parts of nature, but they are in no way arbitrary receptacles of a full-fledged society. On the other hand they are much more real, non-human, and objective than those shapeless screens on which society—for unknown reasons—needed to be "projected" (p. 55). In her essay "A Cyborg Manifesto: Science, Technology, and Socialist-Feminism in the Late Twentieth Century," in *Simians, Cyborgs and Women*, (New York: Routledge, 1991), 149–82, Donna Haraway's infamous "cyborg" is a brilliant model that expresses the social, technological, corporeal, and semiotic complexity pursued in my essay.

7. Also within this tradition are scientists such as Jacques Monod, Ilya Prigogine, and Isabelle Stengers and more contemporary practitioners of complexity theory in mathematics, physics, computer science, and more rarely in the humanities and social sciences (Manuel De Landa bridges many of these divides).

8. The works especially crucial to this essay are Deleuze and Guattari's *A Thousand Plateaus*, trans. Brian Massumi (Minneapolis: University of Minnesota Press, 1987) and *The Logic of Sense*, trans. by Mark Lester with Charles Stivale, ed. Constantin Boundas (New York: Columbia University Press, 1990).

9. Deleuze and Guattari understand the *assemblage* as a historically specific configuration of material, social, pragmatic, and semiotic components that envelops a territory and produces "emergent" properties (that is, it is more than the sum of its parts. As such, *"Assemblages* are passional, they are compositions of desire. Desire has nothing to do with a natural or spontaneous determination; there is no desire but assembling, assembled desire"[Deleuze and Guattari, 1987: 399]). A noteworthy example is the "man-horse-stirrup" assemblage, elucidated by Lynn White, which dramatically effected travel, communications, and war in Medieval Europe (Deleuze and Guattari, 1987: 398–99, 560–61)

10. These two "levels" are not strictly (ontologically) separate but do involve two different kinds of organizational operations.

11. "As" does not indicate "metaphor" in this context, but instead claims that in these two instances of state and planet, there is an equivalence of relations among objects: bodies are captured according to the same "rules" when one deals with (always relatively) large, dense entities, whether States and persons or planets and moons. What the "as" refers to, then, is that each invokes or participates in the same abstract machine, the one of *gravitas.*

12. I am not arguing that architecture is "born" at this moment, yet it is perhaps "born again," and, more recently, seems to be further integrated into social planning despite the triumph of any supposed "postmodern aesthetic." For more on this topic, see Lebbeus Woods, this volume.

13. Deleuze and Guattari, 1987: 364.

14. I refer to the theoretical ground as a "what" in order to point out that theory is not merely epistemology but plays in this case a literally ontological role in the conversion of earth into a "foundation" for building. We shall later argue that theoretical practices "prepare" the earth for the production of spaces and organization of material-social practices.

15. On the advocation of an architecture of indeterminacy, see Woods, this volume.

16. For a comprehensive critique of theories of physical law which presuppose general forms and the instantiation of particulars see Deleuze's *Difference and Repetition,* trans. Paul Patton (New York: Columbia University Press, 1994), especially chapter one.

17. For a Heideggerian deconstruction of the *arché* in the terrain of politics and social action, see Reiner Schürmann's *Heidegger on Being and Acting: from Principles to Anarchy,* trans. R. Schürmann and Christine-Marie Gross (Bloomington: Indiana University Press, 1990).

18. "Prefab" housing does not require "good" building materials but rather relies on a formal structure to assign properties (strength, impermeability, etc.) to materials. Indeed, it would be foolish to use "good materials" for such formal projects since the properties of the materials could not be taken advantage of.

19. For a thorough discussion of the importance of the construction of social spaces, see Henri Lefebvre's *The Production of Space,* trans. Donald Nicholson-Smith, (Cambridge, MA: Blackwell, 1991). As Lefebvre points out, the state does not always create its spaces but appropriates others, which are constructed either "naturally" or "socially."

20. We emphasize metrics and grids as instances of striated spaces because of their recognizability and intelligibility as such, but there are other less perceptible instances.

21. Spinoza-izing Marx involves the injection-recuperation of materialist ontology so wonderfully done in Spinoza's *Ethics.* For lengthy elaborations of the heavily ontological issues involved here see Deleuze's *Expressionism in Philosophy: Spinoza,* trans. Martin Joughlin, (New York: Zone Books, 1990). For a discussion in terms of Marx and the undercutting of historical materialism, see *A Thousand Plateaus* especially the chapters "Geology of Morals" and "The Apparatus of Capture." Although Marx is more overtly dealt with in *Anti-Oedipus,* trans. Robert Hurley, Mark Seem, and Helen R. Lane (Minneapolis: University of Minnesota Press, 1983), the discussions are more centered around psychoanalysis and desire (especially Nietzsche, Freud, Reich, Artaud, and Lacan) and less within the issues of our essay. It is our prejudiced view that *A Thousand Plateaus* makes a more radical break with Hegelian-Marxist "historical materialism" than *Anti-Oedipus* because of its return to Spinozist-Marxism (materialist cartography) and break from epistemology.

22. Two notable works on this topic that are against Deleuze and Guattari are Arkady Plotnitsky's *In the Shadow of Hegel: Complementarity, History and the Unconscious* (Gainesville: University Press of Florida, 1993) and Judith Butler's *Subjects of Desire.* (New York: Columbia University Press, 1987). For a critique of Butler from the perspective of Deleuze and Guattari, see Michael Hardt's *Deleuze: an Apprenticeship in Philosophy* (Minneapolis: University of Minnesota Press, 1993) and more tangentially, Rosi Braidotti's "Towards a New Nomadism: Feminist Deleuzian Tracks; or, Metaphysics and Metabolism" in *Gilles Deleuze and the Theater of Philosophy,* ed. Constantin Boundas and Dorothea Olkowski (New York: Routledge, 1994) 157–86.

23. "*Fuite* covers not only the act of fleeing or eluding but also flowing, leaking, and disappearing into the distance (the vanishing point in a painting is a *point de fuite* ). It has no relationship to flying." (Deleuze and Guattari, 1987: xvi, note by translator Brian Massumi).

24. "Bodies have an age, they mature and grow old; but majority, retirement, any given age category, are incorporeal transformations that are immediately attributed to bodies in particular societies" (Deleuze and Guattari, 1987: 81). Effects come from expressive bodies while incorporeal transformations mark new possibilities for the signification of bodies.

25. For a discussion of "overcoding," see especially Deleuze and Guattari's *Anti-Oedipus.*

26. For a comprehensive treatment of Deleuze's notion of subject see Constantin Boundas's excellent piece in the anthology *Deleuze and the Theater of Philosophy.*

27. Individuals "depend upon" a space, since the possibility of possibilities requires a certain kind of smooth space; however, individuals are not determined by this space, since any number of expressive effects may "take place," depending upon the kind of assembly that results.

28. How could diachronic signification be "transcendentally" historical? Because, following the tradition begun with Hegel (the apogee of Platonism?), and not escaped by Saussure or Lacan, any possibility of difference inhering in substance is "overridden," geography and geology (space and materiality) appear as accidental differences that are transcended by history.

29. Briefly, within the time of Chronos, "the present is in some manner corporeal" and can be measured and described in terms of "states of affairs." Chronos is "clock time" and is as divisible as technologies allow: from sundial to digital to atomic. Because it is incorporeal, the Aion is infinitely divisible, continuously folded and unfolded rather than metrically fractured (striated) and accumulated-counted (Deleuze, 1990: 61–65, 162–67). These two times are mutually exclusive, yet necessary (61).

30. There is a "semiotic" here, but one of "*Indefinite article + proper name + infinitive verb* constitutes the basic chain of expression, correlative to the least formalized contents, from the standpoint of a semiotic that has freed itself from both formal signifiances and personal subjectifications" (Deleuze and Guattari, 1987: 263).

31. The heterarch is not the other of the monarch, as the slave is the other of the master, or the governed is the other of the governor. The heterarch is outside these reciprocal dichotomies of mutual dependence. He or she is the "third term" of in-between space. For example, in Deleuze and Guattari's scheme, the opposite of the sedentary dweller is the migrant, one who must move to find work, the one defined in terms of a "lack." The other of this dichotomy is the nomad or artisan who moves through a different space and follows the expressive traits of matter found in the

"machinic phylum." These latter two, although not equivalent (Deleuze and Guattari, 1987: 409–410), exist outside the dichotomies of the state's metric space-economy. Although they still bear a relation to it, it is not one of codependence or mutual presupposition (Hegelian style dialectical dualism). The relation of the nomad and artisan to the State is Janus-faced; one side connects, the other side escapes along a *ligne de fuite* or as a rhizome forges connections apart from the hierarchical roots-trunk-branches of the tree.

32. See Lebbeus Woods, *War and Architecture* (Princeton, New Jersey: Princeton Architectural Press, 1993).

33. The latter half of this title follows from but is not explicity discussed in this section.

34. Interview with a "squatter" in Joy Press' article "The Killing of Crusty," *Spin*, Vol. 10. #7, (October 1994): 76.

35. Press, p. 69.

36. The title of a treatise on "poetic terrorism" and heterarchical event spaces by Hakim Bey, *T.A.Z.: The Temporary Autonomous Zone, Ontological Anarchy, Poetic Terrorism* (New York: Autonomedia 1991).

37. See Aronowitz and Menser, this volume.

38. I hope it is clear from the expressionist (Spinozist) materialism offered here that, *heterarchs don't do identity politics* (it reeks of what Deleuze's *Nietzsche* calls the reactive significance of "slave morality." I owe this point to Stanley Aronowitz.) But instead, they construct an expressive rather than signifying semiotic in the event (haeccity).

39. This is not to say that signification must be "overthrown" or put down once and for all. Rather, it is claimed that signification may be surpassed given a specific situatedness in a smooth (nonmetrical) space.

40. This point is presupposed, but not fully explicated by Donna Haraway in her "Cyborg Manifesto" and "Situated Knowledge" essays in *Simians, Cyborgs and Women*. I have briefly addressed this point in the discussion of the apposite of "homogenization" in "Major and Minor Science." The basic claim is that *difference inheres in substance*. This claim is similar to Heidegger's claim that "things have a history of presencing all to themselves," that is, without the subjectification done by human beings, however the two statements occur on different planes. For a extremely comprehensive discussion of difference which is *contra* Heidegger and especially Hegel and his lackeys, see Deleuze's *Difference and Repetition*. For a more contextualized discussion of difference's inhering in substance and its relation to signification and the material plane ("machinic

phylum"), see Deleuze and Guattari's "The Postulates of Linguistics," "The Geology of Morals," and "The Treatise on Nomadology—the War Machine," all in *A Thousand Plateaus*.

41. In New York City these kinds of structures can be seen in the "no man's land" between the West Village and the warehouse district, under bridges, and along various undeveloped waterfront sites.

42. Lebbeus Woods, *Lebbeus Woods. Anarchitecture: Architecture is a Political Act* , (New York: St. Martin's Press, 1992), 40.

43. This is currently the case in Haiti, where democracy is seen as that form which the Haitians were unable to maintain—they indeed elected Aristide but were not able to keep him in power. The degree to which the population must be further homogenized remains to be seen. Surely, much deskilling through migration, the closing of schools and death squads has taken place. But to the degree that democracy has been conjuncted with capital formations, Haiti is still not "user-friendly" enough for mass-productionist, "free-market" consumption-oriented machinic enslavement. Given that, we may state, with certain contemporary physicists, that ("historical") time is reversible. Perhaps Haiti will revert to an earlier social formation. Only time will "tell" (maybe).

# Contributors

**Stanley Aronowitz** is Professor of Sociology and Director of the Center for Cultural Studies at the Graduate School and University Center/CUNY. He is the co-author of *The Jobless Future*.

**Jody Berland** is Professor in the Department of Humanities at York University in Toronto. She teaches courses in Women's Studies and Cultural Studies.

**Philip Boyle** Ph.D. is an Associate for Medical Ethics at the Hastings Institute in Briarcliff Manor, New York.

**John Broughton** is Professor of Developmental Psychology at Teacher's College, Columbia University in New York City.

**Manuel De Landa** is the author of *War in the Age of Intelligent Machines*.

**Samuel R. Delaney** is a well-known novelist and a Professor at the University of Massachusetts at Amherst.

**William DiFazio** is co-author with Stanley Aronowitz of *The Jobless Future*. He is Associate Professor of Sociology at St. John's University in Brooklyn, New York.

# Contributors

**Arthur Kroker** is Professor of Political Science at Concordia University in Montreal. He has written about contemporary culture including art, music, and technology.

**Emily Martin** is Professor of Anthropology at Princeton University.

**Barbara Martinsons** is a graduate student in Sociology at CUNY. She is a member of the Found Object collective and is the Associate Director of the Center for Cultural Studies at the CUNY Graduate School.

**Michael Menser** is a Ph.D. candidate in Philosophy at the Graduate School and University Center/CUNY. He teaches philosophy at Brooklyn College.

**Dorothy Nelkin**, a pioneer in the social study of science, is Professor of Sociology at New York University.

**Jennifer Rich** is a Ph.D. candidate in English and American literature at the Graduate School and University Center/CUNY. She is a member of the Found Object collective and teaches English composition and literature at the Borough of Manhattan Community College.

**Andrew Ross** is Professor of Comparative Literature and American Studies and the Director of the American Studies Program at New York University.

**Sharon Traweek** is the Director for the Center for Cultural Study of Science, Technology, and Medicine at UCLA. She is the author of *Beamtimes and Lifetimes.*

**Ralph W. Trottier** is Professor of Pharmacology at the Morehouse School of Medicine in Atlanta.

**Peter Lamborn Wilson** is author of *Sacred Drift: Essays on the Margins of Islam,* available through City Lights Press.

**Lebbeus Woods** is co–founder of the Research Institute for Experimental Architecture. He is Visiting Professor of Architecture at Cooper Union in New York City.

**Betina Zolkower** is a Doctoral candidate in Sociology at the CUNY Graduate School.

# Index

# Index

# Index